Over Exposed

Over

Exposed

ESSAYS ON
CONTEMPORARY PHOTOGRAPHY

Edited by Carol Squiers

The New Press
NEW YORK

Compilation © 1999 by Carol Squiers. All rights reserved.

Library of Congress Cataloging-in-Publication Data

Over Exposed: Essays on Contemporary Photography / edited by Carol Squiers.
 p. cm.
1. Photography, Artistic. I. Squiers, Carol.
TR642.C74 1999
770'.9—dc20

99-81357

Published in the United States by The New Press, New York
Distributed by W. W. Norton & Company, Inc., New York

The New Press was established in 1990 as a not-for-profit alternative to the large, commercial
publishing houses currently dominating the book publishing industry. The New Press operates in
the public interest rather than for private gain, and is committed to publishing, in innovative ways,
works of educational, cultural, and community value that are often deemed insufficiently profitable.

www.thenewpress.com

DESIGNED BY ANN ANTOSHAK

Printed in Canada

9 8 7 6 5 4 3 2 1

Contents

CAROL SQUIERS

Introduction

THE INTEGRATION of photography into the art market, the academy, and the art museum continued at an escalated pace during the 1990s, while at the same time the death of photography was being proclaimed. Digital technology had supposedly killed the medium, at least in its traditional form. But the death of photography, like the end of history, is probably just wishful thinking—another method of backing away from the social, political, and visual complexities with which photography presents us.[1] *Over Exposed* was compiled in the belief that discussions of those complexities will be as important in the twenty-first century as they have been during the previous century.

This is not to say that digital technology will not alter the still photograph in as yet unrealized and profound ways: it has done that already. The photograph is malleable in a way that it never was before and that raises new questions, a circumstance that both Geoffrey Batchen and Tim Druckrey consider in this volume. But the same questions that have been addressed thus far in relation to issues of photographic representation in terms of race, ethnicity, feminist, gay, and lesbian issues; social policy; mass media; propaganda; advertising; etc.; will continue to be important regardless of the technology with which images are made.

This collection is based on an earlier book, *The Critical Image*, which was produced in the late 1980s, in the midst of protracted cultural attacks on both "high" art and popular culture by conservative politicians, right-wing activists, and assorted reactionary opportunists. As the book was going to press, the concerted warfare of the right targeted photography—by Andres Serrano and Robert Mapplethorpe—as a way to assault and dismantle the National Endowment for the Arts (NEA) and attack the difference that the

1. See Francis Fukuyama, *The End of History and the Last Man* (New York: The Free Press, 1992).

photographs expressed.[2] The images by Mapplethorpe and Serrano were read by conservatives as proof that a radical cultural agenda was being promoted by artists and the art world, which, with its support of multiculturalism, feminism, and gay and lesbian politics, was antifamily, antireligious, morally corrupt, pornographic, and anti-American. The fallout from this campaign of cultural reaction continues, and will be with us for the foreseeable future.

Despite all attempts, however, the NEA and its Congressional allies have forestalled the Endowment's destruction. Instead, the attacks had the ironic and unintended result of directing public attention to photography as a medium, as well as widely disseminating the images in question. This particularly modern effect of provocative news coverage proves once again that in the art world as in Hollywood, there's no such thing as bad publicity, or at least that bad publicity does not automatically sink the object of its disapprobations.

Since the mid-1970s, photography has enjoyed several boom-and-bust periods of public interest and market growth. It achieved a modest position alongside the other fine arts in the early 1970s when conceptual artists began using it as an ideational medium. In the 1980s, the preeminence of the art grouped under the contested rubric of postmodernism—which was largely photographic—gave photography a legitimacy in the art world that had been lacking until then. The postmodernist artists used photography to challenge ideas of what constituted the proper subjects for art as well as accepted notions of photography itself. Traditionalist supporters of the medium were outraged by postmodernist art, especially because of its uses of appropriation and quotation. Others responded to the work's intellectual complexities, visual inventions, and subversive strategies. In the process, the heretofore insular ghettoes of the photography community and the art community began considering one another more seriously than ever before.

In particular, postmodernist art made collectors look more earnestly at the medium as a whole. During the 1980s, care was taken to distinguish artists-who-used-photography from mere photographers. But the fact that the postmodern artists *did* use photography inspired a greater interest in the medium. Although photography had already been integrated into the market as a collectible, its value actually increased after the 1987 stock market crash, which negatively impacted an inflated art market swollen by the corporate-takeover, tax-cutting windfalls of Ronald Reagan's rule. When the dust began to settle on Wall Street in the early 1990s, the traders, bankers, and chief executives again wanted to buy art—but not the extremely large and expensive art that they'd been consuming in the previous decade.

2. These stories have been told many times, and so will not be repeated here. See *Culture Wars: Documents from the Recent Controversies in the Arts*, ed. Richard Bolton (New York: The New Press, 1992); Edward de Grazia, *Girls Lean Back Everywhere: The Law of Obscenity and the Assault on Genius* (New York: Vintage Books, 1992), chap. 30; Marjorie Heins, *Sex, Sin, and Blasphemy: A Guide to America's Censorship Wars* (New York: The New Press, 1993).

Photography was one answer to downsized expectations and lower rates of return. It was mostly smaller in scale and lacked the muscular bombast of the painting of the 1980s. It was also sleek, modern looking, and seemingly accessible in a way that a lot of painting and other types of art wasn't. And it was much cheaper: a compelling photograph by a well-known photographer could be had for a fraction of what a painting by a comparable talent cost.

Along with generating collector interest, the medium has made major incursions into museums, which is dependent on collector generosity. In the 1990s two major New York institutions—the Solomon R. Guggenheim Museum and the Whitney Museum of American Art—began photography collections, while other institutions across the United States increasingly featured photography exhibitions. Photography became the hot art form of the '90s, driven by both a dawning appreciation of the medium's significance and the kind of publicity created by fashionable forms of culture.

Photography's first serious postwar incorporation into the art market occurred in the early 1970s, when photo auctions began to move from the province of the rare book dealer to that of the art specialist, and a few photography galleries opened.[3] The medium's most powerful proponent in the United States in that era was John Szarkowski, director of photography at the Museum of Modern Art in New York, who enunciated an elegant, but limited set of formal parameters that wanted to consider "the medium's fine art tradition and its functional tradition as intimately interdependent aspects of a single history."[4] One result of this totalizing desire to see the entire medium as a singular ontogeny was that a small group of photo historians, photo dealers, and curators created a discourse about photography based mainly on the *look* of the images—and, with a few exceptions, largely marginalized the popular, social, commercial, and political *uses* and *meanings* of photography.

By the mid-1970s, however, a counter-history (or series of counter-histories) of photography was being written, which interrogated the foundations on which its history had thus far been built. Essays by people such as Allan Sekula, Victor Burgin, and Martha Rosler, and, slightly later, John Tagg, Rosalind Krauss, and Abigail Solomon-Godeau, drew on a variety of critical and political theories, including Marxism, structuralism and semiotics, poststructuralism, feminist theories, and psychoanalysis, by thinkers such as Walter Benjamin, Roland Barthes, Jacques Derrida, Michel Foucault, Louis Althusser, Julia Kristeva, Jacqueline Rose, Laura Mulvey, and the

3. For early photo collecting and auction information, see Denise Bethel's valuable article, "At Auction and in the Book Trade: Sources for the Photography Historian," *History of Photography* (Summer 1997), pp. 117-128. I'm grateful to the author for supplying me with this article. For information on photography collectors, see John Pultz, "Collectors of Photography," in *A Personal View: Photography in the Collection of Paul F. Walter* (New York: The Museum of Modern Art, 1985).

4. John Szarkowski, *The Photographer's Eye* (New York: Museum of Modern Art, 1966; second edition, 1980), p. 4.

Russian Formalists, which were deployed to plumb the meanings and construction of photography across a variety of discourses, rather than merely its formal attributes.[5]

Over Exposed proceeds from the foundations laid by such work. The intention has been to provide a collection of essays that address multiple issues across the spectrum of contemporary—rather than historical—photography. The essays have been drawn from a variety of theoretical and critical perspectives that deal with different genres and arenas of photography, including photojournalism, digital technology, fashion photography, postmodernist and other kinds of art photography, advertising, pornography, images of women, and photographs of people with AIDS.

One of the overriding themes of the book is the primacy of issues relating to gender, sexuality, and sexual difference as they are constructed in and contested through photographic images. Gender issues are read across a range of photographic practices and cultural regimes by several writers, including fashion photography, pornography, art photography, and the portraiture of AIDS.

"The Pleasures of Looking: The Attorney General's Commission on Pornography versus Visual Images," by Carole S. Vance, provides a good historical context for the "culture wars" that began during Ronald Reagan's presidency (1980-1988) and continue into the present.

The traveling roadshow that was mobilized by Attorney General Edwin Meese as an official "commission on pornography" in 1985-86 gave government support to the demonization and censoring of erotic and sexual materials of all types. With its sensational presentations and public attacks, it paved the way for the assaults by conservative activists and their politician-minions on photographs by Alice Sims, Andres Serrano, Robert Mapplethorpe, Patti Ambrogi, Jock Sturges, the exhibition about AIDS, *Witnesses: Against Our Vanishing*, and a variety of other artists, students, commercial photographers, magazines, and websites.

Conservative attacks succeeded in virtually dismantling the NEA. But the assaults continued even after that victory, against rap music, literature, television programming, children's books, and, of course, photography. Jock Sturges, for instance, was in 1997 and 1998 again harassed by right-wing protests staged at bookstores—which included the destruction of his books—and various state attorneys general were goaded into prosecuting the Barnes

5. Among the earliest texts that I'm aware of are Allan Sekula, "On the Invention of Photographic Meaning," *Artforum* (January 1975); Victor Burgin, "Photographic Practice and Art Theory," *Studio International* (July/August, 1975); Martha Rosler, "Lee Friedlander's Unguarded Strategies," *Artforum* (April 1975). John Tagg's essays from the late 1970s to mid-1980s are collected in *The Burden of Representation: Essays on Photographies and Histories* (Amherst: University of Massachusetts Press, 1988). As co-founder of the journal *October 5*, Rosalind Krauss has both written about and commissioned writing on photography, commencing with *October* (Summer 1978). Abigail Solomon-Godeau's essays are available in *Photography at the Dock: Essays on Photographic History, Institutions, and Practices* (Minneapolis: University of Minnesota Press, 1991).

& Noble bookstore chain for carrying his books.[6] Vance's essay illuminates a moment when conservative morality began decisively shaping public policy as it relates to sexuality, representation, and culture.

But although the right was trying to eradicate the imagery of sexual pleasure and sexual difference, artists and photographers continued creating such images within communities of affective as well as critical support. Deborah Bright provides a history of contemporary self-representation by lesbians—photographic and otherwise—in "Mirrors and Window Shoppers: Lesbians, Photography, and the Politics of Visibility." She discusses the development of subcultural dyke imagery, from "positive images" of lesbians to erotic imagery and the sexually explicit and S&M photography of the 1980s and '90s. She shows how the various lesbian photographies, far from being created in subcultural isolation, have been produced across a range of contexts, including the mass media, feminism, AIDS and the political organizing it spawned, queer-'zine publishing, postmodernist art, reactionary politics, the antipornography movement, corporate marketing strategies, and Clinton administration policies.

One group that sustained heated conservative attacks was gay men, who were demonized not only for their sexual orientation but because AIDS hit the gay community with particular force. The issues of AIDS as an ailment and as a subject for photography was hotly contested until fairly recently, when, as Jan Grover points out, AIDS was "normalized" as just another ailment and it stopped receiving much media attention.

Grover's essay takes a retrospective look at how AIDS was depicted from the time the condition began to be covered in the 1980s—by artists and photojournalists—and how visual representations of people with AIDS (PWAs) changed in the '90s, when the initial hysteria quieted down and new drug mixtures helped reduce the visual symptoms and marks of AIDS. She examines the real differences in discursive practices and representations made by people who are part of the HIV/AIDS communities, who have a complex, humane vision of AIDS, and people who are outside those communities.

Another piece that considers gay representation—along with issues of alterity, race, modern and postmodern aesthetics—is "Mortal Coil: Eros and Dias-pora in the Photographs of Rotimi Fani-Kayode," by Kobena Mercer. Fani- Kayode, a British-Nigerian photographer who died in 1989, is best known to American audiences from his inclusion in the *In/sight: African Photographers, 1940 to the Present* show at New York's Guggenheim Museum in 1996.[7] Mercer traces the origins of Fani-Kayode's Yoruba-influenced iconography—which is indecipherable as anything but exoticism to the typical Western viewer—along with his references to European and American art in order to illuminate the way the artist

6. "Jock Sturge's Books Targeted by Randall Terry," *National Campaign for Freedom of Expression Quarterly* (Winter 1997), pp. 1 and 11; "Grand Jury Indicts Barnes & Noble for Books Depicting Nude Children," *Los Angeles Times*, 29 February 1998.

7. A catalog of the same name was published by the museum.

creates "a world in which the black male body is the focal site for an exploration of the relation between erotic fantasy (sex) and ancestral memory (death)."

In "Adjusting the Focus for an Indigenous Presence," Theresa Harlan also takes on issues of race and ethnicity, along with those of spirituality, imperialism, genocide, memory, and cultural difference as they are interrogated in the work of Native American artists from various tribal nations in North America. As Mercer did for Fani-Kayode's Yoruba references, Harlan explains the cultural and religious references and beliefs at work in native American self-representation. She shows how the native American relationship to the land and tribal identity, and an ongoing negotiation of the historical violence, deterritorialization and destruction of their way of life, informs much indigenous art-making.

Deterritorialization and subordination of urban populations is the subject of "Krysztof Wodiczko's *Homeless Projection* and the Site of Urban "Revitalization," by Rosalyn Deutsche. In it, Deutsche dissects the politics of urban "renewal" in New York City and shows how Wodiczko uses photographic projections to turn the patriotic monuments in Union Square Park into visual interventions that comment on the way gentrification displaces those who are being gentrified out. He transforms the signifiers of nobility and revolution that the statues represent into signifiers of begging, injury, and pathos, which mark the urban homeless. Deutsche argues for the deployment of such alternative art practices, especially in the face of the aestheticizing profit mongering of most urban renewal.

Intervention is a subtext to much art made in the 1980s and '90s, although it is played out in many different ways. Wodiczko's work is a politicized notion of public art that wants to intervene in the politics of real-estate speculation. The politics of representation within postmodernist art is the subject in Abigail Solomon-Godeau's "Living with Contradictions: Critical Practices in the Age of Supply-Side Aesthetics." Solomon-Godeau takes a retrospective look at the critical terms and visual strategies of postmodernism, especially in the work of Sherrie Levine. She sets out the critical frames within which the work was seen and discusses its successes and failures at critiquing both the suppositions of modernist practice and the ascendent rightist politics of its time—the Reagan era—which in the 1990s retained their centrality in the political economy. Although she proposes that much postmodernist art was incorporated as mere style, she also points to work—by artists such as Louise Lawler and Han Haacke—that resisted such incorporation.

In "Missing Women: Rethinking Early Thoughts on Images of Women," Griselda Pollock returns to her well-known 1977 essay, "What's Wrong with 'Images of Women'?" to examine the very concept of such representations. Using psychoanalytic, historical materialist, and structuralist theory, she looks again at a series of advertising images. She offers complex new readings that show how images don't simply exploit the female body but are productive of the very terms by which the notion of the female body is constructed, concluding with the assertion—which will be surprising to many—that "there are no images of women in the dominant culture."

Another feminist critic who offers a revisionist view of "images of women" is Silvia Kolbowski. In "Playing with Dolls," Kolbowski looks at women looking at fashion photography and proposes to map out "a more complex female gaze" in three psychoanalytic critiques which depart from the usual trope of women-as-victims of fashion photography.

Psychoanalysis is also pivotal to "Newton's Gravity," by Victor Burgin. In it Burgin explores the movements of exhibitionism and voyeurism in and around a single photograph by Helmut Newton, as it circulates between viewer and the thing viewed, between the photographer and his model, and the way Newton constructs the image of himself, a nude model, his wife, June, and a fourth woman who is represented only by her legs and high-heel-clad feet. Newton appears as both voyeur and exhibitionist, attired to create a "joke at his own expense" in what Burgin sees as an allegorical image.

Burgin and Pollock both deploy the theory of the fetish in their texts in relation to "images of women." In "Photography and Fetish," Christian Metz interrogates fetishism, too. But he proposes that the photograph does not only offer representations of fetishizing views. Instead, he shows how the photograph can itself *function* as a fetish, while films *activate* fetishism.

Andy Grundberg surveys the long-running intersection of surrealism and photography—an alliance which in itself might be considered fetishistic—from the original surrealists working in the 1920s and '30s to the various "pulses" of surrealizing activity that run through photography from the postwar period to the present. "On the Dissecting Table: The Unnatural Coupling of Surrealism and Photography," which has been updated for this edition, is a look at recent scholarship aimed at revising the history of surrealist photography, staking claims for its current pertinence, integrating surrealism into "the narrative of twentieth-century art," and proposing surrealism as a precursor of the postmodern. Grundberg revisits his original contention that surrealism's "stylistic repetition" within American photography indicates its mannerist exhaustion, but concludes that enervation and mediation do mark contemporary surrealist photography.

Kathy Myers also looks at the aesthetics of photographs, but in terms of the way aesthetics are used to mark their contextual meanings. In "Selling Green," Myers examines images made for the ad campaigns of British corporations in the late 1980s which were aimed at merchandising their products as environmentally "friendly." Myers constructs her argument around three marketing categories for "Green" consumers created by a British product development company to show how photography was used—and how photography was sometimes disavowed—by companies seeking to capitalize on environmental concerns and fears.

Rosalind Krauss's "A Note on Photography and the Simulacral" takes a wide view of aesthetics in art-making and proposes that photography exposes "the multiplicity, the facticity, the repetition and stereotype at the heart of *every* aesthetic gesture," thus deconstructing "the possibility of differentiating between the original and the copy." She points to Cindy Sherman's work as an example of an art that explores this "total collapse of difference," in a discussion that pro-

ceeds from Plato's cave and Gilles Deleuze's understanding of it to Nietzsche's attack on Platonism and a resulting notion of the reality effect. She maintains that "there *is* a discourse proper to photography," but that it is not an *aesthetic* discourse. Krauss ends by questioning the relevance of photographic criticism that isolates the photograph, whether on a gallery wall or in the classroom.

Finally, I look at another form of scandal in photography. "Class Struggle: The Invention of Paparazzi Photography and the Death of Diana, Princess of Wales" considers paparazzi photography, which moved from the periphery to the center as a form of mass cultural communication during the 1990s.

In the first part of the essay, a schematic look at the ways in which paparazzi inverts the terms of other genres of photography, is followed by a history of the origins of paparazzi photography, which emerged in Italy as an anarchically organized practice just after World War II. I propose that what the paparazzi reflect are symptoms of cultural and social dislocation and change, which are read by the Italian photographers in the bodies and behaviors of movie stars and other celebrities.

The last section is devoted to Diana, Princess of Wales, as a subject of scandal. After a short analysis of the market for tabloid journalism in the United States and the United Kingdom, I look at the way Diana was used by the tabloid press to negotiate questions of femininity, motherhood, spousal duty, female sexuality, and royal prerogatives, and how Diana tried, with varying amounts of success, to use tabloid coverage to her own ends.

Indeed, questions about who uses photography, who controls photography, and to what ends it is put are considered in many of the essays in this book. Many other questions remain to be asked. The effect of the Internet on photography, for instance, has hardly been examined. How will the wide-ranging appropriation of photographs that takes place in cyberspace affect the medium, in terms of authorship, copyright, image quality, meaning, and integrity of the image? How will widespread dissemination of photographs in cyberspace affect photographs made for the printed page or the museum-quality print? And what cultural and political effects will that dissemination have as images easily move across national and political boundaries?

Inevitably, a number of issues regarding photography have gone unexamined in this volume. The photography of war and other types of violence is one omission, as are the issues of tourism and photography, corporate photography, portrait photography, the family snapshot and the digital, the centrality and permutations of celebrity imagery, and photography's changing place within the print media. That photography will continue to be widely deployed to produce definitions, appearances, and meanings in both private and public life seems certain, at least in the short term. The essays in this volume offer a variety of strategies for examining the way photographs do their work. It is hoped that they will generate new debates and new forms of critical work in the future.

GEOFFREY BATCHEN

Ectoplasm: Photography in the Digital Age

FACED WITH the invention of photography, French painter Paul Delaroche is supposed to have declared, "from today, painting is dead!"[1] Now, a little over 150 years later, everyone seems to want to talk about photography's own death. Tim Druckrey, for example, has claimed that the "very foundation and status of the [photographic] document is challenged." Fred Ritchin speaks of the "profound undermining of photography's status as an inherently truthful pictorial form." Ann-Marie Willis speculates about the possible disappearance of photography "as a technology and as a medium-specific aesthetic." And William J. Mitchell has asserted that "from the moment of its sesquicentennial in 1989 photography was dead—or, more precisely, radically and permanently displaced.[2]

This sustained outburst of morbidity appears to stem from two related anxieties. The first is an effect of the widespread introduction of computer-

1. Although this exclamation is one of the most repeated quotations in the history of photographic discourse, there is no substantial evidence that Delaroche ever actually made such a statement. It first appears in Gaston Tissandier's *A History and Handbook of Photography*, trans. J. Thomson (London: Sampson, Low, Marston, Low and Searle, 1876), p. 63. Contrary to this account, Delaroche was the first painter of consequence publicly to support the daguerreotype and to argue for its importance as an aid to artists. See Helmut and Alison Gernsheim, *L.J.M. Daguerre: The History of the Diorama and the Daguerreotype* (New York: Dover, 1968), p. 95.

2. See Timothy Druckrey, "L'Amour Faux," *Digital Photography: Captured Images, Volatile Memory, New Montage* (exhibition catalogue, San Francisco: San Francisco Camerawork, 1988), pp. 4-9; Fred Ritchin, "Photojournalism in the Age of Computers," in *The Critical Image: Essays on Contemporary Photography*, ed. Carol Squiers (Seattle: Bay Press, 1990), pp. 28-37; Anne-Marie Willis, "Digitization and the Living Death of Photography," in *Culture, Technology & Creativity in the Late Twentieth Century*, ed. Philip Hayward (London: John Libbey, 1990), pp. 197-208; and William J. Mitchell, *The Reconfigured Eye: Visual Truth in the Post-Photographic Era* (Cambridge, Mass.: MIT Press, 1992), esp. chap. 20. For further commentaries on the purported death of photography, see Fred Ritchin, "The End of Photography as We Have Known It," in *PhotoVideo*, ed. Paul Wombell (London: Rivers Oram Press, 1991), pp. 8-15, and Kevin Robins, "Will Image Move Us Still?" in *The Photographic Image in Digital Culture*, ed. Martin Lister (London: Routledge, 1995), pp. 29-50.

driven imaging processes that allow "fake" photos to be passed off as real ones. The prospect is that, unable to spot the "fake" from the "real," viewers will increasingly discard their faith in the photograph's ability to deliver objective truth. Photography will thereby lose its power as a privileged conveyor of information. Given the proliferation of digital images that look exactly like photographs, photography may even be robbed of its cultural identity as a distinctive medium.

These possibilities are exacerbated by a second source of concern: the pervasive suspicion that we are entering a time when it will no longer be possible to tell any original from its simulations. Thing and sign, nature and culture, human and machine; all these hitherto dependable entities appear to be collapsing in on each other. Soon, it seems, the whole world will consist of an undifferentiated "artificial nature." According to this scenario, the vexed question of distinguishing truth from falsehood will then become nothing more than a quaint anachronism—as will photography itself.

So photography is faced with two apparent crises, one technological (the introduction of computerized images) and one epistemological (having to do with broader changes in ethics, knowledge, and culture). Taken together, these crises threaten us with the loss of photography, with the "end" of photography and the culture it sustains. But exactly what kind of end would this be?

It should not be forgotten that photography has been associated with death since the beginning. Some early onlookers, for example, associated the daguerreotype process with black magic. Nadar tells us with some amusement that his friend Balzac was one person who had an "intense fear" of being photographed:

> According to Balzac's theory, all physical bodies are made up entirely of layers of ghostlike images, an infinite number of leaf-like skins laid one on top of the other. Since Balzac believed man was incapable of making something material from an apparition, from something impalpable—that is, creating something from nothing— he concluded that every time someone had his photograph taken, one of the spectral layers was removed from the body and transferred to the photograph. Repeated exposures entailed the unavoidable loss of subsequent ghostly layers, that is, the very essence of life.[3]

An excess of life was actually a bit of a problem for those early photographers trying to make portraits. Due to the slowness of exposure times, only a slight movement of the subject's head was enough to result in an unsightly blur. Even when this could be avoided, some critics complained that the strain

3. Nadar, "My Life As a Photographer" (1900), *October* no. 5 (Summer 1978), p. 9.

of keeping steady made the subject's face look like that of a corpse. However, a simple solution was soon available. Those wanting their portrait taken simply had to submit to having their head placed within a constraining device which ensured a still posture for the necessary seconds. This device worked in effect to transform the lived time of the body into the stasis of an embalmed effigy. In other words, photography insisted that, if one wanted to appear lifelike in a photograph, one first had to act as if dead.

Portrait photographers soon took this association a step further, developing a lucrative trade in posthumous photographs or "memento mori." Grieving parents could console themselves with a photograph of their departed loved one, an image of the dead *as* dead that somehow worked to sustain the living. This business was taken to another level in 1861, when a Boston engraver announced that he had found a successful way to photograph ghosts. Thousands of photographs were produced that showed the living consorting with the dead, a comfort for those inclined toward spiritualism and a financial bonanza for those who were prepared to manipulate the photographic technology of double exposure.[4]

But not everyone benefited from photography's business success. As Delaroche had predicted, photography's introduction into the capitals of Western Europe spelled doom for many established image-making industries. Miniature painting, for example, was quickly made extinct by the magically cheap appearance of the daguerreotype's exact, shiny portraits. As N. P. Willis, the first American commentator on photography, warned in April 1839, other art practices were also under threat from the new apparatus.

> Vanish equatints [sic] and mezzotints—as chimneys that consume their own smoke, devour yourselves. Steel engravers, copper engravers, and etchers, drink up your aquafortis and die! There is an end of your black art....The real black art of true magic arises and cries avaunt.[5]

But it was not only individual reproductive practices that found themselves having to face a photographically induced euthanasia. In Walter Benjamin's famous essay on mechanical reproduction, he argued that photography would even, by inexorably transforming the aura of authenticity into a com-

4. For more on this genre of photography, see Fred Gettings, *Ghosts in Photographs: The Extraordinary Story of Spirit Photography* (New York: Harmony Books, 1978); Dan Meinwald, *Memento Mori: Death in Nineteenth Century Photography* (CMP Bulletin, 9: 4, California Museum of Photography, Riverside, 1990); Jay Ruby, *Secure the Shadow: Death and Photography in America* (Cambridge, Mass.: MIT Press, 1995); *The Kirilian Aura: Photographing the Galaxies of Life*, eds. Stanley Krippner and Daniel Rubin (New York: Doubleday Anchor, 1974); Rolf H. Krauss, *Beyond Light and Shadow: The Role of Photography in Certain Paranormal Phenomena, A Historical Survey* (Tucson: Nazraeli Press, 1994).

5. N. P. Willis, "The Pencil of Nature" (April 1839), as quoted in Alan Trachtenberg, "Photography: The Emergence of a Keyword," in *Photography in Nineteenth-Century America*, ed. Martha A. Sandweiss (Fort Worth: Amon Carter Museum of Western Art, 1991), p. 30.

modity, hasten the demise of capitalism itself. As a mechanical manifestation of the capitalist mode of production, photography, he argued, necessarily bore the seeds of capitalism's own implosion and demise. In his complicated tale of sacrifice and resurrection, aura would have to die at the hand of photography before any truly authentic social relations could be brought back to life. As Benjamin put it, "one could expect [capitalism] not only to exploit the proletariat with increasing intensity, but ultimately to create conditions which would make it possible to abolish capitalism itself."[6] Capitalism is therefore projected as its own worst nightmare, for its means of sustenance is also its poison. And, for Benjamin at least, photography enjoys this same dual character. Like the daguerreotype, it is a force that is simultaneously positive and negative.

Photography's flirtation with life and death does not end there. It could be argued, for example, that the very idea of photography repeats the theme. As Benjamin reminds us, the beginnings of this idea remain obscured by a "fog" of uncertainties.[7] Frequently cited but seldom seen, the photograph exercised a hallucinatory presence well before its official invention, being conceived by at least twenty different individuals between 1790 and 1839. The manner and timing of photography's conception is in fact a complex historical question. Why didn't previous generations of scholars come up with the idea? Why does it only appear in European discourse around 1800? And this appearance is itself a strange phenomenon, one perhaps best described as a palimpsest, as an event that inscribed itself within the space left blank by the sudden collapse of Natural Philosophy and its Enlightenment worldview.[8] As Michel Foucault says of this moment, "what came into being...is a minuscule but absolutely essential displacement which toppled the whole of Western thought."[9] In other words, photography's birth pangs coincided with both the demise of a pre-modern episteme, and with the invention of a peculiarly modern conjunction of power-knowledge-subject; the appearance of one was only made possible through the erasure of the other.[10]

A life born of death, a presence inhabited by absence—photography's genealogy is repeated in each of its individual instances. William Henry Fox Talbot's earliest contact prints, for example, also hovered somewhere between life and death; perversely, the very light needed to see them proved fatal to their continued visibility. In a sense, Talbot's struggle to overcome this short-

6. Walter Benjamin, "The Work of Art in the Age of Mechanical Reproduction" (1936), in *Video Culture: A Critical Investigation*, ed. John Hanhardt (New York: Visual Studies Workshop, 1986), p. 27.

7. Walter Benjamin, "A Short History of Photography" (1931), in *Classic Essays on Photography*, ed. Alan Trachtenberg (New Haven, Conn.: Leete's Island Books, 1980), p. 199.

8. Michel Foucault, *The Order of Things: An Archaeology of the Human Sciences* (New York: Random House, 1970), pp. 206-7.

9. Ibid., p. 238.

10. For more detailed versions of this argument, see my *Burning with Desire: The Conception of Photography* (Cambridge, Mass.: MIT Press, 1997).

coming was a struggle with mortality itself. Even after he had learned how to arrest his wraith-like apparitions (or at least to delay their departure), Talbot still had to explain the nature of their conjuring. What exactly were these lingering presences, these spectral traces of an object no longer fully present?

In his first paper on photography in 1839, Talbot called his process the "art of fixing a shadow," conceding that the capturing of such elusive shades "appears to me to partake of the character of the marvelous."

> The most transitory of things, a shadow, the proverbial emblem of all that is fleeting and momentary, may be fettered by the spells of our "natural magic," and may be fixed forever in the position which it seemed only destined for a single instant to occupy. . . . Such is the fact, that we may receive on paper the fleeting shadow, arrest it there and in the space of a single minute fix it there so firmly as to be no more capable of change.[11]

Photography is, for Talbot, the desire for an impossible conjunction of transience and fixity, a visual simultaneity of the fleeting and the eternal. It is an emblematic something, a "space of a single minute," in which space *becomes* time, and time space. Louis-Jacques-Mandé Daguerre explicated his process in similarly temporal terms. In March 1839, Daguerre made three identical views—at morning, noon, and in evening light—of the Boulevard du Temple outside his studio window. This series not only calibrated the passing of time in terms of changing shadows and degrees of legibility, but also presented time itself as a linear sequence of discrete but interrelated moments. By bringing the past and the present together in the one viewing experience, Daguerre showed that photography could fold time back on itself.

In stopping or turning back time, photography appeared to be once again playing with life and death. No wonder then that "necromancy" (communication with the dead) is a term used by a number of contemporary journalists to describe the actions of both Daguerre's and Talbot's processes. Some also noted photography's peculiar engagement with time. *The Athenaeum*, for example, commented in 1845 that "photography has already enabled us to hand down to future ages a picture of the sunshine of yesterday."[12] Photography allowed the return of what had come before—and with it a prophecy of future returns. Whatever its nominal subject, photography was a visual inscription of the passing of time and therefore also an intimation of every viewer's own inevitable passing.

11. Henry Talbot, "Some Account of the Art of Photogenic Drawing" (1839), in *Photography: Essays and Images*, ed. Beaumont Newhall (New York: Museum of Modern Art, 1980), p. 25.

12. *The Athenaeum*, no. 904 (February 22, 1845), as quoted in Larry J. Schaaf, "A Wonderful Illustration of Modern Necromancy: Significant Talbot Experimental Prints in the J. Paul Getty Museum," in *Photography: Discovery and Invention*, ed. Weston Naef (Los Angeles: Getty Museum, 1990), p. 44.

Over a century later, Roland Barthes found himself describing photography in remarkably similar terms. In the process, he shifted his own analysis of the medium from a phenomenology of individual images to a meditation on the nature of death in general. He speaks in *Camera Lucida* of the "stigmatum" of the "having-been-there" of the thing photographed. Photography, he says, gives us a "this will be" and a "this has been" in one and the same representation. Every photograph is therefore a chilling reminder of human mortality. Pondering the recent death of his own mother, Barthes looks at an 1865 portrait of a condemned man and observes that the subject depicted there is dead, and is going to die. "Whether or not the subject is already dead, every photograph is this catastrophe." On further reflection, he takes the temporal perversity of this future anterior tense to be the ultimate source of photography's plausibility. For, according to Barthes, the reality offered by the photograph is not that of truth-to-appearance but rather of truth-to-presence, a matter of being (of something's irrefutable place in time) rather than resemblance.[13]

Given this historical background, what does it mean then to speak of the death of photography by digital imaging? There is no doubt that computerized image-making processes are rapidly replacing or supplementing traditional still-camera images in many commercial situations, especially in advertising and photojournalism. Given the economies involved, there will probably come a time when almost all silver-based photographies are superseded by computer-driven processes. Eastman Kodak, for example, in the mid-1990s began putting increasing research and advertising emphasis on its electronic imaging products, worried that it will soon be left behind in the ever-expanding digital industry. As a financial analyst told *The New York Times*, "film-based information is a dying business."[14]

Bill Gates has certainly come to this conclusion. In 1989, the world's richest man established a company specifically to buy and sell the electronic reproduction rights to an array of pictures so extensive that they "capture the entire human experience throughout history."[15] This company, Corbis Corporation, acquired the Bettmann Archive in 1995 and with it came control over one of the world's largest private depositories of images, sixteen million in all. Corbis's principal business involves leasing these images, in the form of data stored on digital files, to those who are willing to pay for specified electronic "use-rights." Thousands of new images are being added to the Corbis collection every week, drawn from a multitude of individual photographers as well as institutions such as NASA, the National Institutes of Health, the Library of Congress, the National Gallery of Art

13. Roland Barthes, *Camera Lucida: Reflections on Photography* (New York: Hill and Wang, 1981).

14. See Claudia H. Deutsch, "Kodak Talks to Buy a Wang Software Unit," *New York Times*, 4 October 1996, C16.

15. This aspiration was voiced by Corbis' CEO Doug Rowen in Kate Hafner, "Picture This," *Newsweek*, 24 June 1996, pp. 88–90.

in London, the Philadelphia Museum of Art and the Hermitage in St. Petersburg. According to its fall 1996 catalogue, Corbis was able to offer its customers over 700,000 digital images to choose from. It is worth noting that when, in April of that same year, Corbis struck an agreement with the Ansel Adams Publishing Rights Trust regarding Adams's photographs, they only bothered to acquire the *electronic* reproduction rights (the traditional rights remaining with the Trust). It seems that the basic assumption behind Corbis is that, in the near future, digital images are the only kind that are going to matter.[16]

The dissemination of photographs as data raises a number of issues, not least of which is the question of image integrity. The fact is that, whether by scanning in and manipulating bits of existing images, or by manufacturing fictional representations on screen (or both), computer operators can already produce printed images that are indistinguishable in look and quality from traditional photographs. The main difference seems to be that, whereas photography still claims some sort of objectivity, digital imaging is an *overtly* fictional process. As a practice that is *known* to be capable of nothing but fabrication, digitization abandons even the *rhetoric* of truth that has been such an important part of photography's cultural success. As their name suggests, digital processes actually return the production of photographic images to the whim of the creative human hand (to the *digits*). For that reason, digital images are actually closer in spirit to the creative processes of art than they are to the truth values of documentary.

This is perceived as a potential problem by those industries that rely on photography as a mechanical and hence nonsubjective purveyor of information. Anxious to preserve the integrity of their product, many European newspapers at one point considered adding an 'M' to the credit line accompanying any image that has been digitally manipulated.[17] Of course, given that such a credit line will not actually tell readers what has been suppressed or changed, it simply casts doubt on the truth of every image that henceforth appears in the paper. This is no doubt why American publishers have been reluctant to adopt such a standard designation (*Time* magazine, for example, describes various covers it published between 1993 and 1996, all digital images, as either "Illustrations," "Photo-Illustrations," "Digital Illustrations" or "Digital Montages"). But this whole dilemma is more rhetorical than ethical; newspapers and magazines have of course always manipulated their images in one

16. For more on Corbis and its operations, see Corey S. Powell, "The Museum of Modern Art," *World Art*, 1: 2 (1994), pp. 10-13; Steve Lohr, "Huge Photo Archive Bought by Software Billionaire Gates," *New York Times*, 11 October 1995, C1, C5; Edward Rothstein, "How Bill Gates Is Imitating Art," *New York Times*, 15 October, 1995, E3; Welton Jones, "Gated Archive," *The San Diego Union-Tribune*, 31 October 1995, E1, E3; Corbis, *Corbis Catalogue: Selections from the Corbis Digital Archive, Volume One* (Seattle: Corbis Corporation, 1996); Richard Rapaport, "In His Image," *Wired*, 4: 11 (November 1996), pp. 172-175, 276-283; Geoffrey Batchen, "Manifest Data: The Image in the Age of Electronic Reproduction," *Afterimage* 24:3 (November/December 1996), pp. 5-6; and Geoffrey Batchen, "Photogenics," *History of Photography*, 22:1 (spring 1997), pp. 18-26.

17. See Keith Kenney, "Computer-altered Photos: Do Readers Know Them When They See Them?," *News Photographer* (January 1993), pp. 26-27.

way or another. The much-heralded advent of digital imaging simply means having to admit it to oneself and even, perhaps, to one's customers.

Or perhaps not. The history of commercial digital imaging thus far is a seemingly endless litany of deceptions and unacknowledged manipulations. Many of these, such as the notorious *National Geographic* cover from February 1982 in which the pyramids were moved closer together or the even more notorious *TV Guide* cover from August 1985 which merged the head of Oprah Winfrey and the body of Ann-Margret, were no doubt conceived by their editors as "illustrative" and therefore not beholden to the same standards of truth as properly journalistic images.[18] *Time* magazine has continued this tradition, regularly employing digital imaging to produce catchy cover art for articles on everything from the conflict between the two Koreas to the popularity of cyberporn. In each case, the resulting illustration is clearly just that, an overtly manipulated or invented image. However, the same magazine stumbled into more controversial waters when it chose to grace the cover of its June 27, 1994, issue with a digitally darkened L.A.P.D. mug shot of O. J. Simpson. Although the extent of this manipulation wasn't mentioned by *Time*, it was made plain by the fact that *Newsweek* chose the same unadulterated mug shot for its cover that week, thus allowing a direct comparison on the newsstand. In the face of considerable public criticism, *Time's* editor was forced to print a full-page letter in the July 4 issue to explain the reasoning behind both the magazine's

18. See Martha Rosler, "Image Simulations, Computer Manipulations: Some Considerations," *Ten.8: Digital Dialogues* 2:2 (1991), pp. 52-63, and Fred Ritchin, *In Our Own Image: The Coming Revolution in Photography* (New York: Aperture, 1990). Incidents such as these continue to occur at regular intervals. The November 1996 issue of *LIFE* magazine contained a quiet apology (hidden away on page 36 at the foot of another story) for having reproduced a digitally manipulated image of a bullfight (in which an inconvenient matador's arm had been removed) in the August issue. The magazine told its readers that "such electronic manipulation of news photographs is against our policy, and *LIFE* regrets the lapse." But if the editors themselves didn't know that the image they used had been altered, one wonders how many other such images they and similar magazines are inadvertently printing. In a different kind of case, the *New York Times* reported on page 17 of its October 13, 1996 issue that an election race for the U.S. Senate had been "shaken up" by the revelation that the media consultant for Senator John Warner had electronically placed his political opponent's head on the body of another man. The combination image had been used in an advertisement that accused the opponent of cavorting "with the nation's most liberal politicians." The *Times* quotes an expert in political advertising as saying that this example was "particularly egregious because it's undetectable to the average viewer." When questioned, one of Senator Warner's campaign aides dismissed the head-swapping exercise as a "technical adjustment." However, under pressure from the press, Warner later fired his media consultant and canceled the advertisement. Other examples show that the Oprah/Ann-Margret merger is not an isolated case. The January/February 1994 issue of *American Photo* magazine featured a cover picture of a diaphanously clad Kate Moss. However, fearing that Southern-based distributors would refuse to handle the issue, the magazine chose to digitally erase any sign of her nipples. This sort of quiet adjustment to pictorial truth is no doubt going to be an increasingly common practice amongst newspapers and magazines. The November 1996 issue of *Ladies Home Journal*, for example, featured an image of a smiling Cher on its cover. Or was it? Cher maintains that everything below the chin in the cover photo belongs to someone else. The magazine's marketing director admitted only that "we used technology to change the dress and remove the tattoo, to make the cover more appealing to our readers." See Jean Seligmann, "Cher Gets an Unwanted Makeover," *Newsweek*, 21 October 1996, p. 95. These kinds of manipulations are also taking place within the practice of nature photography. See David Roberts, "Unnatural Acts: A Feud Over Digitally Altered Photos Has Nature Photographers Rethinking the Meaning of Their Work," *American Photo* (March/April 1997), pp. 28-30.

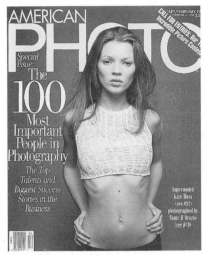

January/February 1994

July 3, 1995

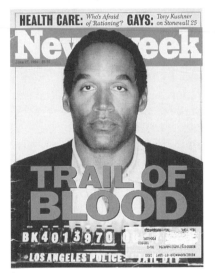

June 27, 1994

apparent racism and its decision to alter "the facts." Arguing that the digital alterations "lifted a common police mug shot to the level of art," the editor argued that such interventions had always been allowable within journalism

19. James R. Gaines, "To Our Readers," *Time*, 4 July 1994, p. 4. More recently, the tables have been turned. In November 1997 both *Time* and *Newsweek* featured photographs of Bobby and Kenny McCaughey, the parents of septuplets, on their respective covers. However, *Newsweek*, unlike *Time*, chose to digitally alter Mrs. McCaughey's teeth, straightening and whitening them. *Newsweek's* editor in chief, Richard W. Smith, claimed that the enhancement was in no way analogous to what *Time* did with O. J. Simpson because the alterations were not made to "harm Mrs. McCaughey or deceive the reader." See Kenneth N. Gilpin, "Doctoring of Photos, Round 2," *New York Times*, 26 November 1997, A14.

as long as "the essential meaning of the picture is left intact."[19] Of course, this double appeal—to art and to essence—could be used to justify silently changing virtually any image in the magazine.

But all this can hardly be blamed on the advent of digitalization. The history of photography is already full of images that have been manipulated in some way or other. In fact, it could be argued that photography is nothing but that history. And I'm not speaking here of just those notorious images where figures have been added or erased in the darkroom for the convenience of contemporary politics.[20] I'm suggesting that the production of any and every photograph involves practices of intervention and manipulation of some kind or other. After all, what else is photography but the knowing manipulation of light levels, exposure times, chemical concentrations, tonal ranges, and so on? In the mere act of transcribing world into picture, three dimensions into two, photographers necessarily manufacture the image they make. Artifice of one kind or another is therefore an inescapable part of photographic life. In that sense, photographs are no more or less "true" to the appearance of things in the world than are digital images.

This argument returns us to the dilemma of photography's ontology, to the analogical operations that supposedly give photography its distinctive identity as a medium. Remember that Barthes has already discounted resemblance to reality as a way of defining photography. In his terms, a given person may not look exactly as the photograph now portrays them, but we can at least be sure he or she was once there in front of the camera. We can be sure they were at some point present in time and space. For what makes photographs distinctive is that they depend on this original presence, a referent in the material world that at some time really did exist to imprint itself on a sheet of light-sensitive paper. Reality may have been transcribed, manipulated, or enhanced, but photography doesn't cast doubt on reality's actual existence.

Indeed, quite the opposite. Photography's plausibility has always rested on the uniqueness of its indexical relation to the world it images, a relation that is regarded as fundamental to its operation as a system of representation. As a footprint is to a foot, so is a photograph to its referent. Susan Sontag says that the photograph is "something directly stenciled off the real," while Rosalind Krauss describes it as "a kind of deposit of the real itself."[21] It is as if objects have reached out and touched the surface of a photograph, leaving their own trace, as faithful to the contour of the original object as a death mask is to the face of the newly departed. Photography is the world's memento mori.

20. For numerous examples of pre-digital alterations to photographs, see Rosler, "Image Simulations, Computer Manipulations," *Digital Dialogues*, and Vicki Goldberg, *The Power of Photography: How Photographs Changed Our Lives* (New York: Abbeville Press, 1991).

21. Susan Sontag, *On Photography* (New York: Penguin, 1977), p. 154. Rosalind Krauss, "The Photographic Conditions of Surrealism" (1981), *The Originality of the Avant-Garde* (Cambridge, Mass.: MIT Press, 1984), p. 112.

It allows that world to become its own photographer. For this reason, a photograph of something has long been held to be a proof of that thing's *being*, even if not of its truth.

Computer visualization, on the other hand, allows photographic-style images to be made in which there is potentially no direct referent in an outside world. Where photography is inscribed by the things it represents, it is possible for digital images to have no origin other than their own computer program. These images may still be indices of a sort, but their referents are now differential circuits and abstracted data banks of information (information that includes, in most cases, the *look* of the photographic). In other words, digital images are not so much signs of reality as they are signs of signs. They are representations of what is already perceived to be a series of representations. This is why digital images remain untroubled by the future anterior, the "this has been" and "this will be" that so animates the photograph. Digital images are in time, but not *of* time. In this sense, the reality the computer presents to us could be said to be a virtual one, a mere simulation of the analogically and temporally guaranteed reality promised by the photograph. And of course, when people seek to protect photography from the incursion of the digital, it is this reality that they are ultimately defending.

But how is it, or photography for that matter, threatened? It should be clear to those familiar with the history of photography that a change in imaging technology will not, in and of itself, cause the disappearance of the photograph and the culture it sustains. For a start, photography has never been any one technology; its nearly two centuries of development have been marked by numerous, competing instances of technological innovation and obsolescence, without any threat being posed to the survival of the medium itself. In any case, even if we continue to identify photography with certain archaic technologies, such as camera and film, those technologies are themselves the embodiment of the idea of photography, or, more accurately, of a persistent economy of photographic desires and concepts. The concepts inscribed within this economy would have to include things such as nature, knowledge, representation, time, space, observing subject, and observed object. Thus, if we do have to define it for a moment, we might say that photography is the desire, whether conscious or not, to orchestrate a particular set of relationships between these various concepts.

While both concepts and relationships continue to endure, so surely will a photographic culture of one sort of another. Even if a computer does replace the traditional camera, that computer will continue to depend on the thinking and worldview of the humans who program, control, and direct it, just as photography now does. As long as the human survives, so will human values and human culture—no matter what image-making instrument humans choose to employ.

But are both "the human" and "the photographic" indeed still with us? Technology alone won't determine photography's future, but new technologies, as manifestations of our culture's latest worldview, may at least give us

some vital signs of its present state of health. Digitization, prosthetic and cosmetic surgery, cloning, genetic engineering, artificial intelligence, virtual reality—each of these expanding fields of activity calls into question the presumed distinction between nature and culture, human and nonhuman, real and representation, truth and falsehood—all those concepts on which the epistemology of the photographic has hitherto depended.

Back in 1982, the film *Blade Runner* looked into the near future and suggested that we will all soon become replicants, manufactured by the social-medical-industrial culture of the early twenty-first century as "more human than human," as living simulations of what the human is imagined to be. Deckard's job as a Blade Runner is to distinguish human from replicant, a distinction that, ironically, is only possible when he allows himself to become prosthesis to a viewing machine. At the start of the film he thinks he knows what a human is. But the harder he looks, the less clear the distinction becomes (like him, the replicants have snapshots, triggers for memories planted by their manufacturer, memories just like his own). Eventually he has to abandon the attempt, unsure at the end as to the status of even his own subjectivity.[22]

The twenty-first century is upon us. And already there is no one reading this who is a "natural" being, whose flesh has not been nourished by genetically enhanced corn, milk, or beef, and whose body has not experienced some form of medical intervention, from artificial teeth to preventive inoculations to corrective surgery. Zucchinis are being "enhanced" by human growth hormones. Pigs are now bred to produce flesh genetically identical to that of humans (replicant flesh).[23] Who can any longer say with confidence where the human ends and the nonhuman begins?

Not that this is a new dilemma. Like any other technology, the body has always involved a process of continual metamorphosis. What is different today is the degree to which its permeability is a visible part of everyday life, a situation that surely insists on a radical questioning not only of the body but also of the very nature of humanness itself. We have entered an age in which the human and all that appends to it can no longer remain a stable site of knowledge precisely because the human cannot be clearly identified. And if "the human" is under erasure, can photography and photographic culture simply remain as before?

If this be a crisis, then its manifestations are all around (as well as within) us. Contemporary philosophy, for example, would question the conceptual stability of the index on which photography's identity is presumed to rest. As we

22. For more on the role of the photograph within *Blade Runner* (Ridley Scott, 1982), see Giuliana Bruno, "Ramble City: Postmodernism and Blade Runner," *October* no. 41 (summer 1987), pp. 61-74; Elissa Marder, "Blade Runner's Moving Still," *CameraObscura* 27 (September 1991), pp. 88-107; Kaja Silverman, "Back to the Future," *CameraObscura* 27 (September 1991), pp. 108-133; and Scott Bukatman, *Blade Runner* (London: BFI, 1997).

23. See Laura Shapiro, "A Tomato with a Body that Just Won't Quit," *Newsweek*, 6 June, 1994, pp. 80-82; and Lawrence M. Fisher, "Down on the Farm, a Donor: Genetically Altered Pigs Bred for Organ Transplants," *New York Times*, 5 January, 1996, C1, C6.

have already heard, photographs are privileged over digital images because they are indexical signs, images inscribed by the very objects to which they refer. This is taken to mean that, whatever degrees of mediation may be introduced, photographs are ultimately a direct imprint of reality itself. The semiotician who devised this concept of the index was the American philosopher Charles Saunders Peirce.[24] However, as Jacques Derrida points out in his own examination of semiotics, the whole Peircean schema "complies with two apparently incompatible exigencies." To quickly summarize Derrida's argument, Peirce continues to depend on the existence of a non-symbolic logic, even while recognizing that such a logic is itself a semiotic field of symbols. Thus, "no ground of non-signification...stretches out to give it foundation under the play and the coming into being of signs." In other words, Peirce's work never allows us to presume that there is a "real world," an ultimate foundation, that somehow precedes or exists outside of representation ("signification"). Real and representation must, according to Peirce's own argument, always already inhabit each other. As Derrida points out, in Peirce's writing "the thing itself is a sign ...from the moment there is meaning there are nothing but signs."[25]

So those who look to Peirce for pragmatic evidence of an extra-photographic real world (the "thing itself"), will, if they look closely enough, find in its place "nothing but signs." Accordingly, if we follow Peirce to the letter and rewrite photography as a "signing of signs" (and therefore, it should be noted, recognizing that photography too is a *digital* process), we must logically include the real as but one more form of the photographic. It too is the becoming of signs. It too is a dynamic practice of signification. Any extended notion of photography's identity must therefore concern itself with the how of this "becoming," with the "tracing" of one sign within the grain of the other. In other words, photography must be regarded as the representation of a reality that is itself already nothing but the play of representations. More than that, if reality is such a representational system, then it is one produced within,

24. See Peirce's "Logic as Semiotic: The Theory of Signs" (c. 1897-1910), in *Philosophical Writings of Peirce*, ed. Justus Buchler (Dover, 1955), pp. 98-119. The erasure of fixed origins of any kind that one finds in the work of both Peirce and Derrida would seem at variance with the distinction Victor Burgin maintains between the digital photograph (a copy with no original) and the photograph (which, he implies in the quotation below, is a copy that does indeed have an origin). "The electronic image fulfills the condition of what Baudrillard has termed 'the simulacrum'—it is a copy of which there is no original. It is precisely in *this* characteristic of digital photography, I believe, that we must locate the fundamental significance of digital photography in Western history." See Victor Burgin, "The Image in Pieces: Digital Photography and the Location of Cultural Experience," in *Photography after Photography: Memory and Representation in the Digital Age*, eds. Hubertus V. Amelunxen, et al. (Siemens Kulturprogramm, Amsterdam: G + B Arts, 1996), p. 29.

25. Jacques Derrida, *Of Grammatology*, trans. Gayatri Spivak (Chicago: University of Chicago Press, 1976), pp. 48-50.

26. Derrida calls *spacing* "the impossibility for an identity to be closed in on itself, on the inside of its proper interiority, or on its coincidence with itself." See Jacques Derrida, *Positions*, trans. Alan Bass (Chicago: University of Chicago Press, 1981), p. 94.

among other things, the *spacings* of the photographic.[26]

This shift in photography's conception obviously has ramifications for the entire epistemological edifice on which our culture is built. As Derrida puts it, "this concept of the photograph *photographs* all conceptual oppositions, it traces a relationship of haunting which perhaps is constitutive of all logics."[27]

Photography, it appears, is a logic that continually returns to haunt itself. It is its own "medium." Accordingly, each of my examples has been part of a photographic ghost story. Each has pointed to the enigmatic quality of photography's death, or, more precisely, each has posed the necessity of questioning our present understanding of the very concepts "life" and "death." Given the advent of new imaging processes, photography may indeed be on the verge of losing its privileged place within modern culture. This does not mean that photographic images will no longer be made, but it does signal the possibility of a dramatic transformation of their meaning and value, and therefore of the medium's ongoing significance. However, it should be clear that any such shift in significance will have as much to do with general epistemological changes as with the advent of digital imaging. Photography will cease to be a dominant element of modern life only when the desire to photograph, and the peculiar arrangement of knowledges and investments which that desire represents, is refigured as another social and cultural formation. Photography's passing must necessarily entail the inscription of another way of seeing—and of being.

My essay has suggested that photography has been haunted by the spectre of such a "death" throughout its long life, just as it has always been inhabited by the very thing, digitization, which is supposed to be about to deal the fatal blow. In other words, what is really at stake in the current debate about digital imaging is not only photography's possible future, but also the nature of its past and present.

27. Jacques Derrida, "The Deaths of Roland Barthes" (1981), trans. Pascale-Anne Brault and Michael Naas, in *Philosophy and Non-Philosophy since Merleau-Ponty*, ed. Hugh Silverman (New York: Routledge, 1988), p. 267.

Versions of this essay have been previously published as "Post-Photography: Digital Imaging and the Death of Photography," and "Post-Fotografie: Digitale Bilderstellung und der Tod der Fotografie," *BE Magazin*, 1 (Berlin, May 1994), pp. 7-13; "Phantasm: Digital Imaging and the Death of Photography," *Aperture*, 136 (summer 1994), pp. 47-50; "Post-Photography: Digital Imaging and the Death of Photography," *Chinese Photography* 15: 5 (Beijing, May 1994), pp. 10-12 (Chinese translation by Huang Shaohua); "Ghost Stories: The Beginnings and Ends of Photography," in *Art Catalogue of the First International Conference on Flow Interaction*; ed. N. W. M. K. (Fung Ping Shan Museum, University of Hong Kong, September 1994), 5-13; "Ghost Stories: The Beginnings and Ends of Photography," *Art Monthly Australia*, 76 (December 1994), pp. 4-7; "Ghost Stories: The Beginnings and Ends of Photography," *Sajinyesul: The Monthly Photographic Art Magazine*, 74 (Korea, 1995-96(, pp. 62-66 (Korean translation by Keun-Shik Chang). Portions of it also appear in my book *Burning with Desire: The Conception of Photography* (Boston: MIT Press, 1997).

GEOFFREY BATCHEN

Mirrors and Window Shoppers:
Lesbians, Photography, and the Politics of Visibility

> I think that for many of us...the ability to attach intently to a few cultural objects, objects of high or popular culture or both, objects whose meaning seemed mysterious, excessive, or oblique in relation to the codes most readily available to us, became a prime resource of survival. We needed for there to be sites where the meanings didn't line up tidily with each other, and we learned to invest those sites with fascination and love.
>
> Eve Kosofsky Sedgwick, *Tendencies*

Lesbians. Daggers. Vamps. Dykes. Stones. Soft Butches. Femmes. Riot Grrrls. Outlaws. Lipstick Lezzies. Fag Wannabes. Vanillas. Baby Dykes. Drag Kings. Fuck Buddies. MTFs and FTMs. Transsexuals. Crunchies. Tops. Leather Dykes. Intersexuals. Transgenderists. Bis. Queers. Butch Bottoms. Dyke Daddies. Perverts.

A ROSTER of names and a panoply of corresponding images present themselves to us at the end of the twentieth century, each with its own codes and signifiers, nuanced differences on a scale of nameable sexual identities for women—not all of whom would call themselves lesbians. What they share in common is a dissatisfaction with conventional binaristic categories of gender and the exclusiveness of cross-sex desire encoded in normative white bourgeois femininity. In recent years, a small number of these identities have even been allowed to seep (in carefully measured doses) into women's advertising and fashion ("lesbian chic"), punk and metal rock (Bikini Kill, L7, Tribe 8, Team Dresch, Sexpod), television ("HeartBeat," "L.A. Law," "Tales of the City," "Roseanne," "Northern Exposure," "Friends," "Melrose Place," "Ellen," and the talk show circuit), Broadway (*Angels in America, Rent*), and mainstream movies (*Go Fish,*

The Incredibly True Adventure of Two Girls in Love, Bar Girls, Even Cowgirls Get the Blues, Antonia's Line, Thieves, Bound, Bastard Out of Carolina). Such incursions of "queer" signs into the mainstream image-scape affirm the possibility of living out transgressive desires (at least for middle-class white women) while injecting normative lifestyles with exotic whiffs of sexual freedom and "spice."

In the art world, high-profile exhibitions of photographs by Nan Goldin, Catherine Opie, and Andres Serrano present to affluent and middle-class audiences a vividly rendered bohemia of polysexuality and gender indeterminacy, though the explicitly objectified S&M acts that made Robert Mapplethorpe's "X Portfolio" so harrowing to consume are generally absent in these works. And unlike earlier *noir* documentations of sexual subcultural types by photographers such as Brassaï, Lisette Model, or her student Diane Arbus, these photographers render their subjects larger than life, in vibrant color and, in Opie's and Serrano's cases, monumentalize them as exemplary icons of proud autonomous selfhood in the late twentieth century.

This transformation took place over a short period of time. It was in 1988 that writer Jan Zita Grover noted the problem of *scarcity* in subcultural representation as the structuring condition for how contemporary lesbians produced and consumed photographs of themselves.[1] Photographs of lesbian subjects made for subcultural consumption during the 1970s and early '80s by photographers such as JEB (Joan E. Biren), Bettye Lane, and Cathy Cade tended to fall into two categories: portraits of individual role models such as Kate Millet and Audre Lorde, and of middle-class lesbian couples (usually white, sometimes with children) in a scene some later-day Norman Rockwell

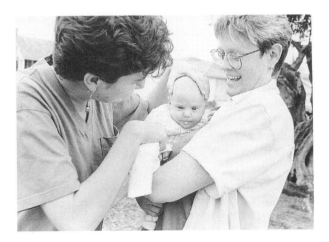

Cathy Cade, *Who Runs the Show?*, from *A Growing Mom* series, 1993.

1. Jan Zita Grover, "Dykes In Context," *Ten.8* no. 30 (Autumn 1988) p. 38.

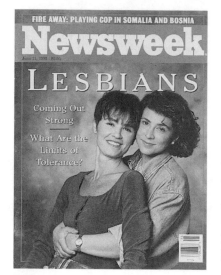

FIRE AWAY: PLAYING COP IN SOMALIA AND BOSNIA

Newsweek

LESBIANS

Coming Out
Strong

What Are the
Limits of
Tolerance?

June 21, 1993

could have rendered. Such "positive images" represented an ideal that was never pictured in the mainstream media. By posing proudly for the camera, lesbians publicly proclaimed their right to exist in a society which outlawed and repudiated their relationships and affirmed their participation in one of the long-standing rituals of normative family life—a life from which many of them had been painfully expelled—where snapshots of marriages, children, birthdays, and anniversaries affirmed the ongoing performance of family cohesiveness, happiness, and generational continuity.[2]

In the 1990s, such "greeting card" images of lesbian couples have appeared twice on the cover of *Newsweek*[3]! Within subcultural contexts and artistic bohemias, however, those positive images of straight-appearing (and straight-laced!) lesbians have seemingly been swept aside by an avalanche of sexually explicit and diverse lifestyle-coded photographs which, far from affirming "family values" of couplehood and stability, assert and privilege an autonomous, defiant, and highly sexualized individuality. How did this change come about so quickly and what does it mean? And how are we to understand this new sex-dissident visibility in an era of conservative backlash, when "traditional family values" have become such a cliché in the domestic political sphere?

For a provisional answer to these questions, we need to step back and take a longer look at the ongoing struggles of women, including lesbians, to represent themselves and their complex desires in a society which has always severely policed such images. What would appear to be paradoxical at first glance—the proliferation of dissident sexual identities and imageries in a fearful and conservative time in the United States—needs to be viewed within the much larger contexts of feminism and feminist conflicts over sexual images, the rise of the conservative right and its ongoing "culture war" against social liberalism, AIDS activism and its grassroots politics, and the needs of a rapidly changing consumption-driven economy.

2. See my "Exposing Family Values: Sexual Dissent and Family Photography," in *A Family Affair: Gay and Lesbian Issues of Domestic Life* (Christopher Scoates, curator), Atlanta College of Art Gallery, 1995.

3. The June 21, 1993, *Newsweek* cover (pictured) featured a smiling, clean-cut, middle-class, white lesbian couple with the banner line, "LESBIANS: Coming Out Strong. What Are the Limits of Tolerance?" The November 4, 1996 cover showed another white lesbian duo, pop singer Melissa Etheridge and her pregnant partner, Julie Cypher, with the banner, "We're Having a Baby—Can Gay Families Gain Acceptance?"

My review of these historical frameworks will be necessarily compressed and simplified. It focuses primarily on photographs by and about middle-class white women in Western industrialized societies such as the United States, Britain, and Canada, women who by virtue of their skin color and access to higher education are already privileged and disproportionally represented in mass media, art, and other image-consumption contexts. Among other communities within the United States, including African Americans, Latinas, Asians, and poor and working-class women of all ethnicities, the issues at stake in sexual dissent are further complicated by ongoing histories of racial- and class-based exclusion and oppression. Working-class lesbians and gay men of color are among the most brutalized of subcultural groups, a situation exacerbated by their overdetermined media representations as prostitutes, hustlers, and drag queens (e.g., *Paris Is Burning, The Crying Game*).[4]

In the Grover essay I cited earlier, the author reminds us that photographs not only "show" us provisional realities, but "erase" other realities simultaneously. Contrary to modernist aesthetic doctrine, no photograph is encountered in an interpretive vacuum, but is filtered through individual desire and memory—the highly selective and fantasy-driven operations of the unconscious. Those positive images of lesbian couples that populated lesbian feminist print media during the 1970s and early '80s, and which have retained their appeal in more mainstream photo books celebrating gay families,[5] *showed* images of commitment, well being, social propriety, and economic stability. At the same time, they *erased* the bedroom, sex toys, lesbian bar culture, poverty, working-class butches, ethnic and racial differences, power asymmetries within and without the social constellation of the couple, nontraditional family models, and the diversity of sexual fantasy and its manifestations in role-playing and other forms of public signifying.

This erasure of economic, social, racial, and sexual diversity—even the sexual itself—from these earlier lesbian photographs reflected the politics of the organized women's movement in its decade of greatest strength—the late 1960s to late 1970s. This was before the movement lost momentum to a politically ascendant conservative backlash, heralded by the 1977 Hyde Amendment eliminating Medicaid funds for abortions, and the 1982 defeat of the

4. See Barbara Smith, "Homophobia: Why Bring It Up?" in *The Lesbian and Gay Studies Reader*, ed. Henry Abelove, et. al. (New York and London: Routledge, 1993). Also Mikeda Silvera, "Man Royal and Sodomites: Some Thoughts on Afro-Caribbean Lesbians," in *Sight Specific: Lesbians and Representation*, ed. Lynn Fernie (exhibition catalogue), Toronto, A Space, 1988; and B. Ruby Rich, "When Difference Is (More Than) Skin Deep," in *Queer Looks: Perspectives on Lesbian and Gay Film and Video*, eds. Martha Gever, et. al., (New York and London: Routledge, 1993).

5. See *Making Love Visible: In Celebration of Gay and Lesbian Families*, photos by Geoff Manasse, interviews by Jean Swallow (Freedom, Calif.: The Crossing Press, 1995); also, see Sarah Wells's photographs in *A Family Affair*.

Equal Rights Amendment.[6] For many middle-class lesbians who came out after Stonewall (1969) and within the context of the second-wave women's movement in the United States, sexual identity was integrated into their feminist gender-based politics to the degree that Ti-Grace Atkinson's slogan, "Feminism is the theory, but lesbianism is the practice," became something of a movement mantra. Lesbian feminist poet Adrienne Rich proposed the notion of a "lesbian continuum" where all women would be united together in a spiritual ideal of solidarity and sisterhood, loving each other *as women* beyond specificities of race, class, and sexual orientation. In contrast, French writer and radical lesbian theorist Monique Wittig asserted that "lesbians are not women," for "'woman' has meaning only in heterosexual systems of thought and heterosexual economic systems."[7] To be a lesbian, in other words, was to radically call into question the "naturalness" of the gender category "woman" with its implicit histories of oppression and subordination.

Such cultural feminist debates influenced photographers Tee A. Corinne, who had trained at Pratt Institute and worked in the San Francisco milieu of countercultural lesbian feminists in the early 1970s. Like lesbian filmmaker Barbara Hammer, Corinne produced lyrically eroticized images of proud women-loving women, alone, paired, and in trios multiracial and differently abled, powerfully autonomous in their gestures, poses and passions. However, Corinne's lack of explicitness, often achieved through solarizing or abstracting women's bodies into patterns or forms in nature, reflected the reticence of feminist publishers about reproducing images of women's bodies that might be seen as prurient. As lesbian "scenes" had long been a staple of straight men's commercial pornography, lesbian feminists were particularly anxious that their images be strictly coded for female, rather than male, viewership. Raunchy poses, close-ups of genitals, signs of gender difference, or the appearance of dominant/submissive sex-play were avoided.

"Sexual Objectification" and Antiporn Politics

Much attention among lesbian feminists in the 1970s was focused on the issue of women's "sexual objectification," or the representation of women as merely "bodies" or eroticized body parts, rather than as fully human subjects. Feminists engaged in lively critiques of all genres of visual culture, from fine art to

6. The mainstream feminist movement also came under attack in the 1980s for its implicit white liberal bias and blindness to the needs of nonwhite and poor women in an economy that was rapidly leaving them behind. And finally, a younger generation of middle-class women (including many lesbians) who came of age in the 1980s rejected the feminist label though they agreed with feminist goals of economic and sexual equality—values they took for granted. In view of their own relative social equality and economic mobility, a "women's movement" seemed no longer needed—a view the mass media and culture/entertainment industries actively fostered. See Susan Faludi, *Backlash: The Undeclared War Against American Women*, (New York: Crown Books, 1991).

7. Monique Wittig, "The Straight Mind," in *Out There: Marginalization and Contemporary Cultures*, eds. Russell Ferguson, et. al. (Cambridge: The MIT Press, 1990).

Tee A. Corinne, *Yantra #56*, 1982.

advertising, even as African American, Asian, and Latina feminists were revising historical representations of raced womanhood. Artists and critics gathered in consciousness-raising groups and founded women's art organizations such as New York's Heresies Collective, Los Angeles' Women's Building, and Chicago's Artemisia Gallery to publicize feminist art and to thrash out the difficult issues of producing and theorizing images of women's bodies from a feminist perspective.

But while feminists began to make their presence felt on the margins of the art world, images of female vulnerability and sexual availability seemed to be everywhere and *incessantly* marketed in the mainstream media: in ads, fashion magazines, beauty pageants, movies and television, the press, and, most blatantly, in the pages of *Esquire, Playboy, Penthouse,* and *Hustler.* The explosion of soft-core porn/consumer men's magazines following the Supreme Court's relaxation of strictures on print pornography in the late 1950s and '60s was another catalyst for women's heightened anxieties about the social stakes of sexual representation.[8]

For those who had suffered male incest, rape, and battering—as many as a third of all women, according to some studies—or who worked in battered-women's shelters and rape crisis centers, it was easy to believe that this continuum of the marketable commodification of women's bodies was not benign, but actively contributed to men's degradation of and violence toward women.

8. In the *Roth* decision (1957), the Supreme Court established that "sex and obscenity are not synonymous." In the notorious *Fanny Hill* case (1966), the Court further ruled that "A [work] cannot be proscribed unless it is found to be *utterly* without redeeming social value. This is so even though the [work] is found to possess the requisite prurient appeal and to be patently offensive. Each of the three federal constitutional criteria is to be applied independently; the social values of the [work] can neither be weighted against nor canceled by its prurient appeal or patent offensiveness." In 1970 the President's Commission on Obscenity and Pornography recommended the repeal of *all* laws prohibiting the distribution of sexually explicit materials to consenting adults and the implementation of a massive sex education program. See Marjorie Heins, *Sex, Sin, and Blasphemy: A Guide to America's Censorship Wars,* (New York: The New Press, 1993), pp. 18-22.

By the late 1970s, a women's antipornography movement grew out of feminist antiviolence organizing. But instead of concentrating its efforts on investigating the social, economic, and psychic causes of actual male violence against women and women's mistreatment by the criminal justice system, it focused exclusively on pornographic images. Any images antiporn activists considered to be degrading to women were "pornographic" and were to be rooted out and banned. Feminist lawyer Catharine MacKinnon developed a body of legal theory justifying this goal as a social necessity and created strategies for pursuing cases in the courts and promoting legislative antiporn initiatives.

Where other feminists, sex/gender theorists, free-speech advocates, and sexual minorities took pointed issue with antiporn feminists was the latter's view of human sexual relations as inherently fixed and oppositional between the two biological sexes. In this unified dualistic system, sexuality was inherently male dominated, violent, and lustful, while women's sexual instincts were tender, wholesome, and nurturing. Women were always already "victims" of male lust, even in consensual heterosexual relations. Thus, any representation of sexuality or sexual pleasure—regardless of who produced it or was its intended audience, whether homosexual or heterosexual, male or female—was regarded by antiporn activists as promoting violence against women.

Meanwhile, the Christian right had become a potent organized force in the Republican Party, and its success in mobilizing its grassroots to elect Ronald Reagan to the presidency in 1980 made it a prominent player in national politics. In the new political climate, antiporn feminists viewed an alliance with fundamentalists and conservatives as an instrumental vehicle for moving antiporn bills through national and local legislatures. That religious conservatives wanted to ban public sexual speech as part of a larger agenda to restore traditional patriarchal order in both private and public life was a contradiction that seemed lost on their new feminist allies. Feminist and right wing politicians joined forces in 1984 to push forward antiporn legislation in Indianapolis and Minneapolis.

But antiporn activists did not confine their targets to legalized porn; they also followed the right wing's lead in harassing and censoring works of art they found offensive. In 1992, an exhibition organized by feminist artist and videomaker Carol Jacobsen at the University of Michigan Law School of photographic and video works by and about sex workers was vandalized and eventually shut down by women students, heeding the directives of MacKinnon, now a professor at Michigan Law.[9] Many other feminists, along with artists and gays and lesbians came to regard antiporn feminists as censorious

9. Jacobsen was able to mobilize a team of civil-liberties lawyers, feminists against censorship, artist anticensorship organizations, and colleagues nationwide to protest and bring pressure on the university to reinstate the show a year later. See Carol Jacobsen, "Who's Afraid of the Big Bad Sex Workers? The Censoring of 'Porn'im'age'ry: Picturing Prostitutes,'" *exposure* 29, 2/3 (1994): 14. Also Carole S. Vance, "Feminist Fundamentalism—Women Against Images," *Art in America* (Summer 1993), p. 35.

"new puritans." Gay men and lesbians, especially, knew that their ongoing struggle to openly identify themselves and to demand respect and equal treatment under the law were the real targets of right-wing campaigns to promote "traditional family values" and banish public sexual speech. And, as the AIDS epidemic was making all too clear, such silencing literally meant death.

Counterattack: Women Against Censorship Meets
Psychoanalysis and the New Gender Studies

The successes of right-wing and feminist antiporn forces in stirring up moral panics over sexual images galvanized a powerful counterattack led by feminists and lesbians who were interested in expanding, rather than contracting, women's repertoires of the erotic. In 1981, *Heresies* published its famous "Sex Issue," featuring a variety of explicit erotic writings and artworks by lesbians. In San Francisco, a lesbian-feminist S&M support group, Samois, published *Coming to Power*, a daring anthology of writings, drawings, and photographs exploring S&M fantasy and lesbian leather culture. Images by Morgan Gwenwald and Honey Lee Cottrell, among others, showed bare-breasted, leather-clad women sporting switchblades, whips, handcuffs, and key chains. Sometimes the subjects stood alone, leveling their gazes into the camera as though challenging the viewer; other times they appeared with lovers in deliberately salacious poses. Despite the low reproduction quality in the book, fetish display for the admiration and aesthetic delectation of the viewer was of paramount importance in these fantasy photographs.

Coming to Power unleashed a torrent of outrage and feminist protest, for here were *women* who openly acknowledged (to the horror of antiporn feminists) that the transgressive fantasy performance of dominance and submission was fundamental to their erotic pleasure. The following year, 1982, the New York chapter of Women Against Pornography picketed, leafleted, and provoked institutional administrators to withdraw support from a scholarly conference at Barnard (attended by over 800 women) exploring female sexuality and sexual politics. In response, some of the organizers and participants in the Barnard conference founded the Feminist Anti-Censorship Taskforce (F.A.C.T.) to combat antiporn feminists and to educate women about a more complex view of human sexuality and its histories.

In 1986, F.A.C.T. published *Caught Looking: Feminism, Pornography and Censorship*, with essays by leading feminist sex researchers, writers, historians, and legal advocates such as Carole Vance, Kate Ellis, Ellen Willis, Pat Califia, Nan D. Hunter, Lisa Duggan, and Ann Snitow. The book was copiously illustrated with pornographic photographs from all periods in photographed history—of individuals, couples, and groups of every determinable gender, arousing themselves and each other in multiple ways. On the cover was a photograph of a young woman in a lacy bustier, her stockinged legs suggestively spread, eagerly devouring what appeared to be a porn novel. Her obvious pleasure and delight in consuming commodified pornography was precisely the

point. Erotic fantasy, F.A.C.T. suggested, is not the exclusive domain of men, but is a normal and healthy aspect of women's sexual lives. The "bodice-ripper" is even named as a known genre of heterosexual women's erotic fiction, often featuring tall, handsome strangers who ravish their swooning "victims."

New scholarship addressing the psychic operations of gendered spectatorship in relation to visual images, particularly in Hollywood films, sparked rich debates among feminists, lesbians, and image-makers in the 1980s. In her groundbreaking essay, "Visual Pleasure and Narrative Cinema" (1975), feminist film scholar Laura Mulvey used classical Freudian theory to explicate the tight linkages between dominant modes of cinematic spectatorship and the oedipal, fetishistic, and narcissistic needs of unconscious male fantasy. Mulvey initially followed earlier feminist paradigms in theorizing these gendered spectatorial positions as fixed by biological sex (man as the owner of the gaze and woman as its object), but her essay launched a whole new and exciting avenue of inquiry for a generation of film and photography scholars, men and women alike.[10]

Studies of the psychoanalytic literature, particularly the works of Jacques Lacan, and explorations of the specificity of desire among different subjects revealed that in the unconscious, erotic fantasy is pervasive, highly nuanced, and does not neatly align with given gender differences. It can attach to any number of objects and censoring one kind of imagery does nothing to quell desire itself. As Simon Watney put it, "It is not pornography which is everywhere, but fantasy."[11] Gay men and lesbians recognized that they had always "homosexualized" images from straight popular culture to satisfy their fantasies, and many lesbian photographers such as myself, the late Tessa Boffin, Jean Fraser, Nina Levitt, Lynette Molnar and others have gleefully "queered" straight icons in our photographic works. In her series *The Knight's Move* (1990), for example, Boffin staged photo tableaux posing lesbians as romantic historical and literary subjects, including as a dashing knight in armor, a leather- and chain-mail-clad knave, and as the eighteenth-century womanizer, Casanova. In my series *Dream Girls* (1990), I montaged my own self-portrait as a butch romantic lead into old Hollywood movie stills with leading ladies such as Linda Darnell, Katherine Hepburn, and Natalie Wood. Also targeting Hollywood's star machine, Nina Levitt's photo series *Think Nothing Of It* (1990), appropriated a Hollywood publicity photograph showing actress Joan Crawford and film director Dorothy Arzner, enlarging particular details

10. Laura Mulvey, "Visual Pleasure and Narrative Cinema," *Screen* 16, no. 3, (Autumn 1975) pp. 6-18. The two foremost exponents of psychoanalytic theory in relation to photographic production and reception are Mary Kelly and Victor Burgin, both of whom were active in London when Mulvey's essay first appeared, and now teach in the United States. Because of its theoretical density, psychoanalytic criticism has had only limited influence in U.S. photographic discourse, compared to film and literary studies.

11. Simon Watney, *Policing Desire: Pornography, AIDS and the Media.* (Minneapolis: University of Minnesota Press, 1987) p. 74.

Deborah Bright, untitled from *Dream Girls*, 1990.

to highlight erotic signifying between the two women, one of whom was an acknowledged lesbian.

In her discussion of the Meese Commission on Pornography elsewhere in this volume, Carole Vance points out that it is the inability to stanch erotic fantasy that gives religious conservatives so much trouble. In the name of "protecting others" they are trying to protect themselves from emotions and desires they cannot control, that generate feelings of shame and disgust. F.A.C.T. squarely countered antiporn feminists' arguments about the implicit violence of sexuality and sexual images by showing that sexual fantasies did not respect biological difference and often featured images of male submission and vulnerability. Instead of liberating women from male sexual oppression, F.A.C.T. argued, censorship only facilitated it by ceding to dominant male-oriented commerces all expressions and definitions of sexual pleasure and power, further silencing and shaming women as sexual subjects. What was needed, F.A.C.T. argued, was *more* sexual expression by and for women, not less.

In 1988, three lesbian artists from Vancouver, calling themselves Kiss & Tell, created a photographic exhibition which would eventually travel to fifteen cities on three continents, exploring how women viewers confront mixed cultural messages and personal ambivalences about looking at sexual images. Titled *Drawing the Line: an interactive photo event*, Kiss & Tell mounted a series of 100 staged photographs by Susan Stewart of the same two women, Persimmon Blackbridge and Lizard Jones, making simulated love in poses

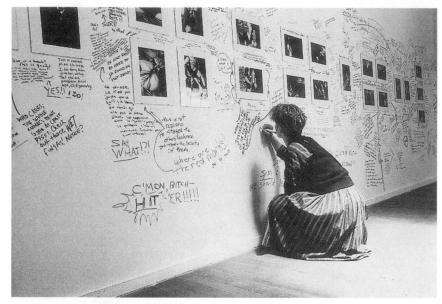

Drawing the Line—lesbian sexual politics on the wall. Copyright © 1991 Isa Massu.

and gestures that ranged on an escalating scale of explicitness from tender gazes, fully clothed, to making love while being watched by a man, to bondage, whipping, and anal penetration. The wall the photographs were mounted on was covered with white paper and marking pens were left in baskets nearby. Women viewers were invited literally to "draw the line" where they felt that the photographs became offensive and write their comments. Male viewers were barred from this "women only" public discussion on the wall, but could record their responses in a "Men's Book" provided.

As Jan Zita Grover commented in a discussion of *Drawing the Line's* 1990 exhibition in San Francisco,[12] women argued vehemently among themselves in their wall comments, no two agreeing about what, exactly, the pictures showed. The comments were "frequently more projective than descriptive," Grover wrote, suggesting that "the site of interpretation was not so much the photographs' contents" as viewers' own projections onto them. "This is what the man who raped me said that women liked," wrote one participant. Some women slashed through the photos with their markers, trying to cancel them out. "They responded," continued Grover, "as if they were gazing through a keyhole and deriving guilty pleasure from it, reacting in rage toward other viewers' enthusiasm."

12. Jan Zita Grover, "Framing the Questions: Positive Imaging and Scarcity in Lesbian Photographs," in *Stolen Glances: Lesbians Take Photographs*, eds. Tessa Boffin and Jean Fraser (London: Pandora, 1991).

Other women, in contrast, expressed frustration with the tameness of the action. "The wanking is fun but I could do without the romanticism," one viewer wrote. "Tear her shirt off!" wrote another. Grover concluded her remarks by noting that it was precisely the scarcity of lesbian sexual representation that made the stakes so high for lesbian viewers and produced internal policing. A show which represented lesbian desire so boldly in a world where such images were never seen in public exhibition spaces carried the burden of representing *all* lesbian desire. And, of course, it could not. But new publications had begun to appear which were trying to plug the gap.

In 1984, Debi Sundahl founded *On Our Backs*, a lesbian porn magazine which featured explicit photographs of lesbian sex, fantasy rape scenes, group sex, sex toys, and gendered role-playing by photographers such as Cottrell, Gwenwald, Katie Niles, C. L. Prochazka, and Cookie (Annjohnna) Andrews-Hunt,[13] along with editorials by Susie "Sexpert" Bright, an outspoken feminist writer, sex advocate, and women's erotica entrepreneur. The publication's title was an irreverent parody of the feminist tabloid *off our backs* and Bright made it clear that the feminist "pc police" were not patrolling her world. In short order, two more lesbian porn rags followed, *Bad Attitude* and *Outrageous Women*, signaling an historic first: a thriving, if small-scale, commercial porn industry by and for lesbians. Lesbian video production companies such as Tigress and Fatale marketed low-budget, low-tech erotic videos to the new and rapidly growing home VCR market. Some feminist bookstores refused to carry the titles, but gay bookstores—already well stocked with gay men's porn videos, magazines, greeting cards, calendars and picture books—happily added them to their inventories.

Staying Sexy, Staying Alive in the Age of AIDS

The AIDS pandemic, first noted among gay men in 1981, and which was devastating gay male communities in the United States by mid-decade, was initially ignored, then only grudgingly acknowledged as a national emergency by Ronald Reagan's administration. The press's reporting on the epidemic exacerbated a new wave of homophobic and bigoted violence toward gays and other sexual minorities. Reports on television and in the print media pandered to old stereotypes of homosexuals as antisocial corrupters of normal society and repeatedly blamed the spread of AIDS on the "gay lifestyle" rather than on a sexually transmissible virus.

In 1989, stereotypes of gay men as AIDS carriers and perverted predators congealed in the larger-than-life ghost of photographer Robert Mapplethorpe who had recently died of the disease. Conservatives in Congress had long sought a strategy to defund the National Endowment for the Arts, and

13. Works by these pioneering erotic photographers and others can be seen in Susie Bright and Jill Posener, eds., *Nothing but the Girl: The Blatant Lesbian Image*, (New York: Freedom Editions, 1996).

Mapplethorpe's posthumous exhibition, *The Perfect Moment,* along with another exhibition of provocative photographs by Andres Serrano, had been partially funded through the agency. *The Perfect Moment* included the "X Portfolio" of photographs from the 1970s showing gay leathermen, including Mapplethorpe himself, performing S&M scenes staged for the camera. The long litany of subsequent acts of censorship, harassment, recrimination, artists' "decency oaths," court battles, and the mobilization of congressional consensus to slash NEA funding and phase out the NEA entirely, does not need to be rehearsed here. But the censorship wars and the broader demonization of nonnormative sexuality and sexual speech in the wake of Mapplethorpe provoked a militant response among gay and lesbian artists who joined forces with anticensorship feminists, civil-liberties lawyers, art-world sympathizers, and AIDS activists to vigorously defend the right to public sexual expression.

The most visible AIDS action group, ACT UP, was founded in New York in 1987 and included among its ranks many artists and arts professionals. Its affiliated artist collective, Gran Fury, produced a brilliantly sophisticated graphics campaign for use in demos and street actions.[14] One of Gran Fury's most famous posters, which appeared on public buses in various cities, shows three young interracial couples kissing—two gay and one straight. The copy reads: "Kissing doesn't kill. Greed and indifference do." Mimicking the hip multicultural look of Benetton's apparel ads, Gran Fury's poster at once affirmed the public expression of queer sexual desire and skewered the inhumanity of corporate and governmental policy.

Lesbians worked alongside gay men in ACT UP and in other direct-action groups across the nation and abroad, forming women's caucuses to address AIDS prevention and health education among women and to counteract negative stereotypes of female sexuality and the publicly funded promotion of abstinence ("just say no") to already sexually active teens, rather than educating them about how the virus was transmitted and what precautions needed to be taken.[15] Observing gay men's vigorous and defiant grassroots campaign to educate their community about safer sex practices and to celebrate expansive modes of sexual expression—even in an epidemic—inspired many urban lesbians to expand their own sexual repertoires and experiment with a much wider array of practices, venues, role-playing, and toys.

In 1991, London-based photographers Tessa Boffin and Jean Fraser published *Stolen Glances: Lesbians Take Photographs,* the first attempt to situate post-Stonewall photographic practices by lesbians in a critical historical context. Though it only stayed in print for four years, it was a landmark

14. See Douglas Crimp with Adam Rolston, *AIDS Demo Graphics,* (Seattle: Bay Press, 1990).

15. See my "Lesbians, Photography and AIDS," in *Stolen Glances,* p. 173-183.

publication and marked the increased visibility of lesbians due to AIDS activism and the new sexual militance. Boffin and Fraser assembled a number of important contemporary lesbian critics of visual media such as Jan Zita Grover, Elizabeth Wilson, Mandy Merck, Sue Golding, and Cindy Patton who excavated and explored lesbian identities and stereotypes across a variety of historical and cultural sites, including interwar Paris (Natalie Barney's circle, Gertrude Stein and Alice B. Toklas, Berenice Abbott and friends); Alice Austen's privileged Victorian world of female love and ritual, and the Cold War era of lurid pulp novel portrayals of forbidden lesbian love. *Stolen Glances* included a broad range of contemporary expressions of lesbian desire and identity by white photographers such as Rosy Martin, Kaucyila Brooke, Hinda Schuman, Tee Corinne, Nina Levitt, Connie Samaras, and Lynette Molnar, and by black, West Indian, and South Asian photographers such as Mumtaz Karimjee, Ingrid Pollard, Jacqui Duckworth, and Jackie Goldsby.

The appearance of a new "dyke street style" among young urban white lesbians made itself felt in *Stolen Glances,* particularly in the photographs of Della Grace, a London-based photographer whose works enjoyed wide circulation as postcards among lesbians and were collected in the book *Love Bites* (1991) which gained notoriety by being banned by customs officials in both the United States and Canada.[16] *Love Bites* showed women in their twenties, posing together and alone, pierced and tattooed, bleached and buzzed, and decked out in black leather motorcycle jackets, harnesses, and other S&M paraphernalia, garter belts, fishnet stockings, jockey shorts, heavy work boots, and brandishing the occasional dildo. Most of the shots appeared to be staged for their erotic and fashion-fetish appeal—often featuring sexual encounters in toilets, back alleys, or at industrial sites—while others had the look of casual club shots. *Love Bites* sparkled with a sassy, youthful energy which seemed less concerned with political resistance than with exulting in dyke nightlife and its correspondingly hip sartorial tastes.

This new lesbian look derived from politically charged sources, however, including the revival of interest in "butch-femme" subcultural histories, and styles associated with militant direct-action groups such as ACT UP and groups mobilized in Britain in the late 1980s to protest the enactment of anti-gay legislation by the Tory government.[17] "Butch-femme" referenced the highly regulated system of subcultural gender coding developed by working-class lesbians who socialized illegally during the "dark ages" between World War II

16. Della Grace, *Love Bites,* (London: GMP Editions, 1991).

17. Specifically, Section 28 of the British Local Government Act (effective, May 1988) which prohibited local authorities from "intentionally promot[ing] homosexuality or publish[ing] material with the intention of promoting homosexuality" and "promot[ing] the teaching in any maintained school of the acceptability of homosexuality as a pretended family relationship." Section 28 was fought bitterly by gay rights groups who staged dramatic public demonstrations against its passage.

and Stonewall, often in Mafia-run bars in urban combat zones. In this era, the choice of whether to identify as butch or femme was a serious matter, determining one's social role and sense of security within a tightly knit community where police brutality was a constant threat.[18] Following turn-of-the-century psychoanalytic theories of sexual inversion which made their desires intelligible to them, butch lesbians often felt as though they were men trapped in women's bodies. For post-Stonewall, post-feminist, and post-deconstructionist dykes, however, butch-femme was a turn-on. It was a poke at both "politically correct" feminism and at religious and social conservatives who, of course, were advocating a return to traditional gender roles *by heterosexuals*. For university-educated dykes who were learning about new theories of gender in their women's studies, art, and cultural studies seminars, butch-femme role-playing even seemed politically subversive.

Political activists of both sexes adopted a militant look for street demos and actions, some of it borrowed from working-class British punk subcultures via the metal rock scene: piercing, tattoos, chains, black leather jackets, T-shirts with in-your-face political slogans or ACT UP's "Silence= Death" logo, buttons, pins, bandannas, and Doc Martens. Chanting slogans and inventively disrupting "business as usual," AIDS and anti-Clause 28 activists created imaginative "media zaps" that garnered national and international news coverage. In the conservative Reagan-Bush and Thatcherite eighties, when the feminist and black civil rights movements, the socialist left and organized labor were demoralized and in disarray, militant queer organizing seemed to be the only visible site of energetic countercultural social protest.

AIDS mobilizing gave a boost to ongoing investigations of the role of sexual fear and fantasy in producing social regulation. The writings of Michel Foucault were of vital importance for the ways in which he explored how modern sexuality was produced by its discourses of repression in the industrialized West, beginning in the Victorian era when sexual expression was confined to the private procreative domain of heterosexual marriage and when all other sexual speech and acts were prohibited by law. Later, sexologists would name and identify homosexuality and heterosexuality as two distinct sexual *identities*. Heterosexuality needed an "other"—homosexuality— against which to establish its hegemony as the "natural" foundation of the bourgeois social order, located in the nuclear family.

Foucault's ideas were revised and elaborated by Judith Butler in her landmark book, *Gender Trouble: Feminism and the Subversion of Identity*

18. For histories of this period, see Lillian Faderman, *Odd Girls and Twilight Lovers: A History of Lesbian Life in Twentieth-Century America,* (New York: Columbia, 1991), and Elizabeth Lapovsky Kennedy and Madeline D. Davis, *Boots of Leather, Slippers of Gold: A History of Lesbian Community,* (New York: Routledge, 1993). Also, the excellent videotape, *Forbidden Love: The Unashamed Stores of Lesbian Lives,* Aerlyn Weissman and Lynne Fernie, 1992.

(1990).[19] Butler brought Foucault into the realm of feminist theory (Foucault had utterly ignored women in his writings), following in the footsteps of feminist anthropologist Gayle Rubin who had first theorized how the creation of a heterosexual "sex-gender" system was necessary to the maintenance of a patriarchal social order.[20] Sexual differences are organized by societies in hierarchies which both privilege and punish, and anthropologists observed that these hierarchies differ significantly among social groups. Things function smoothly as long as the dominant sexual order is perceived as the "natural" order and sexual dissent is stigmatized or kept invisible. The visibility of sexual "others" causes anxiety because it threatens to expose the instability of "normal sexuality," a sexual order that must labor constantly to reiterate its "naturalness" and sustain its power. Butler likened this reiteration to a repeated "performance" of heteronormativity (and its gender codes) in our culture.

Though her "performances" of heteronormative femininity for the camera had commenced over a decade earlier and had derived from a long tradition of feminist performance art, Cindy Sherman's brilliantly staged film stills and giant color photographs of herself posing as grotesques, seductresses, exotics, and ingénues both stimulated and "bodied forth" many of these cross-fertilizing ideas of postmodern gender discourse. By the mid-1980s, Sherman became the benchmark for photographers dealing with cultural codes of sexuality and gender. In one stroke, her photographs called into question not only mass media and cinematic representations of the reiterated performance of femininity, but all of those earnest positive images of "authentic" subcultural identities as well.

AIDS activism and the public discourses around sexuality it produced further highlighted this theatrical space of sex-gender performativity. Indeed, sexual subcultures seemed suddenly to proliferate as Queer Nation, a short-lived sex-radical, direct-action group which branched off from ACT UP in 1990 to promote resistance to "straightness" and its multiple oppressions, included under its political umbrella all who resisted the hegemonic operations of heterosexuality, including progressive heterosexuals, gays and lesbians, bisexuals, transgendered and transsexual folk, intersexuals, and other "queers." Transsexual performance artist Kate Bornstein gave multiple-choice "gender quizzes" to her enthusiastic audiences, showing them how inconsistent and ambivalent their notions and fantasies around gender could be, while Annie Sprinkle and Susie Bright spoofed the whole notion of sexual exclusivity. Traditional gender roles were seen as oppressive and boring besides.

It was in this atmosphere of new openness to nonnormative genders and sexual complexity that a self-identified "dyke daddy," Catherine Opie, began

19. Judith Butler, *Gender Trouble: Feminism and the Subversion of Identity* (New York and London: Routledge, 1990).

20. Gayle Rubin, "The Traffic in Women: Notes on the 'Political Economy' of Sex," in *Toward an Anthropology of Women*, ed., Rayna R. Reiter (New York: Monthly Review Press, 1975).

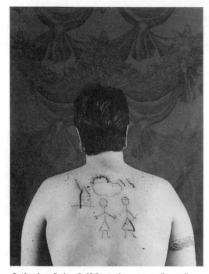

Catherine Opie, *Self-Portrait*, 1993. 30" x 40", chromogenic print. Courtesy Regan Projects, Los Angeles.

making monumental large-format color studio portraits of transsexual and transgendered friends and acquaintances in Los Angeles and San Francisco. Opie's formal close-up portraits of lesbians in facial-hair drag, each with her girl-punk nickname engraved in brass on the pictures' heavy black frames, embellished a 1992 interview with Butler in *Artforum* and launched a body of large-scale portrait work (1992-96) featuring both unknown and celebrity transsexuals, drag queens and kings, pierced, cut and tattooed subjects such as scandalous performance artist Ron Athey, and various other gender-benders posed starkly and regally against plain backdrops of brilliantly saturated hues. One of Opie's most riveting images was a self-portrait of her own nude upper back and head posed against a deep-blue brocade backdrop. A stick-figure drawing of two women holding hands in front of a house was cut into the photographer's pale skin and outlined in her blood. The touching simplicity of the childlike image and its encoded aspirations for "family togetherness" clashed sharply with the graphic transcription of the pain voluntarily embraced by this adult queer body and hinted at its possible psychic underpinnings.

In 1994, the three women of Kiss & Tell published *Her Tongue on My Theory*, an extended postmortem on *Drawing the Line*, and a wide-ranging critical trialogue exploring the political histories, theories, and practice of art about sexual desire from contemporary queer feminist perspectives. The conversational text was accompanied by images from their collaborative performance and video work, *True Inversions*, as well as by short sex-fantasy stories. The conversations touched on a number of issues, including feelings about posing for publicly distributed sexual photographs, feminist conflicts and ambivalences about sexuality, the freedom to invent new paradigms for lesbian desire, and the relationship of images to community building. As Susan Stewart put it, "Lesbian photographs (published and unpublished) get circulated, passed hand to hand, discussed and debated within the community. There is a tremendous demand and need for self-representation by a community whose psychic survival depends on the sure knowledge that there are others like ourselves."[21]

21. Kiss & Tell, *Her Tongue on My Theory: Images, Essays and Fantasies* (Vancouver: Press Gang Publishers, 1994), pp. 52-53.

Kiss & Tell noted the effects of the widespread shift to "queer" identity politics in the early 1990s and debated the trade-offs for lesbians. The authors made the cogent observation that in this new queer world, much as in the older feminist and gay/lesbian worlds, the wide disparities in terms of the risks and privileges among "queer" subcultures, particularly as they split along lines of gender, race, and class, are still rendered invisible. Lesbians tended to be erased in a movement dominated by gay men, even as they had been marginalized in a feminist movement dominated by straight women.[22] Lesbians from racial and ethnic subgroups risked being triply "disappeared": as women, as lesbians, and as nonwhites. Queer visibility also ignored working-class and poor queers in its increasingly upscale market-mediated forms, except as exotic spectacle (e.g., as rural southern "white trash," or as urban black/Latino drag queens). While evoking "outlaw" status might be a good turn-on for sex, Lizard Jones remarked, it's "maybe not a good basis for a politic." Certainly, it was a good turn-on for consumption.

As Queer As You Wanna Be: Sexual Diversity and the Marketplace

> While boomers argue about identity politics, their kids surf it as a sexy fact of life.[23]

The multiply-amplified calls for a more "democratized" and diversely visible sexual expression from an array of political voices by the turn of the 1990s also resonated with ongoing changes in the national economy. For thirty years, the corporate drive for profits in the now-dominant retail/entertainment sector depended on constantly identifying new niche markets of consumers. While the corporate-run media sought, as always, to create a homogenous, middle-class "American public" by erasing cultural and class differences and promoting a notion of "common values," retail marketers and advertisers searched out overlooked subgroups of middle-class consumers to whom they could sell a more upscale, identity-based "lifestyle" with its own music, movies, television shows, fashions, periodicals, and other cultural commodities. The freedom "to be" became the freedom "to buy."

By the early 1980s, affluent urban gay men had been identified by corporate marketers as an untapped gold mine.[24] As middle-class white men earned the highest incomes, this demographic enjoyed maximum spending power and (usually) no financial dependents. In addition, gay men had always been

22. See Harmony Hammond's and Catherine Lord's introductions to the catalogue for their co-curated exhibition of works by lesbian artists, *Gender, Fucked*, Seattle, Center on Contemporary Art, 1996.

23. Richard Goldstein, "The Culture War Is Over! We Won! (For Now)," *Village Voice*, 19 November 1996, p. 51.

24. Danae Clark, "Commodity Lesbianism," *CameraObscura* 25/26, (January/May 1991) pp. 180-201.

trendsetters in male (and female) fashion, so the profitable "trickle-down" to the mainstream marketplace was already a given. Consumption played a large role in post-Stonewall urban gay life with the gentrification of identifiable gay neighborhoods in many cities with their own restaurants, bars, clubs, bathhouses, gyms, bookstores, and services. This creation of "community" through its consumer institutions was further exploited by mainstream corporations and even gay entrepreneurs who began to stimulate identity-based consumption on a much larger scale.

In 1984, Calvin Klein unveiled his first of many "gay window ads"— ads which avoided explicit references to heterosexuality by depicting only one individual or same-sex groups in order to attract gay consumers without alienating straights.[25] A giant billboard in Manhattan featured a hunky young white male model, clad only in his Calvins. Photographed by Bruce Weber, the model posed with his eyes closed, as though lost in thought—a strategy to mitigate his potential homoerotic charge for heterosexual male viewers (he's not looking at *me*!). This nod to straight male anxieties was abandoned by the 1990s, however, as scantily clad butch men with sculpted bodies gazed boldly into the camera, inviting eroticized looks from all "comers." In the pages of gay-oriented consumer magazines, six of which started up or revamped their formats between 1991 and 1992, and in mail-order catalogues, muscle queens in shirts, briefs, and loungewear invited fantasy play with as much coy come-on as any female model from the old days, prompting journalists to note the new "male bimbo" phenomenon in fashion and advertising.[26]

Although heterosexual women—who had always been the major target market, reflecting their role as primary consumers within the privatized contexts of mating and raising families—and affluent white gay men were now firmly ensconced as identifiable consumer groups, middle-class white lesbians remained outside marketers' purviews until the early 1990s. "Lesbian chic" was a short-lived phenomenon in the media,[27] but it marked the new public visibility of high-powered women, including lesbians, among the entertainment, business, and political elites in the years immediately follow-

25. Ibid., 188.

26. New gay consumer magazines which appeared in the early 1990s included *Out, Poz, Ten Percent*, and *Deneuve*, along with a revamped *Advocate* and *Christopher Street*. Mail-order catalogues such as *International Male* blatantly attract gay consumers with pages of well-endowed beefcake modeling form-fitting leisure-wear and briefs, sans airbrushing. Mainstream men's magazines such as *Details* also boast a sizable gay following. See Lena Williams, "Bodies Go Public: It's Men's Turn Now," *New York Times*, 31 October 1990, sec. C.

27. See Linda Dittmar, "The Straight Goods: Lesbian Chic and Identity Capital on a Not-So-Queer Planet," in *The Passionate Camera: Photography and Bodies of Desire*, ed. Deborah Bright (London and New York: Routledge, 1998). "Lesbian Chic" was dubbed by the May 1993 issue of *New York* magazine in its cover story on lesbians. Subtitled "The Bold, Brave New World of Gay Women," it named a trend signaled by the new visibility of lesbians in the political, entertainment, and sports worlds.

ing Bill Clinton's first election in 1992. First Lady Hillary Rodham Clinton represented a new baby boomer breed of independent professional woman in that exemplary outpost of the Feminine Mystique. For the first time in U.S. history, the president appointed an out homosexual politician, Roberta Achtenberg, as assistant secretary of Housing and Urban Development, and named two never-married women, Donna Shalala and Janet Reno, to important cabinet posts. Indeed, an energetic feminist (rather than feminine) presence was felt in political Washington, but it was a presence that vaporized by the 1994 mid-term election and the so-called "angry white male" vote that turned Congress over to conservative Republicans.

In one of his first acts as president, Clinton sought to lift the ban on gay men and lesbians serving openly in the military, an effort vigorously resisted by the Pentagon and ultimately out-flanked by conservatives, but which demonstrated the new top-level political access gay lobbyists, many of them lesbians, enjoyed in the public political sphere. In 1993, lesbian pop idol k.d. lang made the May cover of *New York* magazine and the August cover of *Vanity Fair*, and in June, the left-liberal *Nation* published its first queer theme issue. *Vogue*'s July issue bid "goodbye to the last taboo" in an article touting the new lesbian visibility and in November, *Cosmopolitan*, that bible of obsessive sexual strategizing for upwardly mobile "career girls," featured a lead article on "Being a Gay Woman in the 90s." "Gay women today are more visible than ever before," the magazine gushed. "Every syndicated television talk show has discussed lesbianism in the past year, or so it seems, and news shows like "20/20" have done segments on the topic." Sitcoms and soap operas incorporated sympathetic gay characters into their stories, as did Hollywood movies. In this more relaxed media-sanctioned atmosphere, a handful of female sports and entertainment figures openly confirmed (or did not challenge allegations of) their same-sex orientations, including lang, Melissa Etheridge, Martina Navratilova, Lily Tomlin, Sandra Bernhard, and Janis Ian. But such revelations remain rare, for "star power" in the entertainment, modeling, and sports worlds derives from fans' fantasy-driven identifications with these (presumed straight) heroes and heroines. The corporate entities who virtually own the bodies of movie stars and

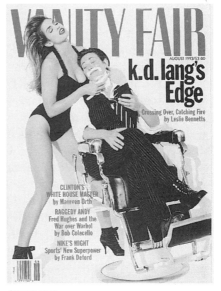

August 1993

sports heroes are all too aware of the impact on profits should this illusion be shattered.[28]

But despite the careful maintenance of the closets of established entertainment figures, the marketers for a younger generation of up-and-coming pop stars saw the profitable potential in exploiting the look of sexual difference. By splicing together gender signifiers (not blurring them androgynously, seventies style) and skimming off the post punk countercultural panache of ACT UP, Queer Nation, the Lesbian Avengers, and other sexual subcultures such as the black and latino drag-ball scene vividly portrayed in Jennie Livingston's widely discussed film, *Paris Is Burning* (1990), pop-culture marketers could bring the exotic look of gender-fuck

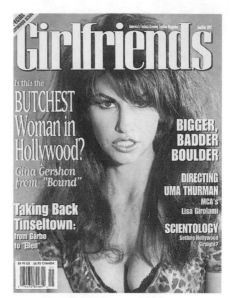

January/February 1997

"realness" to white middle-class youth in a way parents wouldn't object to. Urban black hip-hop, after all, posed a much more radical threat. Madonna vogued her way to riches, "justified her love" with both sexes, and produced her own polymorphous porno book, *Sex*. Although it is easy to see the ways in which Madonna contained and defused the militant critiques of queer activism and radical sexual politics, she nonetheless brought its subversive ghost to the shopping mall. The *New York Times* confidently reassured readers after the 1992 release of her album "Erotica": "in six months to a year, this latest multimedia expression of Madonna's imagination will have played itself out. And then what?"[29]

But despite the fade-out of "lesbian chic" from the mainstream media by the end of 1994, the acknowledgment of a small but affluent lesbian niche market by vodka and liqueur advertisers, credit-card marketers, travel resorts, the entertainment industry, and apparel designers (notably absent is the cosmetics industry) made possible the proliferation of more lesbian consumer magazines beyond the decade-old *On Our Backs* and *Bad Attitude* (which became glossier), including *Deneuve* (whose name was changed to *Curve* when the French film star threatened to sue), and *Girlfriends*, both of which are published in California and have national distribution[30]. As with

28. See Michelangelo Signorile, *Queer in America: Sex, the Media, and the Closets of Power* (New York: Random House, 1993). Also Vito Russo, *The Celluloid Closet: Homosexuality in the Movies* (New York: Harper and Row, 1981, 1987).

29. Stephen Holden, "Selling Sex and (Oh, Yes) a Record," *New York Times*, 18 October 1992.

30. Fara Warner, "More Marketers Aiming Ads at Lesbians," *Wall Street Journal*, 19 May 1995, sec. B.

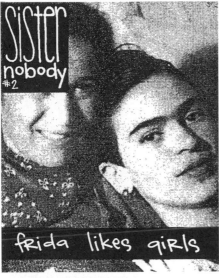

sister nobody #2, frida likes girls

their mainstream counterparts, editorial content in these new magazines reinforces consumption of the products marketed by advertisers while potentially controversial subjects such as political news, religion, AIDS, breast cancer, alcohol abuse, social class, and racial/ethnic diversity are largely ignored. Pages are filled with fashion reports, gossip, commentary on mainstream films, television and media offerings, travel features, and interviews with insiders in the entertainment and fashion worlds. As elsewhere, lesbians are encouraged to see themselves as a "young, hip, urban demographic"—which means white, monied, in good health, and with the leisure time for fantasizing about the good life the ads present—in other words, much like the heterosexual and cross-over consumers traditionally constructed by *Vogue, Elle*, and *Harper's Bazaar*.

But a vital counter-media underground has thrived among a number of younger "gen-X dykes and fags" who scorn the bourgeois market defined by such glossies and the blatant exclusion of those without high-paying jobs, clout, white skin, buff bodies, impeccably tailored tastes, and penthouse apartments. Evolving from the punk fanzine subcultures that flourished in and around the alternative rock scene during the 1980s, queer 'zine publishers adopt the "do it yourself" ethos of punk and turn out cheaply produced little magazines, printed on a word processor and featuring raw cut-and-paste graphics—the clumsier and less slick, the better.[31] No seamless Photoshopped images here! Reproduction is by means of a photocopier, often subversively commandeered at work or at school.

'Zines cater to and create community among queer subgroups ignored by the supposedly "subcultural" media and openly mock the latter's blatant suturing of "gays and lesbians" into normalized channels of consumption. A do-it-yourself dyke video culture thrives in close proximity to the 'zines, pioneered in the early 1990s by Sadie Benning, a teenage dyke who narrated her coming-of-age "diary" with a Fisher-Price Pixelvision camera. Present-day "girl culture" videos such as *She's Real, Worse Than Queer, Mary Jane's Not a Virgin Anymore, Swallow*, and *Lady (Out)laws and Faggot Wannabes* form the visual counterpart to the post punk riot grrrl music scene and often reference it directly. The

31. S. Bryn Austin with Pam Gregg, "A Freak Among Freaks: The 'Zine Scene," in *Sisters, Sexperts, Queers: Beyond the Lesbian Nation*, ed. Arlene Stein (New York, Plume, 1993), p. 81. Also, Stephen Duncombe, *Notes From Underground: Zines and the Politics of Alternative Culture* (London and New York, 1997).

"in your face" feminist militance of much of this production has militated against its easy assimilation by mainstream fashion—for the moment, at least.

With names like *J.D.s, Cunt, Bimbox, Girljock, Sister Nobody, Bamboo Girl, Fierce Vagina, Whorezine, Bust, Jailhouse Turnout, Resister, Princess,* and *Bitch Nation,* dyke 'zines are raw, irreverent, funny, and subversive of any dominant assumptions about queer national (and mainstream) marketing. They are highly specialized as well, each catering to its own self-defined "demographic," whether fans of particular cult or camp icons, religious survivors, aficionados of specialized erotic tastes and fantasies, post-women's movement feminists, working-class queers, or members of racial and ethnic groups. As with the interwar dada and surrealist magazines which were their spiritual and formal predecessors, pictorial content is purloined with illicit abandon, cut up and montaged to force its referents to fit the desires of these resolutely unofficial niche markets.

In 1991, the first international conference of queer 'zines, Spew, was held in Chicago at the alternative Randolph Street Gallery, and in 1996, New York's New Museum acknowledged the phenomenon in its interactive exhibition, *alt.youth.media.* The Internet, as well, has become a refuge for subgroups of computer-literate queers who gather in chat rooms or post their photographs on Web pages in hopes of building a radical community in cyberspace. But the economic advantages required for entry-level access remain a barrier to many potential users, and—as always— corporate and governmental surveillance and attempts to censor such efforts are justified in the name of "protecting children."

Revisiting the conundrum with which I began this essay—how it was possible in a conservative political era to witness an explosion of new sexual subcultural images for women—it becomes clear that this profusion results from a number of intertwined political, social, and economic factors. The women's movement both called into question dominant social representations of women and searched for new ways to express women's experiences and desires, including lesbian desires, without relying on male-identified stereotypes. Antiporn feminists argued that sexual desire itself was so corrupted by patriarchal values as to be irretrievable for women's pleasure and that sexual images played an active role in producing male violence against women. However, antiporn feminists' efforts to censor sexual speech, along with the ascendance of social reaction embodied in the resurgent right's co-optation of "family values" as its political standard, mobilized a strong reaction among feminists and lesbians and gays who, after two decades of slow progress toward gaining recognition of their civil rights, suddenly found themselves under siege. The AIDS epidemic reinforced the gravity of the situation as images of AIDS sufferers were exploited by the religious right and conservatives to persuade the public that homosexuals were the cause of their own misfortune and to advocate a return to stigmatizing and shaming "deviant" sexual behaviors, even sexuality itself.

The movement to empower women to acknowledge the legitimacy of sexual fantasy and to counteract negative social messages about women's bodies and desires generated a renaissance of erotic fiction and photography by and for women by the late 1980s, both in mainstream and lesbian publishing markets. Lesbian who were deeply involved in AIDS organizing and activism also absorbed the defiant political messages groups such as ACT UP promoted about safe sex and more of it, even in an epidemic. Lesbian artists and photographers worked within these campaigns, encouraging the use of porn fantasy, props, costumes and even S&M as safe sex options, and creating new fantasy images of proud, sexy outlaws to show the way. The revival of interest in butch-femme roles among lesbians drew from their own transgressive history of post-World War II bar culture for its imagery, but without the deeply felt sense of authenticity and legitimacy those roles had conferred on older, more working-class lesbians in the years before Stonewall. In a postmodern, "post-feminist," "deconstructionist" age, the naturalness and universality of all categories, including gender, had been stringently called into question.

Given that a capitalist economy must always expand its market reach, the identification of potentially profitable new consumer niches of middle-class white gay men and lesbians by the early 1990s produced a flood of "lifestyle" commodities aimed at these groups. The quest for social equality became conflated with the quest for the kind of confident sense of selfhood and unlimited pleasure promised by the ads to those with the resources to acquire them— seductive images, indeed, for those who are still denied the right to marry, who have often been rejected by their families of origin, and whose intimate acts are still subject to arrest in nineteen states.

As the highly politicized debates over gays in the military, "gay marriage" laws, and organized efforts to repeal local antidiscrimination ordinances indicate, changing a few class-specific media images has little effect on pernicious institutionalized prejudice and ignorance. Public struggles over sexual images and identities—whether among lesbians, feminists and queers, or between these groups and religious and social conservatives—need to be seen within the larger (and profoundly eroticized) contexts of historical power relations between different social groups, including men and women, heterosexuals and queers, whites and nonwhites, affluent and poor, First World and Third World. As Victor Burgin has noted, "The only pertinent *political* question in relation to an 'identity' [or its photograph] is not 'Is it really coherent?' but 'What does it actually achieve?'"[32]

32. Victor Burgin, in "Questions of Feminism: 25 Responses," *October* 71 (Winter 1995), p. 13.

Newton's Gravity

Sex is deadly serious.
—Helmut Newton, *Portraits*

I have a friend in New York. An Australian. A photographer. We're in his loft, and he pulls a print from down under a pile on a metal shelf. Hands it to me with a crazy giggle he has when he's enjoying himself but a bit embarrassed about it. I have to assume that the self-consciousness-looking kid in the photograph is him. Dolled up by his parents for some high-street photographer. Long ago. Far away. "Look on the back," he says, I turn the print over. There's the name of the studio: *Helmut Newton*.

Helmut Newton Portraits, New York: Pantheon Books, 1987

Plates 1-22: Helmut; June; doctors; models... 1934-1986: June on the *métro* in 1957, alongside a much older woman; June in Paris twenty-five years later, looking down at a fresh postoperative scar which starts well above her navel and ends just above her pubis. June in Melbourne in 1947. June in Monte Carlo thirty-five years later.

Helmut adolescent, sprawled on a Berlin beach, a girl in each arm and one between his knees. Helmut fifty-two years later, on his back for the doctors—Paris, San Francisco. *Self-portrait in Yva's studio, Berlin 1936:* all hat and overcoat and gloves and camera case. *Self-portrait during an electrocardiogram, Lenox Hill Hospital, New York 1973:* all naked and wired up, with dangling leads and penis; arms akimbo, elbows bent, raised away from his body; one behind his head; a newly taken prisoner.

All naked (except for high-heeled shoes), arms akimbo, elbows bent, raised away from her body; one behind her head; alongside an older woman; the woman is June; Helmut appears between them, reflected in the mirror which reflects the model—*Self-portrait with wife June and models, Vogue studio, Paris 1981.*

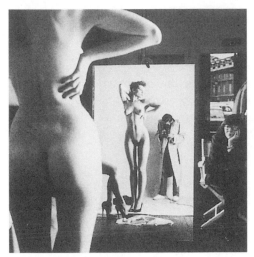

Helmut Newton, *Self-portrait with wife June and models,
Vogue studio, Paris, 1981.* Courtesy of the artist.

We see both the model's back and her reflection in the mirror. The rectangle of
the mirror, in which her image appears full length, fits the space beneath her
right elbow. Helmut's reflection, also full length, fits the space beneath her
reflected elbow. June, just to the right of the mirror, sits cross-legged in a
director's chair. Her left elbow on her left knee, chin propped on her left hand,
mouth tense. Her right hand makes a fist. Helmut is wearing a raincoat, his
face hidden as he bends over his Rolleiflex.

Caught Looking

> **CS:** One of your self-portraits shows you wearing a trench coat with a
> nude model, and your wife sitting off to one side. Does your wife sit in
> on photo sessions?
> **HM:** Never. Ever. She had just come by for lunch that day.
> —Newton talking to Carol Squiers, *Portraits*

Here I am, bent over the keyhole; suddenly I hear a footstep. I shudder as a
wave of shame sweeps over me. Somebody has seen me.
—Sartre, *Being and Nothingness*

I am a voyeur!... If a photographer says he is not a voyeur, he is an idiot!
—Newton, *Portraits*

Every active perversion is... accompanied by its passive counterpart: anyone
who is an exhibitionist in his unconscious is at the same time a *voyeur*.
—Freud, *Three Essays on the Theory of Sexuality*

There are certain clubs here and in Paris where people just watch other people fuck.
—Newton, *Portraits*

Anyone who desires to witness the sexual activities of a man and woman really always desires to share their experience by a process of empathy, generally in a homosexual sense, i.e., by empathy in the experience of the partner of the opposite sex.
—Fenichel, *Collected Papers*

The mirror is there so the model can see herself; the photographer would normally have his back to the mirror; a "correct distance" would divide their supposedly incommensurable roles: exhibitionist, voyeur. But Newton has invaded her space, planted his feet on her paper desert island—that Light Continent inhabited by Big Nudes. From this position, he now receives the look he gives. By entering the model's space he has, in a sense, taken her place—identified himself with her. June, his wife, has taken his place. Newton reveals himself to her, and to us, as a voyeur—the raincoat is his joke at his own expense. A voyeur in a raincoat? The photographer is here both a voyeur *and* an exhibitionist: a flasher, making an exposure. The raincoat opens at the front to form a shadowy delta, from which has sprung this tensely erect and gleamingly naked woman, this *coquette*. The photographer has flashed his prick, and it turns out to be a woman. Who else wears a raincoat? A detective—like the one who, in all those old B-movies, investigates all those old dangerously mysterious young women. Following her, watching her until, inevitably, the *femme* proves *fatale*. Where am I in all this? In the same place as Newton—caught looking.

Keep Looking

Newton has made an indiscernible movement of the tip of one finger. The shutter has opened and paused. In this pause the strobe has fired, sounding as if someone had clapped his hands together, once, very loud. The light has struck a square of emulsion. Out in the street a driver in a stationary car has perhaps glimpsed, illuminated in this flash of interior lightning, the figure of a naked woman. Perhaps not. In the future (now past) the shutter will close. Newton will put down the camera. Helmut and June will go to lunch. The models will put on their clothes; perhaps they will go to lunch together. Perhaps not. I know nothing of this woman who is now "showing everything"; nor of the other woman whose stiletto-heeled legs project from the left into the mirrored space. It is difficult to decide where, precisely, these legs are to be located (with the result that the space of the mirror seems curiously apart from the real space of the room, almost as if the disembodied legs, and Newton, existed *only* in the mirror). Ridiculously, the legs can be "read" as an awkward appendage to the out-of-focus foreground figure—bringing to my mind (more ridiculously) an

old woodcut in which the Devil is depicted with a forked penis. Such provision of a substitute penis for the one the woman "lacks" is what motivates fetishism. The fetish allays the castration anxiety, which results from the little boy's discovery that his mother, believed to lack nothing, has no penis. The contradictory function of the fetish is to deny the perception it commemorates. It is a particular example of a general form of defense against disquieting knowledge of the world which Freud termed "disavowal"—which takes the form "I know very well, but nevertheless..." Other defensive moves are possible. If the penis is not here, then it clearly must be elsewhere, in space or in time. One has only to keep looking. (*All* of this, of course, is ridiculous; but the unconscious is far less sensible about such things than we are.)

> ...whatever uneasiness he may have felt was calmed by the reflection that what was missing would yet make its appearance: she would grow one (a penis) later.
> —Freud, *Splitting of the Ego in the Process of Defense*

That form of masculine behavior we call *Don Juanism* is popularly understood as motivated by an insatiable thirst for conquest. As I wrote some years ago, "we can interpret Don Juan's behavior another way: the most poignant moment for Don Juan takes place...between the bedroom door and the bed—it's the moment of undressing."

> **CS:** When you photographed yourself nude in 1976, your clothes were very neatly folded on a chair in the picture. But when you photograph women who are nude, their clothes are scattered everywhere...
> **HN:** I'm quite a tidy person. I would hate to live in disorder.... But this is interesting—I create that disorder—I want the model to take all her clothes off and just dump them.
> —Newton talking to Carol Squiers, *Portraits*

Waste of Time

> If I say to a person, I want to see you naked, and in my head I say, Well I would like to fuck her but the reason I don't is because I'm scared to get AIDS or something...
> —Newton, *Portraits*

The little boy thought he knew women, now he knows better. In this moment he has also learned that what exists can also *not* exist. The only find of comparable magnitude to the discovery of the reality of sexual difference is the discovery of the reality of death. Small children have a problem with death, the fact of death tends to disappear over their conceptual horizon. "Dead" to the child initially means "not here," which in turn implies "elsewhere." Again, one

only has to "keep looking" to restore what was lost. What was lost *can* be found; but every move repeats the discovery of loss. Observing a universal compulsion to repeat painful experiences, Freud was led to posit a "death drive" alongside the libidinal drive. Much confusion surrounds this concept. I prefer the recent formulations of Jean Laplanche. There is only one drive, and it is sexual, but it has two aspects: one seeks to conserve the self and its object; the other seeks to destroy one or the other (or both, for in reality they are the same—read Freud on narcissism); hence sexual aggression and sadomasochism. Newton's joke at his own expense is self-destructive (the raincoat on this hunched figure, miniaturized by the object of his fascination, reminds me of the phrase—*King Lear*, I think—"a giant's robe on a dwarfish thief"). June's appearing in this picture in public is self-destructive, for she has now changed seats with the woman on the métro. The same "joke" of aging is being played on the shining woman at the center of this image; but only in reality, not in this photograph. Everything pivots around this naked figure (appropriately, we see her from both front and back). There to be admired simply because she exists, she need do nothing more than *be*. She is a statue in marble, like the *Venus Victrix* in Villiers de L'Isle-Adam's *L'Eve Future*, who is imagined to utter, "Moi, je suis seulement la Beauté même. Je ne pense que par l'esprit de qui me contemple" [I, I am simply beauty itself. I think only through the mind of the one who contemplates me]. Yes, I know. The model is a *real* woman, caught up in an economy in which her identity is reduced to that of a figment of a man's imagination. I understand why you think that that's the most important thing about this picture; but economies are not only monetary, they are psychical, and the psychical is worth more than a penny in our exchanges. This statue in marble, like so many of the women in Newton's photographs, is on a marble slab; the photograph, like so many photographs—which annihilate color, movement, and sound—leaves the detective an exquisite corpse. Back in the days of silent movies, Cocteau remarked that the camera "filmed death at work." Portraits are a by-product, a waste product, of time at work—the waste of time.

> All these young photographers who are at work in the world, determined upon the capture of actuality, do not know that they are the agents of Death. This is the way in which our time assumes Death: with the denying alibi of the distractedly "alive," of which the Photographer is in a sense the professional.... For Death must be somewhere in a society; if it is no longer (or less intensely) in religion, it must be elsewhere; perhaps in this image which produces Death while trying to preserve life. . . . Life/Death: the paradigm is reduced to a simple click, the one separating the initial pose from the final print.
> —Roland Barthes, *Camera Lucida*

> I'm not at all interested in death. I'm not preoccupied by death. My wife, June, once said, Helmut, don't you want to discuss this subject?

And I said, It doesn't interest me. I don't want to discuss it, it's a waste
of time. . . . I don't care about it.
—Newton, *Portraits*

Perverse Love

This is a photograph, not a movie; but nevertheless, this is a moral tale. I think
of those allegorical paintings which show *Time ordering Old Age to destroy
Beauty*. Why is there so often a *trio* of principal protagonists in these alle-
gories of the human condition? If I had more time I might write about this. I
immediately think of two images in relation to Newton's *Self-portrait with
wife June and models:* Robert Doisneau's 1948 photograph *Un Regard
Oblique*, which shows a middle-aged couple looking into the window of a pic-
ture dealer, the man's slyly insistent gaze on a painting of a seminaked young
woman; and Balthus's 1933 painting *La toilette de Cathy,* in which a young
man, seated in an attitude which reminds me of June's posture in Newton's
picture, seems to take an anxious lack of interest in the seminaked young
woman who is having her hair combed by a much older woman. ("It doesn't
interest me. . . . I don't care about it.")

In an essay about "The Perverse Couple," Jean Clavreul describes a complex
system of relations which "nest" one inside the other, like "Russian dolls." First,
there is the relation of the fetishist to his object; but the fetishist of whom
Clavreul speaks can value this object only to the extent that *someone else* values
it. Second, then, there is the relation of this second person to his object. Where
this person is his wife, as it very often is, then there also exists the relation of this
woman to her husband, in his relation to his (become "their") fetish object—as
well as, of course, to her. A third person is now called on as *witness*, as the "per-
verse couple" thus formed seek the recognition of an "external" other. Perverse?
All human sexuality is deviant. Nothing about our sexuality belongs to anything
that could be described as a "natural" instinctual process. In the natural world,
instinctual behavior is hereditary, predictable, and invariant in any member of a
given species. In the human animal what might once have been instinct now
lives only in shifting networks of symbolic forms—from social laws to image sys-
tems. Human sexuality is not natural, it is cultural. The same movement which
produces culture, in the broadest sense of the word, also produces the uncon-
scious—psychoanalysis is the theory of this unconscious, and it was in the dis-
covery of the unconscious that Freud first dismantled the barrier between
"normal" reproductive heterosexuality and "perversions." At the end of the nine-
teenth century, Freud inherited comprehensive data on sexual perversions from
the sexologists. For researchers such as Richard von Krafft-Ebing and Havelock
Ellis, the behaviors they catalogued were viewed as deviations from "normal"
sexuality. Freud, however, was struck by the ubiquity of such "deviations"—
whether in dramatically pronounced form, or in the most subdued of ordinary
"foreplay." (It was Freud who remarked that that mingling of entrances to the
digestive tract we call "kissing" is hardly the most direct route to reproductive

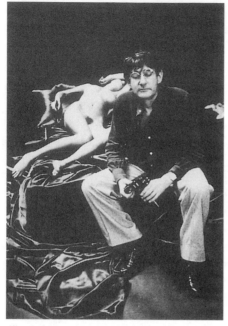

Alice Springs, *Helmut Newton, Paris, 1976.* Courtesy of the artist.

genital union.) In his 1905 *Three Essay on the Theory of Sexuality* he observed, "the disposition to perversions is itself of no great rarity but must form a part of what passes as the normal constitution. In opposition to the sexologists, who took socially accepted "normal" sexuality as inherent to human nature, Freud stated that "from the point of view of psychoanalysis the exclusive sexual interest felt by men for women is also a problem that needs elucidating and is not a self-evident fact." If the word "perversion" still has an air of disapprobation about it today, this is not the fault of psychoanalysis. Perversion is defined *only* in relation to social law, written or not. Robert Mapplethorpe could exhibit his most "perverse" pictures at the Whitney Museum of American Art only in exchange for the redeeming promise of his own impending death. Clavreul recognizes that the pervert within the perverse couple may receive public acknowledgment, even acceptance, of his perversion because it may be recognized as situated within the redeeming field of *love.*

Alice Springs: Portraits, Pasadena: Twelvetrees Press, 1986

> Why is a young girl so pretty, and why does this state last such a short time? I could become quite melancholy over this thought, and yet, after all, it is no concern of mine. Enjoy, do not talk. The people who make a profession of such reflections generally do not enjoy. However, it can do no harm to harbor this thought, for the sadness it evokes, a sadness not for one's self but for others, generally makes one a little more handsome in a masculine way.
> —Kierkegaard, *Diary of a Seducer*

> All men of my generation are concerned with this under their chins. I say I look like an old crocodile!
> —Newton, *Portraits*

His mouth tired, tense—*Helmut Newton, Paris 1976.* Sitting for June; between his legs, his camera, exhausted. Sprawled on the bed behind him a

woman's naked form, in one of those positions, which in painting would imply lascivious exhaustion (the "little death"). One of her arms hides her face, in a gesture reminiscent of Masaccio's shameful Eve being cast from Eden. At the same time, by one of those often absurd spatial collapses produced in the camera, she seems to be whispering in Newton's ear—the profound and dreadful secret of her body, a secret told to no man. In *Une Femme est une Femme*, Angéla, twenty-four, wants a baby. If Angéla had had that baby in 1961, the year the film was made, the year Anna Karina (Angéla) got the best new actress award at Cannes, Angéla's child would now be twenty-eight. Anna must now be fifty-two. Angéla works as a stripper. As she strips she sings, "Je ne suis pas sage, je suis trop cruelle"; but (she sings) all the men forgive her because (final line of the chorus) "Je suis *trés* belle!" In his written outline where Angéla is called "Josette," Godard says, "Josette believes in her art and practices conscientiously in front of a mirror." But the only such scene I remember is when Josette/Angéla/Anna stuffs a pillow up under her jumper to see how she will look pregnant. When her frown of concentration departs her child's face, it will leave no more trace than does her perfect smile. My own reflection now always seems too tired, too tense. I look away. Newton looks down, into the mirror of his Rolleiflex. I see the words "Peau Saine" on one of those pots, which show that a woman shares this bathroom. "Peau Saint," I think, and the image of the woman in Newton's mirror returns to me as a Sainte Sebastienne, waiting to receive time's arrows. June's (Alice's) book lies open on the floor of my office, alongside Helmut Newton's *Portraits*. Helmut is still receiving the young woman's confession. It is the anticipation of this confession—hoped for each time the shutter is withdrawn, exposing the tiny dark room to that which is hopelessly beyond it—that gives Newton's picture its gravity.

ROSALYN DEUTSCHE

Krzysztof Wodiczko's *Homeless Projection* and the Site of Urban "Revitalization"

IN *The City Observed: A Guide to the Architecture of Manhattan*, Paul Goldberger concludes his historical survey of Union Square with the following observation:

> For all that has gone wrong here, there are still reminders within the square itself of what a grand civic environment this once was. There are bronze fountains and some of the city's finest statuary. The best of the statues are Henry Kirke Brown and John Quincy Ward's equestrian statue of Washington, with a Richard Upjohn base, and Karl Adolf Donndorf's mother and children atop a bronze fountain base. There is also an immense flagstaff base, 9 1/2 feet high and 36 feet in diameter, with bas-reliefs by Anthony de Francisci symbolizing the forces of good and evil in the Revolutionary War; *even if a derelict is relieving himself beside it, it has a rather majestic presence.*[1]

This use of a homeless person as a foil for the aesthetic merits of a sculptural base and for the nostalgic visions evoked by civic monuments will not surprise anyone familiar with Goldberger's apologies for the luxury condominiums, lavish corporate headquarters, and high-rent office towers that proliferated in New York City throughout the 1980s. Goldberger was then senior architecture critic of the *New York Times* and, like his account of the Union Square monuments, his appraisals of the decade's profitable new buildings remained indifferent to urban social conditions, divorcing them from the circumstances of architectural production. Goldberger never mentioned the fact that the architects of New York's construction boom not only scorned the glaring need for new public housing but relentlessly eroded the existing low-income housing

1. Paul Goldberger, *The City Observed—New York: A Guide to the Architecture of Manhattan* (New York: Vintage, 1979) p. 92. Emphasis added.

stock, thereby destroying the conditions of survival for hundreds of thousands of the city's poorest residents. Detaching himself from questions of housing and focusing on what he deemed proper architectural concerns, he also impeded the more basic recognition that the destruction of low-income housing was no accidental by-product of the decade's architectural expansionism but was, along with unemployment and cuts in social services, an essential component of the economic imperatives that motivated the new construction in the first place.

But the architecture discourse exemplified by Goldberger's journalism obscures the urban context most effectively not when it turns its back on the city altogether but when it professes "social responsibility" in the form of a concern for the city's physical environment. Intermittently, for instance, Goldberger addressed the substantial threat that the construction of the 1980s posed to New York's light, air, and open space. To meet this threat, however, he espoused a concept of urban planning that, far from offering a solution, was itself a considerable part of the city's social problems.[2] Asserting that the critical factors in development projects are the size, height, bulk, density, and style of buildings in relation to their immediate physical sites, Goldberger disregarded architecture's political and economic sites. True, he conceded in passing that "architecture has now come to be a selling point in residential real estate as much as it has in commercial."[3] But this recognition did not prevent him from aiding the destruction of housing and communities by aestheticizing the real-estate function of current construction much as he did the commercial function of the early twentieth-century skyscraper.[4] In short, he supported contemporary development for the rich and privileged using the same rationale that authorized his description of the sculptural treasures of Union Square: celebration of the essential power and romance of, in the first case, the skyscraper, and, in the second, the historical monument.

2. In 1986, reviewing an exhibition of Hugh Ferriss's architectural drawings held at the Whitney Museum's new branch at the Equitable Center, a building that itself represented a threat to the city's poor, Goldberger claimed that Ferriss "offers the greatest key to the problems of the skyscraper city that we face today," because he demonstrates "that a love of the skyscraper's power and romance need not be incompatible with a heavy dose of urban planning." (Paul Goldberger, "Architecture: Renderings of Skyscrapers by Ferriss," *New York Times*, 24 June 1986, C13).

3. Paul Goldberger, "Defining Luxury in New York's New Apartments," *New York Times*, 16 August 1984, C1.

4. Observing the omission of social or economic history in Goldberger's "history" of the skyscraper, one reviewer wrote: "The building process is born of economics....Some of these factors might be: the state of the national and regional economies; the nature of the local transportation systems; the conditions of local market supply-and-demand; the relationship to desirable local geographic features or elements, such as proximity to a park; the perceived or actual quality of building services and image; and the economies of new construction techniques that reduce building costs or enhance efficiency—*all of which are factors that cannot be seen simply by looking at the building's skin.*" (Michael Parley, "On Paul Goldberger's *The Skyscraper*," *Skyline* (March 1982), p. 10 [my emphasis]. The factors that Parley listed indicate some of the most serious omissions in Goldberger's aesthetic history, although these factors, in turn, need to be placed within the framework of a broader social structure.

The City Observed appeared in 1979, only a few years before "derelicts," along with other members of a "socially undesirable population,"[5] were evicted from Union Square by a massive program of urban redevelopment. Like all such episodes in the latest New York real-estate boom, this one forcibly "relocated" many of the area's lower-income tenants and threatened others with a permanent loss of housing. The publication of Goldberger's guide coincided with the preparatory stage of the redevelopment plan, and the book shares prominent features of the planning mentality that engineered Union Square redevelopment and of the public relations campaign that legitimated it: aesthetic appreciation of the architecture and urban design of the neighborhood coupled with sentimental appeals for the restoration of selected chapters of the area's history.

The thematic resemblance between the book and the planning documents is no mere coincidence. It vividly illustrates how instrumental aesthetic ideologies can be for the powerful forces determining the use, appearance, and ownership of New York's urban spaces and for the presentation of their activities as the restoration of a glorious past. For Goldberger, "Union Square's past is more interesting than its present. Now the square is just a dreary park, one of the least relaxing green spaces in Manhattan."[6] Invariably, the reports, proposals, and statements issued by New York's Department of City Planning, the City Parks Commission, and municipal officials about the various phases and branches of Union Square redevelopment also reminisced about the square's glorious history and lamented its sharply contrasting present predicament. As one typical survey put it: "For the most part, the park today is a gathering place for indigent men whose presence further tends to discourage others from enjoying quiet moments inside the walled open space."[7] These texts paid no attention to the future of Union Square's displaced homeless. Neither did they consider the prospects for new homeless people produced by the mass evictions and increase in property values caused by redevelopment. Instead, they conjured a past that never existed. Narratives recounting vaguely defined historical periods stressed the late nineteenth-century moment of Union Square's history, when it was first a wealthy residential neighborhood and then a fashionable commercial district, part of the increasingly well-known—thanks to a wave of museum exhibitions, media reports, and landmark preservation campaigns—"Ladies' Mile."[8] Redevelopers were most

5. The designation appears in Department of City Planning, *Union Square Special Zoning District Proposal* (originally released November 1983; revised June 1984), p. 3.

6. Goldberger, *The City Observed*, p. 91.

7. Department of City Planning, *Union Square: Street Revitalization* (January 1976), p. 28.

8. For a history of the economic factors—the needs of business—that determined the development of Ladies' Mile, see M. Christine Boyer, *Manhattan Manners: Architecture and Style 1850- 1900* (New York: Rizzoli International, 1985).

eager to revive this presumably elegant and genteel era, and aesthetic discourse helped them construct a distorted architecture and design history of the area, offering reassuring illusions of a continuous and stable tradition symbolized by transcendent aesthetic forms. The history of Union Square, it is said, lies before our eyes in its architectural remains. Using the same methods that smoothed the way for the design and execution of redevelopment, reconstructed histories such as Goldberger's take their readers on a tour of the area's buildings, monuments, and "compositions."[9]

Krzysztof Wodiczko's *Homeless Projection: A Proposal for the City of New York* interrupts this "journey-in-fiction."[10] Using the same terrain and the same "significant" architectural landmarks, Wodiczko's public artwork takes a radically different position within the politics of urban space. Its form: site-specific, temporary, collaborative with its audience; its subject matter: the capitulation of architecture to the conditions of the real-estate industry; the content of its images: the fearful social outcome of that alliance. These qualities render *The Homeless Projection* useless to those forces taking possession of Union Square in order to exploit it for profit. They militate, also, against the work's neutralization by aesthetic institutions. Instead of fostering an unreflective consumption of past architectural forms to oil the mechanism of urban "revitalization," the project attempts to identify the system of economic and political power operating in New York beneath what the artist once called "the discreet camouflage of a cultural and aesthetic `background.'"[11] Eroding the aura of isolation that idealist aesthetics constructs around architectural forms, *The Homeless Projection* also—by placing those forms within a broad and multivalent context—dismantles the even more obscurantist urban discourse that relates individual buildings to the city construed only as a physical environment. Wodiczko's project reinserts architectural objects into the surrounding city understood as a site of economic, social, and political processes. Consequently, it contests the belief that monumental buildings are stable, transcendent, permanent structures containing essential and universal meanings. *The Homeless Projection* proclaims, on the contrary, the mutability of their language and calls attention to the changing uses to which they are put as they are continually recast in new historical circumstances and social frameworks.

Although the architecture and urban discourses circulating in journalism such as Goldberger's and in the documents produced by New York's official urban-planning professionals manufactured an aesthetic disguise for "revital-

ROSALYN DEUTSCHE

9. "The making of compositions, the making of streets, and the making of theater—it is these things that define the architecture of New York far more than does any single style." Goldberger, *The City Observed*, p. xv.

10. Krzysztof Wodiczko, "Public Projection," *Canadian Journal of Political and Social Theory* 7 (Winter/Spring 1983), p. 186.

11. Ibid.

ization," *The Homeless Projection* dramatically interferes with that image, restoring the viewer's ability to perceive the connections that these discourses sever or cosmeticize—the links that place the interrelated disciplines of architecture, urban design, and, increasingly, art in the service of the financial forces that shape New York's built environment. Further, the clear ethical imperative behind the work's intervention in contemporary urban struggles contrasts sharply with the dominant architectural system's preferred stance of "corporate moral detachment."[12]

Wodiczko entered the arena of New York housing politics when he mounted an exhibition in a New York art gallery. *The Homeless Projection* exists only as a proposal first presented at 49th Parallel, Centre for Contemporary Canadian Art, in the winter of 1986. Consisting of four montaged slide images projected onto the gallery's walls and a written statement by the artist distributed in an accompanying brochure, the proposal outlined a plan for the transformation of Union Square Park. Wodiczko's exhibition coincided with the unfolding of the redevelopment scheme that was actually transforming Union Square, opening several months after the completion of the first phase of the park restoration—the ideological centerpiece and economic precondition of the district's "revitalization." Drastic changes in the built environment, such as this revitalization, are engineered by institutionalized forms of urban planning. "What has been of fundamental importance," writes a critic of the history of town planning, "is the role of the project, that is of imagination."[13] These projects mobilize vision and memory. No matter how objectifying their language, they are, by virtue of their selective focuses, boundaries, and exclusions, also ideological statements about the problems of and solutions for their sites. Because *The Homeless Projection*'s potential location was a target of the pervasive and calculated urban process of redevelopment, Wodiczko's photographic and textual presentation in a space of aesthetic display—the gallery—recalled the visual and written forms of city planning. Like the official proposals generated by the teams of engineers, landscape architects, designers, demographers, sociologists, and architects who shaped Union Square's renovation, Wodiczko's presentation envisioned alterations to its prospective site and set forth the principles and objectives governing the proposal. Unlike such documents, however, *The Homeless Projection* offered no suggestions for enduring physical changes to the area under study. Instead, the artist disclosed a plan to appropriate temporarily the public space of Union Square Park for a performance in the course of which he would project

12. Krzysztof Wodiczko, *The Homeless Projection: A Proposal for the City of New York*, installation (New York: 49th Parallel, Centre for Contemporary Canadian Art, 1986). Unless otherwise noted, this and subsequent quotations by Wodiczko are from the brochure titled "The Homeless Projection: A Proposal for the City of New York" that was distributed at the installation. The installation is documented and the brochure reprinted in Krzysztof Wodiczko, "Public Projections," *October* 38 (Fall 1986), pp. 3-20.

13. Bernardo Secchi, "La forma del discourse urbanistico," *Casabella* 48 (November 1984), p. 14.

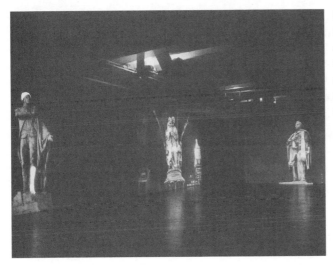

Krzysztof Wodiczko, *The Homeless Projection: A Proposal for the City of New York*, 1986. Courtesy of the 49th Parallel, Centre for Contemporary Canadian Art.

transient images onto the newly refurbished surfaces of the four neoclassical monuments that occupy symmetrical positions on each side of the park. Yet impermanence is not the only quality distinguishing Wodiczko's proposal from official projects. There is another, more crucial difference between the two: mainstream planning claims that its proposals will restore a fundamental social harmony that has been disrupted while Wodiczko's project illuminates the prevailing social relations of domination and conflict that such planning both facilitates and disavows.

The Image of Redevelopment

The Homeless Projection was a proposal for a work to be situated in Union Square, but the work's subtitle, "A Proposal for the City of New York," suggests that Union Square was only a determinate location of an urban phenomenon extending far beyond the immediate area. Indeed, the transformation of Union Square from a deteriorated yet active precinct consisting of a crime-ridden park, low-rent office buildings, inexpensive stores,[14] and single-room occupancy hotels into a luxury "mixed-use" neighborhood—commercial, residential, retail—was only an individual manifestation of an unprecedented degree of change in the class composition of New York neighborhoods. The concluding phases of these metamorphoses—following the preliminary and calculated stages of abandonment, neglect, and deterioration—were identified in the early 1980s by a constellation of inaccurate, confusing, and distorting

14. When this essay was first written, the shops along Fourteenth Street from First to Eighth avenues, including Mays department store facing Union Square, made up the largest shopping district south of Spanish Harlem for Manhattan's Hispanic residents. Some of the stores' sites had already been purchased for future redevelopment. Known as Calle Catorce, this street has traditionally provided the link between the concentrations of Hispanics on the Lower East Side and in Chelsea; both neighborhoods have recently undergone redevelopment, resulting in large displacements of those populations.

terms. Overtly falsifying was the overarching rubric "revitalization," a word whose positive connotations reflect nothing other than "the sort of middle-class ethnocentrism that views the replacement of low-status groups by middle-class groups as beneficial by definition."[15] "Revitalization" conceals the very existence of those inhabitants already living in the frequently vital neighborhoods targeted for renovation. The term most routinely mobilized to designate urban changes was "gentrification," which, coined in London in the 1960s, does suggest the class interests at work in the process. In New York, however, the term was used primarily in a celebratory spirit and, moreover, misidentifies the gentrifying classes as a landed aristocracy.

Where explanations of revitalization and gentrification existed at all, they were generally formulated out of the concepts, values, and beliefs espoused by the financial institutions, politicians, corporations, real-estate developers, landlords, and upper-middle-class residents who benefited from the process. At their most self-serving—and in the form most widely disseminated in the mass media—such accounts repressed the social origins, functions, and effects of gentrification, presenting it as the heroic act of individuals. "When an area becomes ripe for gentrification," New York's former housing commissioner explained,

> a condition that cannot be rigorously identified in advance but seems to depend on the inscrutable whims of an invisible hand, the new purchasers face monumental tasks. First the building must be emptied. Then layers of paint must be scraped from fine paneling; improvised partitions must be removed; plumbing must be installed and heating ripped out and replaced. Sometimes the new buyers spend years under pioneering conditions.[16]

Not all descriptions were so blatantly misleading. But even those that specified or even criticized gentrification's social effects tended to be superficial, impressionistic, or eclectic rather than grounded in an understanding of the specific factors governing patterns of urban growth and change.

By the middle of the decade, however, some efforts had been made to "identify rigorously" the structural elements that prepare the ground for gentrification and to ascertain precisely whose needs regulate the restructuring of urban space within which gentrification was playing a leading role. These new theories were based on the premise that the physical form of the cityscape is inseparable from the specific society in which it develops. The wholesale reorganization of urban space represents, then, no mere surface phenomenon. It

15. Bruce London and J. John Palen, "Introduction: Some Theoretical and Practical Issues Regarding Inner-City Revitalization," in *Gentrification, Displacement and Neighborhood Revitalization*, ed. J. John Palen and Bruce London (Albany: State University of New York Press, 1984), p. 10.

16. Roger Starr, *The Rise and Fall of New York City* (New York: Basic Books, 1985), p. 36.

is part of a full-scale social restructuring. In 1984, trying to place gentrification within the context of this broader restructuring, Neil Smith and Michele LeFaivre developed a "Class Analysis of Gentrification."[17] By contrast with notions of "inscrutable whims" and "invisible hands," these authors examined a systematic combination of economic processes—a devalorization cycle of declining real-estate values—through which inner-city neighborhoods have been historically developed into deteriorated areas in order to create the necessary conditions for gentrification. Taking place within the wider periodicity of capitalist expansion, the devalorization cycle—consisting of new construction, landlord control, blockbusting, redlining, and abandonment—produces a situation in which a developer's investment can yield a maximum profit. Profit maximization depends on the existence of a substantial gap between the current capitalization of real estate in a specific location and the potential return on investment: "When this rent gap becomes sufficiently wide to enable a developer to purchase the old structure, rehabilitate it, make mortgage and interest payments, and still make a satisfactory return on the sale or rental of the renovated building, then a neighborhood is ripe for gentrification."[18]

By the authors' own admission, their analysis of the devalorization cycle is schematic. It must be adjusted to accommodate variations among development procedures in diverse cities and to account for such variables as conflicting capital interests, state interventions, and the emergence of community movements. Nonetheless, the analysis destroys the myth that arbitrary, natural, or individual actions produce neglect and abandonment which are then "corrected" by gentrification. Rather, abandonment and gentrification are tied together within the logic of an economic system, demonstrating that they are integrally linked products of specific decisions made by the primary actors in the real-estate market—financial institutions, developers, government, landlords.

Smith and LeFaivre's description of the real-estate devalorization cycle stresses the commodity function of city neighborhoods under capitalism. The authors emphasize commodification even more strongly when they place gentrification within the larger transformations taking place in central cities. In so doing, they closely follow the detailed study of capitalist urbanization made by David Harvey, a geographer who has tried to understand the factors propelling the flow of capital into the built environment of the city during particular economic periods.[19] Harvey applies to urban processes Marx's critique of

17. Neil Smith and Michele LeFaivre, "A Class Analysis of Gentrification," in *Gentrification, Displacement and Neighborhood Revitalization*, pp. 43-63.

18. Ibid., p. 50.

19. See in particular David Harvey, "The Urban Process Under Capitalism: A Framework for Analysis," in *Urbanization and Urban Planning in Capitalist Society*, ed. Michael Dear and Allen J. Scott (London: Methuen, 1981), pp. 91-121. Other works by Harvey include *Social Justice and the City* (Baltimore: The Johns Hopkins University Press, 1973) and *The Urbanization of Capital: Studies in the History and Theory of Capitalist Urbanization* (Baltimore: The Johns Hopkins University Press, 1985).

the contradictions of capitalist accumulation and a Marxist analysis of the ways in which capitalism attempts to ensure its own survival. He thus emphasizes capitalism's tendency toward overaccumulation, a crisis that occurs when the production of capital in certain sectors of the economy exceeds opportunities to employ it at the average rate of profit. Manifested in falling rates of profit, overproduction, surplus capital, surplus labor, or greater exploitation of labor, overaccumulation crises can be temporarily solved by switching investment into other sectors of the economy. Harvey views extensive investment in the built environment as a symptom of such crisis—"a kind of last-ditch hope for finding productive uses for rapidly over-accumulating capital."[20] Because real-estate investment entails long-term, large-scale projects, the short-lived success of the attempt requires the mediation of financial and state institutions.

Smith and LeFaivre bring Harvey's conclusions to bear on contemporary central-city development and gentrification, which they see as a component of capital's strategy of switching investments. To counteract falling rates of profit, capital moves into areas such as real estate and construction. Describing gentrification as "the latest phase in a movement of capital back to the city,"[21] the authors argue persuasively against the prevailing idea that gentrification is a spontaneous "back to the city" movement on the part of individuals suddenly eager for the excitement of cosmopolitan life.

But the use of city neighborhoods as commodities to be exploited for profit is only one of their purposes in a capitalist economy. Neighborhoods have also traditionally provided the conditions for reproducing labor power. For Smith and LeFaivre, gentrification represents the definitive replacement of the latter function by the neighborhood's alternative service as a commodity: "The economic function of the neighborhood has superseded the broader social function."[22] Yet gentrification is itself a means for reproducing labor power. In 1980s New York, the tension between the two uses may well have signaled internal capitalist conflicts between those interests that required the conditions to maintain the labor force—lower paid and part-time service workers in particular—and those that could profit from the destruction of those conditions. Gentrification is, then, a specific historical instance of a more general contradiction between the imperatives of accumulation and reproduction in the late-capitalist city. In 1984, writing about the new commercial art scene then unfolding on New York's Lower East Side, Cara Gendel Ryan and I situated gentrification within the shifts taking place in the composition of the

20. Harvey, "The Urban Process Under Capitalism," p. 108. For another analysis of the contemporary construction boom as a response to capitalist economic crisis, see Mike Davis, "Urban Renaissance and the Spirit of Postmodernism," *New Left Review* 151 (May/June 1985), pp. 106-16.

21. Smith and LeFaivre, "A Class Analysis of Gentrification," p. 54.

22. Ibid., p. 46.

late-capitalist labor force.[23] Citing heavy losses in manufacturing jobs in New York City, unemployment in the industrial sector due to automatization of labor, and the concomitant steady growth in jobs in the financial, business, and service sectors, we reasoned that gentrification was a crucial part of a strategy for restructuring the nation's work force. Coupled with the loss of blue-collar jobs and cuts in basic services, it has helped impoverish and disperse the traditional, now largely redundant work force and has allocated urban resources to fulfill the needs of the city's corporate workers.

Changes in the nation's labor force were conditioned and modified by a global reorganization of labor that had accelerated since the 1970s. Global restructuring has had profound ramifications for urban spatial organization on a variety of levels. As a system for arranging production on a global scale, the new international division of labor entails the transfer by multinational corporations of labor-intensive and productive activities elsewhere, often to Third World countries, and the intense concentration of corporate headquarters in a few international centers. Enhancing flexibility and control over vastly extended operations, strategies are formulated, managerial decisions made, and financing administered from the global cities. To qualify as such an international center of business a city must possess, first, a high proportion of headquarters of corporations doing the majority of their business in foreign sales, and, second, a centralization of international banks and international corporate-related services: law, accounting, and advertising firms.[24] By the late 1970s in the United States, only New York and San Francisco had emerged as such international centers where "even the international activities of firms headquartered outside these cities were increasingly linked to financial institutions and corporate services within them."[25] But in addition to transforming relationships among international and national cities, the new international division of labor affects the work force within the corporate center itself. These centers present limited opportunities for blue-collar jobs, further "'marginalizing' the lower class which has traditionally found job mobility extremely difficult."[26]

As an arm of broader governmental policy, urban planning in New York City began in the 1970s to focus on the needs of the city's new economy—its corporate-linked activities and workers—and on maximizing real-estate profits. Simultaneously, it engineered the dispersal of that "immobile" population

23. Rosalyn Deutsche and Cara Gendel Ryan, "The Fine Art of Gentrification," *October* 31 (Winter 1984), pp. 91-111.

24. R. B. Cohen devised a "multinational index" for quantifying the status of U.S. cities as international business centers. See Cohen, "The New International Division of Labor, Multinational Corporations and Urban Hierarchy," in *Urbanization and Urban Planning*, pp. 287-315.

25. Ibid. p. 305.

26. Ibid., p. 306.

with no place in the restructured economy. Bureaucratic procedures and planned development programs executed the task. Union Square revitalization was such a program. The close correspondence between its evolution and the unfolding of broad economic trends is clear. In 1976, the area became the object of City Planning Commission attention, and in 1984 the final redevelopment plan was approved. During these years New York lost more than 100,000 blue-collar jobs and gained over twice as many in the finance, insurance, and other business industries. These changes, which had been accelerating since the 1950s, were reflected in the Union Square area. That period, especially the phase between 1970 and 1980, saw an exodus of light manufacturing companies from the district's lofts, which were subsequently converted to more profitable residential and commercial uses compatible with the city's new economic base. Although it is difficult to furnish accurate figures for Union Square itself, since the area includes portions of four separate census tracts, the neighborhood's middle-class residential population substantially increased. By the early 1980s, 51 percent were employed in the service industries and 43 percent in wholesale and retail businesses, while other employment sectors showed "less growth."[27] The disparity in employment possibilities indicates that New York's period of economic prosperity and resurgent business expansion was, in truth, an era of intense class polarization. According to a report prepared by the Regional Plan Association and based on 1980 census data, 17 percent of the New York area's upper-income households accounted for more than 40 percent of the area's total income, while 42 percent—those with incomes under $15,000—accounted for only 14 percent of that income.[28] (By 1983, in New York City itself, those with incomes under $15,000 constituted over 46 percent of the population.[29]) The report surmised that "the economic outlook for hundreds of thousands of poorly educated, low-income residents throughout the New York area, stretching from Trenton to New Haven, is growing more bleak."[30]

The objectives and effects of New York's redevelopment programs can be accurately assessed only within the framework of this larger urban development. The City Planning Commission, however, did the opposite. During this period, it started to constrict its vision by employing a strategy that the Board of Estimate would eventually codify under the name "contextual planning." Further, the commission pinpointed this time of extreme class polarization, wrenching economic restructuring, and social dislocation of the poor—most evident in the forced mobility of people without homes—as the moment when

27. Department of City Planning, Manhattan Office, *Union Square Special Zoning District Proposal* (originally released November 1983; revised June 1984), p. 17.

28. Thomas J. Lueck, "Rich and Poor: Widening Gap Seen for Area," *New York Times*, 2 May 1986, B1.

29. "How Many Will Share New York's Prosperity?" *New York Times*, 20 January, 1985, E5.

30. Lueck, "Rich and Poor," B1.

the city finally began to be conserved, stabilized, and protected from radical change as well as from the radical impositions of modernist architectural concepts. Advised by the architects, urban designers, planners, and engineers who staff the Department of City Planning, the commission modified its zoning regulations, bureaucratic methods, and physical design orientations to "guide" development by the principle of responsiveness to the needs of particular city environments. It pursued a design path directed toward the historic preservation of existing circumstances. With relief, one architect and urban planner for the city praised the preservationist outlook:

> The urban aesthetic of associational harmony is reasserting itself under the banner of *cultural stability* [my emphasis]. The mercurial rise to prominence and power of the urban preservationist movement has helped to fuel this change in direction. Preservation of both our most valued urban artifacts, whether they be the conventionalized row houses of Brooklyn Heights or the sumptuous dissonance of the New York Public Library is an important, if not vital, contribution to our sense of emotional well-being.[31]

This redevelopment—the resurgence of tradition and the emergence of a restricted and spectacularized notion of cultural preservation—helped smooth over violent disturbances in the city's social life.[32]

From its inception, Union Square redevelopment was conceived and executed under the aegis of historic preservation, restoration of architectural tradition, and reinforcement of the existing urban context. These concepts dominated public discourse about the redevelopment scheme and the narrower aspects of the decision-making process. The four bronze monuments in Union Square Park—refurbished and rendered newly visible—incarnate the attempt to preserve traditional architectural appearances in order to deliver Union Square into the hands of major real-estate developers and expedite luxury development. In fact, the patriotic statues became a useful symbol to the proponents of revitalization as early as 1976 when the Department of City Planning received a $50,000 "City Options" grant, part of a New York City Bicentennial Project, from the National Endowment for the Arts. The grant was "to produce designs that would improve city life." After consulting with the community board, elected officials, businessmen, "civic leaders," and other city agencies, the planning department published a report entitled *Union Square: Street Revitalization*, the first exhibit in the case history of Union

31. Michael Kwartler, "Zoning as Architect and Urban Designer," *New York Affairs* 8, no. 4 (1985), p. 118.

32. This process can be observed in the role that architecture and urban design played in the creation of Battery Park City, one of the country's largest real-estate developments. For an account of Battery Park City's housing and design history, see Rosalyn Deutsche, "Uneven Development: Public Art in New York City," in *Evictions: Art and Spatial Politics* (Cambridge: MIT Press, 1996).

Square redevelopment. This report became the basis for the *Union Square Special Zoning District Proposal,* originally released in November 1983, revised in June 1984, and, after passing the city's review procedure, adopted later that year. The final redevelopment plan fulfilled the primary goals and followed many of the specific recommendations outlined in *Union Square: Street Revitalization.* In applying for the City Options grant, the planning department selected four "historic" neighborhoods as the object of its study and design proposals. Its ambition, the application stated, was preservation: "Cities contain many centers and communities rich in history and a sense of place. We seek to develop prototypical techniques by which the particular character of these areas can be reinforced so as to assist in their preservation through increased safety, use and enjoyment."[33] Among the strategies developed to "capitalize on existing elements worthy of preservation"[34] was the first suggestion for improving Union Square Park: "Restore the center flagpole, a memorial to the 150th anniversary of the United States, which features the Declaration of Independence engraved in bronze."[35]

The cover of *Union Square: Street Revitalization* capitalized on another Union Square monument and patriotic event, reproducing an engraving from a nineteenth-century copy of *Harper's Weekly* captioned "The Great Meeting in Union Square, New York, To Support the Government, April 20, 1861." The print depicts a crowd of New Yorkers gathered at the base of the colossal equestrian statue of George Washington, now ceremonially located at the southern entrance to the park but then situated on the small island at the park's eastern perimeter. The illustration evokes a brief time during the Civil War when Union Square became a meeting place for a public believed to be unified by nationalist sentiment. Loyal citizens repeatedly rallied around the Washington statue listening to speeches by Mayor Opdyke and letters of endorsement from the governor, president, and other officials. Newspapers describe the patriotic, unified spirit of these crowds:

> The great war-meeting at Union Square effectually removed the false impression that the greed of commerce had taken possession of the New York community, and that the citizens were willing to secure peace at the sacrifice of principle....The patriotism of the citizens was also indicated by the wrath which that meeting excited at the South. The *Richmond Dispatch* said: "New York will be remembered with special hatred by the South, for all time."[36]

33. Victor Marrero, Chairman, Department of City Planning, "Preface," *Union Square: Street Revitalization,"* p. 3.

34. Union Square: Street Revitalization," p. 33

35. Ibid., p. 37.

36. Benson J. Lossing, *History of New York City,* in I.N. Phelps Stokes, *The Iconography of Manhattan Island 1498-1909* (1926; reprint, New York: Arno Press, 1967), p. 1896.

The name of the square, originally referring only to its physical position at the juncture of Broadway and the Bloomingdale Road, was now imbued with connotations of national unity and shared history, dreams that, it was hoped, had come true as a result of the war.[37] The placard with the word *Union* occupying dead center of the *Harper's Weekly* print affirms these sentiments.

The survival of this myth of unity helped repress beneath lofty ideals of communal harmony the more disquieting memories of the conflicts that characterized modern urban society, conflicts visible in Union Square itself. Union Square Park, for instance, was the scene of some of America's earliest labor demonstrations, including the New York segment of the first May Day celebration in 1886. Class divisions would conspicuously reemerge in the 1930s when the square became the customary New York site for communist rallies and militant demonstrations by the unemployed and homeless. In *Union Square*, published in 1933, "proletarian novelist" Albert Halper used the park's heroic monuments to highlight the contradictions between, on the one hand, idealized representations symbolizing spiritual ideas and the presence of a protective and reassuring authority, and, on the other hand, the current realities of starvation and police brutalization of demonstrators. Halper described Donndorf's mother-and-children fountain on the square's west side—where it still stands—as "a dreamy piece of work" facing Broadway right near the "free Milk for Babies Fund hut."[38] With similar irony, he juxtaposed the "big history" represented by the great men and deeds memorialized in the park's other statues with the historical class struggle, whose skirmishes were then being waged within the square itself.

But the original intentions behind such monuments, when they were erected in American cities in the late nineteenth century, actually corresponds more closely to their later use by the apparatus of Union Square redevelopment. As Christine Boyer argues, neoclassical imitations of Greek and Roman sculptures were designed to conceal social contradictions by uplifting "the individual from the sordidness of reality" through the illusions of order, timelessness, and moral perfection that neoclassicism was supposed to represent.[39] Although never comprising a planned or unified sculptural program, the Union Square monuments exemplify the type of strategically positioned sculpture promoted by the nineteenth-century municipal art movement— copies of Parisian copies of Greek and Roman landmarks of art and architectural history. Decontextualized, invested with new meanings about America's emerging economic imperialism and national pride, they were products of the decorative offshoot of the municipal art movement, itself part of a widespread

ROSALYN DEUTSCHE

37. Robert H. Wiebe, *The Search for Order 1877-1920* (New York: Hill and Wang, 1967), p. 11-12.

38. Albert Halper, *Union Square* (New York: Viking, 1933).

39. M. Christine Boyer, *Dreaming the Rational City: The Myth of American City Planning* (Cambridge: MIT Press, 1983), p. 50.

attempt in the late nineteenth and early twentieth centuries to create order and tighten social control in the American city.[40] Inspired by fears of the unplanned chaos of urban industrialization, squalor and disease in the slums, extensive immigration, and a wave of labor disturbances, the notion of urban planning and design as an instrument that could counteract these threats appeared in nascent form among civic art crusaders. Their activities are, then, only one aspect of the effort, as David Harvey describes it,

> to persuade all that harmony could be established around the basic institutions of community, a harmony which could function as an antidote to class war. The principle entailed a commitment to community improvement and a commitment to those institutions such as the Church and civil government capable of forging community spirit. From Chalmers through Octavia Hill and Jane Addams, through the urban reformers such as Joseph Chamberlain in Britain, the "moral reformers" in France and the "progressives" in the United States at the end of the nineteenth century, through to model cities programmes and citizen participation, we have a continuous thread of bourgeois response to the problems of civil strife and social unrest.[41]

As part of this network, municipal art advocates sought to generate a sense of order and communal feeling through spatial organization and decorative beauty. They targeted public open spaces, such as Union Square Park, as prime locations for shaping the desired community, a public realm of cohesive values formed through moral influence. "Modern civic art," wrote Charles Mulford Robinson, one of its foremost supporters, "finds in the open space an opportunity to call [the citizens] out-of-doors for other than business purposes, to keep them in fresh air and sunshine, and in their most receptive mood to woo them by sheer force of beauty to that love and that contentment on which are founded individual and civic virtue."[42] New York's municipal art specialists consistently lamented that Union Square was a missed opportunity for such civilizing missions.

They were fortunate, however, that the square existed at all. One of the few public squares provided in the 1811 Commissioner's Map that established the rectilinear grid plan for "upper" Manhattan above Washington Square,

40. See Wiebe, *The Search for Order*; Paul Boyer, *Urban Masses and Moral Order in America 1820-1920* (Cambridge: Harvard University Press, 1978); Mario Manieri-Elia, "Toward an 'Imperial City': Daniel H. Burnham and the City Beautiful Movement," in Giorgio Ciucci et al., *The American City: From the Civil War to the New Deal* (Cambridge: MIT Press, 1979), and M. Christine Boyer, *Dreaming the Rational City*.

41. Harvey, "The Urban Process Under Capitalism," p. 117.

42. Charles Mulford Robinson, *Modern Civic Art or, The City Made Beautiful* (New York and London: G. P. Putnam's Sons, 1903).

Union Square almost failed to materialize. In 1812 it was recommended that plans for the square be dropped since they would require the use of land and buildings with high real-estate values. Although the project survived these threats and finally opened to the public in 1839, greatly enhancing land values in the immediate vicinity, civic art reformers regretted that the park was never properly utilized to create a physically—and therefore socially—cohesive public space. One critic proposed that it be turned into the civic center of New York.[43] Another suggested that a proper and elaborate sculptural program be organized there around the theme and images of liberty secured by the War of Independence. "Could anything influence more forcibly the national pride of our coming generations?"[44] Public statues, embodying social ideals, would, it was hoped, "commemorate in permanent materials the deeds of great citizens, the examples of national heroes, the causes for civic pride, and the incentives to high resolve which are offered by the past."[45] As instruments for the pacification of an unruly populace, the sculptures, like the street layouts devised by the municipal art movement, "searched not to transform the contradictions between reality and perfection but for the norms that moral perfection must follow."[46] Indeed, when Robinson, who codified municipal art concepts, turned his attention to conditions in the metropolitan slums, he ignored the problem of poverty itself, declaring, "With the housing problem civic art, its attention on the outward aspect of the town, has little further to do."[47]

Blinding itself to the most troubling facts of urban life, separating the city's social structure from its "outward aspect," the municipal art movement only contributed to the persistence of the housing problem. By the 1980s, the uses of New York's civic sculptures—and of the architectural and urban design system that they represent—had everything to do with the housing problem. This is amply confirmed by the fate of the Union Square monuments. Surely, the appearance of a nineteenth-century American imitation of a Roman equestrian statue on the cover of a late twentieth-century city-planning proposal for redevelopment during a period of fiscal crisis demonstrates the extreme pliability of the monument's meanings and functions. Yet the architects of redevelopment (and the copywriters of real-estate advertisements) used the sculpture to shore up the illusions of cultural stability, historical continuity, and universal values connoted by such architectural forms. They thus denied that their own acts of preservation are ideologically motivated, shaped by particular investments, presenting preservation as, instead, a neutral deed

43. J. F. Harder, "The City's Plan," *Municipal Affairs* 2 (1898), pp. 25-43.

44. Karl Bitter, "Municipal Sculpture," *Municipal Affairs* 2 (1898), pp. 73-97.

45. Robinson, *Modern Civic Art*, p. 170.

46. Boyer, *Dreaming the Rational City*, p. 50.

47. Robinson, *Modern Civic Art*, p. 262.

of cultural rescue.[48] With the title "Union Square: Street Revitalization" unfolding across them, the nineteenth-century print and the George Washington monument were appropriated to embody an idea of urban redevelopment as restoration. The "Union" placard promised that coherence and harmony in the public realm would adhere to the Union Square created by the redevelopment project. Similarly, the monuments themselves, their dirty images cleaned up, layers of grime and graffiti removed from their surfaces as part of the park renovation, were enlisted to project an image of redevelopment as an act of benign historic preservation. Suffusing all official accounts of Union Square's metamorphosis, this became the classic image of gentrification, securing consent to and selling the larger package of redevelopment. The aesthetic presentation of the physical site of development is, then, indissolubly linked to the profit motives impelling Union Square's revitalization.

But this image of redevelopment can be contested by reconstructing the steps taken by the city to create the new Union Square. The fact that the first visible sign of change in the area arrived in the form of the park renovation reinforced the perception of Union Square redevelopment as a beautification program. Media reports, too, focused on the park for almost a solid year before there was any public indication of more comprehensive activities. The sequence in which events were reported and in which changes became visible mirrored the terminological inaccuracies surrounding urban restructuring. Mistaking the new residents of "new" neighborhoods for a lost aristocracy, for example, the term *gentrification*, like the park renovation, participated in the nostalgia that prevailed during the Reagan years for genteel and aristocratic ways of life, a sentiment fully exploited and perpetuated by prestigious cultural institutions. The term also yields erroneous perceptions of inner-city change as the rehabilitation of decaying buildings. Redevelopment, by contrast, involves rebuilding, usually after buildings have been razed and sites cleared. In these aggressive acts, the power of the state and corporate capital is more obvious.

In Union Square, the illusion that the park restoration preceded redevelopment plans produced an equally distorted picture. The actual narrative differed considerably from surface impressions. Documents generated during the process indicate the extent to which planning in the area was part of the

48. Kurt W. Forster has examined current architectural attitudes toward history and preservation using Alois Riegl's 1903 study of monuments, undertaken to direct the Austrian government's policy of protecting the country's historic monuments. Riegl's efforts to understand the nature of what he calls the unintentional monument—the landmark of art or architectural history—led him to conclude that relative and changing values determine the course and management of preservation programs. Riegl devotes much of his essay to an attempt to identify and categorize these conflicting values. To establish unintentional monuments as landmarks is to extract art and architecture from their original contexts and assign new roles in new circumstances. Relating Riegl's insights to current architectural attitudes, Forster has designated the unintentional monument "the homeless of history, entrusted to public and private guardians." He points out that Riegl's study fundamentally undermines the notion that architectural monuments possess stable meanings. (Kurt W. Forster, "Monument/Memory and the Mortality of Architecture," and Alois Riegl, "The Modern Cult of Monuments: Its Character and Its Origins," *Oppositions* 25 (Fall 1982), 2-19 and 21-51, respectively).

comprehensive policy adopted by city government following New York's fiscal crisis. The initial survey of Union Square, financed by the City Options grant, took place at a time when austerity measures had been imposed on city residents. *Union Square: Street Revitalization* completely embraced the popular explanations offered by politicians and financiers about the origins of the fiscal crisis—overborrowing, corruption, greedy workers and welfare recipients—and accepted the "solutions" justified by these explanations—cuts in basic services and deferred wage increases.[49] The report asserted that "public financing of new [housing] projects must be ruled out" in the development of Union Square's housing "frontier."[50] In its place, private development of housing, as well as of office and retail space, became a panacea. Hopefully, efforts might be made to "enlist the real-estate industry in effort [sic] to market new or rehabilitated housing units."[51]

The report's seemingly neutral, descriptive language concealed its own role in executing a brutal solution to a problem larger than Union Square's deterioration: the incompatibility of the city's new economy and its traditional workforce. The solution lay in "attempting to get rid of the poor and take away the better situated housing stock to reallocate to the workers needed by corporate New York."[52] The same year that *Union Square: Street Revitalization* appeared, Roger Starr, who had been the city's housing and development administrator during the fiscal crisis, advocated the "resettlement" of residents no longer needed in the corporate-oriented economy. Referring to deteriorated neighborhoods that, he hoped, would be vacated by such "relocation," Starr asserted that "the role of the city planner is not to originate the trend of abandonment but to observe and use it so that public investment will be hoarded for those areas where it will sustain life."[53] Using Starr's "empirical" methods, the planning department complied with his prescription. Redevelopment, then, was hardly a matter of the city enlisting the real-estate industry to fulfill the needs of residents. Rather, real estate and other capital interests enlisted city government to supply the conditions to guarantee their profits and reduce their risks.

The extent of the city's intervention in the housing market on behalf of corporate profits emerges in its clearest outlines in the 1983 proposal for

49. For a discussion of urban fiscal crisis and its relation to redevelopment, see "Uneven Development: Public Art in New York City."

50. *Union Square: Street Revitalization*, p. 30.

51. Ibid., p. 40.

52. William K. Tabb, "The New York City Fiscal Crisis," in *Marxism and the Metropolis: New Perspectives in Urban Political Economy,* eds. William K. Tabb and Larry Sawers (New York: Oxford University Press, 1984), p. 336.

53. Roger Starr, "Making New York Smaller," *New York Times Sunday Magazine,* 14 November, 1976, p. 105.

redevelopment. The *Union Square Special Zoning District Proposal* acknowledges that "Manhattan-wide market changes in the manufacturing, commercial, and residential sectors"[54] had brought about changes in the population and land-uses of its wider study area: the territory bounded by Twelfth Street to the south, Twentieth Street to the north, Third Avenue to the east, and Fifth Avenue to the west. The proposal points out, however, that Fourteenth Street and Union Square proper had benefited little from prevailing trends in the area. This pivotal center needed infusions of government support. "The Square continues to have a poor image,"[55] the report maintains, affirming that a principal barrier to development were the "social problems" plaguing Union Square Park, particularly its use by a "socially undesirable population (e.g., drug peddlers)."[56] By this time, however, the park had been "fenced off for reconstruction,"[57] a project that had been publicly announced in 1982.

The obstacle that the park's image represented had already been anticipated in the 1976 study. But the full force of the city's class-biased response to the problem and of its rationale for current urban policy is demonstrated by a difference between the 1976 and 1983 documents. In 1976 the surveyors concluded that "high income households...are more likely to be attracted to the Upper East Side or other established prestigious neighborhoods"[58] than to the shabby area around Union Square. Admittedly, the report contains no suggestions for providing low-income housing but it does make some pretense of formulating strategies for furnishing moderate-cost housing. The later proposal disregards both. By 1983 the implications of the original report had become clearer and hardened into policy. At the very moment when services to the poor were cut and the assumption made that no thoughts of public financing of housing could even be entertained, the government, acting through the Parks Commission and Planning Department, was directing its funds toward subsidizing the rich.

The $3.6 million restoration of the park constitutes such a public subsidy. Both the 1973 and 1983 Union Square plans indicate the degree to which the success of redevelopment depended on cleaning up the park's image and transforming it into an external housing amenity. An indication of the accuracy of this prediction is the fact that by the time the restoration was planned and publicized, and, significantly, during the preparation of the final planning department proposal, the destiny of the area's most important development

54. Union Square Special Zoning District Proposal, p. 2.

55. Ibid., p. 3.

56. Ibid.

57. Ibid.

58. *Union Square: Street Revitalization*, p. 30.

parcel—the entire city block occupied by the abandoned S. Klein department store—was being decided. In July 1983 a two-year option to buy the property had been acquired by William Zeckendorf, Jr., New York's most active real-estate developer, particularly in speculation in poor neighborhood lots that were to become catalysts for gentrification. The planning department map labels the property the "S.Klein/Zeckendorf Site." Zeckendorf intended to develop it for luxury commercial and residential use, but his plans depended on the subsequent fulfillment of various city plans. One plan, however, was already under way as the hindrance that the park's image represented to gentrifying groups was being removed. The restoration of the park can, then, only be viewed as that crucial stage of gentrification in which the poor are dislodged in order to make a neighborhood comfortable for high-income groups. Typically, this stage of displacement is sanctioned under the auspices of crime prevention and the restoration of order. The park, in other words, was being reclaimed from thieves and drug dealers. This goal, paramount in determining the urban-design principles that governed the park's renovation, also reveals the limits of the program of historic preservation and of the attempt to create a continuity between past and present. While existing nineteenth-century structures—the park's monuments—were refurbished and sham ones—lights and kiosks—constructed, the park was also bulldozed in preparation for the first phase of its "restoration" to its "original" condition. Phase I thoroughly reorganized the park's spatial patterns to permit full surveillance of its occupants. This change was accomplished through design precepts aimed at creating "defensible space." Oscar Newman, who popularized this phrase, considers "defensible" that space which allows people to control their own environments.[59] But the phrase comes closer to describing the application of the disciplinary mechanism that Foucault termed "panopticism" to state-controlled urban surveillance. By producing defensible space, architects and urban designers become agents of the discreet and omnipresent disciplinary power "exercised through its invisibility; at the same time it imposes on those whom it subjects a principle of compulsory visibility."[60] Grounded in ideas of natural human territorial instincts, defensible space assigns architecture the role of policing urban space:

> Architectural design can make evident by the physical layout that an area is the shared extension of the private realms of a group of individuals. For one group to be able to set the norms of behavior and the nature of activity possible within a particular place, it is necessary that

59. Oscar Newman, *Defensible Space: Crime Prevention through Urban Design* (New York: Collier, 1972).

60. Michel Foucault, *Discipline and Punish: The Birth of the Prison* (New York: Vintage, 1977), p. 187. Boyer analyzes urban planning as a disciplinary technology in *Dreaming the Rational City*.

it have clear, unquestionable control over what can occur there. Design can make it possible for both inhabitant and stranger to perceive that an area is under the undisputed influence of a particular group, that they dictate the activity taking place within it, and who its users are to be.... "Defensible space" is a surrogate term for the range of mechanisms—real and symbolic barriers, strongly defined areas of influence, and improved opportunities for surveillance—that combine to bring an environment under the control of its residents.[61]

That the private corporate and real-estate interests represented by the new Zeckendorf Towers, its future residents, and other beneficiaries of Union Square redevelopment would exercise "unquestionable control" over the public space of Union Square Park was assured by a few decisive changes in the park's physical appearance and circulation system. An open expanse of lawn with two walkways cutting directly across the park replaced the original radial pattern of six paths converging on a circle in the park's center; a pathway encircling the park's periphery provided the major circulation route; trees were removed and thinned out; and removal of walls and trees created an open plaza at the park's southern entrance. According to the police department in Saint Louis, this is the precise configuration of a safe park because it permits "natural" surveillance from a long periphery that can be easily patrolled.[62] A statement by the design office of the New York City Parks Commission applauded the success of Phase I:

> With design emphasis on improved accessibility, visibility and security to encourage its optimal use, the park has once again recaptured its importance as a high quality open space amenity for this community. Since Phase I began, the area around the park has changed quite dramatically. It is felt that the park redesign has contributed greatly to the revitalization of the Union Square area, and regained the parkland so needed in this urban environment.[63]

The manipulation of New York's high level of street crime has proved instrumental in securing public consent to redevelopment and to a planning logic of control through the kind of spatial organization exemplified by Union Square Park's sophisticated new security system. On April 19, 1984, at the inaugural ceremony for the restoration, the existing landscape had already been demolished. Mayor Koch told an assembled crowd: "First the thugs took over, then the mug-

61. Newman, *Defensible Space*, pp. 2-3.

62. Ibid., p. 114.

63. Union Square Park Phase I, statement by the design department of the City Park Commission (1986).

gers took over, then the drug people took over, and now we are driving them out."[64] To present the developers' takeover as crime prevention, however, the social and economic causes of crime were repudiated as thoroughly as the causes and aims of redevelopment were obscured. Koch, for example, wholeheartedly endorsed the resurgence of biological determinist ideas about the origins of "predatory street crime." Reviewing *Crime and Human Nature*, a book by sociobiologists James Q. Wilson and Richard J. Herrnstein, in the neoconservative *Policy Review*, Koch reiterated the authors' explanations of street crime in terms of biological and genetic differences that produce unreformable delinquents.[65] He then used these explanations to justify New York's methods of crime control and its continuing attack on the poor: higher levels of indictments and convictions of felons, an increased police force, the imposition of criminal law for purposes of "moral education,"[66] and, by implication, redevelopment projects that, employing architecture as a disciplinary mechanism, transform city neighborhoods into wealthy enclaves in order to facilitate the movement of "undesirables" and "undesirable market activities"[67] out of the immediate vicinity.

These tactics of urban restructuring are not entirely new. Neither is the erasure of the less appealing signs of restructuring or the disavowal of its social consequences. Over a hundred years ago, Friedrich Engels described similar procedures for transforming the city to meet the needs of capital. At that time, disease, even more effectively than crime, legitimated the violent dislocation of the poor. Engels refers to this process by the word *Haussmann*, appropriating the name of Napoleon III's architect of the reconstruction of Second Empire Paris:

> By "Haussmann" I mean the practice, which has now become general, of making breaches in the working-class quarters of our big cities, particularly in those which are centrally situated, irrespective of whether this practice is occasioned by considerations of public health and beautification or by the demand for big centrally located business premises or by traffic requirements, such as the laying down of railways, streets, etc. No matter how different the reasons may be, the result is everywhere the same: the most scandalous alleys and lanes disappear to the accompaniment of lavish self-glorification by the bourgeoisie on account of this

64. Quoted in Dierdre Carmody, "New Day Is Celebrated for Union Square Park," *New York Times*, 20 April 1984, B3.

65. Edward I. Koch, "The Mugger and His Genes," *Policy Review* 35 (Winter 1986), pp. 87-89. For other reviews by scientists who condemn the authors' methods and conclusions, see Leon J. Kamin, "Books: *Crime and Human Nature,*" *Scientific American* 254 (February 1986), pp. 22-27; and Steven Rose, "Stalking the Criminal Chromosome," *The Nation* 242 (May 24, 1986), pp. 732-736.

66. Koch, "The Mugger and His Genes," p. 89.

67. Union Square Special Zoning District Proposal, p. 23.

tremendous success, but—they appear again at once somewhere else, and often in the immediate neighborhood.[68]

About the housing question, Engels continues: "The breeding places of disease, the infamous holes and cellars in which the capitalist mode of production confines our workers night after night, are not abolished; they are merely *shifted elsewhere!*"[69]

That bourgeois solutions only perpetuate urban problems is indicated by the growing numbers of homeless who live no longer inside Union Square Park but on the surrounding streets and sidewalks. Furthermore crime has, in the words of the *New York Times*, "moved into Stuyvesant Square," only a few blocks away, having "migrated from nearby areas that have been the focus of greater police surveillance."[70] Parks Commissioner Henry J. Stern concurs: "It's clear some of the problems of Union Square Park, and maybe Washington Square Park, have migrated to Stuyvesant Square."[71] By subsuming all of New York's social ills under the category of crime, the rationale for revitalization reproduces and heightens the problems of poverty, homelessness, and unemployment. Simultaneously, it attempts to eradicate their visible manifestations. Embodied in the restored park and its monuments, architectural efforts to preserve traditional appearances also hide the proof of rupture.

The Homeless Projection: Counter-Image of Redevelopment

"Behind the disciplinary mechanisms," writes Foucault, "can be read the haunting memory of 'contagions,' of the plague, of rebellions, crimes, vagabondage, desertions, people who appear and disappear, live and die in disorder."[72] Similar repressions inhabit the controlled urban space that Wodiczko selected as the site of *The Homeless Projection*. Wodiczko's project encourages a critical public reading of this Haussmannian arena of beautified surfaces, suppressed contradictions, and relocated problems. If, as I suggested earlier, the form of the proposal that Wodiczko exhibited at 49th Parallel at once uses and comments on the presentational conventions of contemporary city planning, the project's realization as a performance in Union Square would have critically scrutinized—re-presented—the city environments that such planning produces. For this performance, Union Square would have provided a fully equipped, carefully arranged, and strategically located theater of

68. Friedrich Engels, *The Housing Question* (Moscow: Progress Publishers, 1979), p. 71. First published as three newspaper articles in *Volksstaat*, Leipzig, Germany, in 1872-73.

69. Ibid., p. 31.

70. Keith Schneider, "As Night Falls, Crime Moves into Stuyvesant Square," *New York Times*, 12 October 1985, p. 29.

71. Ibid., p. 31.

72. Foucault, *Discipline and Punish*, p. 198.

urban events. This "fake architectural real estate theater," as Wodiczko describes it, was built by a series of well-calculated strategies in an urban revitalization campaign. Carried out in the name of history—the Zeckendorf Towers were advertised as "The Latest Chapter in the History of Union Square"—that campaign tried to consign its own brutal history to oblivion.

Using the Union Square site, still haunted by memories of recent changes and marginalized city residents, *The Homeless Projection* conjures the memories of alterations and social conflicts from the very spaces and objects designed to exorcise them. To awaken these memories, Wodiczko planned to take advantage of the park's physical configuration and the spectacle created by its restoration. The plentiful lamps—reproductions of nineteenth-century Parisian streetlights—and the platform on which the park is elevated—a legacy of alterations to the Fourteenth Street subway station in the 1930s—furnished a public stage accessible to a ready-made city audience. The setting included tangible reminders of social restructuring in the park's spatial reorganization—redirected pathways, newly sodded lawns, thinned-out foliage. Since Wodiczko's work inserts the park restoration into the context of more extensive architectural activities, the signs of urban change that by 1986 surrounded the park would have completed his set, although most were not yet in existence when the proposal was first designed. Scaffolding, cranes, exposed building foundations, demolished structures, fenced-off construction areas, and emptied buildings attested to the large-scale restructuring of the city. They juxtaposed signs of destruction with the signs of preservation in the park itself. The huge, luxury Zeckendorf building rising across the street—"The Shape of Things to Come," as its billboard announced—indicated the principal beneficiaries of this activity.

In addition to lighting, stage, audience, and sets, Union Square Park provided Wodiczko with actors in the shape of the park's figurative monuments. Wodiczko's temporary appropriation of the statues prompted an awareness of the role they were already playing in New York's gentrification. Evoking memories different from those that the monuments were originally meant to conjure and from those that the restorers hoped to elicit, *The Homeless Projection* probed the less exalted purposes that underlie seemingly reverential acts of faithful preservation. Sculptures once placed in open spaces in the hope of pacifying city residents were manipulated by Wodiczko to construct and mobilize a public, "restoring" the space as a site of public debate and criticism. Using the monuments in their contemporary incarnation—mediums for repressing the changed conditions of urban life—Wodiczko converted them into vehicles for illuminating those conditions. In this way, he planned to make the city's built environment into a type of Brechtian theater about which Walter Benjamin observes: "To put it succinctly: instead of identifying with the characters, the audience should be educated to be astonished at the circumstances under which they function."[73]

73. Walter Benjamin, "What Is Epic Theater?" in *Illuminations*, trans. Harry Zohn (New York: Schocken, 1969), p. 150.

Despite energetic attempts by the mass media, the city, real-estate pro-
motions, and segments of the cultural establishment to present the bronze
statues as representatives of eternal values—aesthetic and moral—the monu-
ments have indeed been recast in compromising situations and positions.
Haphazard from its inception, the Union Square sculptural program is gener-
ally taken to symbolize liberty and individual freedom, an interpretation orig-
inating in the nineteenth century when commentators noted that two of the
sculptures fortuitously share a common subject: heroes of the French and
American democratic revolutions. The George Washington statue was erected
in 1856 and, although it adopts the codes of Roman imperial sculpture, is
habitually described as a symbol of the freedom secured by the War of Inde-
pendence. Standing now on the park's eastern edge, Lafayette, by Frederic
August Bartholdi, sculptor of the Statue of Liberty, was presented to New York
in 1873 by the city's French residents as a memorial to French-American rela-
tions. Inscriptions on the statue's base commemorate two instances of such
solidarity: mutual inspiration and support during the American Revolution
and sympathy extended by the United States to France during the difficult
period of the Franco-Prussian War and the Paris Commune, the latter an
urban revolution for which the monument apparently has no sympathy to
offer. The remaining nineteenth-century statues—Abraham Lincoln, erected
three years after the death of the Civil War president, and the fountain located
on the western side of the park, a "heroic bronze group," of a mother and chil-
dren—do not strictly conform to the Revolutionary War theme but can be
readily assimilated into the general patriarchal program and atmosphere of
eclectic classicism. As the author of the Emancipation Proclamation, Lincoln
contributes to the motif of liberation from tyranny. But on July 4, 1926,
Tammany Hall greatly strengthened the sculptural program's thematic coher-
ence by donating a huge flagpole base that was placed at the center of the
park. The base solidified the topos of freedom, displaying the full text of
the Declaration of Independence, a relief depicting a struggle against evil, a
quotation from Thomas Jefferson, and a plaque stating, "This monument set-
ting forth in enduring bronze the full text of the immortal charter of American
liberty was erected in commemoration of the 150th Anniversary of the Decla-
ration of Independence."

Originally, the park's six pathways converged on the flagpole base. Now
this tribute to freedom is stranded in the middle of a broad expanse of lawn
designed to render the public accessible to surveillance and to prevent illicit
activities at the park's center—the most distant point from the perimeter
policing. The monument's changed position suggests that the enduring prin-
ciple that it now commemorates has little to do with what it ostensibly honors:
the democratic revolution's establishment of the right to freedom. Rather, the
flagpole base memorializes the interests historically protected by principles of
individual liberty: the freedom of private property, in this case, the unfettering
of the financial forces in whose interest the park renovation was largely under-

taken. The meaning of the sculpture's metamorphosis—an example of what Wodiczko terms architecture's "real-estate change"—was confirmed when the park monuments were presented in the Zeckendorf Towers sales office, which opened in the spring of 1986. Framed photographs of the statues were displayed among a group of pictures representing Union Square's history and showing the park's mounted police as a backdrop for a model of the new condominiums, whose prices approach half a million dollars. That a substantial number of apartments were sold in the first week of business fulfills the prophecy of a 1984 *Times* editorial that, urging support for Union Square redevelopment, seconded the City Planning Commission's faith that "the location of the public square and its handsome lines and *great statuary* will attract investment from builders."[74]

Still, the dogma persists that monumental architecture can survive changes in both the immediate context of its display and the broader contingencies of history with its dignity and power intact. Successful monuments, we have recently been told, transcend the "trivialities" of commercialism. This assertion is grounded in the same aestheticist premises as the belief that successful monuments transcend the "trivialities" of social conditions such as poverty and homelessness. It is not unexpected, then, that Paul Goldberger, who elevated the Union Square flagpole base above the "degrading" action of "a derelict," seven years later, during New York's Bicentennial celebration, rhapsodized the "essential dignity" of the Statue of Liberty. Unfortunately, Goldberger's defense was not prompted by a desire to fortify the monument's original message against contemporary waves of anti-immigrant sentiment and attempts to enact repressive legislation against Hispanics and Asians in the United States. Rather, he applauded the statue's ability to rise above such issues and fulfill a monument's "fundamental" role in the urban environment: "The city that is too large and too busy to stop for anyone seems, through this statue, to stop for everyone. Suddenly its intense activity becomes background, and the statue itself becomes foreground: we cannot ask of a monument that it do anything more."[75]

With remarkable clarity, Goldberger inadvertently summarizes not the actual effects of monuments but the ideological operations of his own idealist aesthetic and urban principles. Stretching the tenet of aesthetic autonomy to include the city that surrounds the individual monument, he fetishizes the urban environment at the level of its physical appearance. He thus describes the Statue of Liberty's compositional relationship, by virtue of its permanent position in New York Harbor, to a city which, through that relationship, is rendered more physically coherent. But Goldberger himself, utterly neutralizing and restricting the notion of context, uses architecture to push into the

74. "Speaking Up for Union Square," *New York Times*, 16 August 1984, A22.

75. Paul Goldberger, "The Statue of Liberty: Transcending the Trivial," *New York Times*, 17 July 1986, C18.

Krzysztof Wodiczko, *The Homeless Projection: A Proposal for the City of New York*, 1986. Courtesy of the 49th Parallel, Centre for Contemporary Canadian Art.

Krzysztof Wodiczko, *The Homeless Projection: A Proposal for the City of New York*, 1986. Courtesy of the 49th Parallel, Centre for Contemporary Canadian Art.

Krzysztof Wodiczko, *The Homeless Projection: A Proposal for the City of New York*, 1986. Courtesy of the 49th Parallel, Centre for Contemporary Canadian Art.

background, to blur, the city's "intense activity"—its social processes, its intense real-estate activity.

The Homeless Projection, by contrast, treats architecture as a social institution rather than as a collection of beautiful or utilitarian objects and addresses urban space as a terrain of social processes. It uses the Union Square monuments neither to depreciate the significance of the city's activities nor to minimize the meaning of its individual architectural objects. Instead, the work foregrounds their constitutive relationship. Wodiczko planned to project onto the surfaces of the four figurative monuments in Union Square Park—representatives of architecture's attempt to "preserve its traditional and sentimental appearances"[76]—photographic images of the attributes of New York's homeless population, the group most noticeably dispossessed by such preservationism. Magnified to the scale of the monuments, though not heroicizing or representing homeless people themselves, the images would have remained, as they did in the gallery installation, unchanged throughout the artist's performance. The images show various characteristics of homeless people: their costumes and equipment; their means of travel occasioned by enforced mobility; and the repertoire of gestures that they adopt to survive and to secure an income on the streets. Far from transcending the "trivial" facts of city life, Wodiczko's monuments are forced to acknowledge the social facts they have helped produce.

The Homeless Projection's images are of, precisely, trivial objects: a shopping cart, a wheelchair, a can of Windex. And while these monumentalized commonplace items clash absurdly with the heroic iconography of the neoclassicical statues, they also seem oddly at home there. Wodiczko gives his altered monuments an appearance of familiarity by seamlessly joining the images to the statues' own forms and iconography. He might, for example, superimpose a photograph of a human hand over a statue's bronze one so that the projected image merges imperceptibly with the sculpted figure's anatomy. As in surrealist montage, however, the appearance of continuity only makes the presence of the new material more startling. Disengaging spectators from their customary disregard of the monuments and from the seduction attempted by the restoration program's new presentation, attitudes that isolate the monuments from surrounding conditions, *The Homeless Projection* allows viewers to perceive the sculptures only in relation to those conditions.

The artist ensures this primary reading by means of the images' iconography coupled with montage techniques—the formal relationships that Wodiczko establishes between image and architecture. His careful accommodation of an unchanging image to the appropriated surface of an existing architectural structure has a twofold effect. First, it focuses the viewer's attention on the structure—on the monument's physical stability as well as its

76. Wodiczko, "The Homeless Projection: A Proposal for the City of New York," reprinted in *October* 38 (Fall 1986).

mythical symbolic stability. One becomes aware of the image of inevitability and power that the monument itself normally projects. At the same time, Wodiczko's projection uses the structure's own formal and iconographic codes to undermine its seemingly unshakable homogeneity and authoritative permanence. Manipulating the structure from within, the montage symbolically disturbs the object so that its actual instabilities can be perceived. The congruence between image and architecture is crucial because it renders the projection more astonishing as excluded material—the evidence of homelessness—returns within the vehicle of its repression—the architecture of redevelopment. An evicting architecture becomes an architecture of the evicted. The surprise engendered by this uncanny impression alters the viewer's relation to urban objects. For if dominant representations imprint their messages on receivers by inviting immediate identification with images so "natural" they seem uncoded, Wodiczko's transformed images have the opposite effect: impeding both the monuments' messages and the viewer's identification with authoritative images, they foster a creative consumption of the city. Wodiczko's works are, then, projections onto projections.

But *The Homeless Projection* does not simply interrupt the monuments' speech. It does so precisely by extending, deepening, and radicalizing the statues' own messages. Wodiczko's images of the tokens of homelessness depict the current oppressive outcome of conflictual private-property relations. The images are, however, integrated into architectural and urban forms symbolizing social unity, the common interest of the people supposedly represented by the democratic state. The projection thus highlights a seeming contradiction between the state's claim to represent the common good and its support of economic domination. This contradiction is enshrined in the Union Square monuments in both their present incarnation and their original form. As monuments to the democratic revolutions of the late eighteenth century, the statues not only commemorate social unity, they also celebrate "the rights of man," which, inaugurated by those revolutions, proclaim the individual freedoms guaranteed by the democratic state. Wodiczko's projection suggests that there are good reasons to question the political function of these twin aspects of the state: on the one hand, the state represents an ideal, universal realm elevated above the conflicts of civil life and, on the other hand, it is the guardian of the rights of man. Karl Marx, for one, famously argued that precisely the dual character of the bourgeois concept of the state makes capitalist relations of oppression and exploitation appear inevitable.[77] The real goal of the bourgeois state, he claims, is to naturalize and therefore justify social conflict. The democratic revolution, writes Marx, brought the modern state into existence by separating the state and civil society. Shattering civil society into a depoliticized realm of atomized individuals and of material life, the revolution simul-

77. Karl Marx, "On the Jewish Question," in *Karl Marx: Early Writings*, trans. Rodney Livingstone and Gregor Benton (New York: Vintage, 1975), pp. 211-241.

taneously constituted the state as a domain of harmony transcending the particularities and strife of civil life. Marx reasons further that people in bourgeois society are likewise split in two. As citizens, endowed with civil rights, they live an abstract life as communal beings. But the rights of man—human rights—are the "rights of the *member of civil society*, i.e., of egoistic man, of man separated from other men and from the community."[78] The practical consequence of human rights is to ensure the freedom of private property by protecting the self-interest of each individual against any concern for the social good. For Marx, the bourgeois notion of "political emancipation," the granting of civil rights, implies that people can only be freed from this conflict abstractly, through citizenship in the state. Consequently, individualistic man, the bearer of the rights of man, emerges as "real man." The idea of political emancipation thus presupposes the necessity of private property and precludes the abolition of economic conflict, which, safeguarded in the form of human rights, the bourgeois state is instituted to protect.

We may disagree with Marx's wholesale dismissal of human rights as mere bourgeois delusion. There is another way to think of rights. Criticizing Marx's analysis of the rights of man, the French political philosopher Claude Lefort presents a different theory of democracy.[79] Lefort argues that the split between state and civil society did not take place, as Marx thought, with the democratic revolution but earlier, during the monarchy. At stake in Lefort's "correction" of Marx's history is not chronological accuracy but the meaning of democracy. According to Lefort, Marx's failure to investigate the alteration represented by developments during the monarchical period made him unable to perceive the different alteration brought about by the emergence of the bourgeois state. As a consequence, Marx saw only one aspect of the democratic revolution and could not appreciate the significance of the political revolution that destroyed absolutism, a destruction that occurred with the Declaration of the Rights of Man. For Lefort, the democratic revolution inaugurated a change in the meaning of rights coextensive with equally radical mutations in the meanings of society and of power. Under the monarchy, the meaning and unity of society appeared to rest on an absolute basis—a transcendent foundation that was embodied in the figure of the king and from which the state derived its power. With the fall of the monarchy, the origin of social unity and of power resides, as the Declaration of the Rights of Man states, in "the people." The declaration refers power to the people, but the democratic act deprives "the people" of a fixed source of meaning. They, too, have no substantial identity. The democratic revolution consists, then, of the

78. Ibid., p. 229.

79. See Claude Lefort, "The Question of Democracy" and "Human Rights and the Welfare State," in *Democracy and Political Theory* (Minneapolis: University of Minnesota, 1988) and idem, "Politics and Human Rights," in *The Political Forms of Modern Society: Bureaucracy, Democracy, Totalitarianism* (Cambridge: the MIT Press, 1986).

disappearance of certainty about the meaning of society, which legitimates debate about the question of social unity. The meaning of society is decided within the social itself but is not immanent there. Rather, uncertainty about foundations authorizes democratic debate and questioning of power. Lefort agrees with Marx that the Declaration of the Rights of Man was made in the name of human nature, but because right is deprived by the democratic revolution of an absolute foundation, it, too, is relocated from a transcendent realm to a space within society. Rights become an enigma. Against Marx, Lefort argues that the democratic revolution actually reduces the source of rights not to nature but to the human utterance: it is the essence of rights to be declared. And because neither rights nor "the people" who declare them are given entities but emerge only with the declaration, rights do not, as Marx thought, testify to man's separation from man but to the social interaction implicit in the act of declaring. The human subject as the bearer of rights is not an autonomous but a radically contingent being.

Still, Lefort is careful to point out that what Marx failed to see in the rights of man does not negate what he did see. Defending democracy, in other words, is no reason for dismissing Marx, who "was perfectly correct to denounce the relations of oppression and exploitation that were concealed behind the principles of freedom, equality, and justice."[80] Marx's insight can, then, illuminate both the social functions performed by Union Square's statues in the redevelopment process and the nature of the challenge raised by Wodiczko's *Homeless Projection*. Like the bourgeois state, the public monuments can only symbolize communal harmony and universal good if the sphere of economic conflict— real estate, in this case—is constituted as a private domain dissociated from public life. But precisely this rigid separation of public and private spheres also enabled the monuments to serve as the guardians of real estate. By causing the effects of the private economic sphere to reappear within the public monuments and thus threatening the security of the public-private divide, *The Homeless Projection* revolutionizes the statues, which, in their altered state, are forced to acknowledge their own contradictions and repressions.

But what if, following Lefort, we also find something in the idea of human rights that Marx did not find? What if we see not only a "false" freedom through which the bourgeois state guarantees the rights of private property but also the possibility, inaugurated by the democratic invention, of social groups raising demands for freedoms—for rights—that challenge the omnipotence of state power and the exclusions of property? What if we define public space as the space where society constitutes itself through an unending declaration of rights that question and limit power? *The Homeless Projection* might then be read as a symbolic, if humorous, declaration of new rights—for homeless people. Infiltrated with Wodiczko's images, the statues issue a demand for the legitimacy of homeless residents as members of the urban

80. Claude Lefort, "Human Rights and the Welfare State."

community, a demand raised against the legitimacy of state power to exclude them—from Union Square, from the city, from society itself. Transformed into the medium of such a demand, the Revolutionary War monuments become a commemoration of the democratic revolution, whose most radical act in Lefort's view was to make it possible to question the basis of power. Temporarily, that is, the statues metamorphose into the public monuments, and Union Square into the democratic public space, that they are officially proclaimed to be. For Wodiczko's project takes account of the exclusions that create the social unity that the monuments supposedly represent and thereby subjects the foundation of that unity to democratic contestation. *The Homeless Projection* thus extends the very revolution that Union Square's sculptural program ostensibly memorializes but whose most radical messages it evades. To facilitate what I have interpreted as a democratic questioning of social unity, Wodiczko manipulates the statues' own language, breaking up its apparently unitary and stable meanings. He transforms the classical gestures, poses, and attitudes of the sculpted figures into the gestures, poses, and attitudes currently adopted by people begging on the streets: George Washington's left forearm presses down on a can of Windex and holds a cloth, so that the imperial gesture of his right arm is transformed into a signal made by the unemployed to stop cars, clean windshields, and obtain a street donation. Lincoln's stereotypically "proud but humble" bearing is reconfigured, through the addition of a crutch and beggar's cup, into the posture of a homeless man soliciting money on a street corner. A bandage and cast change Lafayette's elegant stance and extended arm into the motions of a vagrant asking for alms, and the mother sheltering her children metamorphoses into a homeless family appealing for help. In addition, Wodiczko projected a continuously fading and reappearing image onto the Lincoln monument: an emptied building with a partially renovated facade.

This "style" of building—conspicuously empty despite an equally visible need for housing—was a familiar New York spectacle throughout the 1980s. Its surface, like the surface of the monuments, had been partially restored as part of a presentation to encourage neighborhood speculation. Fissuring the surfaces of the Union Square monuments—the images of gentrification—with images of the vacated building and of the mechanisms by which the homeless survive, *The Homeless Projection* concretizes in a temporary, antimonumental form the most serious contradiction embodied in New York architecture: the conflict between capital's need to exploit space for profit, on the one hand, and the social needs of the city's residents, on the other. Mapping these images onto the monuments in a public square, Wodiczko forces architecture to reveal its role as an actor in New York's real-estate market. Wodiczko's intervention in the space of Union Square revitalization thus addresses the single issue most consistently ignored by the city throughout the long and complicated course of redevelopment: displacement. During *The Homeless Projection*, and afterward in viewers' memories, the Union Square monuments,

diverted from their prescribed civic functions, would have commemorated this urban event—mass evictions and development-produced homelessness.

Real-Estate Aesthetics

Indifference to and concealment of the plight, even the existence, of displaced residents was predictable. To foster development, the city encouraged a suppression of data on displacement and homelessness. While *The Homeless Projection* places this issue at the center of urban life, official architecture and urban disciplines took part in its cover-up in Union Square. To appreciate fully the extent of this repudiation, it is necessary to understand the crucial role played by "contextual aesthetics" during a key phase of revitalization.

Government subsidies to real-estate developers are not limited to direct financial outlays or to tax abatements and exemptions. Benefits also accrue from the city's administration of institutional allowances for building, especially through its bureaucratic procedures and zoning regulations. Union Square development depended on a specialized proceeding through which the planning commission permits zoning constraints to be waived or altered. The vehicle for this alteration is the "special zoning district," defined in the planning department dictionary as a section of the city designated for special treatment "in recognition of the area's unique character or quality."[81] Permitting changes in the use, density, or design of buildings in the specified area, the creation of a special zoning district is commonly portrayed as a flexible response to "perceived needs."[82] Commentators frequently demonstrate this flexibility by comparing it to the rigidity of the 1961 Zoning Resolution whose rules the special zoning district has, since the 1970s, tended to modify or circumvent. Champions of the special district start from the premise that the 1961 zoning code is grounded in the principles of European modernist architecture of the 1920s; they then characterize it as "utopian," "antitradition," "antiurban," and "unresponsive to context." Casting support of the special zoning district as a "critique of modernism" and conflating urban and aesthetic problems, advocates present current manipulations of land-use regulations to aid redevelopment as responsiveness to the environment and the social needs of city residents. The following assessment of the problems justifying the use of the special zoning district typifies this logic:

> Less than ten years after the adoption of the 1961 Zoning Resolution, disaffection with the results of the utopian vision set in....The prevailing view was that the new zoning was incompatible with the best efforts of architects and urban designers to produce high-quality architecture and good city form. This belief, while most often heard from

OVER EXPOSED

81. "Glossary: Selected planning terms applicable to New York City real estate development," *New York Affairs* 8, no. 4 (1985), p. 15.

82. Kwartler, "Zoning as Architect and Urban Designer," p. 115.

architects and urban designers was also expressed with great regularity by the developers, bankers, and community representatives, and other professional, lay, and governmental constituencies. They posited that zoning was legislating esthetics, and that a single vision was too restrictive, leaving little room for genuine architectural design quality. The result is a cookie-cutter building that is ugly and sterile, set in an ill-considered and barely usable public open space that is often neglected, or used by the seedier elements of New York's street-corner society. These same buildings appear to be insensitive to the existing buildings around them, creating dissonance in urban form.[83]

The special zoning district is treated, then, as a means to conserve tradition, restore coherence and stability, and ensure architectural diversity. But it serves other functions as well.

The Zeckendorf Company's plans in Union Square depended on the creation of a special district for sites fronting directly on the park. After purchasing the option to build on the Klein site, Zeckendorf announced that the realization of his project, which was itself crucial to the area's redevelopment, was contingent on the rezoning already proposed by the planning department. The zoning change would increase the allowable density for buildings around the square, providing additional space bonuses for the Klein property in return for the developer's renovation of the Fourteenth Street subway station. The 1983 summary of the planning department's two-year study undertaken to "guide" redevelopment so that it would reflect the "existing urbanistic context" set out the rationale for the special zoning district.[84] In recognition of Union Square's architectural uniqueness and to foster "compatibility between any new construction and the existing significant architectural buildings,"[85] the proposal not only suggested increased density allowances for new buildings to match those of the late nineteenth- and early-twentieth-century structures, it also created special "bulk distribution regulations": plazas or ground-floor setbacks were prohibited (the park made plazas unnecessary), and the facades of all buildings on the square had to be built to the property line and to rise straight up for a minimum of eighty-five feet. A system of mandated setbacks and a restriction on towers within one hundred feet of the square would, according to the proposal, ensure light and air.

Zeckendorf's architects had already designed his mixed-use building to conform to these contextualist principles. Four seventeen-story apartment towers would rise from a seven-story base occupying the entire building site. They would begin at a point farthest from the park and terminate in cupolas

83. Ibid., p. 113.

84. Union Square Special Zoning District Proposal, 1.

85. Ibid., 6.

to "echo" the historic tower of the Con Edison building behind them. According to Zeckendorf, the building plan addressed "the concerns we've heard from the community about not overshadowing the park and fitting in with the rest of the structures there."[86] The key point of the zoning rationale and of Zeckendorf's compliance was the contention that the new buildings would not merely harmonize with the existing environment but also recapture its history as an elegant neighborhood. As a *New York Times* editorial put it:

> To understand fully what the rescue of Union Square would mean, the observer has to imagine how it once resembled London's handsome Belgravia and Mayfair residential districts. By insisting on the eight-story rise directly from the sidewalk, the planners hope that modern apartment house builders will produce a contemporary echo of the walled-in space that gives the small squares of London and America's older cities their pleasing sense of order and scale.[87]

Before ultimate approval (with slight modification) in January 1985, both the rezoning proposal and the design of the Zeckendorf Towers had to pass through a public review process. Over a period of seven months, each project was debated at public hearings, first before the community boards, then before the City Planning Commission, and finally before the Board of Estimate. The city and the developer submitted obligatory, highly technical environmental impact statements in which they were required to show "the potential environmental effects of a proposed action on noise level, air and water quality and traffic circulation."[88]

The supreme measure of the city's alignment with corporate interests in the area is the failure of any of its reports to mention the socioeconomic impact of the redevelopment plan on the area's low-income population. Displacement of residents, the most obvious effect of the literal demolition of housing as well as the more extensive effect of revitalization—raised property values—was virtually unremarked in the hundreds of pages generated throughout the planning and review processes. The unquantifiable numbers of homeless people who, according to the New York State Department of Social Services, "find shelter out of the public view"[89] in city parks were driven from the newly visible Union Square, their numbers increased by those made homeless by the larger redevelopment plan.

86. Quoted in Lee A. Daniels, "A Plan to Revitalize Union Square," *New York Times*, 1 July 1984, 6R.

87. "Speaking Up for Union Square," A22.

88. "Glossary," p. 13.

89. New York State Department of Social Services, *Homelessness in New York State: A Report to the Governor and the Legislature* (October 1984), p. 3.

Also not mentioned in the city's reports was the single-room-occupancy hotel that stood on the Klein site. Its demolition was the precondition of the Zeckendorf project, and its address, 1 Irving Place, is now that of the luxury towers. Similarly, the planning department surveyors who in the proposal applauded the increasingly residential character of the neighborhood because of middle-class loft conversions and who examined the quality of existing residential buildings, failed to survey the thirty-seven single-room-occupancy hotels and rooming houses in the area around the special district, buildings containing six thousand housing units for residents on fixed or limited incomes.[90] Yet the relationship between current levels of homelessness and single-room-occupancy displacement in New York City was well known:

> This shrinkage of housing options is nowhere more visible than in the long-time staple housing source for low-income single persons — the single-room-occupancy (SRO) hotel. Across the country the number of units in SROs is declining. In some areas they are being converted to luxury condominiums, while in others they are abandoned by owners unable to afford taxes and maintenance costs. In New York City, SROs have disappeared at an alarming rate. Because of this — and other forces at work — it is estimated that as many as 36,000 of the city's most vulnerable residents, the low-income elderly, now sleep in the streets.[91]

Although the number of lower-priced SRO units in New York declined by more than 60 percent between 1975 and 1981,[92] the burden of surveying the area and determining the effects of Union Square redevelopment on the occupants of these dwellings fell to the housing advocates who argued against development plans at the Board of Estimate hearing. The environmental impact statements ignored the impact of both primary displacement—the direct consequence of the demolition of the SRO on the Zeckendorf site—and the more significant secondary displacement—the displacement caused by higher rents, enhanced property values, real-estate

90. See the statement of Nancy E. Biberman, director, Eastside Legal Services Project, MFY Legal Services, Inc., to the City Planning Commission, October 17, 1984.

91. Ellen Baxter and Kim Hopper, *Private Lives/Public Spaces: Homeless Adults on the Streets of New York* (New York: Community Services Society, Institute for Social Welfare Research, 1981), pp. 8–9, cited in Michael H. Schill and Richard P. Nathan, *Revitalizing America's Cities* (Albany: State University of New York Press, 1983), p. 170, note 120. Schill and Nathan quotes Baxter and Hopper's statement only to discount it and to justify government policies that encourage redevelopment. *Revitalizing America's Cities* concludes that the displacement resulting from these policies does not justify stopping redevelopment. The authors' credibility is compromised by the fact that their methodology included "an effort... to avoid neighborhoods that contained high concentrations of SROs or transient accommodations" and that "the survey of outmovers does not describe the rate of displacement among the most transient households or examine the problems faced by the homeless." In other words, they eliminate the material necessary to support their conclusion.

speculation, legal warehousing, and, temporarily, illegal conversion of neighborhood rooming houses.[93]

Throughout, this concealment was facilitated by appeals to aesthetic contextualism and by the cultural sentiments informing all three phases of Union Square revitalization: the park restoration, creation of the special zoning district, and approval of the Zeckendorf project. Although traveling under the sign of contextualism, the architects and designers who minutely calculated the physical effects of rezoning and of the towers on the shadows and air in Union Square or judged the project's aesthetic effects on the cornice lines of the square's other buildings exemplify what Ernest Mandel calls the "real idol of late capitalism"—"the 'specialist' who is blind to any overall context."[94]

During the same period, the ranks of the city's technocrats swelled to include artists, critics, and curators who were asked to fulfill the task, spelled out at the time in a Mobil advertisement, of encouraging residential and commercial real-estate projects and revitalizing urban neighborhoods. One example of cooperation with these corporate demands by sectors of the art establishment is public art involved in the design of redeveloped spaces and applauded as socially responsible because it contributes, functionally or aesthetically, to the so-called pleasures of the urban environment. Such work is based on the art world equivalent of official urban planners' constricted version of contextualism. Knowing the social consequences of this contextualism underscores the urgency of creating alternative art practices such as *The Homeless Projection*, whose reorientation of vision disturbs the tightly drawn borders secured by New York's contextual zoning.

92. *Homelessness in New York State*, p. 33.

93. Nancy Biberman, a lawyer from MFY Legal Services who at the time this essay was first written was doing private housing consulting, represented the tenants of 1 Irving Place. She was able to obtain a good settlement for the potential victims of direct displacement. Since Zeckendorf was eager to begin construction before December 1985 in order to be eligible for 421-a tax abatements and since legal problems could have held him up past the deadlines, he was pressured into offering these tenants the option of living in the Zeckendorf Towers themselves at the price of the tenants' old rents. For the victims of secondary displacement, Zeckendorf assumed little responsibility. He was required only to purchase and renovate forty-eight units of SRO housing.

94. Ernest Mandel, *Late Capitalism* (London: Verso, 1975), p. 509.

This essay was first published in *October* 38 (Fall 1986), pp. 63- 98. It is reprinted here in the expanded version that appears in my book, *Evictions: Art and Spatial Politics* (Cambridge: MIT Press, 1996).

TIMOTHY DRUCKREY

Instability and Dispersion

> The objective tendency of the Enlightenment, to wipe out the power of
> images over man, is not matched by any subjective progress on the
> part of enlightened thinking towards freedom from images.
> —Theodor Adorno, *Minima Moralia*[1]

Haunting the transformation of photography in the past decade are a series of
shocks broadly compounded by critical theory and technology. The reverber-
ating effects of deconstruction and digitization on the photographic image
demand a reassessment of the crucial role of digital technology in the repre-
sentation of information, particularly as the relationship between an event
and its presence as a mediated image collapses—what Paul Virilio and others
have theorized as the "eviction of direct observation."[2] This disruption of the
information flow is complicated by a rapidly expanding field in which elec-
tronic technology heightened the potential meanings of images while diversi-
fying access to them in extraordinary ways. And surely, the intricacies of an
increasingly networked planet raise some new questions about the function
(and authority) not just of experience, images, and information, but about a
disrupted temporal flow in which electronic events are available outside the
hitherto legitimating and problematic institutional media. The history of
these "shocks" has much to do with an image world whose relationship with
authority, certainty, or authenticity is increasingly challenged by critical
thinking and technical interventions into the very foundations of the image-
making process—from psychological intentionality to the simulation of
events to the virtualization of "reality" itself.

Just after the Rodney King incident (the 1991 episode in which Los Ange-
les police were videotaped using excessive force following the car chase and

1. Theodor Adorno, *Minima Moralia* (New York: Verson, 1978), p. 140.

2. Paul Virilio, *Lost Dimension* (New York: Semoitext(e), 1991), p. 42.

capture of motorist Rodney King), a number of media organizations began to characterize a field identified in *Newsweek* as "vigilante video," that is, media outside the established news media, what we might call post-media, a field in which recorded observation seemed lawless and hence out of the control of "official" news gathering and the editorial monitoring that accompanies it. The riots in Los Angeles after the King verdict (which exonerated the police) demonstrated to law enforcement and a petrified public that surveillance was a two-way street. Suddenly video vigilance came as the guarantor of public security in a new role as observer and evidence. Indeed, ubiquitous observation—in the guise of myriad news network SkyCams or surveillance satellites capable of imaging objects less than one meter across from 35,000 miles in space; the broadcasting of "amateur" video of any "newsworthy" disaster, chase, or tragedy; the use of "private" security cameras as a police investigative tool—posits a public sphere in which visibility is presumed and in which observation encroaches on liberty. High-resolution cameras are currently being used for traffic regulation and are being developed for use in retinal and facial recognition as well. Clearly, a refigured image has emerged as more than anecdotal observation, but as intricately bound to ideologies of technology and to techniques of recording and rendering that have displaced the long and shaky correspondence between experience and recording. The neopanoptic presence of surveillance linked with a seemingly insatiable drive for the invasion of "privacy" (as in the so-called feeding frenzy that characterized the life and death of Diana, Princess of Wales), results in an almost compulsive—one might say fetishistic—desire to make virtually everything available in the form of an image.

In his recent book *Media Manifestos*, Regis Debray outlined a broad framework for distinguishing the social meaning and history of imagery. Introducing three broad epistemological phases—Logosphere, Graphosphere, Videosphere—the book assesses each "regime" (respectively characterized as "after writing," "after printing," and "after the audiovisual") as related to both intellectual and technological histories. And although there are problems in such simplified historical characterizations, Debray uses them to identify significant cultural issues concerning the image. "Thus," he writes, "the artificial image would have passed through three different modes of being in the Western brain—presence (the saint present through his effigy); representation; and simulation (in the scientific sense), while the figure perceived exercised its intermediary function from three successive, inclusive perspectives—the supernatural, the natural, and the virtual."[3] This kind of critically reflexive model conforms with what Debray admits is the work of "mediology"— the intellectual study of the histories of media—rather than historicism. Yet, the scope of the issue of digital media extends beyond the limitations of either mediology or traditional history into the realms of social epistemology,

3. Regis Debray, *Media Manifestos* (New York: Verso, 1996) p. 26.

experiential psychology, and scientific methodology. How the image is perceived must be bound to how the image is produced—especially considering the trajectory of current image technologies. Nevertheless, Debray's outline serves to suggest that the passage from analogue to digital images has histories deeply rooted in semeiotics and reproducibility—although Debray does not fully account for the technologies forming these images nor the psychological impact of representation.

The "passage" from analogue to digital is a key to conceptualizing the differences between the traditional and electronic image and is well articulated in Raymond Bellour's essay, "The Double Helix":

> So the point would rather be to make this commonplace but necessary observation: there is no visual image that is not more and more tightly gripped, even in its essential, radical withdrawal, inside an audiovisual or scriptovisual (what horrid words) image that envelops it, and it is in this context that the existence of something that still resembles art is at stake today. We are well aware, as Barthes and then Eco have been pointing out for some time now, and as was so admirably reformulated by Deleuze with an extraordinary emphasis on the image, that we are not really living in "a civilization of the image"—even though pessimistic prophets have tried to make us believe that it has become our evil spirit par excellence, no doubt because it had been mistaken for an angel for such a long time. We have gone beyond the image, to a nameless mixture, a discourse-image, if you like, or a sound-image ("Son-Image," Godard calls it), whose first side is occupied by television and second side by the computer, in our all-purpose machine society.[4]

Indeed, the consequence of the unsettled state of electronic representation is the equivocal image. Legitimated by the perceptual models of photography and by algorithmic perception, the electronic image vacillates between the actual and the virtual. The alliance between the image and the experience is challenged in this environment. In a culture in which accelerated images have come to constitute a form of experience, the immediate state of perception becomes compressed and volatile. Paul Virilio writes that "the absence of any immediate perception of concrete reality produces a terrible imbalance between the sensible and the intelligible."[5] Undoubtedly, images have never before possessed the potential to support so much information, presence, or meaning. Electronic montage; photographic resolution animation; the erosion of photography by the increasing acceptability of video as a signifier of authenticity; the abandonment, or outright dismissal, of images as evidence;

4. Raymond Bellour, "The Double Helix," in *Electronic Culture: Technology and Visual Representation*, ed. Timothy Druckrey, (New York: Aperture, 1996) pp. 198-99.

5. Paul Virilio, *Lost Dimensions*, p. 31.

and, paradoxically, the concentration on images in a culture where destability is sustained by fleeting computerized optical forms—all these elements conspire to suggest a "refunctioned" (Bertold Brecht's terms for unmasking the techniques of production as an aspect of the politicization of theatre) pervasiveness of vision. The transformation of information generated by so-called post-photographic images affects both knowledge and communication at every level.

Understanding the broad implications of these transformations has generated a number of attempts to grapple with the intricate relationship between culture and technology. Kevin Robins' important book, *Into the Image: Culture and Politics in the Field of Vision*, analyzes the social implications of "screen culture," with an emphasis on dissimulation and repsonsibility, while Patrice Petro's anthology *Fugitive Images: From Photography to Video* contextualizes the image itself as a contested issue enveloped in debates concerned with identity, narrative, cinema, or psychology. While these works clearly suggest that photography can be scrutinized from a number of angles, another trend is emerging that grossly oversimplifies the role of media.

At the end of their blandly academic treatment of what they call "post journalism" in the book *Media Worlds in the Post-Journalism Era*, David Altheide and Robert Snow write: "The United States bombed Baghdad, Iraq, on January 26, 1991. Americans watched it on television. Billy Graham spent the night at the White House." This is hardly the kind of media analysis that will unhinge or explode any assumptions of even the most retrenched broadcast network or demonstrate how media has been assimilated into the texture of our consciousness. What is shocking too is that the authors fail to consider assessments of media from a broad range of critical thought; even Baudrillard's 1991 *La Guerre du golfe n'a pas eu lieu (The Gulf War Did Not Take Place)* had little effect on their hopelessly vague critique, especially considering the ramifications of the so-called "smart" technologies that incorporated powerful imaging into terrifying weaponry. After all, the most powerful impact of media still comes from its images, a field ignored by much sociological theory. Surely the symptomatic effects of electronic media couldn't be avoided by even the most uninformed thinking. Yet the *Media World* authors only express the blandest platitudes: "Political reality in the postmodern world is mediated reality."[6]

The impact of broadcast media has scarcely been examined, even while, according to hype from every corner of the information revolution, the authority of news media has been shattered by digital communication. But with several billion eyes glued to the explosion of the Challenger, the spectacles of the Olympics, the funerals of Diana and Mother Teresa, the power of broadcast media to galvanize the public can hardly be underestimated.

6. David Altheide and Robert Snow. *Media Worlds in the Post-Journalism Era* (Hawthorne, N.Y.: Aldine De Gruyter, 1991), pp. 253, 108.

Though it seems almost trite to reiterate it, spectacle—now extended by the sciences of the artificial—continually dominates the sphere of media.

Downsized news-gathering staffs and diminished public expectations are the result of the politics and economics of electronic production, distribution, and reception. In the print media, images "grabbed" from video news feeds (from CNN, ABC, CBS, and others) replace field-photojournalism, publicity images downloaded from the World Wide Web replace photographs taken by independent agency photographers, so-called "editorial" images (which includes composite and electronically altered images) supplant reportorial images in numerous publications. These developments, along with a refusal by the news photography community to establish ethical limits for digital retouching, have left the field vacillating in the wake of an audience comfortable with the artificiality and instantaniety of an unmediated stream of information. More and more, the predicted "end" of journalism reflects a condition in which the link between technology, imagination, and communication are fueled by the twin compulsions of broad-scale marketing and wide-area access. Unable to find a productive balance between fundamental shifts in its technology and the reformulation of both its sources and audience, the photographic community is reeling in disarray. Decades of resistance to considered theorization and technological realignment has marginalized still photography as hopelessly mired in traditional assumptions of legitimacy. This is especially disturbing in a media environment in which the authority of journalistic photography has been outdistanced by an audience gathering information in the borderless international context provided by the World Wide Web.

II.

A revamped theory of the relationship between representation and reception must accompany any assessment of the electronic media. Modes of experience and modes of perception cannot be easily theorized—or even expressed! However, researchers studying the dynamics of reception, cognition, neurological activity, or artificial intelligence, are focusing their attention on the links between computation, representation, and biology in order to broach the "interface" between experience and behavior. Though outside the bounds of this essay, suffice it to say that research and debates emerging in the artificial-intelligence community concerning "mental representation," computation theories of intelligence, and neural metaphors are paralleled by research represented by virtual worlds, rendered graphic environments, or distributed notions of intelligence.

An inclusive approach will need to conceptualize quickly shifting technologies as intrinsic to digital media and will have to consider the contingency of the electronic image as an essential issue. Simultaneously, the possibility of proposing an algorithmic affinity between the real and the symbolic is a challenge to the entire history of image making. This affinity erodes the boundary between recorded and rendered images, and potentially confuses the image

and its reference as epistemologically identical. More than this, the development of digital media has weakened the educational and artistic institutions that have dominated the fields of art and photography. Very little serious curriculum development, for example, has emerged to address much more than the introduction of image processing in photography programs. Museums, such as New York's Museum of Modern Art or the San Francisco Museum of Modern Art, have also largely ignored the impact of digital media. This kind of refusal suggests that the intrusions of electronics are yet to be fully assimilated into current educational or curatorial practices.

Indeed, recent attempts to rethink the history of photography in widening cultural terms—*The New Vision: Photography Between the Wars, L'invention du regard, Photography Until Now*[7] (to name a few)—suggest that the field continues to be framed as a modernist historical phenomenon. Yet efforts such as *Les Immaterieux, Passages de l'image, The Forest of Signs, Iterations: The New Image*[8] make evident that the shifting boundary of the image extends away from the static photographic model into that of the "dematerialized space" of video, installation, information, and electronics. This "dematerialized space," theorized by the critical thinking of the past decade, represents the confrontation between the questionable status of the analogue photographic image, which has been subjugated and refunctioned, de-authenticated and repositioned, and its electronic correlate, in which the correspondence is less indexical than it is speculative.

"Deception is the innermost principle of technical images," writes Florian R, in the essay accompanying the exhibition and book *Fotografie nach der Fotografie (Photography After Photography)*[9] curated by Hubertus V. Amelunxen, Stefan Iglhaut, and Florian Rötzer. In the accompanying book, Amelunxen writes that the exhibition "establishes a critical relation between the traditional photographic image and the new image-potential provided by algorithms." The exhibition, widely traveled in Europe and the United States, was a crucial forum for considering the effects that technology has had not just on the making of images but on the thinking that underpins them. *Fotografie nach der Fotografie* tracked both the history (in fourteen critical essays) and the production (in works by thirty artists) of images inflected by the consideration and utilization of electronic technology.

In the exhibition and book, one can infer striking juxtapositions between curatorial and aethetic positions. Indeed, these discursive relationships pro-

7. These exhibitions attempted a revision of approaches to photography history that nevertheless sustained the continuity of the tradition.

8. These exhibitions challenged the tradition of continuity and contextualized photography within the broader fields of installation, video, and digital media.

9. Florian Rötzer, "Re: Photography" in *Fotografie nach der Fotografie (Photography After Photography)* eds. Hubertus V. Amelunxen, Stefan Iglhaut, and Florian Rötzer, (Amsterdam: G & B Arts/Overseas Publishers Association, 1996), p.13.

"Mankind" © 1983 Nancy Burson with Richard Carling and David Kramlich

"Warhead I" © 1982 Nancy Burson with Richard Carling and David Kramlich

vide an important reading of the confrontation between the accumulating effects of computerization and an approach to identity, memory, or history. Nancy Burson's computed "portraits," *Mankind* (1983-84), *Big Brother* (1983), *Warhead* (1982), digitally blend images in such a way as to create statistical averaging, where, as in *Mankind*, the mixing of races (based on the global population) creates hauntingly hypothetical portrayals. Yet they also can be compared to the works in Anthony Aziz and Sammy Cucher's *Dystopia Series* (from the mid-1990s) where "transpersonal" (to use their description) presence (one can hardly say portrait) is inflected less by calculation than by a view of biogenetics gone bad, where erasure and depersonalization affect identity and appearance. One can find in this juxtaposition the difference between Burson's now eerily primitive composites and Aziz and Cucher's edgy hyper-realism where the body is not so much engulfed in statistical identity as it is circumscribed by the pervers boundary between cosmetic surgery and the loss of the self. Similarly, the works of Matthias Wähner and Warren Neidich suggest an uncomfortable association between memory, presence, and history. In Wähner's series *Mann ohne Eigenschaften/Man Without Qualities* (1994), the artist digitally "inserts" himself into well-known press photographs as an act of retroactive witnessing, an intrusion into a seemingly inalterable history. Warren Neidich's *Unknown Artist* is more a series of surreal anecdotes than an intervention. Neidich's cut-and-paste "presence" in group portraits of Futurists, Dadaists, or Surreallists seems more an act of psychological association than retrospection. Neidich's "intrusions" into history are less as a witness than as an accomplice projecting into the past.

Fotografie nach der Fotografie makes it abundantly clear that photography has neither exhausted its potential nor limited its goals to recording the

obvious. Instead, it demonstrates that the shift from the recorded image to the rendered image has raised the stakes in which the logic of information, computing, and virtualization have become integral to understanding the image before, during, and after photography.

Surely the deconstructive discourses of postmodern criticism have deeply influenced thinking about photography. Yet the substance of these theorizations largely overlooked the intricate effects of technology in favor of more generalized, though no less valuable, issues of power. What has emerged is a rethinking of photography "after" analogue photography. "Postphotography is no longer modeled on an optical consciousness operating independently of its material and symbolic contexts," writes David Tomas in "From the Photograph to Postphotographic Practice: Toward a Postoptical Ecology of the Eye." It is rooted instead, he says, in an "ecosystemic approach of contextually current processes of production."[10] Although it may be problematic to consider the utter materiality of the image as a reversal of the modernist practices of photography, this notion nevertheless seems important in tracking the significance of the image after photography was engulfed by technologies of artificiality and electronic versions of the semiotic. In his article "The Virtual Unconscious in Post Photography," Kevin Robins more directly implicates the use of electronic technology in the "post-ecological" and the virtual: "Postphotography promises a new image where the real and unreal intermingle."[11] Photography's deteriorating validity as fact surely isn't a consequence of the mere substitution models provided by computer simulation; it is the result of deep problems in representation itself. The limits of photography, paralleling the limits of language, indicate that formal and self-reflexive models of expression no longer can presume to serve the symbolic imperatives of culture.

But these issues have not emerged without precedents. The coercive, propagandistic, political, technological, or imperialistic representations invoked by Walter Benjamin, George Orwell, Michel Foucault, Martin Heidegger, Edward Said, and many others, are those in which the image, word, archive, and power are embedded within structures of control rooted in technology, and that provide critical readings of representation unadorned by the insular aesthetics of modernist art theory. Contingent, episodic, terse, and embedded in lived time, the photographic compels us to encounter its presence as historically specific and as temporally loaded. As the technologies of reproducibility evolved, the implications of visualization expanded. What could be recorded could be controlled. How this relationship between technology and temporal-

10. David Tomas, "From the Photograph to Postphotographic Practice: Toward a Postoptical Ecology of the Eye," *Substance* #55, (1988), p. 65. Reprinted in *Electronic Culture: Technology and Visual Representation* ed. Timothy Druckrey (New York: Aperture, 1996).

11. Kevin Robins, "The Virtual Unconscious in Post Photography," *Science as Culture* (14, v. 3, p. 1, 1992), pp. 99-113. Reprinted in *Electronic Culture: Technology and Visual Representation* ed. Timothy Druckrey (New York: Aperture, 1996).

ity can be assessed is one of the essential issues in the continuing study of photography. How this issue gets exploded in so-called post-photography is crucial in understanding the image in digital culture. Indeed, Edward Said, writing about stereotypical media representations, remarked that "what we must eliminate are systems of representation that carry with them the authority which has become repressive because it doesn't permit or make room for interventions on the part of those represented."[12]

III.

How, then, can the development of electronic imaging be contextualized—in terms of its relationship with the broad histories of photography, media, and as a realization of the transformed potential of imaging made possible with the use of digital technology? The answer does not exist as a simple shift in the structure of image formation and processing, but in a larger historical shift that firstly aligns the production of signs with technology and that further links technology with communication and discourse.

Many of the emerging World Wide Web sites devoted to photography can be understood as resources in a constantly shifting environment of information—a cross between exhibition, publication, and journalism. Traditional channels of communication, including the news magazine, television, the cable network, the in-depth, book-length photo essay, increasingly seem unable to fulfill the demand for the kind of instantaneous access to information made possible by the World Wide Web. From any web browser one can log into and navigate to sites of almost any location in the world for regularly updated images of anything from scientific laboratories to laundromats—a world increasingly expected to be visible.

Yet while the idea of the visible world as a kind of database may seem novel, there is serious work being accomplished utilizing cyberspace as a dynamic resource. For photography this extends from the ability to search archives to the presentation of alternative news images.

One of the most reliable sources for information on photography on the Web in the late 1990s came from a page in Sweden, www.algonet.se/~bengtha/photo/index.html. Maintained by Bengt Hallinger, the site is a series of links that are thematically organized and regularly updated. This cross between an index and an archive connects a database on issues in photography with that of a bibliography. Many sites provide selected, sometimes curated, approaches to alterative material. Most obvious would-be sites such as Yahoo (www.yahoo.com/arts/photo) that both organize and allow searches of materials. Some sites offer more focused approaches: Photoarts (photoarts.com), and Photoperspectives (www.i3tele.com:80/photoperspectives/), are editorial in their approach. Often incorporating online exhibitions,

12. Edward Said, "In the Shadow of the West" in The Imperialism of Representation, the Representation of Imperialism, *Wedge* #7/8 (Winter/Spring 1985), p. 5.

reviews, sales, and links, these sites increasingly approach the Web as a site not just for the dissemination of information, but as an alternative or adjunct to the gallery.

Among the best-known sites of this type are those developed by analog turned digital photographer Pedro Meyer, ZoneZero (www.zonezero.com), Ed Earle at The California Museum of Photography (cmp1.ucr.edu/), and Manual (Ed Hill and Suzanne Bloom) (www.art.uh.edu/dif). ZoneZero criss-crosses between traditionally produced and electronically generated images in more than thirty-five portfolios. Simply organized and contextualized with both editorial and artist statements, the images on ZoneZero are often compelling and provide more challenging and often inaccessible work than that found in photography galleries. By including a broad range of Latin American, American, and European photographers, ZoneZero becomes an international forum that has accomplished what many museums of photography can only do with great difficulty: presenting an ongoing investigation of the state of photography in transition.

In a more established form, The California Museum of Photography tackles the notion of "the museum without walls." Providing access to exhibitions, collections, online forums, and an continuing discourse with Web-based photo projects such as *Womenhouse,* a collaborative environment relating issues of the domestic sphere with cyberspace, or Carol Flax's *fourpieces* that examines the issues of adoption, the CMP site makes a bid to position the traditional institution as integral to the continuity of this developing field. Though less fixed on the individual image maker than ZoneZero, CMP is an important and relevant site.

Manual (Ed Hill and Suzanne Bloom) have established the Digital Imaging Forum (DIF) (www.art.uh.edu/dif) that situates the production of electronic imaging in the context of the seminal 1988 traveling exhibition *Digital Photography: Captured Images, Volatile Memory, New Montage* organized by San Francisco Camerawork. Curated by Jim Pomeroy and Marnie Gillett, the exhibition presented works by Michael Brodsky, Carol Flax, Esther Parada, George Legrady, Alan Rath, and others into the then-embryonic field of electronic media. DIF extends this idea of experimentation and now features monthly portfolios and works by guest artists including Eva Sutton, Mac Adams, and John F. Simon, Jr.

Aside from online archives, museums, and galleries, the Web is sustaining an alternative culture that has little interest in traditional media or exhibition. During the 1996 student-led protests in Serbia, the government maintained a tight grip on media. Alternative media, particularly underground radio B92, distributed information about the protests and were, for a time, shut down to silence their contributions to CNN and numerous other Western news sources. Protesters immediately found that the Web provided a powerful broadcast system that distributed a constant stream of reports, audio netcasts, images, and reliable responses to the events. Their pages

(galeb.etf.bg.ac.yu/~protes96) demonstrate that the network can perform dynamically as a source of unmediated information. The Mediafilter site (www.mediafilter.org) serves as a host for a number of critical source of information. Among them is Saravejo Pipeline, which critiques media reporting in Eastern Europe, and Covert Action, which exposes contradictions in the "secret" iniatives of United States intelligence services.

While the number of organized approaches grows, independent work is also being done by a number of "net-artists." The work of Alexi Shulgin in Moscow (www.easylife.org) and Marina Grzinic in Ljubljana (lois.kud-fp.si/quantum.east/text.html) provide important examples. Shulgin's work oscillates between net-art theory and cut-and-paste bricolage. A frequent contributor to online forums about art and theory, he also produces Web projects. His *easylife* site is an adventurous set of projects that are parodic, parasitic, pornographic, etc. but with the kind of critical fllip that appropriates and usurps. At www.easynet.org/instanity you can watch the countdown until Shlugin is totally "insane," a play on the ubiquitous counters citing hit statistics on so many pages.

Grzinic's electronic "environments" such as *Axis of Life* decisively express a willingness to apply the lessons of critical theory to the transformations of Eastern Europe. *Axis of Life* is partially described thus: "LIFE is a very simple program, a special algorythm! Yes, we are obsessed with History, Geography, Sex and Body." In *Axis* Western feminist theory, postmodernism, and hypermedia meet in a deconstruction of the complex problems of the ex-Yugoslavia. Deeply informed by the Western discourses of media, artists such as Grzinic and Shulgin reintegrate practice and theory in response to urgent events, regional concerns, and the growing international sense of the porous border and the porous image.

The issues raised by the development of electronic imaging, digital communication, networked communities, and cyber-identities, pose stunning challenges to the traditions of photographic culture. Much of the confusion around the role of the image has centered on the erroneous assumption that a history of photography can be written without considering the rival representational strategies of scientific visualization, propaganda, editorial illustration, outright deception, or without a contextual assessment of the use of images to sustain, challenge, or fundamentally represent an objective reality of any kind. Yet the equivocal image has come amid often astonishing techniques, the internationalization of communication, and the virtualization of photographic representation as a subset of computer rendering where algorithmic images signify an epistemological realm that zig zags between dopey electronic ontology and sweeping ersatz immutability.

Simultaneously, it is clear that systems theories of communication, intelligence, biology, identity, collectivity, democracy, and politics will not fully suffice to elaborate the meaning of electronic culture. Instead, theories of communication will need to be reconfigured in terms of interactivity, disper-

sal, and technological representation. This public sphere is taking shape amid tenuous ceasefires or the presence of peace-keeping troops (in Serbia, the Middle East, Haiti) and the political-identity wars of the past decade. Zealously promoted, the technologies of networked communication seem to offer remedies for uprooted cultures and increasingly fragmented populations. As much concerned with ideology as with identity, this "netopolis" is more than a new cyber-sociological issue. It stands as a possible location for the establishment of creative identity in terms of the emerging conditions of dispersed affiliation and distributed power. The network breaks the grip of point-to-point limitations of telephony and shatters the dominance of broadcast media. In their place is a dynamic system in which the abandonment of location is not a signifier of placelessness, and in which authority is not legitimated hierarchically, and in which representation is not a symptom of loss.

JAN ZITA GROVER

OI: Opportunistic Identification,[1] Open Identification in PWA Portraiture

September 1986, San Francisco. I photograph a friend in the foyer of the Castro Theater so he can send his picture to a new boyfriend in New York City. He's wearing a leather jacket, a big grin, and leaning on his tightly wrapped umbrella. A week later he is diagnosed HIV positive. Does this make my picture of him a portrait of someone with HIV/AIDS?

September 1997. I rephotograph my friend in his gym-rebuilt body. He has never looked so fit or been so heavy—solid with muscle. His viral load is now almost undetectable, the result of a protease inhibitor drug "cocktail." My friend has AIDS, but his is one of an extended range of AIDS conditions that make "the face of AIDS" sometimes indistinguishable these days from the face of health. What, if anything, can photographers do to reflect this change in how some people with AIDS [PWAs] are depicted?

WE PROBABLY can all agree that to say only one or the other of these "pictures" is an image of AIDS would be terribly reductive. Certainly my friend's and my fall from innocence since 1986 imbues any photograph made since that time with an added poignance, but I think only a ghoul (or someone pathologically anxious to assign my friend to a fixed category) would call either image a portrait of someone with HIV/AIDS.

Why? Are "portraits of people with HIV/AIDS" defined, then, by a certain intentionality on the subjects'/photographers' part? In other words, would you accept this as a portrait of someone with HIV/AIDS if my friend had already been diagnosed as a PWA at the time the photograph was taken?

1. This use of *OI* as "opportunistic identification" comes to us courtesy of artist Michael Tidmus, who writes, "After [my] ARC diagnosis in 1986, AIDS became an increasingly greater aspect of my identity. In the next seven years, AIDS consumed more and more of 'me.' There was less 'whole' me left to apply to the rest of my life and family and work. I woke up one morning and realized I had become just another aspect of AIDS—an OI, opportunistic identification."

Would you accept this photograph I've described as a portrait of someone with HIV/AIDS if I'd made it a week after my friend thought of himself as a PWA but not a week before? Would his umbrella-leaning then be read as an adumbration of future debility?

By now it is a commonplace that identity is one of the great engines of political and cultural change in late-twentieth-century North American life, as indeed it is throughout much of the world. Whether seen in the emergence of the Christian right in the United States, the resurgence of Quebécois identity in Canada, or the development of queer in contradistinction to lesbian and gay identity, North Americans, after a fifty-year period of widespread enthusiasm for melting pot or consensus identity, increasingly make their political and personal choices on the basis of cultural identification.

It's not particularly surprising, then, that the emergence of AIDS, a disease popularly associated with several already-stigmatized groups, became a focus of identity for those diagnosed with it. From the pre-1982 days when the syndrome was known as GRID (gay-related immune deficiency) until recently, AIDS in North America was viewed primarily as a gay disease, a factoid that immeasurably complicated public policy and treatment of people suffering from the syndrome. After 1986, when it became widely known that intravenous drug users and hemophiliacs were also seroconverting at an alarming rate, AIDS was seen as a disease of poverty, abuse, high-tech medical intervention, and (in the United States) inner-city blacks and Latinos. Demographically, it is true that gay men, blacks, Latinos, and hemophiliacs are still disproportionately represented in the Centers for Disease Control's (CDC) records of PWAs. It has been among people doubly stigmatized by their sexuality, poverty, skin color, or drug use and HIV/AIDS diagnosis that the meaning of identity around these descriptors has been most persistently questioned.

The following discussion turns on a distinction between members of HIV/AIDS communities (intra-HIV community) and people who are not members of those communities (extra-HIV community). This may seem to be an invidious distinction, no matter where one stands in relation to these proposed categories. Like all such binary oppositions, it is reductive, but I hope I shall also make it instructive—that like any good hermeneutic, it will justify itself by what it helps explain. The distinction I am drawing is between people, whether HIV infected or not, who have joined the struggle against HIV/AIDS—as people living with HIV/AIDS, as volunteer buddies for HIV/AIDS service organizations, as activists around treatment issues, as hospital or clinic workers, as writers, artists, filmmakers, curators, teachers, healthcare workers, families and lovers of people with HIV/AIDS—and people who not yet have done or become any of these things. Intra-HIV community people have learned to deal familiarly with the intricacies of medical and social service systems, with physical and mental disability, with death and dying, with the effects of prejudice and discrimination, with the everydayness

of chronic illness, with the containability of HIV's *transmission* in their own lives as well as the uncontainability of its *presence* in their own lives. Those who order their experience of HIV/AIDS into art have developed a wide range of strategies for exploring the problematics of incorporating HIV/AIDS into representations of their personal and social identities.

People who have not chosen (or been forced into) the HIV community may have learned similar lessons from experience with other diseases or conditions, but judging from the artwork they have made about AIDS, their attitudes toward HIV/AIDS have reflected those of public policy and journalism, and these have shifted much more slowly than attitudes within HIV/PWA communities. In the 1980s, extra-community understanding of HIV/AIDS consisted, roughly, of a sense that PWAs could be sorted into innocent and guilty victims; that promiscuity and "unnatural acts" were the root cause of AIDS; that "guilty" victims (gay men, bisexuals, and IV drug users) deserved their fate but that "innocent" victims (children, hemophiliacs, transfusion recipients, wives) did not. Media representations reflected these biases, with gay PWAs often pictured "before and after" (handsome, glossy, sexual/worn, emaciated, lesioned), à la the wages of sin. Photojournalists were fond of photographing PWAs at shuttered or blinded windows, reinforcing the popular wisdom that an AIDS diagnosis radically separated sufferers from life.

The situation was very different when portraits of PWAs were made within HIV/AIDS communities; it has become even more so in the late 1990s. But before discussing the ways in which photographs of PWAs have changed across the last decade in both intra- and extra-community photography, I want to introduce a rough periodization that may be helpful in thinking about the conditions under which these images arose.

Key events in the evolving history of AIDS in North America

MEDICINE, EPIDEMIOLOGY, SCIENTIFIC RESEARCH	MEDIA, POLITICS, CULTURE
1981	
Syndrome, largely reported in gay men, perceived as gay disease by epidemiologists and clinicians; given various names—GRID, CAID, AID, gay plague, WOG2	Reports largely in medical journals.

CDC announces surveillance defini-
tion and name: AIDS.

Diagnosis of AIDS commonly pre-
cedes death by less than 9 months.

Meager coverage in gay press.

First voluntary AIDs service organi-
zations are formed: Gay Men's health
Crisis (New York City) and Kaposi's
Foundation (San Francisco).

1983

French researchers isolate LAV
(lymphadenopathy associated
virus), which is the name they give
to the virus believed to cause AIDS.

Popular media discovers AIDS.

*Journal of the American Medical
Association* publishes report on
"casual" transmission of AIDS.

Medical press covers AIDS.

Gay press increases coverage.

Voluntary AIDS service organiza-
tions formed in large U.S. cities.

Advisory Committee of People
with AIDS formed.

First gay safer-sex publications.

1984

HTLV-III argued as causative agent
for AIDS.

Reports of transfusion and hemo-
philiac cases increase.

Medical and gay press coverage
increases.

1985

HIV antibody test put on market
for blood-banking; antibody
test begins to be applied by U.S.
insurance companies.

Rock Hudson dies. Heterosexual
panic ensues in popular media.

First international AIDs conference in Atlanta, Georgia.

Gay press begins covering AIDS extensively.

PWA Coalition formed in NYC.

1986

Cases involving heterosexuals, children, IV drug users, and transfusion patients widely publicized.

Drug trials in coastal cities.

Heterosexual panic continues.

LaRouche Initiative submitted to California voters for quarantining PWAs; defeated.

1987

Zidovudine (AZT) licensed for use.

Presidential Commission on HIV epidemic appointed in the United States.

Project Inform (San Francisco) urges gay men to get antibody tests.

Aerosolized pentamidine prophylaxis for pneumocystic pneumonia (PCP) begins in NYC.

Helms Amendment forbids use of federal funds for HIV-prevention materials that "promote homosexuality."

Second LaRouche initiative submitted in California; defeated.

NAMES Project Quilt unveiled in Washington, DC.

Publication of trade and pocketbook heterosexual safer-sex guidebooks.

1988

Disputes over estimates of HIV infected.

Presidential Commission returns report calling for more public education and preventative effort; it's ignored by the White House.

Extent of HIV/AIDS in black and Latino communities becomes evident outside those communities.

Masters and Johnson furor.

Third LaRouche initiative in California; defeated.

ACT UP and other activist grouops mount media actions.

Mainstream media highlight AIDS and the arts but otherwise back off widespread AIDS coverage.

ACT UP chapters in New York and San Francisco split over treatment versus other issues.

1993-95

FDA speeds up approval process for clinical trials and licensing of new drugs.

Protease inhibitors, in conjunction with existing antiviral treatment for HIV, prove dramatically effective in clinical trials.

1993-95

Heterosexual transmission continues to preoccupy mass media coverage of HIV/AIDS; newspaper, general-circulation magazine, and broadcast journalists find that editors are less receptive to AIDS stories. Gay/queer magazines and newspapers pay increased attention to the sufferings of HIV-negative gay men, a population whose identity and dilemmas vis à vis the epidemic had previously been ignored or downplayed.

1995-present

First protease inhibitors licensed for use. In approximately 70-75 percent of those who tolerate them, viral loads decline or become undetectable for 18 to 24 months. Average annual cost for protease inhibitors: $8,000-10,000. Because

Art about HIV/AIDS enters an "archiving" phase: creation of slide, print, film, and video libraries of work by and about people with AIDS (PWA). Photo/video work similar to that made early in the epidemic (early to mid-'80s) begins appearing

the treatment has not been tracked for long, physicians cannot yet determine how long treatment remains effective and what percentage of people can tolerate the drugs' side effects.

from arts projects involving women and IV drug users with HIV/AIDS.

Anyone involved in the struggle against AIDS will have many amendments to make to this rough chronology, which after all covers only the United States. But I would argue that it is useful as a starting point in discussing the many strands of the evolving history of *how AIDS has been depicted*. It points out some of the push and pull between dominant and counter discourses about AIDS over time. (In saying this, I am not suggesting that the many constructions placed on AIDS can be understood solely in historical terms; there is far too much of the irrational in our shaping of AIDS to propose that.)

Before roughly 1985, intra-community PWA portraits, like extra-community ones, subsumed their subjects' personal identity into their AIDS diagnoses. The earliest intra-community portraitures I'm aware of took the form of snapshots and videotaped and written interviews with PWAs. Most of these early portraits were elegiac, made after or shortly before the death of their subjects. We need always to remember that as late as 1986, the average life expectancy of someone diagnosed with PCP was less than ten months. These early portraits, for the most part, were of terminally ill people. I believe the effect of this simple fact on these early portraits was profound; the work was tentative, improvisational, and centrally concerned with the imminence of its subjects' deaths. Few of these memorial works rose to the heights of two videotapes made in 1985—Mark Huestis's videotape about the late Chuck Solomon, a founder of San Francisco's gay Theatre Rhinoceros, a video that not only explored Solomon's thoughts about illness and dying but celebrated his life in theatre, and the late Stuart Marshall's *Bright Eyes*, a complex interrogation of AIDS as the site of many cultural identities. These early intra-community portraits differed from extra-community ones made by photojournalists and artists because they represented their subjects as individuals surrounded by friends, pets, and the many other compass points that secure us to our lives, rather than as walking pathologies. Metaphorically speaking, intra-community portraits were *not* made behind shuttered windows.

Two events in the mid-'80s profoundly affected what had previously seemed, both intra-communally and extra-communally, a rather direct link between identities as PWAs and as gay white men. In 1985, an inexpensive serological test for antibody to HIV, the virus most researchers believed to cause AIDS, was developed and marketed. This development introduced two complications into the already-established popular image of the depraved gay

"AIDS victim." First, the HIV antibody test confirmed that hemophiliacs and transfusion recipients, children infected in womb, and other "blameless victims" were indeed infected with the gay plague, thereby upsetting the previous identity of AIDS = Gay, AIDS = Guilty.[3] Second, the announcement in 1987 that AZT had proved effective in prolonging life among men enrolled in clinical trials further complicated HIV/PWA identity. Where earlier the majority of people at high risk for HIV infection in North America had chosen not to take the HIV antibody test ("Why bother? It's not as if they have any drugs that can help me if I *am* infected"), by late 1987 many had decided to find out their serostatus so that if infected they could begin AZT treatment—by then widely touted as a miracle antiviral—to slow the progression of HIV. In San Francisco, Project Inform, the activist treatment group, began urging gay men to be tested and to seek out the new treatments (prophylaxis for PCP also became available about this time). The shift from PWA identity as a terminal condition to something far more extended and ambiguous had begun.

Thus within a very short period of time, HIV/AIDS went from being an untreatable condition commonly diagnosed only shortly before final illness and death to a disease often detectable years before it produced grave symptoms and observable physical changes. This change in the trajectory of illness had immense intra-communal effects on the role of HIV/AIDS in creating personal and political identity. Although there had been intra-community resistance to media depictions of PWAs as "victims" since the early 1980s—the national Advisory Committee of People With AIDS was formed in 1983— early detection of HIV disease after 1987 only increased this resistance, for people were now being diagnosed years prior to end-stage HIV infection. For those already seriously ill, zidovudine and PCP prophylaxis often extended their independence, thus swelling the demands of those living with the syndrome that they be seen not merely as terminally ill "victims," not solely as patients.

These shifts in identity accompanied the well-known move toward militancy among members of the HIV/AIDS community brought about by Burroughs Wellcome's decision to market zidovudine at an initial average cost of over $10,000 per annum in a country—the United States—without national medical insurance. An activist movement was sparked, fueled not only by challenges to drug and treatment availability but also by that organizing principle dear to the heart of North Americans, identity politics.[4]

3. With the travails of Ryan White, who in effect became this country's AIDS poster child, *Newsweek* introduced into media and popular discourse the term "the innocent victim" and its unspoken, but implicit, opposite.

4. I'm mindful that this is an overgeneralized account of HIV/AIDS in the period 1986-1988. Particularized histories can be found in the work of Dennis Altman, Douglas Crimp, Cindy Patton, Randy Shilts, Simon Watney, and others. My objective here is to provide the portraits discussed here a context that accurately reflects the ideas and events surrounding their making.

In 1988, members of ACT UP New York protested an exhibition of portraits of PWAs by photographer Nicholas Nixon at the Museum of Modern Art. In the celebrated and problematic manifesto they handed out to museum patrons, ACT UP called for

NO MORE PICTURES WITHOUT A CONTEXT

We believe that the representation of people with AIDS (PWAs) affects not only how viewers will perceive PWAs outside the museum but, ultimately, crucial issues of AIDS funding, legislation, and education.

The artist's choice to produce representational work always affects more than a single artist's career, going beyond issues of curatorship, beyond the walls on which an artist's work is displayed.

Ultimately, representations affect those portrayed.

In portraying PWAs as people to be pitied or feared, as people alone and lonely, we believe that this show perpetuates general misconceptions about AIDS without addressing the realities of those of us living every day with this crisis as PWAs and people who love PWAs.

FACT: Many PWAs now live longer after diagnosis due to experimental drug treatments, better information about nutrition and holistic health care, and due to the efforts of PWAs engaged in a continuing battle to define and save their lives.

FACT: The majority of AIDS cases in New York City are among people of color, especially women. Typically, women do not live long after diagnosis because of lack of access to affordable health care, a primary care physician, or even basic information about what to do if you have AIDS.

The PWA is a human being whose health has deteriorated not simply due to a virus, but due to government inaction, the inaccessibility of affordable health care, and institutionalized neglect in the form of heterosexism, racism, and sexism.

We demand the visibility of PWAs who are vibrant, angry, loving, sexy, beautiful, acting up and fighting back.

STOP LOOKING AT US; START LISTENING TO US.

ACT UP called for two changes that were already occurring within the HIV/AIDS community: a more mindful, *representative* representation (e.g.,

images of women of color) and a repudiation of opportunistic identification (e.g., AIDS = Death, AIDS = Self). But it also called for something just as selective as Nicholas Nixon's gaunt, dwindling subjects: "vibrant, angry...sexy, beautiful" PWAs. In other words, it called for positive images—counter-images to dominant or stereotypic representations.

Positive images have a history almost as old as photographs. They have been consciously crafted to re-present favorably African American in the Reconstruction South; German workers in the Weimar era; women home workers in industrial Britain. Positive images are always haunted by the images and stereotypes they are constructed to counter. In the case of the "vibrant...sexy" portraits called for by ACT UP, the spectre which activists hoped to vanquish was half a decade's worth of "negative" media images recently complemented by what ACT UP perceived as their arty counterparts in the Nixon exhibition at MoMA and in the Rosalind Solomon portraits displayed at the Grey Art Gallery and Study Center at New York University in July 1988.

Obviously, it is impossible to fix the meaning of a photograph, so at one level the outrage that many activists felt about such portraits was open to the objection that it privileged those activists' interpretations of the images over others'—that what ACT UP found objectionable in the images may have been projective rather than inherent, peripheral or irrelevant rather than central to how the photographs functioned for other viewers.

In the late 1980s, the high theoretical and practical ground in photographic theory belonged to those espousing *self-* representation, and in every medium, people with HIV/AIDS, like people of color in northern countries, have re-present-ed their own realities for the video, film, and still camera—images frequently at odds with those of dominant media. In genuflection to this practice, PWA portraits made within the HIV/AIDS community by non-HIV-infected artists have often included texts written by the subjects themselves; this working method is viewed as "collaboration" or "empowerment," unlike the "indignity of speaking for others" seen as implicit in journalism or portraiture by extra-community artists.[5] ACT UP's argument, like many such made about art in the '80s and '90s, focused more on matters extrinsic to the photographs' contents, the photographs' and photogra-pher's social identities, and the photographs' possible cultural functions than on the actual contents of the images. The activists openly challenged the fairness and accuracy of Nixon's representations; more covertly, they challenged the photogra-pher's authority, as an extra-community artist, to represent PWAs at all.[6]

5. The phrase comes from Michel Foucault and is often invoked in North American discussions about the politics of representation.

6. Since the late '80s symbolic representations related to AIDS—from visual images to the constitution of boards of directors of AIDS-related community organizations—have increasingly been dominated by the HIV infected, who have claimed the authority of experience to authenticate their leadership. Whether this practical complement to cultural theory will prove any more effective than other schemes for ensuring just representation and efficient operations remains to be seen; all calls to clear the decks for one category of experience or identity seem suspect to me.

So much has changed in a decade. In 1986, a bout of PCP amounted to a virtual death warrant, even in San Francisco, the United States's epicenter both for treatment and concentration of PWAs. In those days, representing one's own life was an almost unthinkable luxury under the pressure of unremitting illness. Since then, however, some people who were antibody-tested in the mid- to late 1980s and found to be HIV positive and who then began prophylactic treatment, whether allopathic or alternative, are living lives in which illness is only one of a number of personal concerns and sources of identity. With adequate health care—always an enormous issue in our country—fewer people living with HIV/AIDS must focus on illness as the sole factor in life until far into the trajectory of HIV disease. This change in prognosis has only increased for those able to tolerate and afford the new protease inhibitor "cocktails" that became widely available after 1995.

With this earlier detection and slowdown of illness has come an increasing domestication or displacement of HIV/AIDS as the primary source of identity within the HIV/AIDS community. As California photographer Albert Winn wrote in 1994,

> Having AIDS is not central to my full-time self-identity, although having said that, I have to add that I also never forget that I am ill (or at least in some stage of having a fatal illness). In some ways I feel that I am involved in a balancing act, sometimes a tug of war, between a consciousness of wellness and illness. I don't want to be obsessed with the illness such that I become nothing more than the illness.
>
> I think that my status as a PWA is important to my work. I don't want to be known only as an AIDS artist, any more than I want to be known as a Jewish or gay artist, but I want all that stuff in my work. It is always there when I think what I do. The same with being a writer, lover, son, Jew, friend, human being....I still do dishes, call my mother regularly, say Kaddish for my father, get upset by homelessness, vote, write stories that make no sense, make photographs no one will look at, and walk the dog.[7]

Winn's photographs and accompanying texts are crammed with clues to their maker's personality and interests. The signs of AIDS in these self-portraits are subtle and deeply embedded in his visual chronicle of an ongoing life. "The pictures from 'My Life Until Now,'" Winn writes,

> are a progression of thinking about identity. Now I am a gay man, a gay man with AIDS, a Jew, a lover, a person who has books on a shelf, etc., not just another naked gay man with another naked gay man, and I

7. Letter to author, 1 May 1994.

tried to load the photograph[s] with information. I feel I am determining my identity by making the choice to show all this stuff.[8]

My Life Until Now (1991) consists of formal self-portraits, portraits of Winn's lover and his home, old family photographs, and texts exploring childhood memories of family, sexuality, Jewish and gay identity. AIDS is a part of this mix, but it is present as a tint—a pale wash over the deeper eidetic memories that have formed Albert Winn.

Photographs such as *Tony from my writing group* (1994) make no appeals to the viewer's sense of pity or alienation. Winn's portraits are made from his own life, his own relationships, including his relationship to Judaism. The men in his photographs are situated amid things that anchor and reflect their identity. The photographs on the walls, the books on the shelves, the serene pale walls reflect an individual who cannot be reduced to PWA or "AIDS victim." ("I know people who have made the illness their life...I find it obsessive and quite frankly, boring," writes Winn.[9]) In a moving series of images made from 1994 to '97, Winn has explicitly imposed the practices surrounding HIV/AIDS onto his Jewish practices. Photographs such as *Hanukkiot* (1995) and *Akedah* (1995) emphasize Winn's dual citizenship in the worlds of illness and observant Judaism: "When my arm is bound with a tourniquet and the veins bulge," he writes of *Akedah*, "I am reminded that I am bound to my illness. I look at the rubber strap and see tefillin. Sometimes the impression of the leather straps from the tefillin are still visible on my skin by the time the tourniquet is wrapped around my art. The binding of the tefill-in is a reminder of being bound to my heritage. The straps also make my veins bulge. Except for the needle stick, the binding feels the same."[10] This compounding of Winn's Jewish and PWA identities produced a powerful nonphotographic artwork, *The AIDS Mezzuzah,* which Winn created for a specially commissioned World AIDS Day exhibition at the Judah L. Magnes Museum in Berkeley, California, in 1996. The mezuzah—a small tube containing two passages from Deuteronomy that is commonly affixed to the doorpost of observant Jewish homes—contained instead a transparent tube of Winn's blood, "a gesture," Winn wrote, "that would cause the Angel of Death to pass by me...I needed something that would transform my experience [of AIDS], while staying in the context of my tradition. I wanted something that would continue to make my life and my Jewishness meaningful, and bring a sense of order to the chaos I found myself living."[11] (The exhibit brought at least a half-

8. Ibid., 10 June 1994.

9. Ibid., 1 May 1994.

10. Albert J. Winn, *Akedan* (artist's statement), 1997.

11. Albert J. Winn, "Artist Statement," *Blood on the Doorpost... The AIDS Mezzuzah* (Judah L. Magnes Museum, 1996).

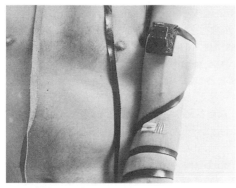

Albert J. Winn, *Akedah*, 1995, black-and-white photograph, © 1995, 11" x 14", gelatin silver print

Albert J. Winn, *Jewish Summer Camp*, 1997, black-and-white photograph. © 1997, Southern California, 11" x 14", gelatin silver print

Albert J. Winn, *Blood on the Doorpost, The AIDS Mezzuzah*, 1996, brass, plastic, blood.

dozen hate calls and one member's resignation from the museum—sympathy with victims, even within the Jewish community, apparently has its limits.) Like many fortunate PWAs, Winn has enjoyed more stable health since protease inhibitors became available; he has begun photographing the world that lies beyond illness. In 1997, he undertook a project to photograph landscapes and interiors from abandoned elements of Jewish culture—old Catskill hotels and yeshivas, Southern California Jewish summer camps. "I don't think it's a stretch to say that so much of what I see is somehow informed (formed) by AIDS," he writes. "Although these are all sort of 'Jewish' landscapes, interiors, they are all vacant. For me tinged with sadness, nostalgia, and loss, which is how I feel about this life with AIDS....[This work] is what I seem to do over and over again, I reframe my disorientation into a context that I can find some meaning. Again, my Jewish experience. The empty spaces of childhood camp, the change in a society that leaves a deteriorated hotel as a relic....I don't think [my life] has changed that much since the advent of protease inhibitors, only the urgency. The loss I feel all around me is chaos on a slow burn. My life is very different now and I can never go back to

that place where I was before the illness. Of course, this was obvious before, but now I have the luxury to look back."[12]

Nixon's PWA portraits, in contrast, are close-ups or shallow-focused medium-range shots that sheer away the markers of personal identity besides AIDS. The final images in his series treat the subject's face as his or her sole possession; hugely magnified, shorn of the relationships, possessions, and surroundings that bear so largely on our construction of self, Nixon's subjects become little more than fields on which to read disintegration. Now, arguably this is a state to which most of us eventually come some time before dying; in that sense, Nixon's final, pore-level portraits of his subjects may be distressingly accurate. But they are also distressingly reductive, for they (and his earlier portraits made in a Cambridge, Massachusetts, nursing home) strip human lives of their accumulated decades of meaning and dignity, leaving nothing but helplessness and indignity. In effect, they deny the complexity of the subjects' *Life Until Now*, with all its sources of identity besides illness.

If Nixon's project fails to speak movingly to many people in the HIV/AIDS community, it is because despite the efforts the photographer and interviewer (Bebe Nixon), it has so little to teach PWAs and their supporters about *living* with HIV/AIDS—it seems less about the journey than the destination, which is death. Extra-community photojournalists and artists, of course, have learned from the demographic shifts and longer life expectancies that have affected PWAs' lives. One sobering lesson committed reporters learned, at least in the United States in the early 1990s, was that AIDS was no longer an editorial must-have; journalists found it difficult to place stories on PWAs. AIDS treatment, and public policy unless their stories had dramatic "hooks." Journalistically, AIDS increasingly assumed the position of yet another dreadful chronic disease. And although this was a positive move in one sense, its implications for vigorous treatment and prevention programs were mostly unfortunate. Journalists have for the most part dropped the innocent versus guilty victim schematic in the 1990s; they recognized and represented PWAs as people experiencing a spectrum of illness. Extra-community portrayers of HIV/AIDS, in other words, moved closer to the positions intra-community photographers had represented five years earlier. What they did not do was to question the absolute centrality of HIV/AIDS in the lives of their subjects.[13] But as I discuss later, perhaps this could not have been expected of them, at least not then; their quests and audiences lay elsewhere.

Extra-community artists' projects less complex than Nixon's tend to rely on the peculiar (since so often disproved) conceit that "personalizing" the

12. Letter to author, 8 September 1997.

13. Another aspect of the unquestioning focus of extra-community photographers on PWAs' identities has been the lack of evident class-consciousness in their work: obtaining therapies like protease inhibitor "cocktails" is very much a function of PWAs' access to high-tech medical care, which in turn is often a function of class.

epidemic (or war, racism, poverty) will inspire sympathy for its victims or prevent similar tragedies. The portrait strategy adopted by these practitioners usually consists of unadorned, uncontextualized studio portraits. Here even more than in Nixon's work, the subject is reduced to his or her "condition"; the viewer scans the image, since little or no other information is offered, looking for signs of the subject's identity, which has already become enormously overdetermined for most viewers by the fact of HIV/AIDS. Imagine a portrait titled *Syphilitic*. Would we be likely to look for anything but signs of incipient madness and decay in such an image? Is it likely that we would look beyond what the portraitist has asked us to see and find anything deeper? If *Syphilitic* were a tight head shot, would there *be* anything more for us to read? It is naïve at best for artists to believe that portraits framed by a diagnosis will be read as much more than embodiments of that diagnosis.

Few people make art without wishing to learn something from it. The photographers who have chosen to portray themselves or others in this epidemic are questers of this sort. Artists living on an intimate, day-to-day basis with HIV/AIDS and artists who do not are struck by different aspects of HIV/AIDS and challenged by it in different ways. The self-portraiture of Al Winn, Andi Nellsun, and Stephen, for example, consists of sequences or multiple images that deal with imposed, internalized, and/or newly constructed identities; with the precarious act of balancing health and illness, sorrow and happiness, death and life (Andi Nellsun, *Synergy*, 1993). San Francisco photographer Mark I. Chester's portraits of his friend and ex-lover, the late Robert Chesley are another case in point. Chester portrayed Chesley bare chested, his torso covered with Kaposi's sarcoma lesions, in his Superman fetish costume—a fully sexual person with AIDS. These portraits were first publicly exhibited on a

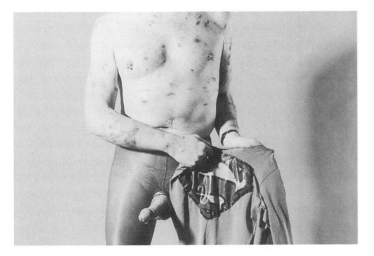

Mark I. Chesther, *Robert Chesley—ks portrait with harddick & superman spandex, #3*

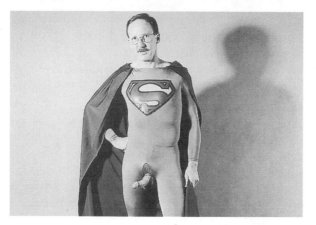

Mark I. Chester,
Robert Chesley—
ks portrait with harddick &
superman spandex #5.

San Francisco college campus, where the juxtaposition of Chesley's KS lesions and his visible sexuality were deemed too controversial by the administration and removed from the walls. Chester's portrait series explored Chesley's body as a site marked not only by disease but by desire. These are issues that people living inside the contradictions of HIV/AIDS are driven to explore and resolve in what is often a flow of images, as if no single photograph could contain the complexity of the journey or destination.

California artist Michael Tidmus addressed similar issues in his 1993 self-portrait, *Prophylaxis: Blind Admonition,* but here the complexity that other PWA artists have distributed over a number of photographs is concentrated in the multiple layers of a single image. Using desktop publishing techniques, Tidmus overlaid childhood snapshots with a current self-portrait, creating a deep map of personal identity. Floating amid these strata of personal visual history is a brief text, the punctum of the piece: "AIDS BABY (BORN 1951)." Here, as in so much else intra-community artwork, the point of departure in the portrait is dominant media's mid-'80s sensationalized and polarizing construction of those suffering from HIV/AIDS. Tidmus's image challenges the peculiarly uneven apportionment of compassion for "innocent" youngsters at the expense of sympathy for the adults children soon become. In the years since Tidmus made *Prophylaxis,* he too has benefited from the new drug therapies and been "blessed with an optimism I didn't have the previous twelve to fifteen years." Taking care of his partner of twelve years while the latter became sick and then died from AIDS, Tidmus writes, taught him that "the luxury of art-making was out of the question. Simply staying alive was all that mattered. I know it sounds odd to most people to describe art-making as a luxury, but the making of art is not a basic human need....And art sure as Hell doesn't save lives." Today, Tidmus works full time in the advertising industry, his AIDS activism "confined to getting out my checkbook,"[14] his "opportunistic identification" as a PWA thankfully set aside for other concerns.

14. Letter to author, 2 September 1997.

I offer you these two artists' experiences because they demonstrate the convergence that I see occurring in the 1980s around HIV/AIDS as a marker of identity and the divergence that has taken place for some people with AIDS since then. Some people choose to integrate their illness into their ongoing lives; others choose to closet it as long as possible. Both tactics clearly work, in art making as well as in personal lives.

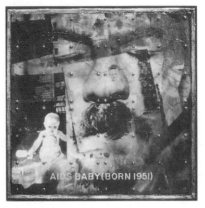

AIDS Baby (Born 1951)

These have been issues with day-to-day resonance for people living with HIV/AIDS. Artists not facing those particular challenges have other things to learn about the syndrome and other audiences to address. Where PWA photo-graphers have strived to articulate their subjects' full social and personal identity, to challenge HIV as the primary engine of identity, to chart the mercurial ups and downs of chronic illness, to conduct full lives, and as artists have created images that explored these complex issues, sympathetic extra-community artists have approached portraying people with HIV/AIDS differently. The disorder their work seeks to vanquish is as much about their own fears as about their PWA subjects; as such, it mines territory closer to that of media than of intra-community discussions. Extra-community portraiture of PWAs remains framed by the older equation between AIDS and personal identity.

Lynn Sloan wrote of her *Faces of AIDS* (1993),

> In their directness these portraits invite us, as viewers, to look carefully at those pictured and to think about their lives.[15] [my emphasis]

But who is being positioned here as the "us" and the "them?" And what can "we" learn about these subjects' lives by contemplating these single images of "them"? Ms. Sloan conceded that her work

> doesn't try to explain the lives of persons living with the illness, it doesn't place them in a social or political framework, it doesn't cover the range of their experiences. What it does do, she concludes, is "depict with deliberate care the integrity of each individual."

This form of direct, unadorned photographic portraiture documents the transaction between the questing artist and her informants, between the

15. "Artist's statement," *Don't Leave Me This Way: Art in the Age of AIDS* (National Gallery of Australia, 1995).

seeker and those with the oracular knowledge she seeks. The quester arms herself with her art, hoping to use it to acquire knowledge and to live down dread. What he brings back for "us," her intended audience, proves to be a map to the unfamiliar territory occupied by Michael Tidmus and Albert Winn. What she brings back to her own community is a report from a country few know personally but many are fascinated, saddened, or moved by. This does not, however, necessarily make her map useful to the people native to the country: they already have their own routes and landmarks, their own knowledge of the land. Nor, in turn, are the things that most concern them necessarily of interest to the questing artist; she is, after all, only passing through.

In the past two years, new treatments for HIV illness have so altered the lives of some people living with AIDS that they have been fortunate enough to return to or pursue new careers, to create new lives. The friend whose photograph I took in 1986 and then again in 1997 has left disability and returned to his profession full time. Images of these shifts will go unmarked save by their absence. For now, at least, some artists who are also PWAs are choosing to leave behind their "spoiled identities"[16] and return to ones that make them indistinguishable from those of gay men who are not PWAs. (The fate of those for whom the new drug regimens do not work has received less media attention, both intra- and extra-communally. Everybody loves a winner, and those who lose their battle with HIV infection do not become the focus of media attention as frequently as Lazarus-like PWAs do.) But the identity of all gay men has been spoiled by association with HIV; even for those not living with infection and those living with it successfully, HIV/AIDS has become an integral part of the complex of gay cultural identity, familiarized in ways that perhaps it never can be for persons who have not suffered such wholesale communal loss.

I ask you to think about these very different but perhaps complementary ways of thinking about AIDS, about cultural identity, as you look at photographs documenting the AIDS crisis in North America. No single approach to representing it will illuminate everyone. Each community—indeed, each of us—works his or her way toward an accommodation to HIV/AIDS that will be more or less intimate, more or less mortal. Taken cumulatively, however, the work of artists addressing AIDS in the 1980s-1990s constitutes a palimpsest of our accumulating knowledge about suffering, striving human creatures— "mortal, guilty, but to me the entirely beautiful."[17]

16. The term is from sociologist Erving Goffman's *Stigma: Notes on the Management of a Spoiled Identity* (186).

17. W. H. Auden, "Lay your sleeping head, my love," *Selected Poems*, ed. Edward Mendelson (New York: Vintage, 1979), p. 50.

ANDY GRUNDBERG

On the Dissection Table
The Unnatural Coupling of Surrealism and Photography

THIS SURREALIST revival is only one of several to have coursed through the last fifty years of art photography; indeed, one could say that surrealism runs like a pulse or throb throughout art photography's modernist presence.[1] This repetition is inherently problematic, however, since it calls into question twentieth-century photography's claims as art. If surrealism is periodically recycled as a style, what constitutes photography's originality, or its own aesthetic field?

We might begin to answer that question by making a distinction between the photographs produced by the Parisian surrealists from 1924 (the date of André Breton's first surrealist manifesto) to 1940 (when the Nazi occupation effectively ended the surrealists' naughty daydreams) and the photographs of the last fifty years that have at one time or another been called "surrealist." Breton's call for an art of "psychic automatism in its pure state" was based in Freudian notions of the sub-conscious mind and in a belief that the irrational could be harnessed as an instrument of refusal directed against the prevailing culture. In effect, surrealist art in general and surrealist photography in particular tried to put the psychic life of the artist in the service of a broad social rebellion. Its conflicts and tensions are due precisely to this conflation of what today we would call the claims of autonomous authorship and the hopes of a critical, oppositional praxis.

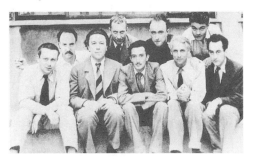

André Breton and the Surrealists, from "Unknown Artist" 1993, 1994. Photo-Researcher

1. The notion of a modernist pulse or throb has been advanced by Rosalind Krauss, who uses it in a more literal sense. She traces an underlying on-off rhythm in the work of Duchamp, Ernst, Picasso, and, in less exalted terms, the functioning of the zootrope. See "The Im/Pulse to See," in *Vision and Visuality*, (Seattle: Bay Press, 1988), pp. 51-75.

The Parisian surrealists used the medium in distinctive ways, some of which we now consider commonplace. They assembled objects and arranged tableaux to present before the camera. They collaged images and rephotographed them. They intervened in the photographic process during development and afterward. These methods distinguish them from "straight" modernist practitioners, as well as from their contemporaries with surrealist affiliations or leanings—Brassai, Henri Cartier-Bresson, André Kertész—who have been more thoroughly integrated into the modernist pantheon we call the history of photography. But formal devices alone do not distinguish the surrealist practice of photography.

Like surrealist painting, surrealist photography alternated between strictly representational and "automatic" abstractionist styles. One can see both these opposing directions at play in the images of Man Ray, the artist whose work best exemplifies the potentials of surrealist photography. His 1930 portrait of a woman's face, called *Larmes,* which uses glass beads as stand-ins for tears, is a deliberate construction, while his Rayographs and solarized portraits rely on chance operations in the darkroom. His photographs of sculptural objects can be read in these same two ways: the image *Le Cadeau,* as a photograph, is simply a record of Man Ray's most famous sculptural incongruity, an iron with a row of tacks fastened to its soleplate, while *Dust Breeding,* an image of Marcel Duchamp's unfinished, dust-covered *Large Glass,* seems to have resulted from a capricious experiment in long exposure.

Like the other surrealists who used photography extensively— among them Hans Belmer, Georges Hugnet, Roger Parry, Maurice Tabard, and Raoul Ubac—Man Ray was fascinated by the female body, which he transformed, cropped, and refigured in an inventive variety of ways. But Man Ray's solarized and drawn-on nudes seem almost romantic compared to Belmer's series of images of discombobulated doll parts. Belmer's "poupées" are gnarled, frightening caricatures of women's bodies, rendered even more perverse and unsightly through the addition of hand-applied color to the black-and-white prints. This disfiguring tendency of surrealist photography is not its most enviable characteristic (one critic has remarked that "one would have to be blind" on this score "not to recognize the unconscious sexism that runs through the Surrealist movement from beginning to end"),[2] but it is from the evidence of *L'Amour Fou,* one of its most salient. All the cropping, distortion, and rearrangement of erogenous zones served as signifiers not only of unconventionality but also of untempered subconscious "thought."

The late 1980s have seen an astonishing revival of interest in surrealism. This revival has been spearheaded in part by such historical exhibitions as "L'Armour Fou: Photography and Surrealism" and "Fashion and Surrealism,"[3]

2. Kathleen Campbell, "Ideology versus History Deconstructing Surrealist Photography," *Exposure* 26 I (Spring 1988), p. 46.

3. *L'Amour Fou* organized by Rosalind Krauss and Jane Livingston appeared at the Concoran Gallery of Art, Washington, D.C. September-November 1985. *Fashion and Surrealism* organized by Richard Martin was seen at the Fashion Institute of Technology, October 1987-January 1988.

both of which argued for surrealism's relevance to our own times. Simultaneously, art photographers—Joel-Peter Witkin being the most noted example—have given surrealism's obsessive fascination with polymorphous sexuality, morbidity, and grotesquerie a new lease on life, creating an atmosphere of chic revulsive/compulsive shivering unseen since Diane Arbus's retrospective exhibition of the early 1970s.

In the United States, the photographer who adopted the example of the Parisian surrealists with the greatest conviction and comprehension was Frederick Sommer. Directly influenced by Max Ernst, whom he met in 1941, Sommer combines an American modernist fixation with the finish of the print and a European surrealist penchant for odd juxtapositions, morbid subject matter, and the operations of chance. Unlike Clarence John Laughlin, the New Orleans autodidactic whose gothic double exposures of cemeteries and ruins are often held up as models of American surrealism, Sommer's work is grounded in theoretical considerations every bit as abstruse, and internally inconsistent, as Breton's. It also incorporates virtually all the characteristic traits and tics of surrealist photography of the 1920s.

Sommer, who was raised in Brazil and trained as a landscape architect at Cornell, seems to have been an innate surrealist. His 1939 pictures of chicken parts, which predate his first encounter with Ernst by two years, are as disconcerting as Belmer's *Les poupées,* made only a few years earlier. In the 1940s he obsessively photographed dead animals, emphasizing both their state of decay and their almost literal flatness, and he made a series of horizonless landscapes of the Arizona desert. Shorn of the usual landscape photograph's orientation to the sky, these pictures seem to be cropped from an infinite pattern; they produce a vertiginous effect that is profoundly at odds with their descriptive fidelity. In the 1950s Sommer employed collage, putting reproductions of etchings, drawings, and other images together in the manner of Ernst's 1921 collage *Sambesiland;* he also painted on cellophane and made photographic prints from the resulting images, a technique akin to Ernst's practice of frottage.

Like Laughlin's, Sommer's photographs had an uneasy relation to the dominant postwar aesthetic of modernism, but they were sufficiently conventional (black-and-white, full toned, greatly detailed, abstractionist) to be accepted into its fold. (Sommer and Laughlin had their work published in *Aperture,* the bible of photographic orthodoxy during its early years.)[4] The modernist aesthetic imperative of so-called straight photography, which prohibited any manipulation of the transaction between the subject and the film, obviously was less omnipotent then than is now commonly believed. In

ANDY GRUNDBERG

4. See, for example, Jonathan Williams, "The Eyes of Three Phantasts: Laughlin, Sommer, Bullock," *Aperture* 9:3, 1961, pp. 96-123.

Sommer's case, the common denominator with modernist practice was an extreme kind of print fetishism.[5]

Nevertheless, it is possible to consider Sommer's photographs as a protest against or antidote to modern photography's concentration on the literal surfaces of things and on subject matter that seems to speak for itself. The same might be said of the throbs of "surrealistic" practice that have occurred regularly in American photography ever since. For example, the overt surrealist revival that occurred in the late 1960s, which centered around Jerry Uelsmann, Ralph Gibson, Les Krims, and Duane Michals, can be seen as a rebellious reaction to the strictures of straight, modernist practice. As with Sommer's photography, however, their work was quickly sanctioned by the guardians of the modernist tradition.

Uelsmann, who was a student of Minor White's at the Rochester Institute of Technology, became known for his seamless prints made from several discrete negatives. Gibson, Krims, and Michals were comparatively conventional in their use of materials, but like Uelsmann they constructed dreamlike narratives that are indebted to René Magritte, Paul Delvaux, and Salvador Dali, the most literal-minded of the European surrealists. Uelsmann, in particular, was recognized for daring to break the long-standing proscription against intervening between the negative and the print. All four were part of the photography-as-fine-art movement of the early 1970s.

The nod to surrealism in their work functioned to set off their images from both documentary photography and the abstract, expressive styles of White, Aaron Siskind, and others. In Uelsmann's images, uprooted trees float in skies, decrepit mansions appear mired in swamps, and female nudes seem to hover under the surface of the ocean. Sometimes these combinations are humorous—*Little Hamburger Tree* of 1971, for example, suggests the existence of a fast-food chain in the heavens—but others seem merely portentous, at least in retrospect. The "hook" in Uelsmann's work is its seamlessness: like any other modernist photographs, his are rendered in nearly microscopic detail, which makes their discontinuous tableaux seem only more unbelievable. If nothing else, this accounts for their being called surrealist.

Michals's "sequences"—narrative series of as many as ten individual pictures, frequently incorporating handwritten texts—are focused (again, sometimes humorously) on metaphysical questions relating to personal and sexual identity, urban life, and loss. What made them seem surrealist in the 1960s was their open debt to Magritte, whom Michals photographed at the beginning of his career, and their insistence on the primacy of the imagination over

5. Even without Sommer's example, the aesthetic of straight photography appears more permeable to surrealist practice than it would at first appear. For example, recent art-historical commentary has focused attention on the inherent surrealism of Edward Weston's close-ups of the 1920s and 1930s and on Weston's more blatant (if not forced) tableaux taken in Carmel during World War II. See Paul Roth's essay for the exhibition "Weston and Surrealism," Center for Creative Photography Library, Tucson, 1990.

material reality. At the time, the idea that photographs could describe dreams and other states of the mind was itself virtually surrealist.

Gibson, who had been Dorothea Lange's assistant in the early 1960s and later worked with Robert Frank, produced a book called *The Somnambulist* in 1970. With a layout based on the idea that the meaning of images grows out of their association and context, *The Somnambulist* paired suggestive, fragmentary images of women's hands, handguns, and shadows. The narrative, such as it was, was left to the imagination of the viewer. Krims's collections of acted-out tableaux, most notoriously *The Incredible Case of the Stack O'Wheat Murders* (1972), acquired their "surrealist" edge by violating social norms regarding nudity. *The Stack O'Wheats* series purports to show the ravaged, lifeless victims of a murderer whose "signature" is a pile of pancakes, using naked young women as models. The real subject, however, is the equation of violence and voyeurism. As is true of Uelsmann, Michals, and Gibson, Krims's attempt to represent his imagination or fantasy life created imagery that lends itself to Freudian interpretation.

At the same time as these overt appeals to the surrealist heritage were being made, the photographer Diane Arbus was taking straightforward, unmanipulated portraits of individuals outside the bounds of polite society. Susan Sontag was to observe in one of her influential essays on photography that these pictures seemed as surrealist as any images consciously wrought. Indeed, they led Sontag to the conclusion that photography needs no elaboration or veneer of intention to render the world uncanny. In her article on Arbus, Sontag wrote:

> The mainstream of photographic activity has shown that a Surrealist manipulation or theatricalization of the real is unnecessary, if not actually redundant. Surrealism lies at the heart of the photographic enterprise: in the very creation of a duplicate world, of a reality in the second degree, narrower but more dramatic than the one perceived by natural vision.[6]

Much as the surrealists appropriated the work of Eugène Atget, Sontag used Arbus as an example of how photographs convert reality into another dimension. However, Arbus's work is surreal only in terms of its solicitation and evocation of the grotesque. Rendering the world uncanny is one of the side effects of a great many photographs, including those produced by the Parisian surrealists, but it is not equivalent to surrealism. Arbus's work has none of the self-conscious cropping, collaging, and refiguring of reality that mark surrealist photography, and little of the fixation on Freudian-defined eroticism, morbidity, and ironic juxtaposition. And it certainly has none of the surrealists' sense of humor. If Arbus's fascination with the grotesque has any precedent in

6. Susan Sontag, *On Photography* (New York: Farrar, Straus and Giroux, 1977), p. 52.

surrealist photography, it is with Belmer's idiosyncratic, even dysfunctional (in surrealist terms) dolls. But then Arbus was dealing with real people.

Today we have Joel-Peter Witkin, who represents yet another pulse of "surrealist" photography, as well as a certain one-upsmanship of Arbus's interest in the freakish and the sexually ambiguous. Drag queens, hermaphrodites, corpses, and taxidermological specimens are the photographer's favorite playthings, and to elevate them to the plane of art, he arranges them in settings that recall well-known paintings and painters. *Harvest* (1984) mimics the fantastic compositions of the sixteenth-century Milanese painter Guiseppe Arcimboldi, whom the surrealists proclaimed a forebear; both *The Bra of Joan Miró* (1982) and *The Sins of Joan Miró* (1981) allude to the Catalan surrealist's work. Indeed, of all of the references to painting found in Witkin's images, those aimed at surrealism seem most pertinent, since he is interested in violating virtually the same sensibilities. But by now it is not these appeals to the surrealist heritage that shock us; what creates the revulsion to Witkin's pictures is the belief that photographs, no matter how scratched, toned, or otherwise manipulated, still have a one-to-one connection with reality.

Like Belmer, Witkin is preoccupied with sexual ambiguity, fetishism, and substitution. But his objectification of the female body—frequently dismembered, sometimes "teased" by his captions—has an unsavory aspect in our supposedly post-Freudian times. While scholars such as Rosalind Krauss have found a way to overlook, or excuse, the Parisian surrealists' fascination with the "forbidden" areas of the female body by interpreting it, and all surrealist gestures, as deconstructive, Witkin's efforts have no such redeeming aspect. Unlike the surrealists, Witkin is not challenging the realm of the social in his appeals to the subconscious; rather, he employs sexual horror as the sign of his own expressiveness. His shocked and titillated audience responds to his personal demons, not to the irrational aspects of life. In this sense one cannot consider Witkin's work surrealist, much less deconstructive.

But it is not only Witkin's photography that is considered *nouvelle* surrealist these days. Several group exhibitions have explicitly maintained that the leading edge of contemporary photography can be located within the surrealist legacy. Why should the tenets and practices of an art movement more than fifty years old become allied with contemporary photography at this historical moment? What critical point is being made, and what critical advantage gained, by such a linkage? Gerard Roger Denson, the curator of a 1987 show called "Poetic Injury: The Surrealist Legacy in Post Modern Photography," has answered these questions quite bluntly: "Just as postmodernism does today, Surrealism sought in the 1920s and '30s to critique and transformation the contents, logical operations, and objects of representation."[7]

7. Gerard Roger Denson, "Grandchildren of the Storm," *Poetic Injury: The Surrealist Legacy in PostModern Photography* (New York: The Alternative Museum, 1987), p. 8. The show included forty-three artists, ranging from Krims, Uelsmann, and Arthur Tress to Sarah Charlesworth, Barbara Ess, William Wegman, and Krzystof Wodiczko.

In short, surrealism, as viewed through the lens of late twentieth-century theory, is seen as postmodernism's precursor. As an avatar of deconstructivist practice and theory, it supplies a rationale both for photography's position within the art world and for those photographic practices that seek to disorient and disrupt our conventional responses to images. Here is Krauss, co-curator of "L'Amour Fou," writing in the same catalogue as Denson:

> If surrealism as a movement was collectively aware of anything, it was that reality and consciousness "produce" one another, that the operations of construction are everywhere....Surrealist photography does not admit of the natural, as opposed to the cultural or made. And so all of what it looks at is seen as if already, and always, constructed, through a strange transposition of this thing into a different register. We see the object by means of an act of displacement, defined through a gesture of substitution.[8]

This sounds itself like an act of displacement. The surrealists knew Freud and the psychological notion of substitution, but they were not acquainted with Jacques Derrida, Roland Barthes, Jean Baudrillard, or the semiotic conception of cultural construction that informs Krauss's assertions.

This is not to deny, however, that the *styles* of surrealism continue to circulate throughout photographic practice, in Europe as well as in America. As Kathleen Kenyon, organizer of the 1988 show "New Surrealism: or, the fiction of the Real," at the Center for Photography at Woodstock, has remarked, the surrealist spirit "keeps surfacing, submerging, and re-emerging...there seems to be a useful need it fills. It's not out of fashion, but in-and-out of fashion. A band of secret surrealists survives."[9]

The survival of "a band of secret surrealists" constitutes a remarkable chapter within the photography and art of the twentieth century, not to mention a rupture with conventional art-historical thinking, which is founded in precepts of progressive evolution. (Aside from self-conscious remakes, like those of Mike Bidlo, cases of stylistic recurrence are rare in modern art.) But today's look-alike surrealist photography, as witnessed by Witkin, is only the hollowed-out shell of surrealism as Breton conceived it. The forms are maintained, as is the penchant for fragmented, cut-up nudity, but precious little of the spirit of social rebellion remains. The tension between the competing claims of autonomous authorship and a critical, oppositional praxis is no longer felt. Indeed, one could say that today's surrealist-inspired practice represents exactly what postmodernism sets out to repudiate.

8. Rosalind Krauss, preface to *Poetic Injury*, p. 4.

9. Kathleen Kenyon, "Surrealism Is a Dirty Word," *Center Quarterly* (Summer 1988), p. 11. The ellipsis is the author's.

Finally, what is there to say about Sontag's contention that photography by its very nature is surrealist? Only that the surrealists, who wrote poetry, painted, put on performances, and utilized many other forms of expression besides photography, did not see it that way. Breton and the other surrealists never argued that photographs were surrealist in and of themselves; if they were, then there would have been no occasion for the sort of intentional disruption of lenticular description seen in the images collected in *L'Amour Fou.* The valorization of Atget's work was an exception in the surrealist scheme of things, roughly equivalent to Breton's retrospective adoption of the nineteenth-century writer Isidore Ducasse, also known as Comte de Lautréamont. Both were "found" surrealists, in the same way that Duchamp's urinal was a found object. In short, inscribing photography as a whole within the rubric of surrealism does violence to both.

Today's photography is a response to living in a world in which what challenges reality is simulated reality, not surreality. Ours is quite a different situation from that of the surrealists, who saw reality as a screen or blockade that masked the irrational, chaotic, childlike, and presumably genuine arena of the subconscious. Today, the subconscious is no longer perceived as innocent of culture. There is no longer anything remarkable about the conjunction of a sewing machine and an umbrella on a dissection table—for us, the image is as denatured, and an anesthetized, as any other. Surrealism no longer serves a critical or rebellious purpose, any more than photography serves as an infallible barometer of true experience, and its stylistic repetition within the tradition of American fine-art photography is at best a kind of mannerism and at worst a symbol of that tradition's exhaustion.

Since the surrealist revival of the late 1980s and early 1990s (and in the seven years since this essay was first written), the subject of surrealism and photography has remained a point of contention. Ongoing developments in three areas—artistic practice, art-historical scholarship, and critical theory—have complicated and problematized any easy dismissal of the latter-day surrealist impulse as a pale, mannered, and misconstrued repetition of the original.

In terms of contemporary photographic practice, at least, the impulse to connect to the aura of surrealist trespass and radicality—whether seen in terms of the irrational of André Breton or George Bataille's *informe*—shows no signs of abating. Andres Serrano may have replaced Joel-Peter Witkin as the reigning model of outrageousness in the service of the cutting edge, but the art world's appetite for the shock of tableaux of sex and death has not been fully sated. Serrano's 1994 series *The Morgue*, depicting cadavers in colorful, curdling close-ups, was followed by his *History of Sex* series, an extension of the possibilities for human coupling sketched two decades earlier by Robert Mapplethorpe. (Human coupling is only part of the repertory of Serrano's studied sodomies; one of his photographs shows a woman caressing the erection of a well-endowed horse.) Serrano is only one of several photographers of

the '90s to regard the morgue as a site of potential aesthetic pleasure, or to locate its opposite in the body. The surrealist equation of eroticism and death has even found its way into popular culture in films such as *Crash*, in which sexual excitement is directly produced by trauma (a pun on auto-eroticism must have been difficult for the producers of *Crash* to resist) and, in extremis, by death itself.

Matthew Barney, meanwhile, continues to create videos, photographs, and installations that feature surrealist combinations of goat-boys, wrestlers, and monochrome-clad motorcycle racers. Equally surrealist, in the sense that they are driven both by chance and by a direct encounter with the phenomenal world, are the recent photographs of Adam Fuss, Christopher Bucklow, and others devoted to the "photogram" or "rayograph" technique first perfected in Paris in the 1920s by Man Ray. Fuss, for example, has used rabbit intestines to make metallic-colored pictures that evoke abstract painting, and he has taken portraits of babies by depositing the infants on photographic paper and exposing them to a brief burst of light.

Scholars and curators have been busy acclimatizing surrealism to the late twentieth century. In addition to dusting off and reprinting surrealist texts,[10] they have continued to revivify the reputations of long-forgotten surrealist artists and to grapple with the much larger task of inscribing surrealism's place in the narrative of twentieth-century art. These efforts have enlarged the sense of surrealism's legacy and broadened the field by which we know it—in particular, by focusing on the persistence of a European-derived surrealist practice in the United States after World War II, and on the influence of Man Ray, Marcel Duchamp and Max Ernst on the American art scene of the time. Just how quickly the art-historical knowledge of surrealism is expanding, especially in regard to its photographic practices, can be measured by the reputation of Claude Cahun. Once thought to have been a male surrealist because of her given name and her mannish appearance in her staged self-portraits, Cahun is not mentioned in Whitney Chadwick's *Women Artists and the Surrealist Movement,* published in 1985, the same year in which Cahun's work appeared in *L'Amour Fou: Photography and Surrealism.* By the time of Sidra Stich's 1990 exhibition *Anxious Visions: Surrealist Art,* at the University Art Museum, Berkeley, Cahun's contribution to surrealism was taken as a given, and in 1997 she was presented as a central artist in the transformation of stereotypes of gender and identity in the exhibition *Rrose is a Rrose is a Rrose: Gender Performance in Photography*, organized by Jennifer Blessing at the Solomon R. Guggenheim Museum.

Cahun's mirrored self-portrait from the late 1920s graces the cover of the catalogue to *Rrose is a Rrose is a Rrose, I* and in a significant way it is emblematic: Cahun's surrealist blurring of self and sex provides an art-historical

10. An example, Maurice Nadeau's *The History of Surrealism,* published in France in 1944 and translated into English in 1965, was reprinted in 1989 by Harvard University Press.

precedent for the exhibition's thesis about contemporary art. As Jennifer Blessing writes in her introduction:

> When the lens of investigation is widened beyond our contemporary preoccupations, it is clear that now is not the first, nor will it be the last, historical moment in which issues of gender and sexuality hold a particular prominence. Not only do aspects of European art production between the two world wars (notably Dada and its legacy in Surrealism) resemble certain features of contemporary art, but some of the psychoanalytic roots of current gender theory date to the late 1920s and 1930s.[11]

For Blessing, surrealist photography is a living presence in today's art because of its subject: its rupturing of conventional categories, including male/female, and its psychological mimesis as exhibited through doubling, mirroring, and the displacement of personal identity. Thus Cahun's work can be compared to Cindy Sherman's because in both cases the fixity of the construction of male and female appearance is decisively undermined. The interpretation of Sherman's work as postmodernist, in the sense of its deconstruction of lens-produced stereotypes and its awareness of the gaze, is deferred or at least reconstituted to the end of providing a lineage of influence that extends back to surrealism and out to Catherine Opie, Lyle Aston Harris, and Yasumasa Morimura. One consequence of this argument is that surrealism is no longer viewed as a pulse or throb that periodically runs through twentieth-century art and photography, but as an unbroken thread.

The issue for the late 1990s, then, is whether surrealism in general and surrealist photography in particular persevere in contemporary art as a continuation of the vanguard surrealism of Paris in the 1920s and 1930s and, if so, to what extent do they retain the vanguard functions of the original? This is an issue of concern to critical theorists who believe that art has a radical, transformative role to play in our lives, and it is addressed directly by Hal Foster in his book *Return of the Real*. Foster distinguishes between an historical avant-garde, located in European Dada, constructivism, and surrealism, and a "neo-avant-garde" starting with minimalism in the 1950s and 1960s and continuing into the postmodernist art of the 1980s. Foster argues that the "return" in postwar art to practices such as photomontage and the ready-made is at heart a radical reconnection to prewar strategies that aimed to disconnect art from its conventional aesthetic, social and political frames.

Arguing against the dismissal of the avant-garde put forth by Peter Bürger in his classic 1974 essay "Theory of the Avant-Garde," Foster says:

11. Jennifer Blessing, Introduction to *Rrose is a Rrose is a Rrose: Gender Performance in Photography* (New York: Guggenheim Museum/Harry N. Abrams, 1997), p. 8.

> rather than invert the prewar critique of the institution of art, the neo-avant-garde has worked to extend it....In doing so the neo-avant-garde has produced new aesthetic experiences, cognitive connections, and political interventions.[12]

Why is Foster at such pains to validate contemporary art by means of its antecedents in the historical avant-garde, including surrealism, while at the same time insisting that it poses a radical new challenge to the structures and institutions that define and determine modern art? Perhaps because so many art historians have worked so hard of late to construct a lineage of twentieth-century art that includes surrealism as simply another thread of style and influence, like Cubism. Seeing surrealism as a thread woven into the fabric of the art of this century is fundamentally different than defining it as a pulse that periodically disrupts the arena of art, which in turn is different from seeing it as a unique episode occasioned by a specific confluence of historical, social, and cultural conditions.

Facing such an unsettled theoretical field, one can understand why artists might concentrate on the arena of surrealist practices, and why so many photographers find in surrealism a ready model for their own impetus to take photography beyond its purely descriptive functions. However, the very ease with which so many photographers now adopt the surrealist mode of photography—indeed, that there now is such a thing as a "surrealist mode"—mitigates against Foster's conception of an art that challenges the order of things. The "trauma" produced by photographs like those of Witkin and Serrano seems less a radical intervention in the art marketplace than an enervated, mediated version of surrealism's true trauma—much like the "shock" one could feel watching Robert Hughes' "Shock of the New" on television.

133

ANDY GRUNDBERGANDY GRUNDBERG

12. Hal Foster, *The Return of the Real* (Cambridge, Mass.: The MIT Press, 1996), p. 14.

Theresa Harlan

Adjusting the Focus for an Indigenous Presence

> The invasion of North America by European peoples has been por-
> trayed in history and literature as a benign movement directed by God,
> a movement of moral courage and physical endurance, a victory for all
> humanity...[T]his portrayal of colonialism and its impact on the unfortu-
> nate Indians who possessed the continent for thousands of years
> before the birth of America, seems to go unchallenged either in politics
> or letters by most mainstream thinkers. It arrives in academia
> unscathed, to be spoonfed to future generations.[1]

Escaping the Frontier Paradigm

In September of 1996 the San Francisco Museum of Modern Art mounted its
photographic exhibition on the American West, *Crossing the Frontier: Pho-
tographs of the Developing West, 1849 to the Present*. The museum presented
the exhibition as "retrac[ing] what we have inherited from the restless, inven-
tive, optimistic nineteenth-century pioneers, and how contemporary photo-
graphers have modified this optimism with an awareness of irony and regret."[2]
This exhibition kept its promise, that is, it evoked "irony and regret." Yet for
Native Americans an apologetic portrayal of the West is still not adequate
enough to bring forth necessary challenges that truly modify the American
frontier paradigm.

One reason for the inadequacy is that crucial voices from the West—
Native American, Asian American, African American, and Chicana/Chi-
cano—were excluded from the show, which curator Sandra Phillips admitted.
"This exhibition, comprising photographs that are essentially a white, male,

1. Elizabeth Cook-Lynn, *Why I Can't Read Wallace Stegner and Other Essays: A Tribal Voice* (Madison:
University of Wisconsin Press, 1996), p. 29.

2. Sandra S. Phillips, *Crossing the Frontier: Photographs of the Developing West, 1849 to the Present*,
exhibition catalogue (San Francisco Museum of Modern Art, September 26, 1996-January 28 1997), p. 1.

Christian record of what was done to possess and civilize the land, thus omits in the main the territory's earlier possessors, Native Americans and the Spanish colonists," writes Phillips.[3] The melding of indigenous peoples and the colonizing Spaniards, as if they shared a similar relationship to the land, is at best misleading. Indigenous possession of the Americas continues—spiritually and philosophically—despite any territorial boundaries that currently exist.

As I walked through the exhibition looking at the way non-Natives perceived and represented land—either as real estate or landscape—I felt the "absence of our [indigenous] presence,"[4] to borrow a phrase from Yuchi/Creek photographer Richard Ray Whitman as well as its counterpoint the "presence of our absence." While the exhibition called for reflection through the act of looking at the "way we use and have used the land,"[5] it did not provide an opportunity to see indigenous ways of relating to the land and how such relationships are rooted in indigenous principles of existence and self-awareness. We, as viewers, had to tightly squeeze together in order to look through a very narrowly defined window of "irony and regret."

The development of the nineteenth-century frontier was not a period of optimism for indigenous peoples. The notion of a frontier was and is very alien and illogical—as illogical as thinking of the world as flat. The vision of a new land glowing with the abundance of fruitful opportunities—ripe for picking— was never part of the teachings given to us by our creators and ancestors nor our experience. The teachings of many indigenous societies tell us that we are given the gifts of life that require many duties and responsibilities to sustain our relationships with the land and other beings, and to continue our way of life—a life guided by principles of peace and reciprocity. The Haudenosaunee (People of the Longhouse/Iroquois Confederacy) follow principles inscribed in their Great Law of Peace. For the Diné (Navajo) it is the way of hózhó.[6] Principles of peace and reciprocity, and intellectual strategies have guided indigenous peoples through the burning trail of frontier expansionism.

3. Ibid., p. 13.

4. I use the term "our" as I am Native American, with family from Santo Domingo Pueblo and Jemez Pueblo.

5. Phillips, *Crossing the Frontier*, p. 1.

6. The Great Law of Peace originated from a time when people were violent and there was much death. According to Haudenosaunee teachings the Peacemaker went forth through the land seeking to persuade the Mohawk, Seneca, Cayuga, Onondaga, and Oneida to agree to live in peace and heal themselves of the death that surrounded them. The Navajos too follow a principle of hózhó, which directs the people to live in peace, balance, and well-being. Navajo artist Jimmy Toddy once explained, "That is the way the Navajo see—the way the people see—hózhóóní. That is: walk in beauty, beauty road, beauty way. Beauty behind me and beauty ahead of me, where I am going, where the grandfathers lived." See Chief Jacob Thomas, "The Peacemaker's Journey," in *The Knowledge of the Elders: The Iroquois Condolence Cane Tradition*, eds. Jose Barreiro and Carol Cornelius, *Northeast Indian Quarterly* (Cornell University, 1991), p. 9; and Jimmy Toddy in *When the Rainbow Touches Down: The Artists and Stories Behind the Apache, Navajo, Rio Grande Pueblo and Hopi Paintings in the William and Leslie Van Ness Denman Collection* by Tryntje Van Ness Seymour, exhibition catalogue, (Heard Museum, 1988), p. 69.

Unlike Euro-Americans, we did not have to wade through decades of disillusionment to watch the fruit of the golden frontier become blighted by urban and technological growth, world wars, depression, unemployment, nuclear destruction, and civil unrest to bring us to the realization that the American West was but an imagined myth. We saw this from the start.

The onslaught of colonizers and settlers who attempted to create a national identity based not from within the land, but rather by the subordination of the land and its people, is the origin for the irony and regret in the American West. We leave the frontier paradigm when we look at the works of indigenous image-makers and photographers, which not only deconstruct the ideology of frontier expansionism, but most importantly construct an intellectual space for a twenty-first-century indigenous presence.

Claiming Difference with Clarity

Eurocentric frontier ideology and the representations of indigenous people it produced were used to convince many American settlers that indigenous people were incapable of discerning the difference between a presumed civilized existence and their own "primitive" state. On the contrary, indigenous people did understand and commented on the differences, although not in a way the settlers might have understood.

Tewa (San Juan Pueblo) anthropologist Alfonso Ortiz explains how Pueblo communities of New Mexico articulate ideas of difference. "In the grand public rituals...the Pueblos repeatedly and regularly, through burlesque, caricature, and the occasional parody of clowns, draw a sharp contrast between the self and the not-self, between what is acceptably Pueblo and what is alien. They burlesque not only the government agents, Protestant missionaries, and anthropologists who have bedeviled them in modern times, but the Spaniards and their priests who beset upon them in earlier times....the Pueblos take important events of the past that intruded upon them and freeze them into place, as it were, by anchoring the historical events onto symbolic vehicles of expression that are traditional and that, thereby, lock those events comfortably onto their own cultural landscape....In this way they collapse history and, in so doing, they turn time into space as well."[7]

For Jolene Rickard, Tuscarora photographer and art historian, the Two Row Wampum belt[8]—created by the Haudenosaunee (Iroquois Confederacy) to document an agreement between the Haudenosaunee and the Dutch in the seventeenth-century—is an example of how difference is noted. "The creation

7. Alfonso Ortiz, "The Dynamics of Pueblo Cultural Survival," in *North American Indian Anthropology: Essays on Society and Culture*, eds. Raymond J. De Mallie and Alfonso Ortiz (Norman: University of Oklahoma Press, 1994), p. 303.

8. The Wampum belt is composed of two separate rows of dark shells against a light background. One row represents the Dutch and the other row represents the Haudonasune. The two rows are parallel and their paths never intersect (read interfere).

of the belt represents a visual marking of ideological and physical space, an understanding of difference, yet acceptance....It is significant that this moment, that is, contact with the West, was marked in this way; the creation of the belt reflects a recognition of a different way of understanding life and the clarity and confidence to claim the difference. Isn't that, in part, what indigenous art does today?"[9]

This confident claim of difference in the way art functions appears in Rickard's 1991 series *What They Do: What We Do*. In one piece Rickard juxtaposes a color image of her sister's elementary class performing a Haudenosaunee story of the three sisters

Jolene Rickard, *What They Do: What We Do*, 1991

(corn, beans, and squash) over a color image of a hydroelectric power plant that sits on Haudenosaunee land and feeds New York. Three important elements are present in Rickard's collage: the contradiction between indigenous and nonindigenous use of land and water; the way indigenous people inscribe history in performance; and the practice of indigenous people of watching and noting the actions and behavior of those not like themselves.

The practice of watching and commenting are seen in the 1991 series *Indian Photographing Tourist Photographing Indian* and the 1993 series *Indian Photographing Tourist Photographing Sacred Sites* by Mandan/ Hidatsa photographer Zig Jackson. He calls the viewer over to share in his delight of catching the "tourist" in a photographic act. Jackson steps outside of the frozen image of nineteenth century "Indian" representations to gaze back, catching non-Natives as they photograph the land and its people.

Zig Jackson, *Indian Photographing Tourist Photographing Indian*, 1993

9. Jolene Rickard, "Frozen in the White Light," in *Watchful Eyes: Native American Women Artists* exhibition catalogue, (Heard Museum, November 4, 1994-October 15, 1995), p. 17.

The Duty and Service of Photographic Representations

> The practice of looking at things to remember is our way. In the past it served
> the truth. Whose "truth" do we observe when we look at photographs?
> —Jolene Rickard[10]

Jolene Rickard's question is critical to understanding the way photography served frontier expansionist ideologies and representations, which portrayed indigenous peoples either as wild savages unworthy of a white Christian society or as a dying people unable to understand the "better" world of that society. Those ideologies resulted in the forced expulsion of indigenous peoples from their ancestral homelands. Mid-nineteenth-century photographic expeditions and photographic journeys by individual photographers helped disseminate these Western expansionists "truths."

In his now well-known formulation, John Tagg has examined how photography serves power. "The representations it [the camera] produces are highly coded, and the power it wields is never its own...but the power of the apparatuses of the local state which deploy it and guarantee the authority of the images it constructs to stand as evidence or register a truth."[11]

Although the medium of photography was a dutiful servant to the nation-building and myth churning of a young America, it now equally serves the interests of Native photographers as they dismantle Eurocentric representations of indigenous people and make way for representations of indigenous sovereign nations. Seminole/Muscogee/Diné photographer Hulleah J. Tsinhnahjinnie sees the time for a change of photographic service. "No longer is the camera held by an outsider looking in, the camera is held with brown hands opening familiar worlds. We document ourselves with a humanizing eye, we create new visions with ease, and we can turn the camera and show how we see you."[12]

Pamela Shields (Kanai) deploys her camera to trace the links between individual occurrences of racism against indigenous people and governmental postures of indifference toward indigenous nations. Shields uses her installation *Blood, Hair and Rust* (1994) to tell her story of two separate events which demonstrate the magnitude of displacement experienced by indigenous people. The first event is the tragic accident of an inebriated Native woman whose arms and legs are severed when she is hit by a train. A news story about the accident was critical of the woman as she fulfilled an

10. Jolene Rickard, "Cew Ete Haw I Tih: The Bird That Carries Language Back to Another," in *Partial Recall: Photographs of Native North Americans*, ed. Lucy Lippard (New York: The New Press, 1992), p. 108.

11. John Tagg, *The Burden of Representation: Essays on Photographies and Histories* (Minneapolis: University of Minnesota Press, YEAR), p. 63-64.

12. Hulleah J. Tsinhnahjinnie, "Compensating Imbalances," in *Exposure* 29 no. 1 (Fall 1993), p. 30.

Pamela Shields, *Blood, Rust, Hair*, 1994, detail

essential stereotype—a drunk Indian. The second event was the refusal of the Lubicon Crees to participate in a fabricated Indian attack on white settlers—presented as part of the 1988 Winter Olympic celebrations in Alberta, Canada. The Lubicon Crees's refusal was in response to the insulting event and to draw attention to Canada's refusal to recognize their treaty agreement with the Lubicon Cree.

Shield's installation is composed of photographs of an old woman seated in a chair and of train tracks, along with handwritten text and suspended silk handkerchiefs imprinted with the image of a young girl. Shield tells the viewer "She was Native. There was no pity. No one asked about her history. Maybe she was from the Blood Reserve—a place of vast plains, deep coulees, the Sun Dance."[13] Shield's use of panels of images simulate the distant and moving views one would see looking through the window of a moving train. Shields relies on a Western symbol, the locomotive, to make her point about how Western society displaces/dismembers history and personal memory from indigenous people. The child's face, with its level gaze, acts as a haunting witness who seems to want to incite the dispassionate viewer.

The comingling of land seizure and denial of indigenous peoples' existence is the subject of Richard Ray Whitman's 1992 series *Enforced Colonization Identity Model*. In a series of black-and-white photographs of billboards Whitman responds to the erasure of an indigenous presence by the substitution of representations of white Americans. One billboard erected by Oklahoma's Department of Tourism proclaims, "Oklahoma, Native America" and depicts a white cowboy riding his horse through Oklahoma country. Whitman counters with "The Absence of Our Presence" in red and black lettering collaged over the image of the cowboy. Whitman's words speak from his personal experiences and the historical experiences of Native people. Such experiences include witnessing others claiming and living on former indigenous ancestral homelands that they call home.

While Richard Ray Whitman challenges the absence of indigenous presence, Hulleah J. Tsinhnahjinnie directs her attention to the absence of indigenous truths in

13. Pamela Shields, artist statement, 1994.

Richard Ray Whitman, *Enforced Colonization Identity Model*,
1992, mixed media.

Grandma and Me, 1994, Hulleah J. Tsinhnahjinnie, hand-colored
black-and-white photograph.

photographs of Diné (Navajo) people in tourist magazines. In her *Grandma and Me* (1994), an enlargement of a 1950s *Arizona Highways'* photographic spread entitled "An Arizona Scrapbook in Navajoland," she leads the tourist back to revisit objectifying representations of Diné people. She superimposes her photographs and captions on top of the original photographs and condescending captions, such as "Aged Navajo," "Modern Belles," and "Rug Weaver." In this way she makes room for photographs of herself and her grandmother onto which she has inserted the Diné names: Anali (granddaughter on father's side) and Ma'sani (grandmother on father's side). Tsinhnahjinnie makes the following distinction between her choice of names and that of the magazine: "These Diné captions recognize intimacy and responsibility, whereas an *Arizona Highways'* caption, 'Aged Navajo,' denies a whole range of her possibilities—a council woman, a medicine woman, a master rug weaver, a star gazer, a translator, a teacher, a writer, a singer, a traveler, an organizer, a woman of thought."[14] By naming herself and her grandmother, she rejects the presumed authority of Western cultural production to present the "authentic" Navajo by inserting her own knowledge of what is real and true.

Tsinhnahjinnie's knowledge of what is real and true extends even to Eurocentric, gender-based notions of male and female identity, which she resists by wearing men's clothing.

Elizabeth Cook-Lynn speaks of the emergence of Native voices in academia (and I would add, the arts as well): "Its emergence has to do with the need of human beings to narrate, to tell the story of their own lives and the lives they have known, the intellectual need to inquire and draw conclusions which is simply part of being human."[15]

14. Hulleah J. Tsinhnahjinnie, artist statement in *Watchful Eyes: Native American Women Artists*, exhibition catalogue, (Heard Museum, November 4, 1994-October 15, 1995), p. 33.

15. Cook-Lynn, p. 77.

> The land claims lawsuit made a great and lasting impression on me. I heard the old folks cry as they talked about the land and how it had been taken from them. To them the land was as dear as a child, and as I listened, I felt the loss and the anger too, as if it all had happened only yesterday."
> —Leslie Marmon Silko, author of *Yellow Woman and a Beauty of Spirit: Essays on Native American Life Today*[16]

The land, which continues to be the source for indigenous being, is a strategic site for Native photographers. The refusal of indigenous people to relinquish the land is the root of what American settlers called the "Indian problem." Cement, steel skyscrapers, and pavement prove no barrier to the love indigenous people hold for the land. In Hulleah Tsinhnahjinnie's 1982 *Metropolitan Indian Series: Glady and Florence Go Shopping* and Zig Jackson's 1994 works, *Indian Man in San Francisco*, black-and-white images show Native people dressed in regalia using public trains and buses in Oakland and San Francisco juxtaposing and asserting their indigenous presence in metropolitan cities.

In another series, *Entering Zig's Indian Reservation* (1997), Jackson is shown holding a sign that reads "Entering Zig's Indian Reservation" in various locations around San Francisco, including the financial district, city hall and the buffalo corral at Golden Gate Park. The buffalo corral is especially significant as Jackson relates to the buffalo as a relative—Jackson's indigenous name is Rising Buffalo. The buffalo stands as a striking reminder of another indigenous being forced to live as a surviving symbol of the frontier. Jackson's sign deliberately mimics the road signs across the United States that inform travelers that they have left state and county boundaries and are now entering the sovereign territories of indigenous nations. Another of his signs states, "Private Property. No Picture taking, No

Metropolitan Indian Series 1982, *Florence and Glady Go Shopping*, Hulleah J. Tsinhnahjinnie, black-and-white photograph.

Zig Jackson, *Indian Man in San Francisco*, 1994

THERESA HARLAN

141

16. Leslie Marmon Silko, *Introduction: Yellow Woman and a Beauty of the Spirit: Essays on Native American Life Today* (New York: Simon & Schuster, 1996), p. 19.

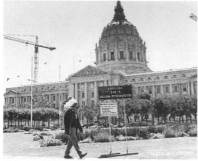

Entering Zig's Indian Reservation, 1997,
Zig Jackson

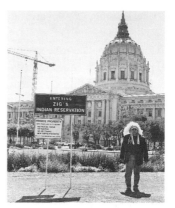

Entering Zig's Indian Reservation, 1997,
Zig Jackson

Hunting, No Air Traffic, New Agers Prohibited without permission from tribal council." By Jackson's own declared possession of San Francisco, he parodies European explorers who claimed exclusive rights on behalf of European nations to indigenous lands, resources, and peoples by way of the "doctrine of discovery"[17] and calls our attention back to when indigenous people held their own place as sovereign nations. Jackson asserts his "title" to San Francisco based not on the doctrine of discovery, but by indigenous sovereignty, as he deliberately did not seek the permission of any municipal authority to install his signage.

Affirmation of Post-Assimilation Grace

> Horace Poolaw always said that he did not want to be remembered himself; he wanted his people to remember themselves through his pictures.
> —Linda Poolaw (daughter of Horace Poolaw)[18]

> My father liked to take informal portraits: the old man with his prize watermelon, the old woman with her oven bread on a board. He knew that these old folks, who had loved him and watched out for him as a child, would pass on to Cliff House soon. We all meet there at Cliff

17. Early European claims on North American land were premised on the doctrine of discovery. "The British (as other European nations) legitimized their acquisition of land through the 'doctrine of discovery' and other legal theories, alien European theories that were imposed on the native population. The cornerstone of colonization 'right,' the doctrine of discovery gave the 'discoverer' of 'unoccupied' lands the right to acquire these lands in the face of the competing claims of other European nations." *A Report of the United States Commission on Civil Rights*, June 1981.

18. Linda Poolaw, Alice Marriot and Stanford University, *War Bonnets, Tin Lizzies, and Patent Leather Pumps: Kiowa Culture in Transition, 1925-1955: The Photographs of Horace Poolaw*, exhibition catalogue, (Stanford University, October 5-December 14, 1990).

House someday, but I think my father couldn't bear to wait that long to see their beloved faces again.
—Leslie Marmon Silko (daughter of Lee Marmon)[19]

Nineteenth-century photographs provided views of an uncontested American West. During a time when Native people were being assaulted by U.S. government troops as well as by private landholders, they could hardly afford the time to become familiar with the camera. As a result, there are few photographs taken by indigenous people in the nineteenth century. One 1882 image of a photographer has been credited to Lakota leader Sitting Bull. That was also the year that one of the earliest known Native photographers was born. Richard Throssel was born a Cree and later adopted by the Crow. According to Throssel's biographer, Peggy Albright, Throssel began working with photography in 1902 when he moved to the Crow reservation and trained with other photographers, including Edward S. Curtis. In time he was hired by the U.S. Indian Service as a photographer and later opened his own photography business in Billings, Montana, in which he offered a line of photographs under the title "Western Classics from the Land of the Indian" marketed to non-Natives.[20] Anthropologist James Faris names Tin Horn as one of the first recorded Navajo photographers working in 1914.[21] Two other early Native photographers are Jean Fredericks (Hopi) and Horace Poolaw (Kiowa), and as more research continues, we certainly will become more aware of others. Many current Native photographers consider Fredericks, Poolaw and others to be the "first generation" of Native photographers, thus creating a familial bond and ancestry.

Jean Fredericks began taking photographs in 1941 and set up a darkroom in his house at Hopi. Fredericks, who was aware of the intrusive force of photography, saw the medium as a vehicle for cross-cultural understanding. "Privately, most Hopis approve of photography and want pictures of their families and celebrations, just like anyone else. Publicly, many feel they have to adopt a political position against photography, to be careful of what they say or what others will say about them. This is to protect their privacy. Personally, I am glad people are interested in my photographs and that my hobby will help people better understand the Hopis," Fredericks wrote.[22] His subjects range from family portraits to documentary photographs of land and water projects for the Bureau of Indian Affairs.

19. Marmon Silko, "On Photography" *Yellow Woman and a Beauty of the Spirit*, p. 186.

20. See Peggy Albright's, Crow Indian Photographer: The Work of Richard Throssel (Albuquerque: University of New Mexico Press, 1997). Albright's biography of Richard Throssel includes not only an expansive collection of his photographs, but also commentary by Crow Tribal members: Barney Old Coyote, Jr., Mardell Hogan Plainfeather, and Dean Curtis Bear Claw.

21. James C. Faris, *Navajo and Photography: A Critical History of the Representation of an American People* (Albuquerque: University of New Mexico Press, 1996), p. 292.

22. Jean Fredericks, artist statement in *Hopi Photographers/Hopi Images* compiled by Victor Masayesva, Jr. and Erin Younger (Tucson: Sun Tracks, University of Arizona Press, 1983, second printing 1984), p. 42.

Horace Poolaw's photographic career began in 1925 and continued until 1978, when failing eyesight prevented him from taking pictures. Horace began his photographic career by taking correspondence courses and later apprenticed himself to landscape photographer George Long and Oklahoma portrait photographer John Coyle. Poolaw documented Native community events and also took staged shots of Native people in traditional regalia holding dramatic poses. During World War II, Poolaw was a training instructor in aerial photography for the Army Air Corps at Fort MacDill in Florida.

In 1989, Poolaw's daughter, Linda Poolaw, directed a project at Stanford University that posthumously archived and printed her father's photographs for the exhibition *War Bonnets, Tin Lizzies, and Patent Leather Pumps: Kiowa Culture in Transition, 1925-1955*. For the opening reception, the Poolaw family held a "giveaway" to recognize those who had assisted in bringing honor to their father. During the emotion-filled event, family members recalled stories of Poolaw as they distributed Native-designed Pendleton blankets and Southern Plains women's shawls. The family's giveaway demonstrated the importance of tradition and protocol in which gifts are bestowed to others to recognize the community effort that contributes to individual achievements. The dignity, honor, and communal spirit of the reception stands in contrast to openings at mainstream galleries and museums, which celebrate the individual artist, separating the artist as a gifted individual from the rest of those in attendance.

Just as Horace Poolaw "wanted his people to remember themselves through his photographs," so does Laguna Pueblo photographer Lee Marmon. Born in 1925 at Laguna Pueblo in central New Mexico, Marmon remembers that when he was a child, only two families at Laguna owned cars. By the time he returned home after World War II, cars, bridges, and paved roads had altered the environment of Laguna. Further changes took place with the discovery of uranium on Laguna reservation land. Mines were opened in preparation for the Cold War, and farmers left their fields to operate heavy equipment at the mines.[23]

When Marmon returned home after the war he purchased a Speed Graphic camera and began taking pictures. Marmon's father suggested that he take pictures of the old people as they were not going to be around for long. Both Poolaw and Marmon thwarted the emptiness of the "absence of our presence" by creating representations that affirm Native memories, self-knowledge, and presence. Marmon's photographs continue the practice of "looking at things to remember," in Jolene Rickard's words. Marmon's photographs of old people are much more than a domestic gallery of snapshots. Marmon's photographs are of people who persisted in holding onto Laguna knowledge despite centuries of plunder and destruction. Beginning in the sixteenth century, first the Spanish and Mexican colonists and later the U.S. government attempted to strip them of their land and eliminate not only their culture and religion, but their memory of their history as well.

23. Lee Marmon, conversation with the author, 1997.

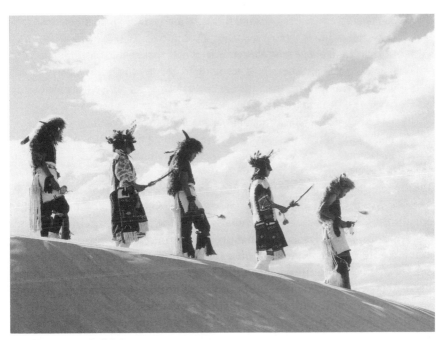

Lee Marmon, 1962, *Buffalo Dancers*

Thus, his pictures are not merely portraits of old Native folks. For instance, one of his signature photographs, *White Man's Moccasins*, shows Jeff Sousa sitting against a wall holding a cigar. Sousa is dressed smartly in a white shirt, khakis and high-top sneakers. Sousa wears a scarf headband as worn by Laguna men. Marmon's 1954 photograph at first glance looks like a predecessor for a Calvin Klein or Gap advertisement, but this image wields a much sharper edge than any ad campaign. As Marmon's clever title is more than ironic, it is Pueblo objectification of Western society through the appropriation of a popular icon—high-tops.

Marmon's approach to photographing his community also follows the necessary protocol of his community. Permission is always obtained and some form of payment is paid to the subject of the photograph. In the case of Jeff Sousa, payment was the stogie he enjoys in the photograph. The payment does not need to be large, for the value of it is in the gesture of courtesy and respect for privacy.

Many of Marmon's photographs are made at the request of the people who appear in them. In 1962, Frances Poncho wanted photographs of himself and other dancers as they practiced the buffalo dance. Marmon's black-and-white photographs show buffalo dancers standing on the peak of a sand dune. The angle of the photograph is near the ground, so that the dancers seem to be larger than life—occupying the horizon of both land and sky. The texture of the buffalo hide of the headdress, the angora goat hair and yarn wrapped around Poncho's legs seems to be repeated in the cumulus cloud cover in the sky. The dancers articulate the familial relationships Native people have with animals and plants as explained by Leslie Marmon Silko,

To demonstrate sisterhood and brotherhood with the plants and animals, the old-time people make masks and costumes that transform the human figures of the dancers into the animal beings they portray. Dancers paint their exposed skin; their postures and motions are adapted from their observations. But the motions are stylized. The observer sees not an actual eagle or actual deer dancing, but witnesses a human being, a dancer, gradually changing into a woman/buffalo or a man/deer. Every impulse is to reaffirm the urgent relationships that human beings have with the plant and animal world.[24]

California Native photographer Dugan Aguilar's addresses the "absence of our presence" in his work by presenting portraiture of northern California Native people dressed in the traditional regalia of deer skin, bear grass, and abalone shells, thus showing the revitalization of cultural traditions in California today. Aguilar has spent over twenty years photographing his extended family, which includes Maidu and Pit River from his mother and Walker Paiute (Nevada) from his father, and more recently has begun to look at northern California indigenous communities of basketweavers, dancers, and singers.

Aguilar works against a backdrop of the particularly brutal and violent treatment of California indigenous people by the Spanish and Mexican govern-

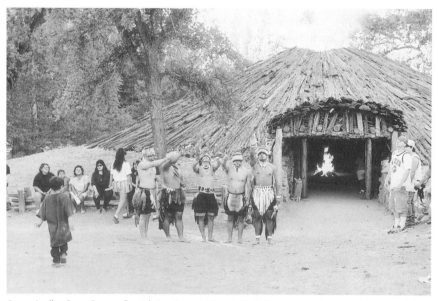

Dugan Aguilar, *Pomo Dancers Preparing to Dance at Chaw'se Roundhouse*, 1996. photo credit: © Dugan Aguilar

24. Marmon Silko, "Yellow Woman and a Beauty of the Spirit," *Yellow Woman and a Beauty of the Spirit*, pp. 68-69.

25. Albert Hurtado, *Indian Survival on the California Frontier* (New Haven: Yale University Press, 1988), p. 1.

ments, and the Catholic church, which were then followed by American gold miners, and ranchers. According to historian Albert Hurtado, the population of California indigenous people at the onset of Spanish settlement in 1769 was 300,000. Once California became a state, the indigenous population figures dropped more than eighty percent: only 30,000 people were left.[25]

Aguilar was particularly impressed when he photographed California Native basketweavers; consequently, he altered his approach to photography. "I was inspired by the process of basketweaving as it requires a lot of time and effort. Photographs take a lot of time and work to get the right contrast with dodging and burning. Now when I go into my darkroom, I say a prayer just like the basketweavers. They pray to the Creator for the materials and reflect on what they are creating. I do the same."[26]

Aguilar's *Pomo Dancers Preparing to Dance at Chaw'se Roundhouse* (1996) is a black-and-white photograph of five young men standing in prayer before entering the roundhouse, the ceremonial house where people gather to pray, sing, and dance. The ceremonial fire is visible through the entryway of the roundhouse. Aguilar's photograph allows us to witness a community of indigenous people renewing their relationship with their ancestors and spiritual place of origin through prayer, song, and dance. Aguilar characterizes his photography with a northern California Pit River phrase *Wa'tu Ah'lo*, which means a connection of a person or thing by an umbilical cord to the earth.

Much photography by Native photographers carries what Hulleah Tsinhnahjinnie has called a "post-assimilation grace." The photographs of Fredericks, Poolaw, Marmon, and Aguilar portray the humanity of a people who persisted despite a wretched struggle for existence in the face of conflicting ideologies. Family photographs in indigenous homes all across America are the significant markings of cultural persistence and presence carried forth by grace and love.

The Continuum of Our Teachings

> The relationship between the oral tradition and the mnemonic objects that serve it—the wampum belt, the condolence cane, the sacred tobacco, the rattles—continues to this day. In my community there is a relationship between all the objects that we create and the words that surround us. The words are here to teach and guide us through life; the objects are here to serve the memory and meaning of the word. The practice of looking at things to remember is our way.
> —Jolene Rickard[27]

26. Dugan Aguilar, artist interview in *Wa'tu Ah'lo: Dugan Aguilar, Northern California Indigenous Photography*, exhibition monograph, (University of California, Davis, Carl Gorman Museum, February 20-April 5, 1996), p. 4.

27. Rickard, "Cew Ete Haw I Tih," p. 108.

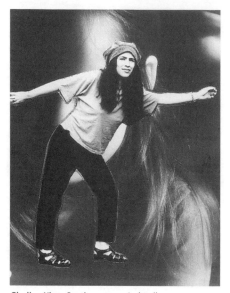

Shelley Niro, *Continuum*, 1996, detail.

The use of photography by indigenous peoples is a strategic way to continue the relationship between traditional teachings and the mnemonic objects that serve the memory of such teachings. Like Rickard, Mohawk photographer and filmmaker Shelley Niro has referred to the Haudenosaunee Wampum belt as the source for an installation. Instead of stringing shell beads into belts to carry agreements and messages, Niro has created a Wampum belt of collaged black-and-white photographs. *Continuum* (1996) is composed of two horizontal bands of photographs of her college-aged daughter collaged over images of Niro, Niro's mother as a young woman, and Niro's college-aged daughter as a child. In the piece we see one generation in another generation. The face of Niro is in one place cut out in the shape of her daughter's body, while Niro's mother as a young woman is cut out in the form of her granddaughter's body.

Niro's photo-collage of three generations of women relays multiple messages about the place of women in the traditions of the Haudenosaunee way of life. The use of wampum as a means to carry her message is a way of securing a link to ancient teachings. Niro's selection of images of herself, mother, and daughter as the wampum shells recalls the roles assumed by women to ensure the continuation of Haudenosaunee culture and society. According to teachings, a woman named Jikonsaseh, the first clan mother, was the first to accept the Great Law of Peace from the Peacemaker, which was essential to the formation of the confederacy of the Mohawk, Oneida, Onondaga, Cayuga, and Seneca (The Tuscarora joined the Confederacy in the 1700s). It was a woman who gave the people foods which have female identities—"three sisters": corn,

beans, and squash. The Haudenosaunee are matrilineal people as explained by Audrey Shenandoah, Clan Mother of the Onondaga, "The mother's clan determines the clan of her children, and so we have a clan mother. She must perpetuate the ways of our people; she must be able to teach the ways of our people to the young people."[28] Niro's collage expresses the continuum of blood, clanship, and culture through three generations of women.

As wampum shell belts carry stories about Haudenosaunee existence, Hulleah J. Tsinhnahjinnie tells us the story of her existence in her 1994 series *Photographic Memoirs of An Aboriginal Savant*, which combines digitized images and text printed on pages torn from second-hand books. The piece consists of fifteen pages with introduction and epilogue framed without protective glass. In her introduction she writes that this is:

> The vision of a forty-year-old female aboriginal savant. Thought provoking pages photographically illustrated with unexpected post-assimilation grace. Journey to the center of an aboriginal mind without the fear of being confronted by the aboriginal herself....As a self-described aboriginal savant, I have photographed and written about my observance of myself, family, community and those other people.[29]

Tsinhnahjinnie's act of naming herself an "aboriginal savant," is in itself a "thought-provoking" act. As she clearly knows that dominant society is so

149

THERESA HARLAN

Hulleah Tsinhnahjinnie, *Aboriginal Savant Series*, 1994, photo credit: Lynn Matteson

28. Audrey Shenandoah, "Jikonsaseh and the Women of the Nations," in *The Knowledge of the Elders*, p. 23.

29. Tsinhnahjinnie, *Photographic Memoirs of an Aboriginal Savant: Hulleah J. Tsinhnahjinnie*, exhibition monograph, (University of California, Davis, C.N. Gorman Museum, 1994), p. 4.

tightly bound by stereotypes of Native people, that only a Native would be so rebellious to create an indigenous space for Native intelligence. Tsinhnahjinnie's self-assertion may even be considered a 1990s rendition of the 1970s "black is beautiful," only this time it is "Natives are intelligent."

On one page of her memoirs is a photograph of her father Andrew Van Tsinajinnie (father and daughter use different spellings of their last names) as a nineteen-year-old military recruit in World War II. Entitled *"March of Culture,"* it includes his traumatic story of running away from government boarding school after receiving severe punishment for speaking Navajo.

> Ever since I can remember Dad has told us the story about him and his buddies running away from Fort Apache Indian School. It was a two hundred mile trek. The younger ones cried at night....They caught donkeys at Donkey Springs and bribed a ranch hand with a wristwatch. Two weeks later they arrived at home, at least the ones that didn't get caught. Dad slept one night at home and the next morning an Indian policeman arrived on horseback. Dad was taken to Chinle to the jail. There he saw the rest of his friends. They had all been caught. To prevent any methods of escape on the journey back to Fort Apache they were shackled and handcuffed. Back at school they were made to wear dresses while dragging logs around the school marching grounds. They were about eight years old.[30]

Hulleah Tsinhnahjinnie, tells her father's harsh story with both love and anger, contrasting the government's brutal treatment of her father with her knowledge of his achievements as an important Navajo painter and his service to the government as veteran of World War II in the Pacific and Asian Theater.[31]

Tsinhnahjinnie's manipulations of image and text challenges a Eurocentric preference and methodology for what she calls a "written existence." She links her memoirs with *Bearing Witness,* a book of African American memoirs edited by Henry Louis Gates, Jr. Tsinhnahjinnie explains,

> In the foreword Gates mentions the creating of presence by...writing one's own existence...realizing the impact of a written existence, which is considered more real than an oral existence (where a Native presence exists)—and rather than have an anthropologist interpret my existence—I have taken control of how I am presented. My experiences, in my chosen words, be they positive or negative are my life.[32]

30. Tsinhnahjinnie, artist text, 1994.

31. Andrew Van Tsinajinnie, born (1918) at Rough Rock, Arizona, on the Navajo reservation, studied painting at the Santa Fe Indian School in New Mexico with Dorothy Dunn from 1932 to 1936. Tsinajinnie went on to become one of the most prolific and successful Navajo painters, muralists and illustrators of his time. He is most well known for his fire dancers, Yé 'ii Bicheii Dancers, gamblers and horses.

32. Tsinhnahjinnie, *Photographic Memoirs of an Aboriginal Savant,* p. 4.

Tsinhnahjinnie's *Photographic Memoirs of an Aboriginal Savant* cuts through the carapace of a capitalist, sexist, and racist society to give life to an "aboriginal" presence. James Faris observes how she navigates toward Navajo principles of hózhó—living in balance. Tsinhnahjinnie "sees her work as a locus of struggle to represent and 'compensate' for what she calls 'imbalances'— including not only the genocidal history of the West vis-á-vis Native Americans but also racism and sexism in general. For Tsinhnahjinnie the use of the term imbalance is complexly interesting, for it refers both to the Navajo notion of imbalance (a condition of being out of order and thus potentially dangerous and ugly) and to the imbalance of relative power between the classic subjects of photography and photographers (and between Native Americans and the West)."[33]

Fixing Native Art to Native Principles

Some art critics have enlisted the theories of modernism and postmodernism to analyze the art-making of indigenous artists in the twentieth century. Others have called for a Native form of postmodernism, as Western theories do not adequately address the phenomena of contemporary art-making by Native artists.

Art-making as an expression of cultural autonomy and sovereignty must remain rooted within indigenous principles and teachings. This will not happen by embracing postmodernist ideas. Even theories of multiculturalism are unable to understand fully the historical, political, and spiritual roles of indigenous art-making. Indigenous experiences with, and relationships to, the U.S. government is based on nation-to-nation treaty agreements and should not be confused with civil rights entitlements. Multiculturalism is ill-equipped to handle the diversity of racially identified communities let alone the plurality of indigenous nations.

The attempt to label indigenous artists as either modern or postmodern is another form of assimilation, a recontextualization by Western thinkers that preserves and extends Western Eurocentric paradigms. This is not to say that indigenous artists should work and be judged in a vacuum separate from the rest of the art world. But comparisons between contemporary Native and non-Native art frequently strips away the context of an indigenous world for that of a Eurocentric world which is still unwilling to comprehend or respect indigenous principles and intelligence.

Many indigenous artists feel the need to locate and fix their image-making to indigenous principles in order to assert an indigenous sovereign presence for future generations. The Native photographers discussed in this essay keenly understand the critical relationship between indigenous teachings to sovereignty and cultural autonomy and bring to their image-making an understanding of the dynamics of Eurocentric ideology and its self-assumed

33. James C. Faris, p. 295.

power to name what is knowledge and truth, while denying indigenous knowledge and truth.

One might wonder why indigenous people have not given in to assimilationist pressures or been crushed by the weight of the hegemonic West. Or why indigenous artists persist in enlisting traditional teachings to challenge the American West and its colonizing truths. Karuk historian and linguist Julian Lang reasons, "For all intents and purposes a complete collapse of Native culture should have occurred, except for one element that Washington's power hierarchy was not able to see; the innate power of love that existed between the tribal people and world. [A love affair] that continues in profound ways, ways that the white man is still unable to see."[34]

While frontier photographers believed they were photographing our demise, anthropologists and historians were elegizing us and tourists were buying images of us at the "end of the trail"[35]—we, as indigenous people, were just beginning to focus the camera for an indigenous presence.

OVER EXPOSED

34. Julian Lang, "World Renewal: A Contemporary Fine Arts Theory," in *Ancestral Memories: A Tribute to Native Survival*, exhibition catalogue (Falkirk Cultural Center, San Rafael, California, 1992), p. 7.

35. "The End of the Trail" is an image that exists in almost every form, from photography, painting and sculpture, to T-shirts and belt buckles. The original form is a bronze sculpture by James Earl Fraser circa 1894. It is an image of an Indian warrior on a horse. Both horse and rider look as if they are ready to drop dead from battle fatigue. Many (Native and non-Native) like the image as it commemorates the honor of an Indian struggle against the white man. Equally as many dislike it as it can also romantically symbolize a Native defeat.

Silvia Kolbowski

Playing With Dolls

ENTER THE major university library in which some of the research for this article was carried out, and look for the section on photography. Situated between *Human Nutrition* and *Industrial Chemistry*, it contains a narrow assortment of books, titles such as *The Photographic Lab Handbook, Image Science, Autoradiography in Biology and Medicine, Overexposure: Health Hazards in Photography,* and *Theory of Development,* as well as a variety of coffee-table monographs, histories of the "evolution" of the medium and its techniques, "styles," and genres. Critical theory does not seem to have made much of an incursion into these shelves; a book identified on its spine as *Introduction to Photographic Theory* turns out to be a technological thesis on the silver halide process. Books on media, Marxist and feminist theories, psychoanalytic theories of sexuality and the gaze, critical art histories, as well as those on the philosophy of history, or race and representation, are to be found on different floors, which makes writing on photography from a cross-cultural perspective a physical affair. Even the library's computerized catalogue, able to traverse shelves at the touch of a button, stubbornly refuses cross-referencing.

The titles listed above were intended to be a representative register, a cross-section. But all of the titles I chose contain words that make associative references to medical science or the body: *lab, science, image, radiography, biology, medicine, overexposure, health, development.* These choices were overdetermined, perhaps, by the context of my first encounter with the subject of this text—fashion photography—as an adolescent in the waiting room of a doctor's office. There, to allay my anxiety about the impending unveiling of my body to a strange man (who would discover what?) whose gaze could not be contained within professional parameters, I directed my own gaze to, touched the surface of, photographic images of feminine "perfection." An image from a recent fashion magazine layout comes to mind: it is of a Caucasian model standing in naked profile on a beach, her arms sinuously caressing her own body, which suntan oil has made into a gloss of uninterrupted surface. There are no clothes or makeup being peddled in this image—just

perfection. Where the unstable territory of my own body would be partitioned into zones of exposure (following the nurse's directives, this part must be covered with a gown, that part must be left uncovered), the bodies that my gaze would capture and that captured my gaze, looked stable, imperturbable, self-sufficient. Those bodies, like my body on the examining table, were there to be looked at. Unlike my body, the models' bodies were contracted to appear to be comfortable objects of a gaze.

> Through the creation of meaning, the advertisement works to simultaneously create identities for both the product and the reader, who will be addressed as a potential consumer. In order to engage the reader's attention, both text and image must be capable of offering certain forms of interest and pleasure. Crucially, for the image to fulfil its advertising function, it must not offer satisfaction in its own right. The advertisement works to displace satisfaction, promising fulfillment upon purchase of the commodity, at which point the reader becomes a consumer. It then articulates meaning and pleasure through a complex relationship, which it establishes between reader, advertising image and commodity. This relationship is orchestrated by the overall marketing considerations, which determine not only where the advertisement will appear, but also where the commodity advertised will be distributed, retailed, etc....The image of woman is used as a complex signifier to associate the advertised product with other aspects of the cultural and ideological system: art, status, wealth, etc.
> —Kathy Myers, "Fashion 'N' Passion"[1]

> What is there to prevent [the woman]...from appropriating the gaze for her own pleasure? Precisely the fact that the reversal itself remains locked within the same logic. The male striptease, the gigolo—both inevitably signify the mechanism of reversal itself, constituting themselves as aberrations whose acknowledgement simply reinforces the dominant system of aligning sexual difference with a subject/object dichotomy.
> —Mary Ann Doane, "Film and the Masquerade: Theorizing the Female Spectator"[2]

The meager critical writing that exists on fashion photography either implicitly or explicitly poses the female spectator of such images as a consumer, part of a targeted market, a "user" who gets used through the manipulative seduction of an advertising/fashion/publishing complex. By implication, the female

1. Kathy Myers, "Fashion 'N' Passion," *Screen* 23, no. 3/4 (1982), pp. 90, 94, 96.

2. Mary Ann Doane, "Film and the Masquerade: Theorizing the Female Spectator," *Screen* 23, no. 3/4 (1982), p. 77.

spectator is a passive, masochistic statistic who attains that status through an identification with images of fashion models in the service of a market construct, through the lures of photographic codes. Such descriptions of or allusions to this identificatory process underplay the contradiction inherent in any "passive" identification, that is, the active role of looking. All identificatory looks presuppose fluctuating subject/object positions. Even the woman's identificatory gaze at a fashion model frozen into an image by the camera involves an active process of looking. In his discussion of maternal identification, Freud saw a *one-way* identification of the girl with her mother. The young girl's game of playing with dolls, Freud wrote, "served as an identification with her mother with the intention of substituting activity for passivity. *She* was playing the part of her mother and the doll was herself: now she could do with the baby everything that her mother used to do with her."[3] In Freud's analysis of the scene, the girl assumes an active role as mother within a dualistic logic where only active *or* passive positions are available. But identification, as French psychoanalyst and theorist Luce Irigaray writes, is a multifaceted game: "a game—even of dolls—is never simply active or passive, but rather frustrates that opposition by the economy of repetition that it puts 'into play.'"[4] That is, the girl never *exclusively* assumes the part of her mother, or herself, or the doll in such a game. Instead, the process of identification could be referred to through metaphors of, for example, layering, simultaneity, fluctuation, nonlinear density.

My point in juxtaposing the two quotations at the beginning of this section is not to render the kind of primarily economic determination being argued in the first quote by Kathy Myers invalid or irrelevant but to indicate the dangers of its determination and to argue that whenever it is used in isolation it is bound to be *over*determined. For what such fundamentally paranoid scenarios tend to reduce to effects of economic motives are the unconscious and sexual difference. These scenarios suggest that those who advance advertising/photographic/editorial/fashion industry interests exercise total understanding and control of their own motives. Through the deployment of images, they are then thought to exercise a similar power over their targeted objects. That is to say, such an argument implies that the meanings produced by these images are fully determined before they are viewed by the female spectator and that they produce a narrowly defined subject/audience/consumer. Following this logic, opposition to such manipulation (which is to be desired on the part of an "enlightened" spectatorship?) would be theorized as an equally conscious function. That is, both processes, manipulation and resistance, are understood as fully conscious events, put into effect by an undi-

3. Sigmund Freud, "Femininity" (1933), quoted by Luce Irigaray in *Spectrum of the Other Woman*, trans. Gillian C. Gill (Ithaca: Cornell University Press, 1985), p. 77.

4. Irigaray, *Spectrum of the Other Woman*, p. 77.

vided "self" that is invulnerable to the vicissitudes of the unconscious and the imaginary. Contradictorily, such an argument must implicitly recognize the unconscious as a function that allows for manipulation to achieve its effects and is implicitly dependent on the enlisting of the faculty of fantasy. But fantasy cannot be so easily enlisted to a single aim, not only on the part of a persuasive strategy, but also on the part of the desiring subject herself. As Jean Laplanche and J. B. Pontalis point out "[fantasy] is not an *object* that the subject imagines and aims at, so to speak, but rather a *sequence* in which the subject has his own part to play and in which permutations of roles and attributions are possible."[5] Laplanche and Pontalis then refer the reader to Freud's analysis of the fantasy "A Child Is Being Beaten," where the patients' recountings resist singular identifications, with no exact parallel between the identifications of the male and female patients. Freud writes: "Who was the child that was being beaten? The one who was himself producing the phantasy or another? Was it always the same child or as often as not a different one? Who was it that was beating the child? A grown-up person?...Or did the child imagine that he himself was beating another one?...In these circumstances it was impossible at first even to decide whether the pleasure attaching to the beating-phantasy was to be described as sadistic or masochistic."[6]

In fantasies, identification resists rigidity. The feminine gaze at the fashion photograph's image of feminine perfection could be described as engaged in a one-way prescriptive identification (I become the object of my gaze); it could also be seen as simultaneously taking on a number of other forms: the embodied gaze of the spectator that is never in full disavowal of the schism between subject and object of the look (I see myself, or know myself to be, gazing at the image), the gaze that is aligned with that of the photographer/camera/frame, the gaze positioned "behind" the photographer. Pleasure, therefore, could be said to reside as much in the slippages of positions, the misalignments, as in the masochistic alignment with an unattainable object of perfection that is culturally reinforced. As opposed to the permutability of the identificatory gaze of fantasy, closed systems constructed through scenarios of full intentionality and control make even consciously willed or differing looks difficult to theorize or define. In fact, any theorization of a purely oppositional stance within such systems would not only have to deal with the intransigence of systemic structure, but would also fall within the dualistic logic to which Doane refers: opposition can be perceived as an aberration that reinforces a dominant subject/object hierarchy. That is, resistance can be read only as the exception to the social rule of hierarchic dichotomy, thus at the same time

5. Jean Laplanche and Jean-Bertrand Pontalis, *The Language of Psycho-Analysis*, trans. Donald Nicholason-Smith(New York: W. W. Norton and Company, 1973), p. 318.

6. Sigmund Freud, "A Child Is Being Beaten," in *The Standard Edition of the Complete Psychological Works of Sigmund Freud*, ed. and trans. James Strachey (London: Hogarth Press, 1953-74), vol. 17 (1919), p. 181; hereafter cited as S.F.

reinforcing it: if female spectatorship is willed an exclusively active gaze, it is at the expense of sustaining a strict active/passive division, of playing by the conventional rules of the game.

It is to the breaking down of such a division that Irigaray's comment is directed. For in Irigaray's psychoanalytic critique of identification, "identity" never fully coheres, is never circumscribed by a finite moment. This proposition therefore leaves room for the theorization of an identificatory relationship between a female spectator and a photographic image that is not purely dichotomous and hierarchic, not predictably defined and determined. While there is very clearly an identificatory process at work in the interplay between the feminine gaze and the product of a photographic language, which creates images of idealized femininity, idealized female bodies, it could not be said that this look is fully manipulated by the persuasion tactics that work on such a fantasized identification.

What this text will attempt to do is inquire into whether there is something in the nondichotomous structure of identification that exceeds the parameters of masochism in relation to fashion images, something in the nonstatic gaze directed at static images that might allow for the theorization of another, perhaps coexistent, gaze. It will also question what it is about the specifically photographic language of fashion images that might assist in the exercise of what might be typified as a more resistant gaze, while at the same time assisting in the replication of manifestly conventional codes of femininity.

Without underestimating the significance of economic forces, I would argue for a morphology of the sites of representation constructed by fashion photographs (argued here in a very partial way) that accommodates the heterogeneous complexity of most social/psychical scenarios, the reciprocity of effect, and the (in)coherency of "identity." Issues of class and consumption are of crucial significance in analyzing mass media images, but making these issues predominant can screen out other, significant, albeit more "silent," issues that play a role in the construction of feminine subjectivity and pleasure.

"Pleasure" takes shape in the overlap of the social and the psychical and is not an innate response to outside stimuli. So how would one talk about the pleasurable stakes for women in the fascination with fashion photographs of women? (What do they "see" in these images?) By fashion photographs I mean, in this case, the overwhelming majority of contemporary fashion photographs as they appear in the West, those banal images of models—in magazines that target women of different classes and colors—posed so as to be caught by the camera in the midst of action, work, play, and repose, as well as those of figures facing the camera/reader/photographer head on, silhouetted against back-drops, or in cropped close-ups. Those images that do not make use of an overtly theatricalized sadism or sadomasochism (a phenomenon of fashion photography that appears, disappears, and reappears, but is by no means predominant) are nonetheless "eroticized." To isolate "erotic" images of women is to misunderstand the way in which images are accorded meaning,

through the sexualized nature of any gaze. Is there something in the spectator-ship of these images that strains the readings favored by a logic of economic determination and exceeds the logic of a subjugation of woman? Is there something that could instead inscribe a type of feminine spectatorship that creates a field of tension occupied not only by oppressive demands made attractive through the lure of goods promising satisfaction, but also by an attraction that is given meaning through a look different from the ones described above? And, if so, what are the implications of such "excesses" or tensions? What are the academic/critical/popular props that lend support to the conventional construction of the female spectator as masochist? Is the demand for slavishness built into these images? Such a reading would be dependent on a notion of inherency, a notion that critical writing on photography has worked to challenge. In an example of this writing Alan Sekula writes:

> The photograph is imagined to have a primitive core of meaning devoid of all cultural determination. It is this uninvested analogue that Roland Barthes refers to as the denotative function of the photograph. He distinguishes a second level of invested, culturally determined meaning, a level of connotation. In the real world no such separation is possible. Any meaningful encounter with a photograph must necessarily occur at the level of connotation. The power of this folklore of pure denotation is considerable. It elevates the photograph to the legal status of document and testimonial. It generates a mythic aura of neutrality around the image.[7]

Is a reading that sees fashion photographs as, for example, unequivocally responsible for the replication of an oppressive social definition of femininity, not too dependent on a (somewhat repressed) realist (or denotative) reading? Instead of pursuing this line of reasoning, it could be argued that these images are representations that gain meaning in relation to a myriad of factors, events, and processes that shape subjectivity, meanings that are never graspable in isolation, never even serially singular.

I will now introduce three psychoanalytic, feminist critiques—of masquerade, narcissism, and identification—in an attempt to theorize a more complex feminine gaze. These critiques are not formulated along the same lines. In fact, when placed side by side they will diverge from and collide with one another. My purpose in bringing them together is not to develop a singular, determinative reading of fashion photography, but rather to indicate the possibility of how some differently positioned readings unsettle the more manifest narratives of such images. I will also look at how realist readings of

7. Alan Sekula, "On the Invention of Photographic Meaning," *Artforum* (January 1975). Reprinted in *Thinking Photography*, ed. Victor Burgin (London: Macmillan, 1982), p. 87.

the photographic mediums tend to obscure the subtle fluctuations of such an identificatory gaze.

The Masquerade: The Missing Look

It seems significant that the bodies in the magazines that were gazed at in the doctor's waiting room were not only objects of the gaze, but were also physically handled. Mary Ann Doane has noted (after Christian Metz and Noël Burch) that the voyeuristic gaze of the cinematic spectator is dependent on a physical distance in the viewing situation: "The cinephile *needs* the gap which represents for him the very distance between desire and its object." Metz writes: "It is no accident that the main socially acceptable arts are based on the senses at a distance, and those which depend on the senses of contact are often regarded as 'minor' arts (culinary arts, arts of perfumes, etc.)." Those arts that are dependent on proximity and tactility are, not surprisingly, commonly associated with women and femininity and can be related to Doane's theorization that the female gaze at the screen lacks the gap necessary for the representation of sublimated desire: "the female look [at/from the screen] demands a becoming"[8] due to the imaging of the woman's beauty, the adoration of her body through the cinematic codes of framing, lighting, camera movement, and angle, that keep her "more closely associated with the surface of the image than its illusory depths."[9] These codes repeatedly narrativize her as desirable body and close the distance between desire and object through an "over-identification" between woman and image, creating one in the image of the other, leaving the female spectator vulnerable to the cinematic codes that promote conventional "feminine" values. Because woman is narrativized and pictured as a desired and desirous *body,* as identifying spectator she lacks that gap that is the distance necessary for assuming a position productive of knowledge, of *re*-presentation rather than replication. "More so than men," Doane writes citing Helene Cixous, "who are coaxed toward social success, toward sublimation, women are body." "In opposition to this 'closeness' to the body (of the woman) a spatial distance in the male's relation to his body rapidly becomes a temporal distance in the service of knowledge."[10] In Freud's castration scenario, the girl sees the penis and knows in the same instant that she does not have it and wants it; the boy (upon "seeing" the girl's genitals), however, undergoes a process of disavowal, irresolution, lack of interest, rereading, the endowment of meaning in relation to subjectivity—in short a "re-vision of earlier events...which invests the events with a significance which is in no way linked to an immediacy of sight." Although Doane does not explicitly frame it as such, her use of Freud's "observation" of the castration scenario

SILVIA KOLBOWSKI

8. Doane, "Film and the masquerade," p. 78.

9. Ibid., p. 76.

10. Ibid., p. 79.

situates it as a kind of textual phenomenon, as an event give meaning by larger cultural encodings. Following this argument, the female spectator must gain access to the "gap between the visible and the knowable" denied to her by the cinematic institution if she is to participate in the process of her representation, the sublimation from body to "knowledge."[11]

For Doane, psychoanalyst Joan Riviere's concept of the masquerade opens the way for the production of the gap necessary for the re-presentation of woman in relation to a dominant logic, for the achievement of distance from the body narrativized by cultural forms.[12] In her text of 1929, Riviere describes the case of a patient who appears to compensate for her public-speaking successes (which situate her as "masculine" subject) by engaging, after such events, in exaggerated feminine behavior—flirtation, coquetry, seductive deployment of the body. Riviere saw these gestures as "womanliness worn as a mask" in the service of camouflage (the woman's "masculinity" is hidden by the gestures) and relieving anxiety (staving off the expected reprisals directed at her by the men from whom she had stolen masculinity). By not distinguishing between "genuine womanliness" and the feminine masquerade, Riviere, at least in part, theorized femininity as a condition formulated in response to and through, the dense material of the psychical *and* social.

According to Doane, "The masquerade, in flaunting femininity, holds it at a distance....The masquerade's resistance to patriarchal positioning would therefore lie in its denial of the production of femininity as closeness, as presence-to-itself....The effectivity of masquerade lies precisely in its potential to manufacture a distance from the image, to generate a problematic within which the image is manipulable, producible, and readable by the woman."[13] In this text Doane raises questions about, but stops short of defining, the female spectator's distancing masquerade, or of specifying what its relation would be to the masquerade of femininity that the cinema itself makes use of. Perhaps these issues should remain questions. Her conclusion suggests, through the emphasis on the manipulability and readability of all images, a productive refusal to label certain images of women as inherently and irrefutably negative.

According to the logic of the masquerade, distance can be achieved through an exaggerated closeness to the socially determined codes of femininity, but not to a femininity that is essential, natural. (For if I am overtly playing a role, then it cannot also be a "natural" condition.) Cosmetics and the elaborateness of feminine fashion codes are often regarded as elements of the manipulation of and prescription for a feminine look, or as serving a compen-

11. Ibid., p. 80.

12. Joan Riviere, "Womanliness as a Masquerade," in *Formations of Fantasy*, eds. Victor Burgin, James Donald, Cora Kaplan (London: Methuen, 1986). First published in *The International Journal of Psychoanalysis* 10 (1929).

13. Doane, "Film and the masquerade," pp. 81, 87.

satory function for feminine "lack." But it could also be argued that some women take refuge in the material "layering" of femininity that they afford. For where there is layering, there is no absolute substance.

A consideration of masquerade in regard to fashion photography of/for women indicates several things. One is that a fascination with the image of feminine perfection can be seen as drawing on an identification with a masquerade. The very changeability, repetitiveness, and excessiveness of/in images that pass through one's hands with relative ease undeniably serve the marketplace. But in their proliferation, they also give form to the superficiality of that which is considered proper to femininity. If the cinema demands a becoming of the female spectator, closeness could be said to be literalized in the case of fashion photography in magazines, where bodily proximity is a precondition of viewing. (This is perhaps one of the things that gives commercial photography a "minor" status as opposed to the higher ranking achieved for "art photography," which can be seen—at a distance—on gallery and museum walls.) But it is perhaps the fashion photograph's status as a still image, its arrest of narrative that makes it possible to theorize a gaze that achieves distance through access to masquerade and fantasy. What we have in fashion photographs is *frozen* masquerade unexasperated by the movement and narrative that "exasperate" masquerade in the cinema.[14] Fascination can be seen to lie in such an arrest, such a making of a mask. In this sense, the simple transmission of socially coded femininity cannot be fully relied on.

Photographic meaning has been rhetoricized through discourses of verisimilitude and illusion. Umberto Eco has pointed out that "the only property that the true object (of the photographic image) *does not have* is the representation of a body in a continuous outline" as it is portrayed in a photograph.[15] It then follows that a disavowal must take place in the viewer in order for the incongruence between image and referent to be smoothed over. But the fantasized look that is necessary for such a disavowal is not narrowly circumscribed. Identificatory entry into the elaborate "real-life" settings often used for fashion shots produced "on location" rather than in the studio, is dependent on a capacity for fantasy that is rooted in an ability to imagine a multitude of "realities." Identificatory entry is also dependent on the continuing dominance of belief in photography's verisimilitude—a belief that seems

14. Stephen Heath, "Joan Riviere and the Masquerade," *Formations of Fantasy*, pp. 57-58. "The masquerade is obviously at once a whole cinema, the given image of femininity. So it is no surprise that cinema itself can be seen as a prime statement of the masquerade....Cinema has played to the maximum the masquerade, the signs of the exchange femininity, has ceaselessly reproduced its—their—social currency: from genre to genre, film to film, the same spectacle of the woman, her body highlighted into the unity of its image, this cinema image, set out with all the signs of its femininity (all the 'dress and behavior')... Spectacle *and* narrative, image *and* movement, cinema in its films exasperates the masquerade and also tries to get women right, know her identity as reassurance—which rightness itself can only be masquerade...." (emphasis added)

15. Umberto Eco, "Critique of the Image," *Thinking Photography*, p. 33.

to accommodate (perhaps on the level of fantasy) the contradictory discourses surrounding photography.

The Double Discourse: Verisimilitude and Illusion

> There are two kinds of documents, or two tendencies within the documentary genre. The first, the more common, gives information to the intellect. The second informs the emotions.
> —William Stott, *Documentary Expression and Thirties America*[16]

> 150 years ago a language was invented that everyone understood.
> —Kodak Advertising Board, Grand Central Terminal, New York, April 1989

Photography has many stories of origin. In one, Joseph Nicéphore Niépce, a retired French army officer who fooled around with lithography, comes to the "invention" of photography by reproducing a seventeenth-century engraving not with a camera but through the employment of photographic means: the production of a negative of sorts, light sensitivity, and so forth. In effect, a light-sensitive substance was applied to a metal plate onto which was placed an oiled—and thereby translucent—engraving. These were then exposed to light, which caused the areas of the light-sensitive substance that were exposed to adhere to the plate; the other areas dissolved when placed in an appropriate solvent. The resulting image on the plate was then engraved more deeply by a traditional engraver, and "copies" of the original engraving were pulled.[17]

This production of verisimilitude has been cited by historians of the medium as a forerunner of the "first" photograph, Niépce's famous view from the window of his home near Chalon-sur-Saône. The collapsing of the engraving reproduction, which in fact produced only a direct imprint of a two-dimensional original, and the very differently conceived view from the window taken with a simple camera, seems to arise from a desire to grant the quality of verisimilitude, of a "reality stripped bare" to the photograph. The legacy of the medium's invention includes the fact that Niépce formed a partnership with Louis Daguerre, a showman who needed the exactitude of the photographic process to create "absolute illusion" in his performances of historical scenes. However, the photograph's fidelity to an immediate "reality," its truth, is still loudly proclaimed in the mass media and many areas of the academy.

Academic discourses sustain the concept of the photograph's truth or reality through the production and maintenance of official categories and

16. William Stott, *Documentary Expression and Thirties America* (New York: Oxford University Press, 1973), p. 12.

17. Beaumont Newhall, *The History of Photography*, rev. ed. (New York: The Museum of Modern Art, 1982), p. 14.

genres, such as documentary and photojournalism, genres that compartmentalize their messages to appeal to such pseudocategories as "the emotions" or "the intellect." The photograph's potential for fantasy has also been accorded labels such as art photography, or manipulated photography (as though all photographs were not manipulated). To put it another way, dichotomized discourses—illusion and reality, fantasy and verisimilitude, emotion and intellect—framed, legitimate(d), and explain(ed) the medium. But these dichotomized discourses are rarely allowed to function in tandem, in which case their conflicting interests would threaten the assumed neutrality of those discourses. More often, the discourses function through the repression or dominance of one or the other of them. There are particular social/historical contingencies that draw on one or another discourse, or ways in which the discourses feast on contingent factors, with a multiplicity of effects. I pose this material here in order to ask whether the arguments that hold fashion photography of/for women responsible for the replication of ideological femininity rely primarily and inadvertently on one of the dichotomized discourses: that of the "reality" of the image or of an instrumental illusionism of fantasy that always meets its aim?

"On Narcissism": A Different Look

In most of Freud's writings on femininity, woman is rendered as an enigma, a dark continent created by the veils that cover and compensate for her "natural deficiency," her "castration." Veils such as beauty, charm, modesty, coquetry are thought to aid in the cover-up of a frightening absence. Woman's ability to seduce is in direct proportion to her use of these veils. French psychoanalyst Sarah Kofman reads Freud's "On Narcissism: An Introduction," as deviating from this path in that it locates woman's enigma in her self-sufficiency.[18] I quote the passage from Freud's "On Narcissism" that Kofman focuses on in full so that the reader may have the benefit of Freud's own words (albeit in translation):

> A comparison of the male and female sexes...shows that there are fundamental differences between them in respect of their type of object-choice, although these differences are of course not universal (complete object-love of the attachment type is properly speaking, characteristic of the male. It displays the marked sexual overvaluation, which is doubtless derived from the child's original narcissism and thus corresponds to a transference of that narcissism to the sexual object)....A different course is followed in the type of female most frequently met with, which is probably the purest and truest one. With the onset of puberty the maturing of the female sexual organs, which up till then have been in a condition of latency, seems to bring about an

18. Sarah Kofman, *The Enigma of Woman*, trans. Catherine Porter (Ithaca, N.Y.: Cornell University Press, 1985).

intensification of the original narcissism, (of the infant), and this is unfavourable to the development of a true object choice with its accompanying sexual overvaluation. Women, especially if they grow up with good looks, develop a certain self-contentment, which compensates them for the social restrictions that are imposed upon them in their choice of object....The importance of this type of woman for the erotic life of mankind is to be rated very high. Such women have the greatest fascination for men, not only for aesthetic reasons, since as a rule they are the most beautiful, but also because of a combination of interesting psychological factors. (It seems very evident that another person's narcissism has a great attraction for those who have renounced part of their own narcissism and are in search of object-love.) The charm of a child lies to a great extent in his narcissism, his self-contentment and inaccessibility, just as does the charm of certain animals which seem not to concern themselves about us, such as cats and the large beasts of prey. Indeed, even great criminals and humourists, as they are represented in literature, compel our interest by the narcissistic consistency with which they manage to keep away from their ego anything that would diminish it. It is as if we envied them for maintaining a blissful state of mind—an unassailable libidinal position, which we ourselves have since abandoned.[19]

In Freud's "On Narcissism," Kofman argues, beauty is no longer conceived of as covering or compensating for a natural deficiency, but rather compensating for what Freud calls "social restrictions imposed upon [women] in their choice of object."[20] What makes the narcissistic woman attractive and enigmatic is that she "has managed to preserve what man has lost." Or at least, Kofman's argument suggests, it could be said that this is what the man fantasizes about the woman. Women have "been able to preserve their narcissism, their terrifying inaccessibility, their independence, their indifference," Kofman writes, and although they have been compared to cats and beasts of prey before (" 'Nietzschean' animal *par excellence*") she finds less common Freud's analogy to criminals and humorists. The criminal, as a type, is the great skeptic, whose position articulates a socially buried secret: "Nothing is true, everything is allowed"; criminals "keep away from their ego anything that would diminish it"[21] (and would therefore threaten their narcissism). As for the humorist, he "fend[s] off everything that might debase him...such as fear or terror: humor is particularly suited for freeing and exalting the ego. 'Look! [Kofman quotes Freud on humor] here is the world, which seems so danger-

19. Sigmund Freud, "On Narcissism: An Introduction," S. E. vol. 14, pp. 88-89.

20. Ibid.

21. Kofman, *The Enigma of Woman*, pp. 52-55.

ous! It is nothing but a game for children—just worth making a jest about.'"[22] Kofman does not set up a rhetorical spectacle to determine the accuracy or plausibility of a Freudian "explanation" of the enigma of woman in her examination of Freud's text. Freud's assertion of woman's "enigma" due to her recuperation of a primary narcissism is treated by Kofman as a radical theorization and re-presentation of femininity, not as a biologically or empirically rationalized truth. Freud's conceptualization of woman's privileged relation to narcissism is regarded as discursive rather than diagnostic.[23]

I discuss Kofman's text here in order to ask again, in a different way, whether it is the accordance of a conventional reality/truth status to fashion photography that prevents us from seeing or perceiving these images as games, images "just worth making a jest about" (albeit images that are serious enough to be played with). Could it be that what women "see" in these images, among other things, is a representation of femininity that exceeds the "lack" of sexual organ that is generally imposed on them by the culture? Without discarding the Lacanian theorization that *both* men and women assume sexualized subjectivity as a lack- in-being in relation to the privileged status of the phallus, the other-presumed-to-know, the Name-of-the-Father, the paternal metaphors, a subjectivity formed through the gap that exists between any formulation of "self" and lack in the place of the Other, the question remains of how to respond critically to the "vast social connivance" that makes of the woman a "privileged site of prohibitions"[24] and renders her a "symptom" for the man by her construction as "the place onto which lack is projected, and through which it is simultaneously disavowed."[25]

Is it possible that the idealizations formulated through photography, the narcissistic identification with a representational plenitude that the fullness of fashion photographs solicit from the female spectator, play a part in contradicting the more explicit scenario of a superiority/deficiency dichotomy or the function of economic determination. This is not to imply that the reading I suggest here is in fact the "truth" of these photographs, but rather that it can exist alongside and also complicate the other meanings produced. The closeness of an iden-

22. Sigmund Freud, "Humour" (1927), in Kofman, *The Enigma of Woman*, p. 55.

23. This encapsulation of Kofman's text cannot do justice to the subtlety of her argument. But it is important to note that in the end Kofman contends that Freud abandons the path toward the conception of a less conventional femininity opened up by "On Narcissism" because he is scared off by what he sees as the immoral character of narcissistic love, and he rescues the woman by collapsing femininity and motherhood. The narcissistic woman can, he suggests, direct her love out to an object, which was a part of her body, and is also separate from her—the baby. Additionally, in Kofman's reading, Freud's rivalrous eagerness to oppose Jung's monism at the time of writing his text, and Freud's moralism, obscure the fact that, his alternative dualism—narcissistic love and object-love—does not hold up to inquiry, for Freud "tends to reduce object-love to narcissistic love...since [the man's] sexual overvaluation of the love-object results from the simple transference to woman of one's overvaluation of oneself." p. 56.

24. Jacques Lacan, *Seminar XVIII* (1969-70), quoted by Jacqueline Rose, "Introduction II," *Feminine Sexuality* (London: Macmillan, 1982), p. 39.

25. Rose, *Feminine Sexuality*, p. 48.

tification with a narcissistic object such as a fashion photograph could be seen as affording the female spectator the distance of an imaginary self-sufficiency that separates her from a rhetoric of insufficiency. In the reverie of this identification (encouraged by the capacity of photography to create unbroken contours, to thus render bodies "whole" even in cases of cropped imagery), her "sexual organs" are no longer subject to a logic of masculine/feminine or phallic/castrated comparison. The question remains as to the relationship between this illusionary sufficiency and the loss of distance between desire and object that Doane and others have identified as necessary for representation and access to *revision*. But the strength of Kofman's argument remains its insistence on textuality as a way of rethinking femininity, of femininity produced through retextualization, rather than femininity as the effect of biological drives.

The Third Woman: Identification

The writer who "returns" to Freud has the methodological option of evading the intratextuality, symptomatological contradictions, and nonteleologic turns in his work, of acknowledging only a *solid*, logically unfolded body of work, or of reading and writing against, as well as with, the already variegated grain of his hypotheses and declarations.

French psychoanalyst Luce Irigaray has chosen to psychoanalyze Freud's writings, to insist on the symptomatic nature of his, and any, texts. For Irigaray, Freud himself supplies, in his methodological approaches, the tools necessary for questioning the investedness of his own writing, his own historical blind spots. Irigaray sees Freud as a "prisoner of a certain economy of the logos, of a certain logic, notably of 'desire,' whose link to classical philosophy he fails to see—he defines sexual differences as a function of the *a priori* of the same, having recourse, to support this demonstration, to the age-old processes: analogy, comparison, symmetry, dichotomic oppositions" and elaborates on the blind spot of sexual difference in Freud's writings by questioning those "age-old processes" of classical philosophy.[26] She attempts to find representational economies that do not fully depend on analogy, comparison, symmetry, and dichotomic oppositions.

To Freud's question: "What exactly is it that the little girl demands of her mother?" and his response that it is to get her mother with child (preferably with a boy) in order to produce evidence of her own fantasized phallism *and* to get the phallus from the (therefore phallic) mother, thus disavowing her own "castration," Irigaray addresses the following speculation:

> One might advance the hypothesis that the child who is desired in the relationship [of the girl] with the mother must be a girl if the little girl herself is in any degree valued for her femaleness. The wish for that girl child conceived with the mother would signify for the little girl a desire

26. Irigaray, *Speculum of the Other Woman*, p. 28.

to *repeat and represent* her own birth and separation of her "body" from the mother's. Engendering a girl's body, bringing a third woman's body into play would allow her to identify both herself and her mother as sexual women's bodies. As *two* women, defining each other as both like and unlike, thanks to a third "body" that both by common consent wish to be "female." This would attenuate the lack of differentiation between the daughter and the mother or the maternal function which is inevitable when the desire for origin is not referred back to a relation between a man and a woman, a relation that in turn implies a positive representation of femininity (not just maternity) in which the little girl can inscribe herself as a woman in the making.[27]

The conceptualization of a "third body" that by common wish is made female allows for a breaking down of strict hierarchy. The condition of being *both* like and unlike undermines any notion of a one-way identification and could be seen as allowing the female gaze to gain the distance of representation, distance from replication, from simple reproduction. The "woman-in-the-making" affected by the represent-ability of the "third woman" is more readily able to establish distance from the closure of an essential image of femininity. Representation is then seen as a process, rather than an unchangeable chain of images.

How could one conceive the location of the "third woman" in fashion photography? First, in the very obvious sense of the invisible triangle that is set up between the place of the maternal, the female subject's gaze, and the "third woman" of the image. The fashion photography genre creates this "third woman" as a plenitudinous ideal that can be seen as encouraging both "overidentification" in Doane's sense of the term, *and,* from Irigaray's perspective, a process of "repeating and representing" birth and separation from a mother's body that is socially encoded and biologically reinforced (or vice versa) as a sameness from whose replication the woman does not escape. Thus "overidentification" is also at the same time "exasperated" by separation and distance. What I am suggesting is that the aim of an economy of repetition can be seen as getting women to buy things, to buy a code of femininity. But there is also an economy of repetition at play that "exasperates" such aims at the same time.

Realism

> Though the parade of models is constantly changing, the gut-level reaction from their audience stays the same: women always sneak a self-comparison to a beautiful ideal. The appeal is that today's models make that critical measuring-up less of a stretch.
> —Jody Shields, "Facing the Future," *Vogue,* January 1989

27. Ibid., pp. 35-36.

The fact is, the primal scene story about the doctor's waiting room that I opened this text with is not true. Had it been, the fact that the images I would have been looking at would have been implausible objects of my identification, according to a realist schema of measurability, is irrelevant. The "self-comparison" of the above quote is described as a less than direct, but uncomplicated and achievable look. Popular arguments such as the one from *Vogue* are unmindful of the psychical/social overlap that constitutes such a look. They also, symptomatically, treat the medium as transparent. In these popular arguments, it is the models that are constantly changing and the models that are paraded in front of purportedly definable and predictable audience, to be looked at. It is the unselfconscious assumption of a realist discourse about photography that allows for the mediation of the medium to recede. Such a discourse, of course, elides the issue of the photograph's illusionism, investedness, socially naturalized status. It is disengaged from a discourse that would seek to question the way in which photographic codes produce looks, as well as the way in which socially/psychically/historically situated looks produce photographic meaning. While fashion photographs have not been elevated to what Alan Sekula refers to as the "legal status of document and testimonial," the industry itself, along with certain theoretical, critical, and journalistic discourses, trades on an implied realist discourse of naturalized referentiality, even when describing these pictures with a vocabulary of fantasy (the images as dreamlike, otherworldly, and so forth). It is not solely a question of taking less seriously the codes at play in fashion photographs, or of whether this in fact can be accomplished. It is a question of considering the complexity of interrelated looks and objects in a social context. To argue that such images can be simultaneously oppressive and enabling raises more questions than can be answered in this text. But it poses the possibility of an *in*effectiveness of intended aims, a falling short that allows for the possibility of interventionary looks that would not depend on alternative truths.

Inconclusion

There are not only unanswered questions raised by this text, there are also significant unasked questions. Questions about how these arguments would be inflected by an address to a panoply of differences and contingencies: race, class, politics, object-choice, geography, and so on. My insistence on developing an argument for a kind of resistance-in-the-making in the regard of such images would seem to downplay the significance of their manifest "content." Instead, it is to emphasize that the assumption that a resistant stance can be formulated only through the imposition of knowledge achieved from either empirical data or that which can be theorized through a social realm that lies *outside* or irrespective of the psychical is a weak one.

For resistance or intervention to become something other than an aberration that confirms in its exclusiveness that which is dominant, we need to look for fissures in the existing morphology of representation, rather than overestimate the efficacy of cultural or economic determinations, an overestimation that ironically sometimes results in an overidentification with such systems.

Rosalind Krauss

A Note on Photography and the Simulacral

In 1983 French television launched *Une minute pour une image*, a program conceived and directed by Agnès Varda. True to its title the show lasted just one minute, during which time a single photograph was projected onto the screen and a voice-over commentary was spoken. The sources of these reactions to the given photograph varied enormously—from photographers themselves to writers like Eugène Ionesco and Marguerite Duras, or political figures like Daniel Cohn-Bendit, or art critics such as Pierre Schneider to a range of respondents that one could call the man-on-the street: bakers, taxi drivers, workers in a pizza parlor, businessmen.

This very gathering of response from a wide spectrum of viewers, including those who have no special expertise in either photography or the rest of what could be called the cognate visual arts, in its resemblance to an opinion poll and its insistence on photography as a vehicle for the expression of public reaction—this technique was a continuation, whether intentional or not, of a certain tradition in France of understanding photography through the methods of sociology, and insisting that this is the only coherent way of considering it. This tradition finds its most lucid presentation in the work of the sociologist Pierre Bourdieu, who twenty years ago published his study *Un art moyen.* This title uses the notion of *moyen,* or middle, to invoke the aesthetic dimension of middling or fair as a stage between good and bad, and to mean midway between high art and popular culture; it also employs *moyen* to call up the sociological dimensions of middle class as well as distributed middle or statistical average. But before looking into Bourdieu's argument about this art for the average man, it might be well to examine a few samples of Varda's photographic showcase, to which public response was vigorous enough to warrant a morning-after publication in *Libération,* where each day following the transmission, the photograph was reproduced, its commentary forming an extended caption.

Here, for example, is a photographer's response, as Martine Frank comments on a 1958 image by Marc Riboud:

Marc Riboud

Deborah Turbeville

Are these workers from a camera factory who have been sent to amuse themselves in the country; is this a photo contest; or is it a photography class? I can't tell. In fact, as a photographer, I have always been intrigued by this image and struck by the fact that amidst all these men there is not a single woman taking a picture. What's interesting in this photo is that it puts the whole idea of photographic talent into question because in the end all these photographers find themselves in the same place, at the same moment, under the same light, before the same subject, and one could say that they all want to make the same photo. Yet, even so, among these hundreds of photos perhaps there will be one or two good ones.

Varda elicited these comments from Marguerite Duras in front of a Deborah Turbeville photograph:

> I think she's dead. I think she's fake. It's not a person; yet around the mouth there is something alive, a trace of speech. She is behind a windowpane. That's not blood in her hand, it's paint, perhaps it is the allegory of painting. No, she isn't dead. She's on top of a closed trunk or a door. There is a shipping label, perhaps it is her coffin. No, she isn't dead. No. I don't see her as a woman from my novels.

And Daniel Cohn-Bendit, faced with an image of three dancers made in Tokyo in 1961 by William Klein, began:

> The first reaction anyway is: it's frightening, it's the devil, the devil without a face. I see this hand that...that denounces...that says, uh...don't go any further...stay there, uh, there where you are. At first I

didn't understand. The man, in the end, I think that, yes, it's a man at the right who is in drag, with his little finger lifted as though he were drinking a coup of tea. It's very disturbing. By chance I came across the puddle of water that is one of the most luminous moment of this photo, brighter than all the rest of this view that has something so oppressive and fearful about it. It's really the abyss, the pits, it's...

In the *Libération* version of Cohn-Bendit's response, his comments broke off with this last "it's," this last attempt to say what it is that he's looking at, a last, though obviously not a final term to a potentially endless list of possible subjects, for this one-minute commentary contained seven candidates for what "it" is.

That, of course, does not distinguish the nature of Cohn-Bendit's reactions from those of Marguerite Duras, who for her part enunciated eight possibilities for the identity of her subject. Nor does it differ generically from the way the photographer Martine Frank approached her image, again beginning with an attempt to specify the subject before breaking into a slight reflection on the problem that so many shutterbugs in the same place might raise for the aesthetic status of photography. But what is striking in her brief meditation is that it remains in the transparent, behind-the-surface space of "it's an x or a y"— because her little cough of photo criticism is really a speculation on the photographs that one or another of these eager men might make rather than a pictorial, aesthetic consideration that reflects on the success of the very image she is now looking at, and

Marie Paule Nègre

reflects as well on its capacity to account for its own structural conditions. This commentary by means of "it's"—in the very primitivism of its character as aesthetic discourse—is, not surprisingly, even more present in the response from the men on the street.

Thus an industrialist commented on an image by Marie-Paule Nègre taken in the Luxembourg Gardens in 1979, a photograph that, to say the very least, uses the conditions of atmosphere and place to reconstitute the limitations of surface and frame within the space of the photographic subject. The businessman's remarks have a certain monotonous relation to what one has already witnessed:

It's the arrival of a train, it's the arrival of a train in a dream, a woman waits for someone and obviously makes a mistake about the person; the man she was waiting for obviously is...he isn't in the shot, he has aged, and she was waiting for someone much younger, more brilliant than the little fellow we see there...She dreams and in her dream she is also much younger, at the time when her feelings developed as she would have liked to recover them there, now. It's a dream that doesn't work out.

And finally, here is a botanist commenting on a recent image by Edouard Boubat, an homage to the Douanier Rousseau, which specifically constructs a relationship between photography and painting based on imitation:

In front of this tree, which is obviously a quinquéliba, the Crotons are of the family Croton Tiglium, and in the back you have Cecilia leaves which would lead one to the idea that the woman is called that; it's a very beautiful woman from what one can see. She is alone. She is cold because she is on a marble slab and she is filled with anxiety by all this vegetation that runs riot and could possibly threaten her, submerge her, cover her over, such that she seems to look for refuge in this kind of vault that she glimpses into and stares at.

Eduoard Boubat

In fact, within all this monotony of approach to, or judgement of, the photographic object by means of "it's," in a potentially endless taxonomy of subjects, the one notable exception is the commentary of the art critic Pierre Schneider. Speaking of a work by François Hers, he said:

François Hers

The wallpaper mural, with its motif of repeated flowers that one finds, for example, in hotel rooms, is an instant producer of insomnia. When I look at the decorations of this room I say to myself that all this, covered

over by fabric printed with a repetitive, decorative motif, becomes surface; that is, if you take the paintings by Matisse from the 1920s where he paints many interiors in perspective, with heavy pieces of furniture completely modeled in three dimensions, well, their volume disappears and the picture beccmes a play of colored surfaces that breathe because Matisse knows how to make them breathe.

This notion that the depicted object might be nothing but a pretext for the accomplishment of a formal idea—here, the play of colored surfaces—is, of course, second nature to the critic of modernist art, and so, as though by a reflex response, Pierre Schneider has recourse to this type of experience of a visual field in terms of its formal order when interrogating the photograph. But whether this makes his interrogation anymore legitimate than the other, more possibly primitive responses—the judgments according to "it's"—is a question to which we will have to return.

It is the thesis of Pierre Bourdieu that photographic discourse can never be properly aesthetic, that is, can have no aesthetic criteria proper to itself, and that, in fact, the most common photographic judgment is not about value but about identity, being a judgment that reads things generically; that figures reality in terms of what sort of thing an x or a y is—thus the repetitious judgments in terms of "it's a so-and-so" that emerge from the Varda experiment. When the judgment backs up far enough to encompass the photograph as a whole and not just its separate components, then the assignment or judgment is commonly by genre. "It's a landscape," "it's a nude," "it's a portrait." But, of course, a judgment of genre is completely transparent to the photograph's represented objects. If a photograph belongs to the type *landscape* or *portrait,* that is because the reading of its contents allow it to be recognized and classed by type. And it is the nature of these types—according to Bourdieu's assessment of photographic practice—to be ruled by the rigid constraints of the stereotype.

The experience of photography in terms of the stereotypical—which is what the "it's" judgment involves—is maintained almost without exception among the lower and less well-educated classes, whether urban or rural. Bourdieu's analysis, which begins by asking the question, "Why is photography within our culture so fantastically widespread a practice?" proceeds to the understanding that photography as an *art moyen,* a practice carried out by the average man, must be defined in terms of its social functions. These functions he sees as wholly connected to the structure of the family in a modern world, with the family photograph an index or proof of family unity, and, at the same time, an instrument or tool to effect that unity.

Simply put, families with children have cameras; single people, typically, do not. The camera is hauled out to document family reunions and vacations or trips. Its place is within the ritualized cult of domesticity, and it is trained on those moments that are sacred within that cult: weddings, christenings,

anniversaries, and so forth. The camera is a tool that is treated as though it were merely there passively to document, to record the objective fact of family integration. But it is, of course, more active than that. The photographic record is part of the point of these family gatherings; it is an agent in the collective fantasy of family cohesion, and in that sense the camera is a projective tool, part of the theater that the family constructs to convince itself that it is together and whole. "Photography itself," Bourdieu writes, "is most frequently nothing but the *re*production of the image that a group produces of its own integration."[1]

From this conclusion Bourdieu naturally goes on to discredit any notion of photographic objectivity. If the photographic image is considered to be objective, that designation occurs within an entirely tautological or circular condition: the societal need to define something as fact leads to the insistence on the utterly objective factuality of the record that is made. But, says Bourdieu, "In stamping photography with the patent of realism, society does nothing but confirm itself in the tautological certainty that an image of reality that conforms to its own representation of objectivity is truly objective."[2]

Given the narrow social functions that both promote and radically limit the photographic practice of the common man, the result is an insistent stereotyping of both photographic subjects and the way they are rendered. The photographic subject, the thing deemed worthy of being recorded, is extremely limited and repetitive. Its disposition is equally so. Frontality and centering, with their banishing of all signs of temporality or contingency, are the formal norms. Bourdieu continues:

> The purpose of a trip (like the honeymoon) lends solemnity to the places passed through and the most solemn among them lends solemnity to the purpose of the trip. The truly successful honeymoon is the couple photographed in front of the Eiffel Tower because Paris is the Eiffel Tower and because the real honeymoon is the honeymoon in Paris. One of these [honeymoon] pictures in the collection of J. B. is split right down the middle by the Eiffel Tower; at the foot is J. B.'s wife. What might strike us as barbarous or cruel is in fact the perfect carrying out of an intention.[3]

1. Pierre Bourdieu, *Un art moyen. Essal sur les usages socioux de la Photographie* (Paris: Editions de Minuit, 1965), p. 48.

2. Ibid., p. 113.

3. Ibid., p. 60.

4. Ibid., p. 60, n. 34.

And Bourdieu muses, "Conscious or unconscious? Of all the photos, this and another representing the couple in front of the Arch of Triumph are their author's favorites."[4]

Stereotypy lends to this practice a quality of allegory or ideogram. The environment is purely symbolic, with all individual or circumstantial features relegated to the background. "In J. B.'s collection," remarks Bourdieu, "nothing is left of Paris except atemporal signs; it is a Paris without history, without Parisians, unless accidentally, in short, without events."[5]

To all of those who are interested in serious or art photography or even in the history of photography with its cast of "great photographers," Bourdieu's analysis of the photographic activity of the common man must seem extremely remote. What can J. B.'s inept honeymoon snapshots, no matter how amusing their inadvertent play of sexual symbolism, have to do with serious photographic practice?[6] But this is precisely where Bourdieu's sociological approach becomes somewhat more painful, because it starts to cut closer to home. Sociologically speaking, Bourdieu claims, photography fills another function, namely that of a social index. The ubiquitous practice of these hicks with their Instamatics becomes an indicator of class or caste against which members of other classes react in order to mark themselves as different. One of the ways of expressing this difference is to abstain from taking pictures; another is to identify oneself with a special kind of photographic practice, which is thought of as different. But the notion that there is really an art photography as opposed to a primitive photography of common usage is, for Bourdieu, merely the extension of the expression of social distinctions. His feeling that art photography's difference is a sociological *effect* rather than an aesthetic reality stems from his conviction that photography has no aesthetic norms proper to itself; that it borrows its caché from the art movements with which various serious photographers associate themselves; that it borrows certain aesthetic notions from the other arts as well—notions like expressiveness, originality, singularity, and so forth—but that these notions are utterly incoherent within what purports to be the critical discourse of photography; and that, finally, most photographic discourse is not inherently different from the judgment of the common man with his Instamatic. They reduce, on the one hand, to a set of technical rules about framing, focus, tonal values, and so on, that are in the end purely arbitrary, and, on the other hand, to a discussion of genre, which is to say the judgment "it's an x or a y." Agnès Varda's experiment does nothing, of course, to disprove all of this.

5. Ibid., p. 61.

6. Roland Barthes expresses irritation with Bourdieu's approach, denying its legitimacy as a means of discussing the nature of photography, but simultaneously denying the alternative of aesthetic categories: "What did I care about the rules of composition of the photographic landscape, or, at the other end, about the Photograph as family rite?...another, louder voice urged me to dismiss such sociological commentary; looking at certain photographs, I wanted to be a primitive, without culture" [Roland Barthes, *Camera Lucida*, trans. Richard Howard (New York: Hill and Wang, 1981)].

Bourdieu's insistence that photographic discourse borrows the concepts of the high arts in vain—because that borrowing only leads to conceptual confusion—is confirmed by the intellectual discomfort that is provoked by Pierre Schneider's comparison of the François Hers photo to Matisse's painting. And Bourdieu analyzes the various aesthetic unities of the other arts to demonstrate that the mechanical nature of photography makes them inapplicable. The specter raised by Martine Frank that those hundreds of Japanese men will in fact make hundreds of identical images, insofar as it is a theoretical possibility, explodes the grounds on which there might be constructed a concept of photographic originality and, for Bourdieu, reduces all critical discussions of such originality in the photography magazines to mere cant.

Photography's technical existence as a multiple thus joins the theoretical possibility that all images taken of the same object could end up being the same image and thus partake of sheer repetition. Together these forms of multiplicity cut deeply against the notion of originality as an aesthetic condition available to photographic practice. Within the aesthetic universe of differentiation—which is to say: "this is good, this is bad, this, in its absolute originality, is different from that"—within this universe photography raises the specter of nondifferentiation at the level of qualitative difference and introduces instead the condition of a merely quantitative array of differences, as in a series. The possibility of aesthetic difference is collapsed from within, and the originality that is dependent on this idea of difference collapses with it.

Now, this very experience of the collapse of difference has had an enormous impact on a segment of the very artistic practice that is supposed to occupy an aesthetic position separate from that of photograph: the world of painting and sculpture. For contemporary painting and sculpture has experienced photography's travesty of the ideas of originality, or subjective expressiveness, or formal singularity, not as a failed version of these values, but as a denial of the very system of difference by which these values can be thought at all. By exposing the multiplicity, the facticity, the repetition, and stereotype at the heart of *every* aesthetic gesture, photography deconstructs the possibility of differentiating between the original and the copy, the first idea and its slavish imitators. The practice of the multiple, whether one speaks of the hundreds of prints pulled from the same negative or the hundreds of fundamentally indistinguishable photographs that could be made by the Japanese men—this practice has been understood by certain artists as not just a degraded or bad form of the aesthetic original. It has been taken to undermine the very distinction between original and copy.

From contemporary practice an obvious example would be the work of Cindy Sherman. A concatenation of stereotypes, the images reproduce what is already a reproduction—that is, the various stock personae that are generated by Hollywood scenarios, TV soap operas, Harlequin romances, and slick advertising. And if the subject of her images is this flattened, cardboard imita-

Cindy Sherman, *Untitled*, 1981. Courtesy of Metro Pictures.

tion of character, her execution is no less preordained and controlled by the culturally already-given. One is constantly confronted by formal conditions that are the results of institutional recipes: the movie still with its anecdotal suggestiveness, or the advertising image with its hopped-up lighting and its format dictated by the requirements of page layout.

That Sherman is both subject and object of these images is important to their conceptual coherence. For the play of stereotype in her work is a revelation of the artist herself as stereotypical. It functions as a refusal to understand the artist as a source of originality, a fount of subjective response, a condition of critical distance from a world which it confronts but of which it is not a part. The inwardness of the artist as a reserve of consciousness that is fundamentally different from the world of appearances is a basic premise of Western art. It is the fundamental difference on which all other differences are based. If Sherman were photographing a model who was not herself, then her work would be a continuation of this notion of the artist as a consciousness which is both anterior to the world and distinct from it, a consciousness that knows the world by judging it. In that case we would simply say that Sherman was constructing a critical parody of the forms of mass culture.

With this total collapse of difference, this radical implosion, one finds oneself entering the world of the simulacrum—a world where, as in Plato's cave, the possibility of distinguishing between reality and phantasm, between the actual and the simulated, is denied. Discussing Plato's dread of the simulacral, Gilles Deleuze argues that the very work of distinction and the question of how it is to be carried out characterizes the entire project of Plato's philosophy.[7] For Plato, difference is not a matter of classification, of properly separating out the various objects of the real world into genus and species, for example, but of

7. See Gilles Deleuze, *Logique du sens* (Paris: Editions de Minuit, 1969), pp. 292-307. This section on Plato appears in English as "Plato and the Simulacrum," trans. Rosalind Krauss, *October* 27 (Winter 1983), pp. 45-56.

knowing which of these objects are true copies of the Ideal Forms and which are so infinitely degraded as to be false. Everything, of course, is a copy; but the true copy—the valid limitation—is that which is truly resemblant, copying the inner idea of the form and not just its empty shell. The Christian metaphor rehearses this distinction: God made man in his own image and therefore at the origin man was a true copy; after man's fall into sin this inner resemblance to God was broken, and man became a false copy, a simulacrum.

But, Deleuze reminds us, no sooner does Plato think the simulacrum, in the *Sophist* for example, than he realizes that the very idea of the false copy puts into question the whole project of differentiation, of the separation of model from imitation. For the false copy is a paradox that opens a terrible rift within the very possibility of being able to tell true from not-true. The whole idea of the copy is that it be resemblant, that it incarnate the idea of identity— that the just man resemble Justice by virtue of being just—and in terms of this identity that it separate itself from the condition of injustice. Within this system, separations are to be made between terms on the basis of the particular condition of inner resemblance to a form. But the notion of the false copy turns this whole process inside out. The false copy takes the idea of difference or nonresemblance and internalizes it, setting it up within the given object as its very condition of being. If the simulacrum resembles anything, it is the Idea of nonresemblance. Thus a labyrinth is erected, a hall of mirrors, within which no independent perspective can be established from which to make distinctions—because all of reality has no internalized those distinctions. The labyrinth, the hall of mirrors, is, in short, a cave.

Much of the writing of poststructuralism, in its understanding of the Real as merely the effect of simulated resemblance, follows Nietzsche's attack on Platonism in which he insisted that there is no exit from this cave, except into an even deeper, more labyrinthine one. We are surrounded, it is argued, not by reality but by the reality *effect*, the product of simulation and signs.

As I have said, at a certain point photography, in its precarious position as the false copy—the image that is resemblant only by mechanical circumstance and not by internal, essential connection to the model—served to deconstruct the whole system of model and copy, original and fake, first- and second-degree replication. For certain artists and critics, photography opened the closed unities of the older aesthetic discourse to the severest possible scrutiny, turning them inside out. Given its power to do this—to put into question the whole concept of the uniqueness of the art object, the originality of its author, the coherence of the oeuvre within which it is made, and the individuality of so-called self-expression—given this power, it is clear that, with all due respect to Bourdieu, there *is* a discourse proper to photography; only, we would have to add, it is not an aesthetic discourse. It is a project of deconstruction in which art is distanced and separated from itself.

If Sherman's work gives us an idea of what it looks like to engage the photographic simulacrum in order to explode the unities of art, we might choose an example from serious "art" photography to look at the reverse situa-

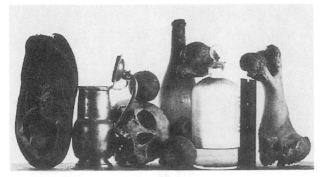

Irving Penn, *Still Life with Shoe*, 1980. Courtesy of the artist. © 1980.

tion—the attempt to bury the question of the simulacrum in order to produce the effect of art, a move that almost inevitably brings about the return of the repressed. As one of many possible examples, one might look at a recent series of still lifes by Irving Penn through which the domain of high art is self-consciously evoked by calling on the various emblemata of the *vanitas* picture or the *memento mori*—the skulls, the desiccated fruit, the broken objects that all function as reminders of the swift flight of time toward death.

But beyond this iconographic system that is copied from the world of Renaissance and baroque painting—and one has the right to ask if this is a true or a false copy—there is another aspect of the aesthetic system that Penn wishes to annex for photography, or at least for this photography. This is the combined aspect of rarity and uniqueness that a pictorial original is thought to possess in the first degree and a print made after the painting would possess only in a degraded second degree. Again one is confronted with the question of whether or not Penn's strategy for acquiring these qualities only produces a simulation of them. His strategy involves the production of opulent platinum images, contact-printed from huge negatives. The platinum, with its infinite fineness of detail, provides the sense of rarity; and the process of contact-printing, with its unmediated connection between plate and paper, gives the work a sense of uniqueness not unlike that possessed by the photogram, which then implies the further system of uniqueness of the arts of painting and drawing.

In order to obtain the size negative needed to produce these prints without the use of an enlarger, Penn turned to a particular kind of camera—an antiquated instrument called a banquet camera—which with its bellows and enormous plates would allow him to enlarge the photographed object during the very process of making the negative. This camera, invented for the recording of groups of people—whether football teams or Elks Club dinners—was also the generator of the format we see in Penn's images: a horizontally splayed rectangle whose height/width ratio is very different from that of most cameras.

Irving Penn, Clinique advertisement. Courtesy of Clinique.

But what the format of these pictures is *not* different from is the peculiar shape of the double-page spread of the slick magazine: the most opulent of the typographic theaters of mass advertising, the most luxurious print screen of the Platonic cave of a modern consumer society. Now, the double-page spread, in sumptuous, seductive color photography, is something of which Penn is a master, and for the last several years he has produced a series of still lifes for this commercial context, a series that in format, disposition of objects, frontality of composition, and shallowness of space is identical to the *memento mori* images of his own aesthetically tagged platinum prints. The work Penn has done for Clinique cosmetics, which month after month has filled facing pages in *Vogue, Harper's Bazaar,* and *Town and Country* with elegant, shallow, luminous still lifes of bottles and jars—creating a kind of centerfold of cosmetic promise—is the visual twin of its conceptual counterpart, the platinum work that speaks not of perpetual youth, but of death.

Penn's Clinique ads are photographs that are thoroughly open to the analysis by Bourdieu that we entertained earlier. They are posing as pictures of reality, marked by a straightforwardness that proclaims the supposed objectivity of the image. But they are, instead, the reality that is being projected by an advertising company, by a given product's imperative to instill certain desires, certain notions of need, in the potential consumer. The very determination to fill both facing pages with a single image and to close the visual space of the magazine against any intrusion from outside this image/screen is part of this strategy to create the reality effect, to open up the world of the simulacrum, which here means to present advertising's false copy as though it were innocently transparent to an originary reality: the effect of the real substituting for the real itself.

And if one pursues this analysis one step further, one sees how Penn's image of art—in his *memento mori* still lifes— is itself dependent on the space

of that photographic project that preceded this series for some years: the Clinique ad and its staging of visual reality. There is here no *direct* relation to a specific subject—whether one thinks of that as the eroticism of death, or the presence of art, or whatever else one determines as Penn's meaning in the platinum prints. There is, instead, an elaborate system of feedback through a network in which reality is constituted by the photographic image—and in our society that increasingly means the image of advertising and consumption—so that the art-effect is wholly a function of the photographically produced reality-effect.

Penn has turned to art undoubtedly as a means of escaping the world of commercial photography. This has happened at the same moment that the art world has turned to commercial photography as the description of the very limits of vision. Like many other photographers, Penn presumably believes that he can transcend those limits. But that belief is, clearly, tantamount to repressing the existence of the limits. And the burgeoning of Clinique's claims within Penn's "art" is the return of the repressed, one compromising the other within the system of the simulacrum.

Penn wishes to affirm photography as the proper object of criticism, which is to say, the photograph as a work of art. But, symptomatically we might say, Penn's "art photographs" are like screen-memories behind which lurk the forms and images of the primal scene: that moment—viewed with a shudder by Baudelaire in the 1850s—of art debauched by commerce.[8]

As distinct from Penn's, Sherman's work stands in an inverse relationship to critical discourse, Sherman having understood photography as the Other of art, the desire of art in our time. Thus her use of photography does not construct an object for art criticism but constitutes an act of such criticism. It constructs of photography itself a metalanguage with which to operate on the mythogrammatical field of art, exploring at one and the same time the myths of creativity and artistic vision, and the innocence, primacy, and autonomy of the "support" for the aesthetic image.

These two examples, we could say, operate at the two opposite poles of photography's relation to aesthetic discourse. But transecting the line that connects these two practices is the socio-discourse of the Varda experiment with which I began. *Une minute pour une image*, with its system of presenting the isolated photograph as an invitation for the viewer to project a fantasy narrative, and its abandonment of the notion of critical competence in favor of a kind of survey of popular opinion, occupies a position as far as possible from the rigors of serious criticism. But in taking that position

8. Baudelaire expresses his horror in terms that sound very familiar to contemporary critical thought; he invokes the supplement: "If photography is allowed to supplement art in some of its functions, it will soon have supplanted or corrupted it altogether, thanks to the stupidity of the multitude which is its natural ally" [*The Salon of 1859*, sec. 2, "The Modern Public and Photography," in *Baudelaire, Art in Paris*, trans. Jonathan Mayne (London: Phaldon, 1965), p. 154].

it raises the possibility of the utter irrelevance of such criticism to the field of photography.

The specter of this possibility hangs over every writer who now wishes to consider the field of photographic production, photographic history, photographic meaning. And it casts its shadow most deeply over the critical project that has been engaged by a growing number of writers on photography as they try to find a language with which to analyze the photograph in isolation, whether on the wall of a museum, a gallery, or a lecture hall. For, they must ask themselves, in what sense can this discourse be properly sustained, in what sense can it, as critical reflection, be prolonged beyond the simple inanity of "a minute for an image"?

This essay was originally published in *October* 31 (Winter 1981) and is reprinted here with permission of the author and MIT Press. A version of this essay was delivered as the keynote address for the National Conference of the Society for Photographic Education in Philadelphia, March 1983.

KOBENA MERCER

Mortal Coil: Eros and Diaspora in the Photographs of Rotimi Fani-Kayode

> What threatens man today is not material pleasure at all. In principle, material pleasure conflicts with the accumulation of wealth.... The accumulation of wealth leads to overproduction, whose only possible outcome is war. I am not saying that eroticism is the only remedy against the threat of poverty. Far from it. But unless we consider the various possibilities for consumption which are opposed to war, and for which erotic pleasure—the instant consumption of energy—is the model, we will never discover an outlet founded on reason.
> —George Bataille, *The Tears of Eros*[1]

EXPERIENCING THE intense beauty of the photographs Rotimi Fani-Kayode made before his death in December 1989, we encounter nothing short of an enigma. The blend of elements from African and Western sources creates a cohesive visual world out of the almost "indecipherable"[2] meeting of disparate cultural signifiers. We are compelled to look but we may never know what we are actually seeing: the plunge into uncertainty is exhilarating.

A viewer already familiar with Fani-Kayode's oeuvre would instantly recognize its allusions to the European and American modernist canon, ranging from references to painters such as Edouard Manet, René Magritte and Francis Bacon, to photographs of the male nude by George Platt Lynes or Robert Mapplethorpe. But anyone unfamiliar with Nigerian Yoruba iconography (such as myself) is strangely positioned with regards to grasping the meaning(s) it produces as a consistent and defining feature of Fani-Kayode's work. Without access to the signified, I cannot reach the referents these elements inscribe, yet the sheer affect involved is overwhelming. The last photographs, in particular, bring back a vision of the human body that is almost unbearably charged

1. George Bataille, *The Tears of Eros* [1961] (San Francisco: City Lights, 1989), p. 149.

2. Okwui Enwezor and Octavio Zaya, "Colonial Imaginary, Tropes of Disruption: History, Culture and Representation in the Works of African Photographers," *In/sight: African Photographers, 1940 to the Present*, eds. Clare Bell et al. (New York: Guggenheim Museum, 1996), p. 42.

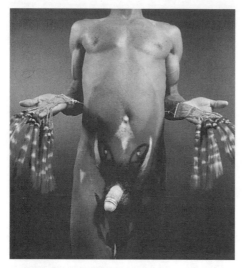

Rotimi Fani-Kayode and Alex Hirst,

Communion (II), 1989

with the feeling of having been executed in the presence of death. And yet, in tracing the passage of a body that bursts into a state of ecstasy, these images emit an aura of calm, a "tranquility of communion with the spirit world," as Robert Farris Thompson might put it, discussing the cardinal value of *ashe* in Yoruba cosmology.[3] Creating a world in which the black male body is the focal site for an exploration of the relation between erotic fantasy (sex) and ancestral memory (death), Fani-Kayode brought something new to the illumination of an ancient enigma: astonishing the gods, as novelist Ben Okri might say.[4]

Posthumously entitled *Communion* (1989), this suite of photographs, curated by Mark Sealy of Autograph: The Association of Black Photographers, was exhibited for the first time in Britain in 1996 (at Impressions Gallery, York, and Chapter Arts, Cardiff).[5] The photographs suggest a series or a sequence: but there is a puzzle because there is no script indicating a narrative order to which the photographs belong (or, indeed, whether there is one). Rotimi died, at age thirty-four, without leaving a will, much less any directions about how these photographs should be exhibited and seen.

The set includes *The Golden Phallus* (1989), an image made by Fani-Kayode in collaboration with his partner, Alex Hirst, which was widely disseminated at the time of its production. Appearing on the cover of *Ecstatic Antibodies: Resisting the AIDS Mythology*, by Tessa Boffin and Sunil Gupta (1990) and in *Critical Decade: Black British Photography in the '80s*, by David A. Bailey and Stuart Hall (1992), this individual picture has acquired a pivotal resonance of its own.[6] Deciphering its meaning, however, is made all the more complex by issues of attribution which have come to haunt its circulation and reception. Although it is

3. Robert Farris Thompson, "Black Saints Go Marching In: Yoruba Art and Culture in the Americas," *Flash of the Spirit: African and Afro-American Art & Philosophy* (New York: Vintage, 1984), p. 16.

4. See Ben Okri, *Astonishing the Gods* (London: Picador, 1996).

5. See Mark Sealy, "A Note from Outside," in Rotimi Fani-Kayode, *Communion* (London: Autograph in association with Impressions Gallery and Chapter Arts, 1996). The exhibition was presented in the context of the *africa95* arts program.

6. See *Ecstatic Antibodies: Resisting the AIDS Mythology*, eds. Tessa Boffin and Sunil Gupta (London: Rivers Oram, 1990) and *Ten. 8* s no. 2, "Critical Decade: Black British Photography in the '80s," eds. David A. Bailey and Stuart Hall (1992).

widely understood that Fani-Kayode and Hirst worked collaboratively in producing this body of work as a whole, confusion has arisen over the authorship of the individual pieces that have appeared in various permutations. The ambiguity has been compounded by the fragmented condition of its dissemination and

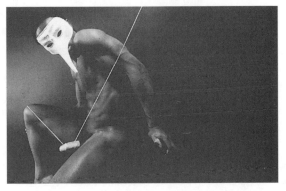

Rotimi Fani-Kayode and Alex Hirst, *The Golden Phallus*, 1989.

by the inclusion of some of the photo- graphs in Alex Hirst's solo exhibition, *The Last Supper* (Lighthouse Gallery, Wolverhampton, 1992).

Similar ambiguities surrounded the first memorial exhibition, *Rotimi Fani-Kayode, Photographer (1955-1989): A Retrospective* (1989), organized by the Friends of Rotimi Fani-Kayode, and held at London's 198 Gallery, at the top of Railton Road in Brixton, where Rotimi and Alex lived. Ever since, I have sensed that perceptions of the interracial character of Alex and Rotimi's relationship have somehow colored the way in which the aesthetics of hybridity are read off the photographs themselves. But what happens, when anxieties about interracial homosexuality are elided with the dynamics of interculturality that underpin Fani-Kayode's art, is that the edge and depth of his photographic world is misrecognized and is seen in only limited ways that obscure the broader implications of his visual *metissage*.

Reviewing critical approaches to the reading of Rotimi Fani-Kayode's work, what seems to emerge is a conceptual displacement of background and foreground. When his work is enframed by questions of identity and otherness it is subjected to a categorical either/or in which his gayness is acknowledged but his blackness can only be exotic or alien; whereas when his Africanness is recognized his homosexuality is downplayed or evaded.[7] While the identity-and-alterity couplet has played an important role in addressing art that comes from more than one kind of cultural context, it also hinders appreciation of the ways in which Diaspora artists may take their hybrid conditions of existence for granted as simply the starting point and not the terminal destination of their artistic projects.

7. Compare the differential emphasis in Emmanuel Cooper, *Fully Exposed: The Male Nude in Photography* [2nd ed.] (London and New York: Routledge, 1995); and Olu Oguibe, "Photography and the Substance of the Image," in *In/Sight: African Photographers, 1940 to the Present*, p. 236. On the other hand, the critical analysis of the work itself is entirely displaced into the background by an anxious concern over the status of Fani-Kayode and Hirst's collaborative authorship in Octavio Zaya, "On Three Counts I Am an Outsider: The Work of Rotimi Fani-Kayode," *Nka: Journal of Contemporary African Art* no. 4, (Summer 1996), pp. 24-29.

Fani-Kayode occupied multiple subject positions as a postmodern African artist, an out black gay man, and a key animateur in the field of black British photography. Although it remains crucial to recognize his ability to move between such diverse worlds as an important influence on his artistic choices, the irony is that while many critics seem beguiled by the combination of plural adjectives, identity is really the last thing that his body of work can be said to be about. The body is transfigured in Rotimi's pantheon of "smallpox gods, transsexual priests and desirable black men in a state of sexual frenzy," by an aesthetic which transforms photography into a "technique of ecstasy."[8] Filtering African and Western elements through his lens, his optic nerve brings about a heightened encounter with the emotional reality of the flesh in which it is precisely the ego's ecstatic *loss of identity* that his vision celebrates and bears witness to. The concept of identity is singularly inappropriate here because it overlooks what is most transgressive about Fani-Kayode's art: namely, its Dionysian quest to liberate the body from the ego and its obligations of identity.

Widely underrecognized during his lifetime, Fani-Kayode's artistic journey cut a path through long-standing traditions in which art and religion alike produce representations of what happens to the human being when it crosses the boundary that links sex and death. Venturing into realms where it is hard to tell where sexuality ends and where spirituality begins, Fani-Kayode was, I think, profoundly immersed in a critical inquiry into the human universality of such limit-experiences. In this essay I want to seek out alternative routes into the interpretations which the enigma of the *Communion* suite provokes.

Intercultural Spaces: After Identity and Otherness

> Is there such a thing as pure origin? For those of the postcolonial generation this is a difficult question. I'm bilingual. Because I was brought up in Lagos and London—and kept going back and forth—it is extremely difficult for me to have one view of culture. It's impossible. How do I position myself in relation to that multi-faceted experience of culture?[9]

The preceding statement, from the London-based Nigerian-British painter Yinka Shonibare, serves as a succinct distillation of the postcolonial conditions which have shaped the outlook of African artists who have lived and worked outside of Africa itself, either as exiles and expatriates or as migrant settlers and itinerant travelers who constantly shuttle between more

8. Rotimi Fani-Kayode, "Traces of Ecstasy," *Ten.8* 1 no. 28 (1988), p. 42.

9. Yinka Shonibare quoted in Kobena Mercer, "Art That Is Ethnic in Inverted Commas," *frieze* no. 25 (November-December 1995), p. 40.

than one geographical location. Once we locate his biography within the post-colonial lifeworld, and recognize the characteristic Diaspora experiences of critical displacement and dislocation, we can see that far from being unique to Fani-Kayode, such conditions have been taken for granted as ordinary, rather than as exceptional, amongst successive generations. In the case of Nigeria's artistic Diaspora, from the painter Uzo Egonu who moved to Britain in the 1940s or Taiwo Jegede based in the United Kingdom since the 1960s, to such contemporaries as Sokari Douglas Camp (London) or Ike Ude (New York), the experience of moving between cultural territories has persisted over time as a commonplace and amounts to a viable (minor) tradition as such.[10]

Born in Lagos in 1955, Rotimi Fani-Kayode grew up as a child in Africa, as an adolescent in Europe, as a young adult in America, and he returned to Britain as an artist. His father—Chief Remi Fani-Kayode—was the Balogun of life, a high priest in a city of ancestral importance in Yoruba culture. The Kayode family held the traditional title of Akire and were endowed with custodial responsibilities as Keepers of the shrine of Ifa, the Yoruba oracle. Chief Fani-Kayode also held prominent positions in Nigerian politics, for at the time of political independence in 1960 he was leader of the Opposition in the Nigerian Parliament and later became Deputy Prime Minister (Western State) in 1964, when the family moved from Lagos to Ibadan.

As a result of military coup in 1966, the Kayode family moved to England and settled in Brighton. Rotimi attended various schools in Sussex, Glouster-shire, and Somerset. He completed his studies in the United States where he took his first degree in economics and fine art at Georgetown University in 1980 while living in Washington, D.C. He then moved to New York and completed his M.A. in fine art and photography at the Pratt Institute in 1983 before returning to the U.K. later that year. He met Alex Hirst while at Brighton Polytechnic in the mid-'80s and Rotimi and Alex lived and worked together in Clapham and Brixton up to Rotimi's death in December 1989. Alex Hirst died of HIV-related causes in 1992.

During the brevity of his career, which spanned a mere six years between 1983 and 1989, Rotimi exerted prodigious energy at the intersection of the cross-cutting movements which defined the insurgent cultural politics of the '80s. His chosen focus on the male nude featured significantly in his M.A. portfolio. Often staged in an overtly performative or theatrical manner, these early experiments in color photography, such as *Batu* (c. 1984) depicting a male figure adorned with a raffia headdress, found their way into metropolitan gay culture via the weekly listings press that provided Fani-Kayode with an initial commercial outlet. Contributing images to the queer arts magazine *Square Peg*, of which Hirst was one of the founding editors, Fami-Kayode inhabited a bohemian space whose irreverence for gay orthodoxy was

10. See Olu Oguibe, *Ozu Egonu* (London: Kala Press, 1996)) and on Taiwo Jegede, see *The Artpack: A History of Black Artists in Britain* (London: Haringey Arts Council, 1988).

influenced by such precursors as Derek Jarman and Andrew Logan (with their Genet-inspired predilection for an aesthetics of homosexual baroque).

The supportive environment provided by London's gay culture, and Rotimi's integral role in its diversification, is indicated by the fact that his first collection of photographs, *Black Male/White Male* (1987), was published by Gay Men's Press (run by Aubrey Walters and David Fernbach, formerly activists who helped found the Gay Liberation Front in the U.K. in the early 1970s). Rotimi's significance in the broader dissemination of a postliberationist sexual politics was reflected in the selection of one of his images, *Stations of the Cross*, used on the cover of Jonathan Dollimore's *Sexual Dissidence* (1991).

Concurrently, Fani-Kayode played a crucial role in the black British visual arts sector. His interest in the studio-based tradition of the nude led to the opening of artistic trajectories that broke away from the predominance of documentary realism. Alongside image-text work by Joy Gregory and Roshini Kempadoo, Fani-Kayode's richly elaborated tableaux marked a new found confidence in the production of constructed imagery that helped to pluralize the scope of black photography. Moreover, considering anxieties that often inhibit artist exploration of the nude when volatile relations of "race" and representation overdetermine perceptions of the black body, his forthright interest in exploring the realm of sexuality threw a vital challenge to complacent orthodoxies that would proscribe the nude as something off limits to acceptable black art practices.

His impact on black visual culture was registered beyond photography in *Twilight City* (1989), the film by Reece Auguiste of Black Audio Film Collective, which featured a sequence enacting the photograph *Fish Vendor* (1989), and in a filmic portrait of Fani-Kayode himself, *Rage and Desire* (1990) by Rupert Gabriel. Above all, his work holds a prominent place in the spectacular culmination of the audio-visual survey of a decade of black British photography, *Recontres Au Noir* (Arles Photography Festival, 1993), not only on account of his generosity in opening up new possibilities for Diaspora aesthetics, but on account of the pivotal role he played in helping to create an infrastructural basis from which black British photography has flourished.

Fani-Kayode was a founder-member and the first chair of Autograph: The Association of Black Photographers. Formed in 1987 amongst black practitioners within commercial and funded sectors, the organization has played a key role in gaining wider commissioning and exhibition opportunities for British photographers of Caribbean, African, and South Asian descent. That it has also helped to pluralize the public sphere by creating a context for criticism and debate is tribute to the breadth of vision that Rotimi and his peers, including Sunil Gupta and Armet Francis, pursued. Advocating an initiative that challenged official discourses of multiculturalism by presenting new positions on the politics of black representation, Autograph emerged in a moment of rupture, which jumped over parochial boundaries so as to connect with broad developments that have internationalized the circulation of black

British work. It is at precisely this stage, however, that we encounter the double-edged politics of identity and difference that has come to overdetermine the reading of Fani-Kayode's work.

On the one hand, bringing together the diverse strands of his practice, his contribution to the formation of a transnational black gay culture singularly encapsulates his role as an intercultural translator. The American black gay scene had been a particularly formative influence—*Black Male/White Male* is dedicated to "Toni and the spirit of the Clubhouse, DC"—and the book contains portraits of Steadman Scribner, with whom he lived for several years while in the United States. The intimate portraits of poet Essex Hemphill and activist Denis Carney, of musician Blackberri, and of poetry-performance diva Assoto Saint, all speak of Rotimi's involvement in a moment of vibrant cultural renewal among artists who were also his friends. There is no confrontational shock effect being sought in the portraiture, but an empathic ordinariness that speaks to the way Fani-Kayode lived his gayness and blackness as integral to his mode of being in the world. But because it gained wider exposure at a time when the backlash against the new cultural politics of difference precipitated the turmoil of the U.S. culture wars, his subject matter has been misread as a mere inscription of identity politics.

An image from *Black Male/White Male* was chosen for the cover of *Tongues United* (1987), a poetry anthology featuring Isaac Jackson and Dirg Aarb-Richards, Essex Hemphill and Assoto Saint, published by Gay Men's Press. The book was taken up as the inspiration for Marlon Riggs' video *Tongues Untied* (1989), a first of its kind work which borrowed the title in an act of intertextual translation by which all cultures create themselves through acts of citation and reiteration. But when a clip from Riggs's film was then appropriated by the fundamentalist politician, Pat Buchanan, in his 1992 U.S. presidential election campaign, a further twist was added which implicated black gay cultural production in the moral panic over arts funding previously played out when Jesse Helms used the charge of obscenity against Mapplethorpe's photographs to attack the National Endowment for the Arts.[11]

Such reductive polarizations were implicit in the either/or evaluations which had earlier bedeviled Fani-Kayode's work with a misleading comparison to the photographs of Robert Mapplethorpe. Black gay artists were certainly in dialogue with Mapplethorpe's gaze: "returning the look" in films such as Isaac Julien's *Looking for Langston* (1988); playing with reversibility as Lyle Ashton Harris's self-presentation in whiteface suggested, in his *Americas* (1988) and *Confessions of a Snow Queen* (1989) series; or examining the interracial dynamics of sameness and difference more broadly, as the title of Roti-

11. The U.S. culture wars are discussed in Kobena Mercer, "Busy in the Ruins of Wretched Phantasia," *Mirage: Enigmas of Race, Difference and Desire*, ed. David A. Bailey (London: Institute of Contemporary Arts and Institute of International Visual Arts, 1995).

mi's *Black Male/White Male* had implied.[12] And yet to posit the dialogic relationship to the visual tradition of Mapplethorpe's racial fetishism as providing the only context for the appraisal of Fani-Kayode's approach to the male nude is to overlook how he lived as a black gay artist whose primary narcissism was fully intact: "he did not have an identity crisis," as Mark Sealy aptly puts it.[13]

It is not so much ironic as merely tragic that, despite numerous group shows, including *Sacred and Profane Love* (South West Arts, 1985), *Same Difference* (Camerawork, 1986), *Misfits* (Oval House, 1987) and *Transatlantic Dialogues* (Camerawork, 1989), Rotimi Fani-Kayode enjoyed only one solo exhibition in Britain during his lifetime—*Yoruba Light for Modern Living* (Riverside Studios, 1986). To what extent did this marginalization occur because of the way his supposed identity was exoticized as "other" on account of the art world's narrow view that there could only be one way of seeing the black male nude? At issue here are three interlocking issues—about institutions, intentions, and agency—which can be disentangled by rereading his 1988 essay "Traces of Ecstasy."[14]

Aware of the risk of being anthropologized by the transcultural position he was placed in with regard to the Western art world, Fani-Kayode commented that

> It is no surprise to find that one's work is shunned or actively discouraged by the Establishment. The homosexual bourgeoisie has been more supportive—not because it is especially noted for its championing of black artists, but because black ass sells almost as well as black dick...But in the main, both galleries and the press have felt safer with my "ethnic" work. Occasionally they will take on board some of the less overtly threatening and outrageous pictures—in the classical liberal tradition. But black is still only beautiful as long as it keeps within white frames of reference."[15]

Identifying the residual dominance of modernist primitivism in the institutional inertia whereby African artists are obliged to address this category simply by virtue of their ethnic origin, it was his acute analysis of this predicament that led him to define his own project as arising from a counter-narrative of rage and desire in which photography would perform a task of alchemical transformation:

12. Fani-Kayode's approach to the black male nude was discussed in Kobena Mercer, "Reading Racial Fetishism: The Photographs of Robert Mapplethorpe" and "Dark & Lovely: Black Gay Image Making," in *Welcome to the Jungle: New Positions in Black Cultural Studies* (London and New York: Routledge, 1994), pp. 210-15 and pp. 226-29.

13. Mark Sealy, "A Note from Outside," unpaginated.

14. Rotimi Fani-Kayode, "Traces of Ecstasy."

15. Ibid., p. 42

> [T]he exploitative mythologising of black virility on behalf of the homo-
> sexual bourgeoisie is ultimately no different from the vulgar objectifica-
> tion of Africa which we know at one extreme from the work of Leni
> Riefenstahl and, at the other, from the victim images which appear con-
> stantly in the media. It is now time for us to reappropriate such images
> and transform them ritualistically into images of our own creation.[16]

In diacritical response to such institutional conditions, Fani-Kayode produced the
following self-description as a mission statement to convey his artistic intentions:

> My identity has been constructed from my own sense of otherness, whether
> cultural, racial or sexual. The three aspects are not separate within me. Pho-
> tography is the tool by which I feel most confident in expressing myself. It is
> photography therefore—Black, African, homosexual photography—which I
> must use not just as an instrument, but as a weapon if I am to resist attacks
> on my integrity and, indeed, my existence on my own terms.[17]

Understanding how these positions informed his attitude to the politics of
identity is complicated, however, by the views of Alex Hirst, which changed
emphasis at different times. While Hirst's statement that Fani-Kayode "was
not interested in being seen as a 'gay' or 'black' artist and especially not as a
'black gay' artist," seems flatly contradicted by Fani-Kayode's own words, his
broader comment that Rotimi's, "approach to his work was political, but it had
no manifesto beyond an anarchic desire to create something that would shake
the established view of the world, his own included," valuably elucidates the
anti-identitarian stance they shared.[18] Such a skeptical disposition toward
fixed political alignments may be seen in the light of his family's experience of
being forced into exile as a result of political exigencies. Yet, rather than dis-
claim it, what is more compelling to consider are the ways he chose to position
his black gay identity in relation to the multiple and complex locations that
shaped his postcolonial lifeworld. As he emphatically announced:

> It has been my destiny to end up as an artist with a sexual taste for
> other young men. As a result of this, a certain distance has necessarily
> developed between myself and my origins. The distance is even greater
> as a result of my having left Africa as a refugee over twenty years ago.[19]

191

KOBENA MERCER

16. Ibid., p. 39.

17. Ibid., p. 42.

18. Alex Hirst, "Unacceptable Behaviour: A Memoir," in *Rotimi Fani-Kayode, Photographer (1955-1989): A Retrospective*, eds. Friends of Rotimi Fani-Kayode (London: 198 Gallery, 1990), unpaginated. The Friends comprised Sonia Boyce, Michael Cadette, Alex Hirst, and Margaret Procter.

19. Fani-Kayode, "Traces," p. 39.

Echoing Audre Lorde's self-description as *Sister Outsider,*[20] Rotimi fore-grounds his condition of outsideness as a liminal place of critical (dis)location which is valued for the new practices of freedom it makes possible:

> On three counts I am an outsider: in matters of sexuality, in terms of geographical and cultural dislocation; and in the sense of not hav-ing become the sort of respectably married professional my parents might have hoped for. Such a position gives me a feeling of having very little to lose. It produces a sense of personal freedom from the hegemony of convention. It opens up areas of creative enquiry which might otherwise have remained forbidden. Both aesthetically and ethically, I seek to translate my rage and my desire into new images which will undermine conventional perceptions and which may reveal hidden worlds.[21]

The paradoxical emphasis on finding one's freedom in the loss of one's origins locates his outsideness in a Diasporic condition which, far from offering the dubious comforts of minoritarian self-certainty, produces "a kind of essential conflict through which to struggle to new visions."[22] To the extent that Diaspora entailed a rupture between "myself and my origins," it can be seen as opening up an abyss out of which Rotimi tapped into the catalytic energies of rage and desire which formed the mainspring of his unique aesthetic. On this view, the dynamic equilibrium brought about by Fani-Kayode's techniques of visual interculturation can be located in the broader representational matrix formed by the historical convergence of modernism, colonialism, and Diaspora.

At the apex of this triangular relationship lies the vexed question of the mask and what it masks. This includes art histories of cultural traffic, as well as struggles over the psychic reality of the masks which Frantz Fanon spoke to in *Black Skin, White Masks,*[23] where he sought to decolonize the black body from its representation as the Other. To recontextualize Fani-Kayode's photo-graphic transfiguration—in which the body becomes a site for translation and metaphor, transporting meanings across codes of racial, cultural, and sexual difference—we can separate two strands whose interrelationship is poorly understood: the dynamic between interracial homosexuality and the aesthet-ics of interculturality. Both come together in the enigmatic function of the mask that lies at the heart of Fani-Kayode's visual world.

20. Audre Lorde, *Sister Outsider: Essays and Speeches* (Freedom, Calif.: Crossing Press, 1984).

21. Fani-Kayode, "Traces," p. 39.

22. Ibid.

23. Frantz Fanon, *Black Skin, White Masks* [1952] (New York: Grove, 1967).

The Mask and What it Masks: The Loss of Difference

> In African traditional art, the mask does not represent a material reality; rather, the artist strives to approach a spiritual reality in it through images suggested by human and animal forms. I think photography can aspire to the same imaginative interpretations of life.[24]

In the sense that the body serves as a site for exploring the relationship between the sexual and the spiritual, it is crucial to address the question of Fani-Kayode's relationship to his Yoruba sources. What we find, however, once we incorporate his self-understanding as an African artist, is that we cannot romanticize this relationship as an Afrocentric return to one's roots. In place of continuity with one's origins Fani-Kayode's critical outlook foregrounds the ruptures of Diaspora. Commenting that, "an awareness of history has been of fundamental importance in the development of my creativity," his remarks imply that far from being a naturalistic inheritance, his knowledge of Yoruba cosmology was acquired through negotiating its (mis)representation within the West as an embodiment of the exotic or the primitive. He wrote that

> In exploring Yoruba history and civilization, I have rediscovered and revalidated areas of my experience. I see parallels now between my work and that of the Osogbo artists in Yorubaland who themselves have resisted the cultural subversions of neo-colonialism and who celebrate the rich, secret world of our ancestors. It remains true, however, that the great Yoruba civilizations of the past...are still consigned by the West to the museums of "primitive" art.[25]

Aware of the ideological equivalence between the exotic and the erotic in the construction of the primitive as modernism's Other, he delineated the interstitial conditions which shaped his mediated relationship to his Yoruba sources:

> Modern Yoruba art (amongst which I would situate my own contributions) may now fetch high prices in the galleries of New York and Paris. It is prized for its exotic appeal. Similarly, the modern versions of Yoruba beliefs carried by the slaves to the New World have become, in their carnival form, tourist attractions. In Brazil, Haiti and other parts of the Caribbean, the earth reverberates with old Yoruba rhythms which are now much appreciated by those jaded Western ears which are still sensitive enough to catch the spirit of the old rites. In other words, the Europeans, faced with the dogged survival of alien cultures, and as

24. Fani-Kayode, "Traces," p. 38.

25. Ibid., p. 41.

mercantile as ever they were in the days of the Trade, are now trying to sell our culture as a consumer product. I am inevitably caught up in this.[26]

While Picasso's 1907 epiphany before the traditional African masks he encountered in the storerooms of the Trocadero Museum is a commonplace in the received narratives of Western modernism, there are two other strands to this history of interculturation that are less widely known. On the one hand, amongst artists such as Aina Onabolu in Nigeria, whose paintings date from 1906, it was paradoxically the post-Renaissance aesthetic of Western Verisimilitude that inaugurated a modernist break in African consciousness, for the artifacts which Europeans valorized for their alienness were taken by their African counterparts to epitomize mere traditionalism.[27] And on the other hand there is a third strand to the story: namely the shared fascination with African masks among black American artists of the Harlem Renaissance who were as equally alienated as Matisse or Modigliani from the indigenous meanings of such foreign objects.

Responding to Alain Locke's 1925 essay, "Legacy of the Ancestral Arts," which suggested that an alternative apprenticeship for the New Negro could be found by turning to the formal discipline of African artifacts, artists such as Palmer Hayden, in his *Fetisches et Fleurs* (1926), Malvin Johnson, in his *Self-Portrait* (1938), and Lois Mailou Jones, with her *Fetishes* (1938), all embraced the iconicity of the generic African mask.[28] As objects which had entered Diaspora consciousness mostly through Western museum collections and ethnographic photography, the mask was appropriated into Afro-American art as a touchstone for an altered identification which enunciated a Pan-African ethnicity. Indeed, acknowledging its recurrence as a distinctive visual trope, from the photomontages of Romare Bearden through to the parodic neoprimitivism of Jean-Michel Basquiat, it may be argued that by reappropriating that which was always already appropriated by the West, the mask functions in black modernism not so much to allude to Africa as it is but to an idea of "Africa" as it exists within the Diaspora imagination. It is the signifier of a lost origin reconstructed in collective memory as the presiding symbol for the production of syncretic subjectivity. Alongside other contemporary artists who share an interest in the body as it is hinged between material and spiritual worlds—such as Rene Stout's *Fetish #2* (1988), or Alison Saar's *Lazarus* (1988) in the medium of sculpture, or the *I-Traits* (1982-85) photographs by Jamaican-Chinese artist Albert Chong—the aesthetic mixity brought about

26. Ibid.

27. On Ania Onubolu, see Evelyn Nicodemus, "Inside Outside," in *Seven Stories about Modern Art in Africa*, ed. Clementine Deliss (London: Whitechapel Art Gallery, 1995), pp. 29-36.

28. See Alain Locke, "Legacy of the Ancestral Arts, in *The New Negro* [1926] (New York: Atheneum, 1977).

by Fani-Kayode's use of such elements as the mask sits full square within this Diasporic tradition.

The sightliness which thus cut across Fani-Kayode's field of vision are clearly illuminated by Stuart Hall's lucid observations in which he points out that

> The black male body becomes the locus for a number of intersecting planes of meaning. The hieratic, carefully ritualized posture of the figures, their central framing, the deliberate use of costume, body decoration, *and above all*, masks, reference Fani-Kayode's exploration of his Yoruba background...Yet this 'African' plane of reference is, almost immediately, subverted by other meanings and languages. The symbolism hovers between a public or collective, and a more private and personal, set of codes.[29] [emphasis added]

These "other meanings and languages," I would suggest, come from Fani-Kayode's mastery of mainstream Western modernism and the subcultural codes of modern gay iconography. Hall places Africa in quotation marks precisely to indicate that what is at issue is not the unconcealing of an authentic Africanity but the bringing into vision of a new and unprecedented body whose presence, so often fetishized by the difference that history has written onto the skin, is transformed in its meaning by the unresolved and open-ended inter-

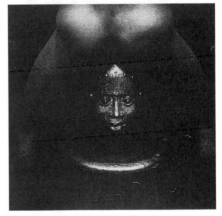

Rotimin Fani-Kayode and Alex Hirst, *Bronze Head*, 1987

play of incommensurable codes. The blindspot to the Mapplethorpe comparison is that it fails to see how the racialized dynamics of the look are radically interrupted by the auratic presence of the mask. Although it is obvious and logical that a mask deflects the exchange of direct looks (which is central to the power-laden polarities of the male gaze), it is remarkable that its presence has been overlooked. It is a central motif whose recurrence, from work such as *Ebo Orisa, Farewell to Meat (Carnavale)*, and *Bronze Head* (all 1987) the *The Golden Phallus* (1989), inscribes a carnival of condensation and displacement in the critical difference that Rotimi brings to his visual depiction of the black male body. As Hall continues:

29. Stuart Hall, in *Rotimi Fani-Kayode: A Retrospective*, op cit, unpaginated.

The faces are all "masked." In his most compelling erotic image—Technique of Ecstasy—the face, concentrated in desire, is finally hidden from the viewers' gaze. Fani-Kayode "subjectifies" the black male, and black sexuality, claiming it without making it an object of contemplation and at the same time without "personifying" it. Because the masking is not a compositional trick, but an effect drawn from another iconographical tradition, the truncation of the body condenses the visual effect, displacing it into the relation between the two figures "at rest" with the weight, the specific gravity of concentrated sexual pleasure, without translating them into fetishes.[30]

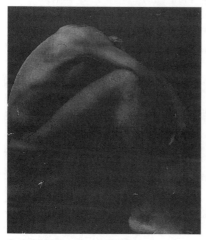

Rotimi Fani-Kayode and Alex Hirst,
Techniques of Ectasy, 1987

Whereas the scopophilic force exerted by Mapplethorpe's gaze fetishizes the black body in order to ward off a threat to the ego's loss of control, in Fani-Kayode's tableaux the viewer's look is drawn into a scenario of sexual enjoyment in which the loss of difference dissolves the ego's boundaries of self and other. Genital-centred excitement gives way to a sensation of erotic reverie and drift.

Concluding that "Rotimi has both learned from Mapplethorpe, fought him off, and brought another tradition of representation to his work,"[31] Hall's insights allow us to recognize such influences in early formalistic sketches such as *Knave of Spaces* or *Joining of Equal Forces* (1987), and also to move on to a wider view of the "other meanings and languages" that Fani-Kayode plays with. *White Bouquet* (1987), for example, is a queer Diasporic parody of Manet's *Olympia* (1863). Through a point by point reversal of the painting's racial and gendered positions, it playfully suggests a subtextual homoeroticism in the original (between white courtesan and her black female maid); and by perverting the copy, which shows a white man offering flowers to a black man who reclines on a couch, it subverts the gesture of withholding into a reciprocal exchange of gifts (as the prone body presents its rear).

In contrast to the phallic *jouissance* prompted by Mapplethorpe's fixation on the visible difference of black skin, which uses interraciality to excite the

30. Ibid., p. 21.

31. Quoted in Derek Bishton, "A Black British Photographer," in *Rotimi Fani-Kayode & Alex Hirst: Photographs*, eds. Mark Sealy and Jean Loup Pivin (Paris: Editions Reveue Noir, 1997), p. 69.

sharply defined subject-object polarities of the look (thereby substituting racialized positions in a masculinist fantasy of mastery staged around the possession or lack of the phallus), Fani-Kayode quietly steps outside the Manichean absolutism that often accompanies the Catholicism that was part of Mapplethorpe's Irish-American ethnic background. Because black bodies are coupled and contextualized in Rotimi's vision, the loss of difference arising in the *petit mort* of sexual pleasure is infused not with the terror of castration but with a sublime depth of feeling that reveals sexuality as something both animal and divine. Returning to *Techniques of Ecstasy* (1987), which refers to the expressive homoeroticism of Francis Bacon's *Two Figures* (1957), we can see how Fani-Kayode's approach to the ecstatic dissolution of the ego differs from that of gay artists working in a monocultural tradition alone. The frenzied liquidation of boundaries in Bacon's radical loss of self is here becalmed in a state of postcoital triste.[32] Commenting on how this picture came about, Alex Hirst reveals how hybridity was integral to their working methods:

> *Techniques of Ecstasy* [stems from] the idea that the babalawo (father of the secrets or priest) goes into an ecstatic trance in order to communicate with the god. Rotimi and I understood the artist to be doing something parallel to that and also, on a more jokey level, we wanted to show that two black men can have sex as a means of communicating with the spirits.[33]

As a limit-experience in which the feeling of self gives way to something that is not self, the "I" plunges outside its being and the relation of self and other is torn apart. The subject crosses over into a state of nonbeing that, for thinkers like Georges Bataille, is likened to death.[34] Fani-Kayode's photographic vision embraces a pictorial classicism that evinces his mastery of Western art historical traditions of the male nude, yet his interest in the way AIDS transformed equations of sex and death was grounded in the temporal specificities of his time. This needs to be borne in mind considering his complex relationship to Yoruba spirituality which his key statement from "Traces of Ecstasy" expresses:

> My reality is not the same as that which is often presented to us in western photographs. As an African working in a western medium, I try to bring out the spiritual dimension in my pictures so that concepts of reality become ambiguous and are opened to re-interpretation. This requires what Yoruba priests and artists call a technique of ecstasy.[35]

32. See Ernst van Alpern, *Francis Bacon and the Loss of Self* (London: Reaction, 1992).

33. Alex Hirst, interview with Rupert Gabriel, in Alex Hirst, *The Last Supper: A Creative Farewell to Rotimi Fani-Kayode* (Wolverhampton: Lighthouse Gallery, 1992), p. 8.

34. See George Bataille, *Eroticism: Death and Sensuality* [1960] (San Francisco: City Lights, 1986).

35. Fani-Kayode, "Traces," p. 38.

When he says that "my reality is not the same," far from implying an essential self behind the mask, I take him to mean that his contingent conditions of existence led him to an artistic position in which the ritual function of the mask presaged the transformation of reality. Art was his life-affirming motivation for examining the relationship between ancestral memory (death) and erotic fantasy (sex). It may be pointed out that there is nothing ordinary about being the gay son of a high priest who was also a member of the political aristocracy. And yet, far from rebelling against his background, he overcame the feared loss of love that his individual difference might bring to his fate, by honoring his Yoruba traditions in the most postmodern way imaginable. As Hirst revealed, almost comically, their inspiration for works such as *Technique of Ecstasy* came from stories encountered in ethnographic texts such as Suzanne Wegner's "A Life with the Gods." In other words, the natives had to become what they were by reading the anthropologists!

Although the man in the pictures is often Rotimi himself, his work is not about an autobiographical or confessional self because the use of the mask foregrounds the "I" over the "me." By depolarizing the ego's boundaries, what results is the sensation of "hovering" between two worlds that Hall described. It is the oscillation activated by this "fugitive aesthetic"[36] that delivers the viewer's response to a liminal place of voluptuous indeterminacy. Worldly codifications of difference are freed up by movement *between* the fixed polarities—sacred and profane, masculine and feminine, Africa and Europe—which have anchored the messy edges of human corporeality to the social obligations of identity.

It is therefore crucial to recognize that, as well as an elegiac vision of transience, there is the laughter of a trickster's mischief that flows from the freedom Rotimi found in the abyss that opened between "myself and my origins." In *Milk Drinker* (1987) a man drinks eagerly from a gourd, a cultural artifact whose presence connotes Mother Africa. And while the overflowing milk makes the container a metonymic symbol of the maternal breast—the Kleinean good object *par excellence*—the gourd is also a penis, and a connotation of fellatio inescapably arises by virtue of the way it looms above the mouth as if it belonged to a saint or a god. Interposed between gods and mortals, the mask serves a limbic or gateway function which does not conceal a "true" self (as masquerade in Western traditions often assumes), but rather serves to liberate heterogeneous elements from the psyche. As Hirst elucidates one of Fani-Kayode's key works, *Bronze Head* (1987), we realize that the task is to de-anthropologize the interpretative enigma. Knowledge of Yoruba codes, although necessary, does not fix the meaning or arrest the ambiguity of the image but expands critical awareness of the psychic realities which the image communicates:

36. The concept of a fugitive aesthetic in African American music and literature is developed by Nathaniel Mackey, "Other: From Noun to Verb," *Representations* no. 39, (Summer 1992).

In *Bronze Head* Rotimi is 'giving birth' to an Ife bronze. Ife, the cradle of an ancient Yoruba culture, is also his city of origin. The head, ori, which for the Yoruba is the seat of the spirit, orisha, represents a god. Symbolically, the artist is transforming his old culture into contemporary terms, having understood that the old values no longer "work" but still have power as archetypes. Also, he is presenting his rear-end, a traditional affront to the powers that be. The image contains the idea of the head as a "higher phallus," penetrating and fecundating the artist. Although a man, destined to penetrate the depths of the unconscious, here the artist is also a feminine "receiver" who is fertilized by it and thus able to bring forth a "son" of God.[37]

The mask configured in *Bronze Head* thus reveals what Freud called the universal bisexual disposition of the human psyche, reaching a view not only shared by Yoruba beliefs but echoed by James Baldwin when he wrote:

> [We] are all androgynous, not only because we are all born of a woman impregnated by the seed of a man but because each of us, helplessly and forever, contains the other—male in female, female in male, white in black, black in white. We are part of each other.[38]

Of the many orisha evoked in Fani-Kayode's depiction of acts of propitiation— the gift by which the protection of the gods is requested—there is a strong sense in which Eshu Elegba, the orisha of fate, chance and indeterminacy who inhabits a place of crossroads, pervades the oeuvre as a whole. This is because Eshu, "the childless wanderer, alone, moving only as a spirit," is the messenger of all the gods as well as "the imperative messenger-companion of the devotee."[39] In an earlier exhibition, in which he presented *Abiku* (1988)—the changeling or protean spirit-child of Yoruba mythology here shown with a caul around his neck— Fani-Kayode illuminated the logic of his visual thinking by showing how human laws of sexual difference are overturned by the sexual *in*difference of the gods:

> Esu presides here, because we should not forget him. He is the Trickster, the Lord of the Crossroads, sometimes changing the signposts to lead us astray. At every masquerade (which is now sometimes called Carnevale—a farewell to flesh for the period of fasting) he is present, showing off his phallus one minute and crouching as though to give

37. Alex Hirst, "Unacceptable Behaviour: A Memoir," (unpaginated).

38. James Baldwin, "Here Be Dragons," in *The Price of the Ticket: Collected Non-Fiction 1948-1985* (New York: St. Martins, 1985), p. 685.

39. Robert Farris Thompson, "Black Saints Go Marching In: Yoruba Art and Culture in the Americas," p. 19.

birth the next. He mocks us as we mock ourselves in masquerade. But while our mockery is joyful, his is potentially sinister. In Haiti is known and feared as Baron Samedi. And now we fear that under the influence of Esu's mischief our masquerade children will have a difficult birth or will be born sickly. Perhaps they are abiku—born to die. They may soon return to their friends in the spirit world, those whom they cannot forget. We see them here beneath the caul of the amniotic sac or with the umbilical cord around their neck or wrist. We see their struggle for survival in the face of great forces. Esu's phallus enters the brain as if it were an asshole. He drags birth from the womb by means of a chain gangling from his own rectum. These are examples of his "little jokes." These images are offered now to Esu because he presides here. It is perhaps through him that rebirth will occur.[40]

Numerous homosexual artists have visited this liminal place of gender hybridism. The more relevant precursors to Rotimi's project would be the Trinidad-born Geoffrey Holder, whose *Adam* (1980) reworks the Biblical creation-myth of Genesis, or George Platt Lynes, whose *Birth of Dionysus* (1935-39) drives from a reinterpretation of Greek myth through surrealist photomontage. Patriarchal religions may harbor the male fantasy of a god whose birth occurs without women, but the idea of rebirth often calls sexual difference itself into question. The quest for renewal enters a psychically androgynous zone which Audre Lorde called "a resource within each of us that lies in a deeply female and spiritual plane, firmly rooted in the power of our unexpressed or unrecognized feeling," when she put forward the view that "the erotic is a measure between the beginning of our sense of self and the chaos of our strongest feelings."[41] This pansexualist view was voiced in the *Black Male/White Male* introduction, when Alex Hirst wrote:

Male: in which the female-fantasy is ever present, even in remaining unseen. No threat in these images but only a delicious vulnerability, learned from our mothers and our sisters. [We] see no women here, but I don't feel I've swaggered into one of those gloomy men-only places where tired infibulators can relax and get away from their responsibilities for a night, while they marvel at themselves in the full-length mirrors.[42]

40. Rotimi Fani-Kayode, "Abiku—Born to Die," in *The Invisible Man,* eds. Kate Love and Kate Smith (London: Goldsmiths' Gallery, 1988) (unpaginated).

41. Audre Lorde, "Uses of the Erotic: The Erotic as Power," in *Sister Outsider: Essays and Speeches,* p. 53 and p. 54.

42. Alex Hirst, "Introduction" in Rotimi Fani-Kayode, *Black Male/White Male* (London: Gay Men's Press, 1987), p. 3.

Grounded in an implicitly political critique of gay masculinism, Alex and Roti-mi's collaborative project in *Bodies of Experience/Every Moment Counts* (1989) led them to investigate the spiritual realm as the fulcrum of their syncretic turn. Against the grain of AIDS activism as such, the aim of their journey into was to ask what art could do to "produce spiritual antibodies to HIV." And as they put it:

> There is nothing easy or straightforward about it. [We] have drawn on transcultural and trans-historical techniques to offer our response to a phenomenon which is specific only in terms of the individuals it affects here and now. We (happen to) have been inspired in this by ancestral African, ecclesiastical, and contemporary "Western"/erotic images. HIV has forced us to deal with dark ambiguities. Where better to look for clues than in the secret chambers of African shrines, the sumptuous ruins of Coptic and Eurasian temples, and the boarded-up fuck rooms of the American dream. In the European "Dark Ages" faith in ancestral values ensured a survival of sorts until a time of rebirth or enlighten-ment (resurrection was a good idea even then).[43]

While their apparently poetic rather than political stance appeared controver-sial, in a context where AIDS activism had seen mourning and militancy as either/or responses,[44] we can come to the photographs of the *Communion* suite with a view to unraveling the broader question of rebirth or resurrection as it is envisaged in their transfiguration of the body which, in the code-switching of their visual syncretism, transmits a cool glow of almost angelic indeterminacy.

Eshu Dionysus: Love Will Tear Us Apart (Again)

A nude black male sits in a darkened space and looks out to us across the viewing plane. His masked face is obscured by a bird-like visage painted in white, and his penis, painted gold, is suspended on a piece of string, creating diagonal lines that bisect the axis of his gaze. Hirst eloquently describes the picture's aims:

> *The Golden Phallus* is there to show that we were dealing with issues of stereotyped black male sexuality, linked to issues of AIDS, but not direct-ly. We wanted to challenge [this idea that black men are studs—The Phal-lus]. The gold makes the dick the center of attention but the string shows the burden is too much to live up to. It's a very subversive picture.[45]

43. Rotimi Fani-Kayode and Alex Hirst, "Metaphysick: Every Moment Counts," in *Ecstatic Antibodies: Resisting the AIDS Mythology*, p. 78 and p. 80.

44. See Douglas Crimp, "Mourning and Militancy," *October* no. 43 (Winter 1987); and Lee Edelman, "The Mirror and the Tank: 'AIDS,' Subjectivity and the Rhetoric of Activism," in *Homographesis: Essays in Gay Literary and Cultural Theory* (London and New York: Routledge, 1994).

45. Alex Hirst, in *The Last Supper*, p. 10.

Indeed, *The Golden Phallus* gains visual power by deploying syncretism to subvert any attempt to master its plural meaning(s). The two isolated body parts—penis and head—entail elements of Yoruba color symbolism and the use of animal forms: but what is the nature of their relationship to the stereotype? Discussing the untranslatable concept of *ashe* as "the power-to- make-things-happen," which is identified as the substance of God, Olorun, who "is neither male nor female but a vital force," Robert Farris Thompson examines conceptions of beauty and character in Yoruba aesthetics.[46] "Artistic signs communicating this noble quality, *iwa*, are often white," he says, adding that

> A main focus of presentation of ideal character (*iwa rere*) in Yoruba art is the human head, magnified and carefully enhanced by detailed coiffure or headgear...According to traditional authority, shrines of the head also conceal an allusion to a certain perching bird. This is the "bird of the head" (*eiye ororo*) enshrined in whiteness, the color of *iwa*, and in purity. It is the bird which God places in the head of man or woman at birth as the emblem of the mind. The image of the bird of mind fuses with the image of the coming down of God's *ashe* in feathered form.[47]

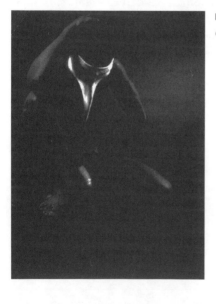

Rotimi Fani-Kayode and Alex Hirst,
Communion (I), 1989.

46. Robert Farris Thompson, "Black Saints Go Marching In: Yoruba Art and Culture in the Americas," p. 5.

47. Ibid., p. 11.

Insofar as the white bird's elongated beak visually rhymes with the gold penis at the center of the field of vision a contrapuntal dynamic of similarity and difference is established. Recalling the symbolism of the head as a "higher phallus" that was seen in *Bronze Head,* it may be suggested that *The Golden Phallus* deploys the mask in order to seek protection against the historically material force of the gaze that appropriates the black penis as the *objet petit a* that is fixed in colonial fantasy to secure the *jouissance* of the Other "who is also the Master," as Fanon would say.[48] Engaging the mind/body dichotomy of racial fetishism, the picture could also be read as the ultimate answer-word to Mapplethorpe's *Man in Polyester Suit* (1980) as it changes the terms of the conversation about what the black penis supposedly symbolizes.

Fani-Kayode and Hirst are operating in the psychic terrain described by Fanon when he experienced the look that comes from the place of the Other— "Look, a Negro!"—as a violently shattering force in which "I found I was an object among other objects."[49] Because the black body has already been objectified into a *symbol* that represents, for the West, all this is not self, the colonized subject cannot constitute its ego on the basis of the neutral bodily schema ordinarily identified with in the mirror stage. Instead of mutual recognition, Fanon says that "when I had to meet the white man's eyes [a]n unfamiliar weight burdened me," namely the "legends, stories, history" by which colonial racism perceives the body as the locus of absolute otherness. Hence, "assailed at various points, the corporeal schema crumbled, its place taken by a racial epidermal schema...I was responsible at the same time for my body, for my race and for my ancestors."[50] The burden of having to represent the Other, so that someone else's Self may be constituted by antithesis, means that the Negro does not have an Other of its own. Like the structural position of the woman, whose lack defines the power and plenitude that possession of the penis confers on the man, when the black male body is colonized by the symbolic duty of *being* the phallus, rather than merely *having* it, access to subjectivity is annulled because one is already the signifier of the Other's desire and therefore cannot have a desire of one's own. Where the phallus is the signifier of desire, the Other *is* it to the extent that she or he *does not have* it: or as Fanon puts it: "one is no longer aware of the Negro, but only of a penis; the Negro is eclipsed. He is turned into a penis. He *is* a penis."[51]

48. Frantz Fanon, *Black Skin, White Masks,* p. 138.

49. Ibid., p. 109.

50. Ibid., p. 110 and p. 112.

51. Ibid., p. 170.

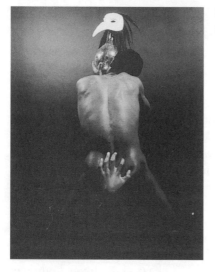

Rotimi Fani-Kayode and Alex Hirst,
Communion (III), 1989.

The existential dilemma that arises from this dialectic of being and having results in the torment of an impossible identification with the object of the Other's desire. The black penis is overburdened with the symbolic weight of too much meaning, or as Clyde Taylor has put it, in the context of the 1994 *Black Male* exhibit:

> The psychic sickness of America is such that everyone, White Man, White Woman (and Black Woman too), wants to tell the Black Man what they would do if they had his penis.[52]

The trouble is, however, that the black male subject himself does not know what to do with it either because he does not even enjoy the possession of his own penis—it has always been already appropriated into the master code of the symbolic as the prize signifier of absolute difference. It was precisely a political desire to liberate black masculinities from this no-win situation, where self-definition which fixates on the phallus can only confirm the symbolic control of the master's power, that Essex Hemphill expressed in his poem "Black Machismo":

> When his big black dick/ is not erect/ it drags behind him,/ a heavy, obtuse thing, his balls and chains/ clattering, making/ so much noise/ I cannot hear him/ even if I want to listen.[53]

52. Clyde Taylor, "The Game," in *Black Male: Representations of Masculinity in Contemporary Art*, ed. Thelma Golden (New York: Whitney Museum of American Art/Abrams, 1994), p. 168.

53. Essex Hemphill, *Ceremonies: Prose and Poetry* (New York: Plume, 1992).

On this view, *The Golden Phallus* is gold because gold symbolizes a universal standard of absolute value which governs the fetishism of commodity exchange. Because gold functions as a signifier of material desire (and, like the phallus, is the symbolic measure by which all differences are evaluated) its presence in the photograph is to condense the history of commodification through which the black male body was colonized into a double-bind: black men can only be valued or desired for their bodies in a Manichean world in which the mind/body split already devalues the body as the symbol of the Other's undesirable ontology. Gold thus turns to lead as history unleashed the violence of castration against the weight it condemned us to carry between our legs: "balls and chains," indeed.

And yet, instead of *sturm und drang* in rage and resentment at history's cruelty, which crucified black male bodies in a Lacanian knot where the signifier claims its pound of flesh, *The Golden Phallus* produces a structure of feeling in which the mask protects the shrine of the mind and casts the body in cool repose.

Elsewhere, in *Sonponnoi* and *Babaoluaye* (both 1987), Fani-Kayode invoked the smallpox god Obaluaiye, and he worked with a deep interest in the homeopathic logic of the pharmakon, whereby poison and cure may share an identical substance—the critical difference depends on finding the right equilibrium. In that the white ororo bird may signify an appeal to Osanyin, the orisha of herbal medicines, the prophylactic role of the white mask may be illuminated by Farris Thompson's observations in which he states:

Rotimi Fani-Kayode and Alex Hirst, *Communion (IV)*, 1989.

Birds, especially those connoting the ashe of "the mothers," those most powerful elderly women with a force capable of mystically annihilating the arrogant, the selfishly rich, or other targets deserving of punishment, are often depicted in bead embroidery clustered at the top of special crowns worn by Yoruba kings, signifying that the king rules by mastering and participating in the divine command personified by them. The veil that hangs across the wearer's face protects ordinary men and women from the searing gaze of the king in a state of ritual unity with his forebears.[54]

54. Robert Farris Thompson, "Black Saints Go Marching In: Yoruba Art and Culture in the Americas," pp. 7-8.

Is the black man in The Golden Phallus protecting himself from our desire to look or is he protecting us from his own gaze which is in contact with a divine power? It is the undecidability that unsettles our response. While it has been noted that "the averted gaze of the models enhances the sense of reverential calm,"[55] the underlying complexity of the syncretic code-switching which engenders this aesthetic effect in Fani-Kayode's visual world also produces a further critical difference that has been so far overlooked: namely, the absence of the mortified body that lies at the heart of Christianity. Examining *Communion* may bring us to a provisional answer.

Although *The Golden Phallus* was first exhibited in *Every Moment Counts/Bodies of Experience,* (which featured nudes adorned with flowers in a mise-en-scène reminiscent of the Sicilian ephebes depicted by Baron Wilhelm von Gloeden), the recurrence of key elements suggests it has pivotal interpretative importance in the *Communion* suite as a whole. There is an alternate version, in which the masked figure crouches with a downcast gaze, despondently contemplating his penis; an image in which the head is cropped, and the gold penis becomes the nose of a horned animal (an antelope?) painted onto the pubis and torso, with the model's upturned hands showing the feathery red tassels of a beaded waistband. To these are added a shot in which the model is seen from behind, holding the white bird-like mask on top of a glass jar above his head, with another man's hand emerging from between his buttocks to grasp his cheeks; and, finally, a frontal view showing the figure with the lower-body painting of the animal form and the gold penis clasping a black horsetail fly-wisk to this chest, as his head, which is concealed by the white mask, is thrown back sharply to reveal his opened mouth.

Without a script to plot their relationship, the five images nonetheless imply the sequential depiction of an act that is being performed in a time-based ritual. Because the potential sequence has not been narrativised by authorial intentions, we are obliged to travel through a more circuitous route in order to arrive at an idea of what this act might be. It seems to me that the *absence* of the crucified body supplies a clue. With the exception of *Crucifix* (1987) and the image of Rotimi himself that appeared in Hirst's memorial work *The Last Supper* (1992)—of which Alex said, "After he died I found the Crucifixion picture, which I had forgotten about. It had been a joke—a naked dread posing as 'Our Lord'—but it was much more poignant after his death"[56]—it is strikingly unusual that such an iconic way of seeing is missing from Fani-Kayode's field of vision.

Portrayals of the male nude within the symbology of the crucifixion can be seen as a significant point at which the visual codes of African Diaspora culture and of Euro-American gay culture converge, producing different meanings out

55. Mark Sealy, "A Note from Outside," (unpaginated).

56. Alex Hirst, in *The Last Supper,* p. 6.

of a shared interest in what the body-in-pain can be made to say. Once we consider the central role that depictions of a "black Christ" have played amongst visual artists of the African American Diaspora, where the spectacular suffering of the body-in-pain is implicated in the broader Afro-Christian envisioning of redemption, we are confronted by yet another enigma: namely, the absence of the sadomasochistic dynamic that makes the crucified body an equally central point of reference within the homoerotic imagination of the West. Although the accoutrements of sadomasochism are present in works such as *Punishment and Reward* (1987), and a black man strapped into a leather harness contemplates a mask in the *Every Moment Counts,* the Christian belief in the redemptive power of pain is not. In this regard we may observe how Fani-Kayode's syncretic transgression opens fugitive lines of flight that bypass the polarities of difference on which the tragic view of human desire depends.

In the light of the previous discussion of the black phallus, the recurrence of the crucified body in African American art—from Aaron Douglas's *The Crucifixion* (1927), through David Hammon's *Injustice Case* (1970), to the skinless and skeletal bodies of Jean-Michel Basquiat's paintings, such as *Untitled* (1981)—may be taken to imply a tragic vision of black desire. Where history has condemned our bodies to be overburdened with more meanings than any mortal could ever hope to bear, the sacrificial scapegoat represented in "the nude of pathos" can be understood to expresses a belief that freedom can be found only in death.[57] Discussing configurations of pain in Basquiat's work to reveal how they speak "the anguish of sacrifice," bell hooks insightfully reads the masochistic emphasis on self-immolation as a distinctly masculinist response that remains unreconciled with "a world of blackness that is female."[58]

On the other hand, revisiting the question of femininity in male homosexuality, Kaja Silverman identifies the volitional suffering chosen in ecstatic masochism as a complex and subtle strategy that subverts phallocentrism's gendered equations of passive and active aims.[59] Similarly, following Bataille's view that what eroticism transgresses is precisely the subject-object dichotomy from which identity and difference arise, Leo Bersani reveals the primacy of masochism in sexual pleasure *tout court*. He suggests that because "the self which the sexual shatters provides the basis on which sexuality is associated with power," gay sadomasochism entails a radical *dis*-identification with patriarchal power: it involves a transvaluation of powerlessness as a source of exuberant self-shattering.[60] Once we situate Fani-Kayode's body of work

57. See Kenneth Clarke, "Pathos," *The Nude* [1956] (Harmondsworth: Penguin, 1987).

58. bell hooks, "Altars of Sacrifice," *Art in America* (June 1993), p. 74.

59. See Kaja Silverman, *Male Subjectivity at the Margins* (London and New York: Routledge, 1992), especially chapters 5 and 7.

60. Leo Bersani, "Is the Rectum a Grave?" *October* no. 43, p. 218. See also, Leo Bersani, *The Freudian Body: Psychoanalysis and Art* (New York: Columbia University Press, 1986).

in the purview of Jonathan Dollimore's summation of this far-reaching debate, new light is shed on the Dionysian "nude of ecstasy" which we see in the *Communion* suite:

> On the one hand is the yearning to compensate for the loss which haunts desire, to overcome or redeem a loss experienced as unwelcome, unbearable, yet seemingly unavoidable (the Aristophanes myth). This is the drive towards unity. On the other hand there is the yearning to become lost: to annihilate the self in ecstasy: to render oblivious the self riven by, constituted by, loss. This is the drive to undifferentiation (Schopenhauer, Freud, Bataille). Now an attempt to flee that sense of separation and incompletedness, a wish for difference without pain, for unity, identity, and selfhood, through union with the other; now a desired, even willed loss of identity in which death is metaphor for, or fantasized or the literal event guaranteeing, the transcendence of desire.[61]

To the extent that this enables us to recognize how the cruciform body resonates in gay culture as masochism's life-risking symbol of self-shattering desire, and in Diaspora culture as a site in which the redemptive transformation of the pain experienced in being shattered by the Other finds transcendence in death, both are circumscribed by Christianity's injunction to identify with the self-sacrifice that is displayed on the cross. The *Communion* photographs, alternatively, deliver us to a place that is beyond good and evil: although the gift relationship of propitiation involves an act of sacrifice, the relationships between humans and gods at issue in the values of beauty, character, and *ashe* do not entail self-sacrifice as such but the humility of honoring the memory of ancestral dead. Is this the reason why we can find no trace of self-pity or guilt in Rotimi's work?

Bataille reminds us that the sexual is but one route into the realm of the sacred, itself a word derived from the verb "to sacrifice," and spiritual belief systems often overlap when the loss brought about by death is held to lead to renewal. Yoruba-derived religious systems, such as candomble in Brazil, vodun in Haiti, and Santeria in Cuba, or syncretic forms of Afro-Christian revelation such as glossolalia, or speaking in tongues, involve psychic states such as the trance in which the elective loss of self enables the loa or orisha to descend. Nonetheless, it strikes me as suitably ironic that the awe-inspiring ex-stasis of the postcolonial body depicted in *Communion* can be clarified by the (ethnocentric) views of art historian Kenneth Clark. Moving from the nude of pathos and the nude of energy to discuss the nude of ecstasy in the poses and movement of Greek art, "which expressed more than physical abandonment, which were in fact images of spiritual liberation or ascension, achieved through the Thiasos or processional dance," his remarks vividly

61. Jonathan Dollimore, "Sex and Death," *Textual Practice* 9 no. 1 (1995), p. 48.

encapsulate the dynamism of the final image in which the masked man's head is thrown back with mouth agape and the camera's shutter-speed traces the fugitive movement of his indecipherable levitation:

In the nude of energy the body was directed by will. In the nude of ecstasy the will has been surrendered and the body is possessed by some irrational power; so it no longer makes its way from point to point by the shortest and most purposeful means, but twists and leaps, and flings itself backwards, as if trying to escape from the inexorable, ever-present, laws of gravity. The nudes of ecstasy are essentially unstable.[62]

Offering his view of Michelangelo's drawings, including *Risen Christ* (c. 1532) which dates from "a period in his life when the physical beauty of the antique world had laid its strongest enchantment on him, and seemed to have been reborn in the person of Tommaso Cavalieri [his patron]," Clark not only (inadvertently) reveals the centrality of homoerotic desire to the West's most cherished self-representations of the sacred, but (equally unwittingly) provides us with an enhanced understanding of the pagan joy of Rotimi Fani-Kayode's syncretic aesthetic, which I would therefore describe as somewhat Afro-Greek:

Like all Dionysiac art they celebrate the uprushing of vital forces break-ing through the earth's crust. For the nude of ecstasy is always a *sym-bol of rebirth*. Of all the themes which [his Christian meditations] suggested, *none was more apt for pagan interpretation* than that of the slain God emerging from the tomb. Iconographic tradition had shown him only half awake from the trance of death; but Michelangelo imag-ined him as the embodiment of liberated vitality. A finished study of the risen Christ is perhaps the most beautiful nude of ecstasy in the whole of art. The thrown back head, the raised arms, the momentary pose, the swirl of drapery, are all those of the old Dionysiac dancers.[63]

In the sense that Yoruba orisha and Hellenic gods are brought into a dance that encircles death with a vital desire for rebirth, Rotimi and Alex's shared lifework brings a new interpretative challenge to the ways we perceive the relationship of sex and death. Their aim was not to answer this ancient enig-ma for once and for all time, but to enhance our awareness of ecstasy as a sov-ereign moment in "the ruined fabric of the shattered human"[64] which has the

62. Kenneth Clark, *The Nude,* pp. 264-266.

63. Ibid., p. 296, p. 297, and p. 298.

64. Wilson Harris, quoted in Ann Walmsely, *The Caribbean Artists Movement, 1966-1972: A Literary and Cultural History* (London: New Beacon, 1992), p. 174 and p. 176. The concept of "sovereignty" is developed by George Bataille, *The Accursed Share,* Vol. III [1976] (New York: Zone Books, 1991).

potential to bring forth renewal from the loss of the self. This is the beauty of their creative gift. Remembering his partner, Alex Hirst shares insights into the wonder which contemporary art and imagination has acquired by way of Rotimi's journey of exilic regeneration, when he wrote that

> It is important to know that he kept faith with many of the values which his background had given him. Leaving Africa as an exile at the age of eleven meant that he was haunted for the rest of his life by a desire to get to grips with certain mysteries he had glimpsed there: in the traditions and beliefs of his ancestors. He tried to make sense of them in the context of a dislocated world. Brighton and school in the English countryside was obviously quite different from that of Lagos and Ibadan. He never really considered returning to Nigeria permanently, although he visited it often during the seventies and early eighties. In any case, Nigeria was in his imagination.[65]

65. Alex Hirst, "Unacceptable Behaviour: A Memoir," (unpaginated).

CHRISTIAN METZ

Photography and Fetish

To BEGIN I will briefly recall some of the basic differences between film and photography. Although these differences may be well known, they must be, as far as possible, precisely defined, since they have a determinant influence on the respective status of both forms of expression in relation to the fetish and fetishism.

First difference: the spatio-temporal size of the *lexis*, according to that term's definition as proposed by the Danish semiotician Louis Hjelmslev. The lexis is the socialized unit of reading, of reception: in sculpture, the statue; in music, the "piece." Obviously the photographic lexis, a silent rectangle of paper, is much smaller than the cinematic lexis. Even when the film is only two minutes long, these two minutes are *enlarged*, so to speak, by sounds, movements, and so forth, to say nothing of the average surface of the screen and of the very fact of projection. In addition, the photographic lexis has no fixed duration (= temporal size): it depends, rather, on the spectator, who is the master of the look, whereas the timing of the cinematic lexis is determined in advance by the filmmaker. Thus on the one side, "a free rewriting time"; on the other, "an imposed reading time," as Peter Wollen has pointed out.[1] Thanks to these two features (smallness, possibility of a lingering look), photography is better fit, or more likely, to work as a fetish.

Another important difference pertains to the social use, or more exactly (as film and photography both have many uses) to their principal legitimated use. Film is considered as collective entertainment or as art, according to the work and to the social group. This is probably due to the fact that its production is less accessible to "ordinary" people than that of photography. Equally, it is in most cases fictional, and our culture still has a strong tendency to confound art with fiction. Photography enjoys a high degree of social recognition in another domain: that of the presumed real, of life, mostly private and family life, birthplace of the Freudian fetish. This recognition is ambiguous. Up to

1. Peter Wollen, "Fire and Ice," *Photographies* 4 (1984).

a point, it does correspond to a real distribution of social practices: people do take photographs of their children, and when they want their feature film, they do go to the movies or watch TV. But on the other side, it happens that photographs are considered by society as works of art, presented in exhibitions or in albums accompanied by learned commentary. And the family is frequently celebrated, or self-celebrated, in private, with super-8 films or other nonprofessional productions, which *are* still cinema. Nevertheless, the kinship between film and collectivity, photography and privacy, remains alive and strong as a social myth, half true like all myths; it influences each of us, and most of all the stamp, the look of photography and cinema themselves. It is easy to observe—and the researches of the sociologist Pierre Bourdieu,[2] among others, confirm it—that photography very often primarily means souvenir, keepsake. It has replaced the portrait, thanks to the historical transition from the period when long exposure times were needed for true portraits. While the social reception of film is oriented mainly toward a show-business-like or imaginary referent, the real referent is felt to be dominant in photography.

There is something strange in this discrepancy, as both modes of expression are fundamentally *indexical,* in Charles Sanders Pierce's terms. (A recent, remarkable book on photography by Philippe Dubois is devoted to the elaboration of this idea and its implications.[3]) Pierce called indexical the process of signification (*semiosis*) in which the signifier is bound tot he referent not by a social convention (= "symbol"), not necessarily by some similarity (= "icon"), but by an actual contiguity or connection in the world: the lightning is the index of the storm. In this sense, film and photography are close to each other, both are *prints* of real objects, prints left on a special surface by a combination of light and chemical action. This indexicality, of course, leaves room for iconic aspects, as the chemical image often looks like the object (Pierce considered photography as an index *and* an icon). It leaves much room for symbolic aspects as well, such as the more or less codified patterns of treatment of the image (framing, lighting, and so forth) and of choice or organization of its contents. What is indexical is the mode of production itself, the principal of the *taking.* And at this point, after all, a film is only a series of photographs. But it is more precisely a series with supplementary components as well, so that the unfolding as such tends to become more important than the link of each image with its referent. This property is very often exploited by the narrative, the initially indexical power of the cinema turning frequently into a realist guarantee for the unreal. Photography, on the other hand, remains closer to the pure index, stubbornly pointing to the print of what *was,* but no longer *is.*

2. Pierre Bourdieu, *Un art Moyen, Essai sur les usages socioux de la photographie* (Paris: Editions de Minuit, 1965).

3. Philippe Dubois, *L'acte photographique* (Paris and Brussels: Nathan and Labor, 1983).

A third kind of difference concerns the physical nature of the respective signifiers. Lacan used to say that the only materialism he knew was the materialism of the signifier. Whether the only one or not, in all signifying practices the material definition is essential to their social and psychoanalytic inscription. In this respect—speaking in terms of set theory—film "includes" photography: cinema results from an addition of perceptive features to those of photography. In the visual sphere, the important addition is, of course, movement and the plurality of images, of shots. The latter is distinct from the former: even if each image is still, switching from one to the next creates a *second movement,* an ideal one, made out of successive and different immobilities. Movement and plurality both imply *time,* as opposed to the timelessness of photography, which is comparable to the timelessness of the unconscious and of memory. In the auditory sphere—totally absent in photography—cinema adds phonic sound (spoken words), nonphonic sound (sound effects, noises, and so forth), and musical sound. One of the properties of sounds is their expansion, their development in time (in space they only irradiate), whereas images construct themselves in space. Thus film disposes of five more orders of perception (two visual and three auditory) than does photography, all of the five challenging the powers of silence and immobility which belong to and define all photography, immersing film in a stream of temporality where nothing can be *kept,* nothing stopped. The emergence of a fetish is thus made more difficult.

Cinema is the product of two distinct technological inventions: photography, and the mastering of stroboscopy, of the Ø-effect. Each of these can be exploited separately: photography makes no use of stroboscopy, and animated cartoons are based on stroboscopy without photography.

The importance of immobility and silence to photographic *authority,* the nonfilmic nature of this authority, leads me to some remarks on the relationship of photography with death. Immobility and silence are not only two objective aspects of death, they are also its main symbols, they *figure* it. Photography's deeply rooted kinship with death has been noted by many different authors, including Dubois, who speaks of photography as a "thanatography," and, of course, Roland Barthes, whose *Camera Lucida*[4] bears witness to this relationship most poignantly. It is not only the book itself but also its position of enunciation which illustrates this kinship, since the work was written just after (and because of) the death of the mother, and just before the death of the writer.

Photography is linked with death in many *different* ways. The most immediate and explicit is the social practice of keeping photographs in memory of loved beings who are no longer alive. But there is another real death which each of us undergoes every day, as each day we draw nearer our own death. Even when the person photographed is still living, that moment when she or he *was* has forever vanished. Strictly speaking, the person *who has been photographed*—not the total person, who is an effect of time—is dead: "dead

4. Roland Barthes, *Camera Lucida,* trans. Richard Howard (New York Hill and Wang, 1981).

for having been seen," as Dubois says in another context.[5] Photography is the mirror, more faithful than any actual mirror, in which we witness at every age, our own aging. The actual mirror accompanies us through time, thoughtfully and treacherously; it changes with us, so that we appear not to change.

Photography has a third character in common with death: the snapshot, like death, is an instantaneous abduction of the object out of the world into another world, into another kind of time—unlike cinema, which replaces the object, after the act of appropriate, in an unfolding time similar to that of life. The photographic *take* is immediate and definitive, like death and like the constitution of the fetish in the unconscious, fixed by a glance in childhood, unchanged and always active later. Photography is a cut inside the referent, it cuts off a piece of it, a fragment, a part object, for a long immobile travel of no return. Dubois remarks that with each photograph, a tiny piece of time brutally and forever escapes its ordinary fate, and thus is protected against its own loss. I will add that in life, and to some extent in film, one piece of time is indefinitely pushed backwards by the next: this is what we call "forgetting." The fetish, too, means both loss (symbolic castration) and protection against loss. Peter Wollen states this in an apt simile: photography preserves fragments of the past "like flies in amber."[6] Not by chance, the photographic art (or acting, who knows?) has been frequently compared with shooting, and the camera with a gun.

Against what I am saying, it could of course be objected that film as well is able to perpetuate the memory of dead persons, or of dead moments of their lives. Socially, the family film, the super-8, and so forth, to which I previously alluded, are often used for such a purpose. But this pseudosimilarity between film and photography leads me back, in a paradoxical way, to the selective kinship of photography (not film) with death, and to a fourth aspect of this link. The two modes of perpetuation are very different in their effects, and nearly opposed. Film gives back to the dead a semblance of life, a fragile semblance but one immediately strengthened by the wishful thinking of the viewer. Photography, on the contrary, by virtue of the objective suggestions of its signifier (stillness, again) maintains the memory of the dead *as being dead.*

Tenderness toward loved beings who have left us forever is a deeply ambiguous, split feeling, which Freud has remarkably analyzed in his famous study, "Mourning and Melancholia."[7] The work of mourning is at the same time an attempt (not successful in all cases: see the suicides, the breakdowns) to survive. The object-libido, attached to the loved person, wishes to accompa-

5. Dubois, *L'acte photographique*, p. 89.

6. Wollen, "Fire and Ice."

7. Sigmund Freud, "Mourning and Melancholia," in *The Standard Edition of the Complete Psychological Works of Sigmund Freud*, trans. James Strachey (London: Hogarth Press and the Institute of Psycho-Analysis, 1953-1974), vol. 14.

ny her or him in death, and sometimes does. Yet the narcissistic, conversation instinct (ego-libido) claims the right to live. The compromise which normally concludes this inner struggle consists in transforming the very nature of the feeling for the object, in learning progressively to love this object *as dead*, instead of continuing to desire a living presence and ignoring the verdict of reality, hence prolonging the intensity of suffering.

Sociologists and anthropologists arrive by other means at similar conceptions. The funeral rites which exist in all societies have a double, dialectically articulated signification: a remembering of the dead, but a remembering as well *that they are dead*, and that life continues for others. Photography, much better than film, fits into this complex psycho-social operation, since it suppresses from its own appearance the primary marks of "livingness," yet nevertheless conserves the convincing print of the object: a past presence.

All this does not concern only the photographs of loved ones. There are obviously many other kinds of photographs: landscapes, artistic compositions, and so forth. But the kind on which I have insisted seems to me to be exemplary of the whole domain. In all photographs, we have this same act of cutting off a piece of space and time, of keeping it unchanged while the world around continues to change, of making a compromise between conservation and death. The frequent use of photography for private commemorations thus results in part (there are economic and social factors, too) from the intrinsic characteristics of photography itself. In contrast, film is less a succession of photographs than, to a large extent, a destruction of the photograph, or more exactly of the photograph's power and action.

At this point, the problem of the space off-frame in film and in photography has to be raised. The fetish is related to death through the terms of castration and fear, to the off-frame in terms of the look, glance, or gaze. In his well-known article on fetishism,[8] Freud considers that the child, when discovering for the first time the mother's body, is terrified by the very possibility that human beings can be "deprived" of the penis, a possibility which implies (imaginarily) a permanent danger of castration. The child tries to maintain its prior conviction that all human being have the penis, but in opposition to this, what has been seen continues to work strongly and to generate anxiety. The compromise, more or less spectacular according to the person, consists in making the seen retrospectively unseen by a disavowal of the perception, and in *stopping the look*, once and for all, on an object, the fetish—generally a piece of clothing or underclothing—which was, with respect to the moment of the primal glance, near, just prior to, the place of the terrifying absence. From our perspective, what does this mean, if not that this place is positioned off-frame, that the look is framed close by the absence? Furthermore, we can state that the fetish is taken up in two chains of meaning: metonymically, it alludes to the contiguous place of the lack, as I have just stated; and metaphorically,

8. Freud, "Fetishism," *S. E.*, vol. 21.

according to Freud's conception, it is an equivalent of the penis, as the primordial displacement of the look aimed at replacing an absence by a presence—an object, a small object, a part object. It is remarkable that the fetish—even in the common meaning of the word, the fetish in everyday life, a re-displaced derivative of the fetish proper, the object which brings luck, the mascot, the amulet, a fountain pen, cigarette, lipstick, a teddybear, or pet—it is remarkable that it always combines a double and contradictory function: on the side of metaphor, an inciting and encouraging one (it is a pocket phallus); and, on the side of metonymy, an apotropaic one, that is, the averting of danger (thus involuntarily attesting a belief in it), the warding off of bad luck or of the ordinary, permanent anxiety which sleeps (or suddenly wakes up) inside each of us. In the clinical, nosographic, "abnormal" forms of fetishism—or in the social institution of the striptease, which pertains to a collective nosography and which is, at the same time, a progressive process of framing/deframing—pieces of clothing or various other objects are absolutely necessary for the restoration of sexual power. Without them nothing can happen.

Let us return to the problem of off-frame space. The difference which separated film and photography in this respect has been partially but acutely analyzed by Pascal Bonitzer.[9] The filmic off-frame space is *étoffé*, let us say "substantial," whereas the photographic off-frame space is "subtle." In film there is a plurality of successive frames, of camera movements, and character movements, so that a person or an object which is off-frame in a given moment may appear inside the frame the moment after, then disappear again, and so on, according to the principle (I purposely exaggerate) of the *turnstile*. The off-frame is taken into the evolutions and scansions of the temporal flow: it is off-frame, but not off-film. Furthermore, the very existence of a sound track allows a character who has deserted the visual scene to continue to mark her or his presence in the auditory scene (if I can risk this quasi-oxymoron: "auditory" and "scene"). If the filmic off-frame is substantial, it is because we generally know, or are able to guess more or less precisely, what is going on in it. The character who is off-frame in a photograph, however, will never come into the frame, will never be heard—again a death, another form of death. The spectator has no empirical knowledge of the contents of the off-frame, but at the same time cannot help imagining some off-frame, hallucinating it, dreaming the shape of this emptiness. It is a projective off-frame (that of the cinema is more introjective), an immaterial, "subtle" one, with no remaining print. "Excluded," to use Dubois's term, excluded once and for all. Yet nevertheless present, striking, properly fascinating (or hypnotic)—insisting on its status as *excluded* by the force of its absence *inside* the rectangle of paper, which reminds us of the feeling of lack in the Freudian theory of the fetish. For Barthes, the only part of a photograph which entails the feeling of an

9. Pascal Bonitzer, "Le Hors-champ subtil," *Cahiers du cinéma* 311 (May 1980).

off-frame space is what he calls the *punctum*, the point of sudden and strong emotion, of small trauma; it can be a tiny detail. This *punctum* depends more on the reader than on the photograph itself, and the corresponding off-frame it calls up is also generally subjective; it is the "metonymic expansion of the *punctum*."[10]

Using these strikingly convergent analyses which I have freely summed up, I would say that the off-frame effect in photography results from a singular and definitive cutting off which figures castration and is figured by the "click" of the shutter. It marks the place of an irreversible absence, a place from which the look has been averted forever. The photograph itself, the "in-frame," the abducted part-space, the place of presence and fullness—although undermined and haunted by the feeling of its exterior, of its borderlines, which are the past, the left, the lost: the far away even if very close by, as in Walter Benjamin's conception of the "aura"[11]—the photograph, inexhaustible reserve of strength and anxiety, shares, as we see, many properties of the fetish (as object), if not directly of fetishism (as activity). The familiar photographs that many people always carry with them obviously belong to the order of fetishes in the ordinary sense of the word.

Film is much more difficult to characterize as a fetish. It is too big, it lasts too long, and it addresses too many sensorial channels at the same time to offer a credible unconscious equivalent of a lacking part-object. It does *contain* many potential part-objects (the different shots, the sounds, and so forth), but each of them disappears quickly after a moment of presence, whereas a fetish has to be kept, mastered, held, like the photograph in the pocket. Film is, however, an extraordinary activator of fetishism. It endlessly mimes the primal displacement of the look between the seen absence and the presence nearby. Thanks to the principle of a *moving cutting off*, thanks to the changes of framing between shots (or within a shot: tracking, panning, characters moving into or out of the frame, and so forth), cinema literally *plays* with the terror and the pleasure of fetishism, with its combination of desire and fear. This combination is particularly visible, for instance, in the horror film, which is built upon progressive reframings that lead us through desire and fear, nearer and nearer the terrifying place. More generally, the play of framings and the play with framings, in all sorts of films, work like a striptease of the space itself (and a striptease proper in erotic sequences, when they are constructed with some subtlety). The moving camera caresses the space, and the whole of cinematic fetishism consists in the constant and teasing displacement of the cutting line which separates the seen from the unseen. But this game has no end. Things are too unstable, and there are too many of them on the screen. It is not simple—although still possible, of course, depending on the character of each

10. Barthes, *Camera Lucida*, p. 45.

11. Walter Benjamin, "A Short History of Photography," trans. Phil Patton, in *Classic Essays on Photography*, ed. Alan Trachtenberg (New Haven, Conn.: Leete's Island Books, 1980).

spectator—to stop and isolate one of these objects, to make it able to work as a fetish. Most of all, a film cannot be *touched*, cannot be carried and handled: although the actual reels can, the projected film cannot.

I will deal more briefly with the last difference—and the problem of belief-disbelief—since I have already spoken of it. As pointed out by Octave Mannoni,[12] Freud considered fetishism the prototype of the cleavage of belief: "I know very well, *but....*" In this sense, film and photography are basically similar. The spectator does not confound the signifier with the referent, she or he knows what a *representation* is, but nevertheless has a strange feeling of reality (a denial of the signifier). This is a classical theme of film theory.

But the very nature of *what* we believe in is not the same in film and photography. If I consider the two extreme points of the scale—there are, of course, intermediate cases: still shots in films, large and filmlike photographs, for example—I would say that film is able to call up our belief for long and complex dispositions of actions and characters (in narrative cinema) or of images and sounds (in experimental cinema), to disseminate belief; whereas photography is able to fix it, to concentrate it, to spend it all at the same time on a single object. Its poverty constitutes its force—I speak of a poverty of means, not of significance. The photographic effect is not produced from diversity, from itinerancy or inner migrations, from multiple juxtapositions or arrangements. It is the effect, rather, of a laser or lightning, a sudden and violence illumination on a limited and petrified surface: again the fetish and death. Where film lets us believe in more things, photography lets us believe more in one thing.

In conclusion, I should like to add some remarks on the use of psychoanalysis in the study of film, photography, theater, literature, and so on. First, there are presentations, like this one, which are less "psychoanalytic" than it might seem. The notion of "fetish," and the word, were not invented by Freud; he took them from language, life, the history of cultures, anthropology. He proposed an *interpretation* of fetishism. This interpretation, in my opinion, is not fully satisfactory. It is obvious that is applies primarily to the early evolution of the young *boy*. (Incidentally, psychoanalysts often state that the recorded clinical cases of fetishism are for the most part male.) The fear of castration and its further consequence, its "fate," are necessarily different, at least partially, in children whose body is similar to the mother's. The Lacanian notion of the *phallus*, a symbolic organ distinct from the penis, the real organ, represents a step forward in theory; yet it is still the case that within the description of the human subject that psychoanalysis gives us, the male features are often dominant, mixed with (and as) general features. But apart from such distortions or silences, which are linked to a general history, other aspects of Freud's thinking, and various easily accessible observations which confirm it, remain fully valid. These include: the analysis of the fetishistic

12. Octave Mannoni, "Je sais bien mais quand même...," *Clefs pour l'imaginaire; ou, L'autre scène* (Paris: Seuil, 1969).

nature of male desire; in both sexes the "willing suspension of disbelief" (to use the well-known Anglo-Saxon notion), a suspension which is determinant in all representative arts, in everyday life (mostly in order to solve problems by half-solutions), and in the handling of ordinary fetishes; the fetishistic pleasure of framing-deframing.

It is impossible to *use* a theory, to "apply" it. That which is so called involves, in fact, two aspects more distinct than one might at first believe: the intrinsic degree of perfection of the theory itself, and its power of suggestion, of activation, of enlightenment *in another field* studied by other researchers. I feel that psychoanalysis has this power in the fields of the humanities and social sciences because it is an acute and profound discovery. It has helped *me*—the personal coefficient of each researcher always enters into the account, despite the ritual declaration of the impersonality of science—to explore one of the many possible paths through the complex problem of the relationship between cinema and photography. I have, in other words, used the theory of fetishism as a fetish.

Psychoanalysis, as Raymond Bellour has often underscored, is contemporary in our Western history with the technological arts (such as cinema) and with the reign of the patriarchal, nuclear, bourgeois family. Our period has invented neurosis (at least in its current form), *and* the remedy for it (it has often been so for all kinds of diseases). It is possible to consider psychoanalysis as the founding myth of our emotional modernity. In his famous study of the Oedipus myth, Lévi-Strauss has suggested that the Freudian interpretation of this myth (the central one in psychoanalysis, as everybody knows) could be nothing but the last variant of the myth itself.[13] This was not an attempt to blame: myths are always true, even if indirectly and by hidden ways, for the good reason that they are invented by the natives themselves, searching for a parable of their own fate.

After this long digression, I turn back to my topic and purpose, only to state that they could be summed up in one sentence: film is more capable of playing on fetishism, photography more capable of itself becoming a fetish.

13. Claude Lévi-Strauss, chap. 11, "La structure des mythes," in *Anthropologie structurale*, (Paris: Plon, 1958); translated as *Structural Anthropology* (New York: Basic Books, 1963).

This essay was originally published in *October* 34 (Fall 1985) and is reprinted here with permission of the author and MIT Press. An earlier version was delivered at a conference on the theory of film and photography at the University of California, Santa Barbara, in May 1984.

Kathy Myers

Selling Green

In Britain, a new vogue in advertising appeared at the end of the 1980s. The words "nature" and "environmentally friendly" began to crop up with increasing frequency. New Zealand lamb is hand-reared by "Mother Nature." Timotei hair conditioner contains "natural" herbs, and woolen sweaters breathe "naturally." Nor is this phenomenon confined to "natural" products: AEG washing machines offer to look after our underwear and "the environment," and Subaru announces that its hatchback cars are "environmentally friendly."

How has this come about? Did advertisers discover a "back to nature" appeal two decades too late? Not quite, but what was once considered to be a parochial, folksy conservation movement is now being seriously reconsidered by advertisers faced with a western world in the process of "going Green." Green politics has suddenly become big business, and everybody from the Prime Minister to the industrial oligopolies of Lever Brothers and Proctor and Gamble wants to cash in on it.

How to sell Green politics is, however, a matter of considerable debate. Green pressure groups have never been at the forefront of the "image business," preferring to rely on old-fashioned forms of communication, like leaflet drops, pamphleteering, flyer-posting, and the occasional advertisement in a sympathetic magazine. These forms of communication are now regarded as quaint, out of touch with a modern world, where the medium is the message and the shoppers of tomorrow are weaned on high-tech video and Hollywood production values.

Most notably, Green publicity to date has been characterized by a remarkable resistance to the photograph. And, of course, it is the use of the photograph that characterizes much of contemporary advertising. The reasons for the resistance to photography as a legitimate form of expression in Green advertising are threefold.

First, many alternative groups believe that photography is a waste of economic resources. These groups have been hard pressed for cash, subsisting on voluntary donations and small local government grants, and advertisements

featuring color photographs are expensive to make and to place in magazines. Second, the photography and lush design associated with advertising are thought to run counter to the philosophy behind the Green movement. Green sympathizers have always positioned themselves on the margins of the consumer economy. Green advertising reflects a preference for the natural and homemade through the use of simple type design and a recourse to graphics and line illustration rather than photography. Their belief is that a straightforward approach is more appropriate than the slick persuasion tactics associated with contemporary advertising.

Third, there is a belief that advertising should just "tell the facts." It should be a transparent and innocent form of communication. Unlike most contemporary advertising, Green publicity does not offer the advertisement as a source of visual pleasure in its own right. The photograph—tined, teased, colored, and molded to sell a product—is seen as indulgent and dishonest.

Although this approach has served the Green movement well over three decades, a broader perspective is needed to reach a wider public.

Finding out how to talk to would-be-Greens, without alienating the die-hard Greens, was the subject of a unique conference held in London at the Marriott Hotel, January 1989. There, politicians and representatives from the government's Department of the Environment rubbed shoulders with delegates from Mobil Oil, ICI Chemicals, Coca-Cola, Saatchi and Saatchi Advertising, Greenpeace, Friends of the Earth, and a host of other ecology conservation groups.

The community of interest among these groups was described in the conference brochure as "The Eleventh Commandment—or how to search for and exploit Green Market opportunities." In one of the opening speeches, Dorothy Mackenzie from the Brand New Product Development Company clarified the issue: "Meeting the needs of the Green Consumer and exploiting the opportunities offered by a change in attitude and values represents [*sic*] for many companies the biggest challenge of the 1990s." According to the latest round of market research from "Brand New," there are at least three groups of Green consumers.

The smallest but most influential group is the Bright Greens. This group is made up of the original environmental political activists, people who either belong to the Green Party or to ecological organizations like Greenpeace and Friends of the Earth. The second, and by far the biggest group, is the Pale Greens. It accounts for the bulk of the British population and addresses ecological issues from a personal point of view. Pale Greens are concerned with family health, wholesome foods, and clean air and water.

Finally, Turquoise Greens represent the right wing of public concern. These are often affluent people interested in traditional values and preserving England as a green and pleasant land. They include Mrs. Thatcher and NIM-BYs (Not In My Back Yarders), people who are against any infringement on their land, environment, and leisure pursuits.

Between them, these three groups are estimated to account for 70 percent of the British population. A recent survey indicated that, in addition, nine out of ten British citizens were at least "concerned" about the environment and ecological issues. As the "Who Is the Green Consumer" report concluded: "Manufacturers with brands which could have poor environmental consequences should not be panicked into action; however, ignoring the problem could be a risky approach....The Green Consumer who is influenced by ecological concerns is very much with us and there will be more of them."

So how have manufacturers and advertisers set about talking to these important consumer groups? Agencies are well aware that invocations of social success and sex appeal simply will no longer do. Nor can they expect today's high-tech consumer to embrace the unsophisticated values espoused by traditional ecology groups. British advertising is still finding its way, but it is possible to detect certain trends in the efforts to target diverse Green interests.

Bright Green Advertising

What differentiates Bright Greens from other Greens is their attitude toward consumption, and their own advertising reflects this. Bright Greens who align themselves with active ecological groups such as Greenpeace believe that we abuse the world's resources not only by the way we consume, but also by virtue of consuming too much. Bright Greens blame this "galloping consumption" for much of the world's problems. As the recently published *Green Consumer Guide* put it: "One area where we are spending increasing amounts of money is on consumer durables. They accounted for less than 4 percent of our expenditure in the early 1950s compared with more than 11 percent in the 1980s."

Bright Greens are anti-high-tech. They believe that even the paper used for advertisements should be recycled. They consider that advertising should be as straightforward and factual as possible and that fancy photographs and high production costs are a waste of raw materials. But it is also true to say that the activist ecological groups that Bright Greens belong to operate on a financial shoestring and out of economic necessity must keep costs down. This style is exemplified by the Green and the Labour parties' own advertisements. An abrupt, factual style of writing conveys the dangers facing the planet and invites readers to "do" something about it. Friends of the Earth ask "How many skin cancers must aerosols cause before you join us?" using typography and layout reminiscent of a wartime government information bulletin. A crude graphic montage depicts the "enemy" as an aerosol can. The heroes, Friends of the Earth, invoke our fear of illness and death to rally us to their sides. It is as if in the war of defending the planet, the advertiser has no time for the frills and flourishes traditionally used to make advertisements seductive. In equally polemical tones, the Labour Party says "Toxic waste, acid rain, sewage on the beaches. That's not what I want my children to thank me for."

Pale Green Advertising

How to combine a simple ecological message with sophisticated advertising imagery is the problem facing advertisers who wish to talk to the Pale Greens. The Pale Green Consumer, as far as market definitions go, comprises the majority of people in Britain. They are the sort of people who are "into" health but not into direct political action, who are worried about the ozone layer and skin cancer but find the greenhouse effect a difficult concept to grasp. *The Green Consumer*, a market-research guide, warned advertisers to produce "a more normal progressive, sophisticated image which can be communicated with easygoing entry points for action. Overt 'Green-ness' could become unattractive and undesirable."

The difference in Bright Green and Pale Green advertising statements can be seen by comparing two petrol ads. Both are for unleaded petrol, but each adopts a different tone. The first, "Caring for tomorrow's quality of life," appeared in *The New Statesman,* a newspaper that expresses overt liberal, left-wing, and Green Party sympathies. The do-it-yourself graphic style of the advertisement is in keeping with the Green Party and Labour Party advertisements in the newspaper. In this context, "graphic" and "home-drawn" symbolize a no-fuss, "responsible" attitude to advertising. It conveys the message that Esso understands the concerns of its target market.

The second ad—in which the phrase "Ecologically Sound" is conflated with "Economically Sound"—is reserved and conservative in its choice of image, typography, and design yet obeys many of the conventions of mainstream advertising. Because it appeared in a car magazine and was aimed at the "average" motorist, the ad does not address its reader from the point of view of ecology, but from the point of view of thrift. Its message: "Now, thanks to Mr. Lawson [the Chancellor of the Exchequer for the British government], it makes even more sense to switch to unleaded petrol."

Advertisers were initially very tentative about addressing the Pale Green Consumer, although many have made concessions in this direction. Elida Gibbs, a company that makes a range of toiletries, has put a discrete "Ozone Friendly" sticker on its aerosol canisters. Tesco supermarkets, while still offering the traditional range of brands, offer the consumer a choice about whether to "Go Green" or not. This choice extends to recyclable packaging, chlorofluorocarbon gas-free aerosols, organically grown vegetables, and health-information packs. Tesco's competitor, Safeways, has produced its own range of information packs, such as a booklet warning consumers about food additives and pesticides. On the face of it, much Pale Green advertising looks like any other mainstream promotion. An ad for Sensiq makeup, for example, shows a beautiful model, rendered in sepia tones, reclining against a sunny rock. Against this brown-and-white world is a hint of color: the color of Sensiq. It could be any other fashion statement were it not for the discreetly printed copy that gives the brand its Green credentials: "Free of known sensitizers. No fragrances. No cruelty [to animals in testing]. And no inflated prices." Along

detail: Shell
advertisement.

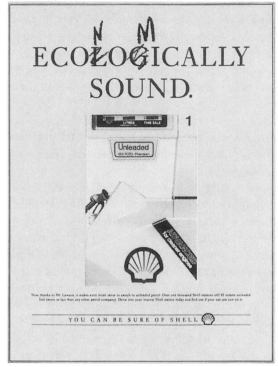

detail: Esso
advertisement.

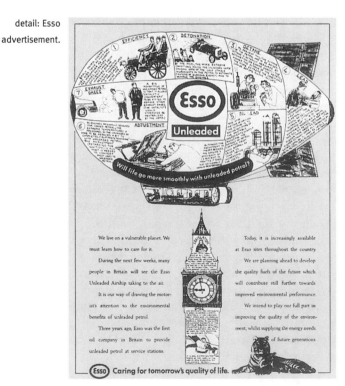

these lines, ads for wool and New Zealand lamb emphasize the natural, the personal, and the body. The issue being addressed is what will this brand do for you: how can a "natural product" improve your life?

Turquoise Green Advertising

The address to the Turquoise Greens is quite different. Unlike the Bright Greens, who view ecology in terms of politics, or the Pale Greens, who see it in terms of personal health, the Turquoises see "Green-ness" in terms of conservation of comfort and privilege. Turquoises are by far the most affluent group. They buy expensive products and live in lavish houses in the professional belts around Britain's major cities. Turquoises have their roots in the mud of the home-county 'Shires, where an arcadian, almost pre-industrial vision of England can still be captured. Turquoise advertising is to be found in lush color magazines and in newspaper supplements such as *The Observer, The Sunday Times,* and *The Independent.*

An advertisement for the Subaru Justy is a good example of Turquoise sensibilities. Parked outside one of Britain's country mansions, the Subaru is presented as a new thoroughbred among hatchbacks: "in a class of its own." The sales pitch combines the performance of the car with its Green credentials. Running on unleaded petrol, this "environmentally friendly" little runabout won't pollute the pastures of your country estate.

Similarly, Bovis Homes appeals to the nostalgic arcadian fantasies that beat deep in the Turquoise heart. A large, traditional 1920s-style country house is juxtaposed with a "collectible" painting of innocent badgers—themselves an endangered species—at play. The ad sells the green magic of Britain that has been lost forever, a magic that was in reality the prerogative of the rich and privileged few. Bovis offers to reconstruct this green heritage: "We've also planted thousands of trees—mainly native British broadleaf species; we've been recreating village greens, encouraging butterflies, and preserving wildflower meadows." The title itself, "A badger doesn't know the Green Cross Code," is significant on three levels: The Green Cross Code is learned by British children at school; it explains how to cross the road safely. A green light also suggests progress as well as regulated access. And, of course, green refers to the countryside and to ecological issues. In one sentence, Bovis has harnessed its brand name to the values of care, modernity, exclusivity, and ecology.

Sporting Green credentials can be lucrative business, but how Green is Green? Should a company with only one ecologically responsible brand be allowed to call itself a Green company? It is very easy for advertisers to exploit the public's concern about the environment. For example, Cadbury Chocolate's only concession to Green-ness is putting endangered wildlife on its candy wrappers. This raises money for the Wild Life Nature Fund, and it encourages children who love animals to buy Cadbury's in preference to other brands. But only the packaging has changed: manufacturing, processing, and distribution techniques remain the same.

Even more pronounced are the efforts by some corporations—especially petrochemical companies—to make consumers feel good about the company concerned. A public relations booklet for Shell is a typical case. Entitled *Good Neighbors*, the booklet purports to describe "How the oil and petrochemical industry goes about its task of protecting the environment." A crucial part of this communication is the cover image, which is disingenuously spare. Amid a balmy glow of late spring sunlight, a clutch of fragile eggs nestle in the protecting shell of an oil worker's helmet. Lévi-Straussian in its opposition, nature and culture are harnessed: man is juxtaposed with the animals, wisdom with innocence, experience with new beginnings, and emotive values with big business. Indirectly we are invited to buy into this caring philanthropy by buying Shell products—although in the genteel world of corporate advertising nothing so vulgar as sales and profit are mentioned.

The press advertising for AEG also sells a caring approach. Simple cartoon graphics and a photograph of a modern washing machine are accompanied by the line: "People don't buy AEG just to care for their clothes. Our Lavamat automatic washing machines are also designed to look after something much more delicate. The environment." Yet when *City Limits* magazine investigated the company, it found that AEG was supplying electronic systems for advanced weaponry, a fact not apparently shared with Friends of the Earth, who had been asked by AEG to enter into a joint promotion of "ecologically friendly" kitchen gadgets.

detail:
Subaru advertisement

From the consumers' point of view, the Green upholstering of the planet is just part of a much more complex social and political issue. This move to "save our planet" coincides with a moment in late capitalism when even diehard libertarians are forced to check their zealous pursuit of the free market. What is the point of putting money by for a rainy day if the rain that falls is acid rain? Most people in Britain have been forced to take ecology seriously, motivated by fear, not benevolence.

To some extent, the consumer bubble has burst. We live in a time when even the poor of the Western world have access to commodities that only twenty years ago would have been considered luxuries. Most people now own a refrigerator; in 1955 that was the privilege of a mere 5 percent of the population. Similar figures apply to other domestic gadgets we take for granted: cars, washing machines, and electrical appliances of all kinds. We are saturated with consumer durables, and the question must be posed, how many more can we absorb? As we replace goods in our homes and on our person at an increasing rate, our relationship to these goods grows more tenuous and confused. Some advertisers have responded to consumers' anxiety that this pattern of consumption is itself a root cause of the ecological crisis.

Thus, the manufacturer of Pepe jeans has turned to the Native Americans for product endorsement. In place of hip teenagers lounging about in Pepe jackets and trousers are Native Americans performing a rain dance set to the sultry tunes of The Smiths. Nature-culture, paganism-modernism, youth-wisdom, pop music-ancient ritual, fire-rain, clothing-nakedness: a series of structural oppositions appear to harness the earth's elements at the behest of the brand. The Pepe TV commercial is, as it were, the flip side of Green advertising. For whereas Green environmental advertising presents the planet as vulnerable and in need of our protection, the Pepe jeans commercial depicts the elements as powerful, dangerous, and almost uncontrollable.

There is an increasing vogue for this sort of advertising, which depicts Mother Nature as a powerful force dictating our lives. And while the simple interpretation is that advertisers are enjoying a period when nature in all its manifestations is fashionable, there is clearly something more at play. When asked to predict the trends for the future, advertisers describe the same

At Shell, we wear two hats.
We're businessmen, and we're environmentalists.
Our new brochure, 'Good Neighbours'
describes how we manage to combine the two roles.
For a copy, write to
Hayley Ranger, UK PA/242, Shell UK Limited,
Shell-Mex House, The Strand, London WC2.

detail: Shell advertisement

phenomena: ecology issues and the need to buy a "vision." On the simple level, this "vision" is a reassurance that England is still the green and pleasant land of tradition. On a deeper level, dissatisfaction with the relentless cycle of consumerism is producing a need to find something more than material goods. In the late 1980s, the metaphor used to describe that desire is The Earth or Mother Nature, the community from which we were born and to which we must surely return.

This "soft-sell" is a far cry from the harsh graphics traditionally associated with Green political propaganda. And within this transformation, the photograph has achieved an almost magical or mystical status. It has become the medium through which advertisers bid us to capture a glimpse of the future. If saving the planet cannot be left to the world's unscrupulous politicians, it is ironic that it should be advertising that now acts as the prophet of that better, brighter tomorrow.

GRISELDA POLLOCK

Missing Women:
Rethinking Early Thoughts on Images of Women

> We learn ourselves through women made by men.
> —Sheila Rowbotham, *Woman's Consciousness, Man's World*[1]

THE POLITICAL identity of the women's movement has been formed in large part by a critique of the representations of women that circulate through "high" culture and the media, including film, television, advertising, and pornography. These "images of women" have been denounced by some in the name of feminism. Yet they are difficult to disavow because of the potency of their formulations of femininity, their fascination, and their pleasures. We recognize a gap between idealized or debased versions of "woman" and the lives and identities we ordinarily inhabit, but in spite of the gap, we cannot but acknowledge that to a certain extent our identities are formed through such imageries.

Feminist cultural theories of the image have moved along a trajectory from an initial denunciation of stereotyped images of women to a more exacting assessment of the productive role of representation in the construction of subjectivity, femininity, and sexuality. In this essay I want to revisit an article I wrote in 1977, at the beginning of my political and theoretical engagement with feminist studies of the image, entitled "What's Wrong with 'Images of Women?'" in order to draw out more clearly what has been gained by the substitution of one paradigm, "images of women," for another, "representation/ sexuality/femininity." As paradigms, they inhabit different theoretical universes, differently valorized by their advocates in terms of accessibility and relevance versus theoretical sophistication. My concern in 1977 was to establish a point of contact between women who had become conscious of the problem with "images of women" and the theoreticians who were attempting to work the problem through. That dialogue is ongoing and continues to be relevant.

1. Sheila Rowbotham, *Woman's Consciousness, Man's World* (London: Penguin Book, 1973), p. 40.

Back then, I was a "star-struck structuralist."[2] During my formal training as an art historian, I had had little access to any of the currents that were so dramatically reshaping neighboring disciplines, such as literary criticism and film studies. New possibilities were opened up in journals such as *Screen* and *Screen Education*, which published seminal texts in semiotic theory, particularly such works as Roland Barthes's "Rhetoric of the Image."[3] An equally important part of the *Screen* initiative of the early 1970s was the critical examination of structuralist developments in Marxist theories of ideology.[4]

My 1977 text was the result of the desire to enter the theoretical community associated with the *Screen* project, but symptomatic of the difficulties of doing so. Semiology and ideology, however crudely understood, were enough to make me worry about the term "images of women," which then served to advertise courses run by feminists about the representation of women in art and the media. While challenging social definitions of women's roles and spheres, feminists were also contesting socially accepted *images* of women: the limited repertory of dumb blond, *femme fatale*, homely housewife, devoted mother, and so forth, which were judged in a vocabulary of absolutes: right or wrong, good or bad, true or false, traditional or progressive, positive or objectifying. But as an organizing principle, the phrase "images of women" seemed to me then—and now—theoretically impossible. Claiming to be no more than the simplest of descriptions, it assumes a world already formed, defined, and meaningful, which "images" depict in a direct relation of picturing, figuring, visualizing. Hence, images are judged against the world they reflect or reproduce or, as feminists have claimed, distort or falsify. The *real* is always present as the criteria against which images are assessed, a real which is never interrogated as itself a product of representations. The image becomes the true or false reflex of the real, and thus, posed in a hierarchical relation, the real precedes and determines the image.

"Realism is a social practice of representation: an overall form of discursive production, a normality which allows a strictly delimited range of variations."[5] In his analysis of the historical developments of photography in the nineteenth century, John Tagg identifies the realist mode as the dominant

2. The phrase is originally from Geoffrey Nowell-Smith, "I was a star-struck structuralist," *Screen* 14, no. 3 (1973), pp. 92-100.

3. Roland Barthes, "Rhetoric of the Image," reprinted in *Image-Music-Text*, ed. Stephen Heath (London: Fontana, 1977).

4. Anthony Easthope, "The Trajectory of *Screen*," in *The Politics of Theory*, ed. Francis Barker, Essex conference on Sociology of Literature, 1982 (Colchester: University of Essex, 1983), pp. 121-133. As I understand the position set out by *Screen* contributors, signification and ideology were seen as complementary, the one being the form of the other's existence. Ideology motivates and limits the potential polysemy of the sign. Signification generates the field of meanings that ideology organizes in the interests of the dominant social groups, be they of class, race, or gender.

5. John Tagg, "Power and Photography—Part I," *Screen Education*, no. 36 (1980), p. 53. Reprinted in John Tagg, *The Burden of Representation* (London: Macmillan, 1988).

mode of signification in bourgeois society. It operates by establishing a network of mutually referring references, which by constant repetition and cross-echoing create "a generally perceived picture of what may be regarded as 'real' or 'realistic,' which is not recognized as such—as a picture—but presents itself as, precisely, the Reality."[6] The implication is that across any one society there are diverse discourses, some of which are specifically but never exclusively visual, each producing specific representations. These representations interact, cross-refer, and accumulate around certain fixed points to create a dense texture of meaning that then acquires the authority of the obvious, commonsensical, and self-evident to the point that their status as *representation* is occluded. From this perspective we see that the phrase "images of women" obscures the issues of representation as a process that produces meaning and is inadequate to understanding representation as a process in history, society, and ideology. I want now to develop this argument by means of some examples.

In a photographic collage by the Hackney Flashers, a socialist-feminist photography cooperative active in London in the early 1970s, a contrast is made between a middle-aged female machinist who works in a north-London garment factory and the model used in a magazine advertisement for the kind of clothing produced by the first woman and now being sold by a West-End department store. This juxtaposition prompts the viewer to make a simple judgment about the two images, presented as exemplars of the good and the bad, the "real" and the glamorized, the positive and the distorted. One image is claimed to be closer to a truth in the "real" and the social, in the world of labor as opposed to that of consumption and/or fantasy. The recognition that both images are densely rhetorical products of material, social, and aesthetic practices is suppressed.

The advertisement is the result of a capitalized process producing high-gloss, airbrushed photography. Carefully composed, constructed, and selected from many shots, it is printed for mass circulation. The other image is a black-and-white photograph produced under artisanal conditions either at home or in a small-scale darkroom with limited resources. It takes its place in a tradition of documentary photography dating from the 1930s. Black-and-whiteness and the graininess of the image stand as signifiers for authenticity and directness, for closeness to the "real" of the working class observed by another class. Such codes and rhetorics are specifically classed and are associated with the treatment of the social problem, the life of labor, the urban poor. The high-gloss glamour photograph, with its selected bodies and lack of realized surroundings, also has a tradition, and a referent powerful enough to evoke and create a "reality effect" for its appeal to fantasy. It is by means of an address to the viewer through fantasy that the spectator is converted from casual witness to the desiring consumer. In the "realist" photograph, the signifiers (the grain, the black-and-whiteness, and so forth) are themselves signifieds. For the advertise-

6. Ibid., pp. 53-54.

ment, the manufacturedness, the signifying process must be repressed so that the image seems a spontaneous and credible world in which money is the only mediator, apparently operating freely in a realm of commodities.

But we cannot simply ignore these specificities and compare some abstract common component called "images of women." The case to be made is not that one kind of photograph is more real or more authentic or positive than another as a depiction of women. Rather, both are fictions that product distinct meanings both for the term "woman" and through the inclusion of woman in their semantic field. Both deploy specialized and historically grounded rhetorics within economically and ideologically different practices.[7]

My 1977 text was an attempt to go beyond these confines. The first breakthrough was to attend to the internal organization of a visual field: the image is not simply an icon, dominated purely by a figurative element. To think of it as such, one would have to isolate one element from the totality of codes, rhetorics, devices, techniques, competences, and stylistics that make up the image. Color, focus, texture, printing procedures, airbrushing, grain, and so forth, all constitute signifying elements that must be scrupulously decoded in their interaction within a specific visual configuration. This requires an in-depth study of the internal organization of an image. But its decoding demands a constant comparison of the image to those like and unlike it across all the levels of its signification. What I am describing is fundamentally the semiotic procedures of syntagmatic analysis of all the elements within one statement, and the paradigmatic analysis of the relations of those elements to the "sets" or connotational groups upon whose existence any one item or technique relies for signifying at all.

Such paradigmatic analysis raises important questions about the specificity of sites of representation and about history. In my earlier article, I used examples from contemporary advertising, nineteenth-century painting, pornography from the 1890s and 1970s, and amateur photography. At that time, feminists were adamant about clearly showing that there were links between elite cultural forms legitimated as art and those generally agreed to deal with sexuality on the edges of the licit. The traffic between various sites and diverse forms of representation was a clumsy but politically significant exposé. Nonetheless, there was and is a danger in extracting "images of women" with a shared iconography from their specific system of production and consumption. The common ground is easily reduced to the observation of a general tendency to debase women, to exploit their bodies. If the unclothed female body turns up in high art in the guise of the nude and in pornography as a masturbating, voyeuristic turn-on, is anything gained by reducing their differences of effect and circulation to the fact of nudity and femaleness? The

7. But why then are female bodies so often figured as a component of these fantastic visions? I shall not try to answer this question here, but I will return to it later. In 1977, I rashly asserted that "woman" signified "sale"; that is, it was the presence of a female figure that converted a bunch of commodities from the status of still life into objects of desire and consumption.

questions raised about their distance, difference, and reference are more important than the act of merely denouncing them. Undoubtedly there *is* traffic between different sites of representation. But we have to make a crucial distinction, which comes back again to the trap laid down by "images of women." What we identified as the common link was something external to the representations, something signified by the image that has its cause and existence elsewhere—in ideology, sexism, the terms of patriarchy. Nudity and the recurrence of the female body were read as the result of the patriarchal system in which women were exploited by men, sexually objectified in images used by men for sexual pleasures.

But such generalizations have turned out to be far less useful than careful analysis of the specific constructions of the feminine body as well as of specific modes and sites of representation and discussion of address and the imagined spectator. Here, woman/women cease to be the topic of representation. Instead, it becomes possible to perceive that the function of representation is the production of sexual differentiation for which a certain body image is the signifier. Representation is one of many social processes by which specific orders of sexual difference (internally differentiated across the axes of class, race, sexuality, age, ability, and so forth) are ceaselessly constructed, modified, resisted, and reconstituted. The issue here is whether we can transcend the idea that representations are symptoms of causes external to them (sexism, patriarchy, capitalism, racism, imperialism) and learn to understand their active role in the production of those categories. Representations articulate/ produce meanings as well as re-presenting a world already meaningful.

Ironically, one of the key texts for understanding the role of representation can be found at the heart of historical materialism. The Marxist concept of the base/superstructure seems to represent the cultural domain as a secondary structure, dependent upon an economic base that is both its cause and its content. In the essay *The Eighteenth Brumaire of Louis Bonaparte* (1852), Marx carefully studies the sequence of historical events that led from the defeat of the revolution in France in February 1848 to the coup d'état of Louis Bonaparte in December 1851. It is a narrative of a series of moments focusing specifically on the political machinations of various parties and interest groups in the struggle to control the state and the government, and the final withdrawal of all save Louis Bonaparte from the political stage.

The theoretical importance of this text is the understanding it produces of the domain of the political as a stage on which class struggles were acted out by representatives of diverse economic and social classes and class fractions. The text concludes by suggesting the relative autonomy, in modern terms, of the ensemble of social practices that can be classified as "the political." Relative autonomy means that there is at some level a relation between the ultimately material determinants on social life—how and in what relations people work—and the concrete practices in which these forces and relations of production are articulated and acted out. What's more, it means that once this

level of representation is in place, its goings-on obey internal pressures and limits and, in turn, act upon the economic and social relations that they articulate. Stuart Hall argues that the economic must pass through specific forms of representation that constitute the political:

> And once the class struggle is subject to the process of "representation" in the theatre of political class struggle, that articulation is permanent: it obeys, as well as the determinations upon it, its own internal dynamic; it respects its own distinctive and specific conditions of existence.[8]

He goes on to note that once class forces appear as political forces they generate their own effects, which "cannot be *translated back* into their original terms."[9]

It is not difficult to extrapolate a theory about the effectivity of *the cultural* as an equally significant articulation of the social forces of a society after looking at the formative relation between the political and the economic in bourgeois society. Furthermore, we can adapt the theory to accommodate relations other than those of class, especially in terms of race and gender and their mutual and complex inflections. Such potentialities are even more obvious as a result of the actual terminologies that recur in Marx's writing.

As many commentators have noted, Marx's text relies on numerous theatrical metaphors: acting out, masquerade, borrowed costumes, comedy, tragedy, and farce.[10] Representation should be understood through the metaphors of enactment, dramatization, performance, and masquerade. This displaces the typical notions of reflection or mirroring associated with the phrase "images of women." But feminist theory offers an even more radical reworking of ideas about representation.

In 1978, Elizabeth Cowie published the essay "Woman as Sign," which provided an anatomy of tendencies within feminist film analysis, while at the same time offering parallels with other areas of cultural critique. Cowie states the problem of "images of women" succinctly: "What must be grasped in addressing 'women and film' is the double problem of the production of woman as a category and of film as a signifying system."[11] Both sides of the equation, be it woman and film, or "images of women," require analysis. In my first example above, I suggested how semiotics allows us to attend to the specificities of systems of representation (film, images, and the like). But what about the other term, "women?"

8. Stuart Hall, "The 'Political' and the 'Economic' in Marx's Theory of Classes," in *Class and Class Structure*, ed. Alan Hunt (London: Lawrence and Wishart, 1977), p. 77.

9. Ibid.

10. John Coombes, "The Political Aesthetic of the 18th Brumaire of Louis Bonaparte," in *1848: The Sociology of Literature*, ed. Francis Barker (Colchester: University of Essex, 1978), pp. 13-21.

11. Elizabeth Cowie, "Woman as Sign," *M/F*, no. 1 (1978), p. 49.

Cowie suggests that it is common for film analysis to treat "woman" as a category already constituted in society through social and economic roles that form the lived world of women. Film is representation and therefore a secondary, ideological process reworking what has been formed prior to filmic practices. On the other hand, Cowie notes that some semiotic analysts of film acknowledge the active role of film as a signifying system. It produces meanings by organizing signifying elements within a specific narrative or textual system. But even in this formulation, we are still left with the categories of "woman" or "man," assumed to have a meaning produced somewhere else before the film put these elements into play. It is, at one level, common sense to acknowledge that there are men and women outside of film. But the existence of "real" people of the female persuasion is not what is at stake here. More useful is to question how categories of difference, and specifically of sexual difference, are produced and persons are subjected to them, indeed are subjected precisely by being thus placed.

Using structuralist readings of anthropology based on the work of Claude Lévi-Strauss, Cowie argues that society is a complex of signifying systems that establish both sexual divisions in the socioeconomic realm and sexual differentiation of the subject at the psychic level.[12] Cowie stresses that film is one such signifying system that actively produces definitions of difference within a network of signifying systems.

For Lévi-Strauss, society, which is synonymous with culture, is a series of systems of exchange and is defined by rules that produce meanings by constituting a grid of differences. The most significant are the rules governing kinship, for these define the social or cultural family group—kin—against the biological family by determining who may or may not be allied through marriage. Marriage is at once the site of economic, social, and sexual practices— the exchange of wealth, the establishment of reciprocal relations, and the regulation of sexuality and reproduction.

Kinship systems, then, appear to be systems in which men exchange women: woman is the currency, both the token of exchange and the sign of those relations and meanings. But that formulation, to which Lévi-Strauss himself was susceptible, obscures the radical implications of the thesis. The basic difference established by kin structures is between exchangers and exchanged: the system designates a set of positions as potential exchangers and receivers—husbands, brothers, fathers, uncles, brothers-in-law, fathers-in-law. These positions collectively constitute the signification "man." Those who are distributed to the places in this system as wives, mothers, daughters, and daughters-in-law, for example, collectively produce the term "woman." Thus, far from assuming that man and woman are given through biology, or

12. For a comparable attempt to think through the sex-gender system as a simultaneous formation at the cultural and psychic levels, see the highly influential essay by Gayle Rubin, "The Traffic in Women: Notes on the Political Economy of 'Sex,'" in *Toward an Anthropology of Women*, ed. Rayna Reiter (New York: Monthly Review Press, 1975).

some moment outside of social time, the terms are presented as the general-ized designations of places assigned by a signifying system—no more inher-ently meaningful than the value of numbers one through ten, which only signify according to relative positions in a numerical system. To recognize the arbitrariness of the system, we need only image that the difference that could distinguish exchangers from exchanged could be size, hair, color, six-toedness, or any other feature.[13]

Cowie's thesis, that woman is a sign within a signifying system, has quite radical implications for feminist analysis. On the one hand, woman as a cate-gory is produced, and we must attend to the mode of its production in any sys-tem we are studying, for example, film. On the other hand, woman is produced as a sign central to key social systems; what is signified by "woman" has nothing to do with femaleness—lived, imagined, or denounced.

> To talk of woman as sign in exchange systems is no longer to talk of
> woman as the signified, but of a different signified, that of the estab-
> lishment/re-establishment of kinship structures of culture. The form of
> the sign—the signifier in linguistic terms—may empirically be woman,
> but the signified is not "woman."[14]

This is difficult to grasp. "Images of women" places the emphasis on the problem of the images vis-à-vis contested ideas about what women are or would like to be. The concept of "woman as sign" makes us doubt that images signify women at all, though they undoubtedly circulate the sign Woman incessantly—and with the purpose of seducing persons of the female persuasion to recognize them-selves in these signs and places. Visual images that proffer iconic figurations of the feminine body through rhetorics technically and ideologically aiming at the "reality effect"—this is, the disavowal of their rhetorical character behind the illusion of direct reproduction, transcription, and replication—play a particular-ly important role in this masquerade. The visual signifier "woman" is potent pre-cisely insofar as the forms of representation, especially those associated with photographic processes, naturalize their constituents, masking their constitut-edness and presenting themselves as mere descriptions of a neutral content. Woman can therefore simply be seen, that is, in "images of women."

Cowie qualifies her use of Lévi-Strauss carefully. The structuralist tends to seek for the structure, signaled by the interest in the rules of formation of a given system. The rules do not limit, but are the very means by which social

13. Of course, it would be disingenuous to pretend that there is no significance in the fact that the found-ing difference is that which engenders and sexualizes us. But it is necessary to imagine a non-sexual divi-sion in order to overcome any residual naturalism with regard to the materialist and historical terms of difference, not as a logical system, but as the forms of existence of the organization of the reproduction of the population. In the same way historical materialism defines class as the form of existence of an oppres-sive and exploitative organization of the means of producing daily life and social subsistence.

14. Rubin, "Traffic in Women," p. 60.

systems can be generated and modified. It is necessary, however, to lay much greater emphasis on any system as a process rather than a structure. For instance, if we perceive kinship as a structure, we may be tempted to conclude that it is the cause of women's seemingly universal position as exchanged, secondary, different. This would lead us to seek some cause for it—men are beastly and aggressive—or some originating moment that easily slipped into inevitability. The important methodological point is that in a signifying *process*, origins matter far less than actual effects. This is not to abandon history, or diachrony, in favor of abstracted conjunctures. It is to repudiate a narrative that binds any group of historical moments in a long-term chronology that easily supports some trans-historical tradition rooted in the mythicized past.

Cowie's turn to anthropology is not an attempt to discover founding systems that produce sexual difference, but rather to make us think about all social practices as signifying processes, which are productive of meaning. If one of the defining features of all societies is the ways in which they sex their populations and organize reproduction, and hence sexuality, definitions of sexual difference will be multiply produced across many signifying systems, though not in any necessarily corresponding manner. We can grasp the accumulations of meanings, the attempted fixities, and the recurring patterns, which are then mutually reinforced by repetition and circulation in diverse forms across many sites of signification.

In a sense, then, the identification of stereotypes is an important recognition of such patterning. Such overdetermined significations utilize the body of woman for the meanings they attempt to generate. But every time the body of woman is put on display, it raises the repressed question of what it is and what it signifies.

One of the major theories of meaning, subjectivity, and the relations between subjectivity and systems of signification, is psychoanalysis. But both the foundation and the failure of its discourse can be found in the question of what woman is. Posed as a science that can confirm that woman *is* (explicable, knowable, reassuring, definable), its discourse continually exposes woman as a sign for the phallocentric system of signification. For Freud, the body of woman can be imagined/imaged only in fetishistic form—she is lacking and can be viewed only by restoring this lack, which threatens the very possibility of masculinity. For Lacan, woman is phallus.

> In Lacanian theory a series of lacks and losses, of the object in the drive, or the subject in relation to language, are overlaid and signified by the phallus (always a signifier, not a signified) and by the woman in so far as she assumes the position of the phallus. As man's missing part, as a substitute for what he has had to sacrifice or mortgage to the Law, the woman-as-phallus comes to signify in Lacan's terms, "what he has to renounce, that is jouissance."[15]

15. John Fletcher, "Versions of Masquerade," *Screen* 29, no. 3 (1988), p. 52. I am indebted to this paper for its clarifications between the various interpretations of the masquerade of femininity.

Both Freud and Lacan pose woman as representation, as fetish or signifer. The body to which representation refers is always, however specific the representation, the maternal body. But it is important to realize that the maternal body itself is already representation; the body figures the place of the Mother, the desire of the Mother, the status of the formative Other in relation to which subjectivities are initially outlined. Despite the literalness of Freud's account of boys' shock at the sight of their mother's body, the whole theory of psychoanalysis functions as a study of representations—imaginary, in fantasy, symbolic. It is a theory of substitutions and the forms (literally) of figuration. Jacqueline Rose clarifies this when she writes that it is not that "sexual anatomical difference *is* sexual difference (the one as strictly deducible from the other) but that anatomical difference comes to *figure* sexual difference; that is, it becomes the sole representative of what the difference is allowed to be."[16]

Any image of a feminine body is thus a trace of a body (the mother's), a memorial to it as lost, a sign of threat because of its seeming lack. This lack can be disavowed by making the body image a substitution for it and for what it lacks, necessary insofar as both viewer and viewed are captured in a system of sexualized and sexualizing difference enacted in a familial system in which the actors are named in accord with a familial script—mother, father, son, daughter. To call it the mother's body is to name a relation that is figured by an image, rather than to fall back on some final excavation and validation of the nurturing mother—though that haunts us all as a fantasy because of the very system I am describing.

In light of this somewhat abstract rereading of current positions for approaching "images of women," I want now to reconsider some of the examples I used in the 1977 article. In trying to get a distance from the overwhelming naturalism of photographic imagery and the ideologies of woman, I looked at an advertisement for a large chemical company, which featured a series of seven ads. One of them showed a photograph of a young girl, nude. What I noted at the time was the elision of nakedness, bodyness, and woman, a combination which the reversal—using a man's body—made strange. In subsequent considerations of the original advertisement, much more complex readings became possible. The advertisement was composed of a large photograph accompanied by text which read:

> Adolescence—a time of misgiving. Doubts about the site offered by parents to build a life on. Both head and heart subject to the tyranny of hormones. Youth under stress in search of an identity.
>
> Bayer is there to help her through this period of self-seeking. With textile fibers and die stuffs for the fashionable clothes she needs to

16. Jacqueline Rose, "Introduction II," in *Feminine Sexuality: Jacques Lacan and the École Freudienne*, ed. Juliet Mitchell and Jacqueline Rose (London: Macmillan, 1982), p. 42.

Test-tube baby

wear....With raw ingredients for the cosmetics she uses to create her own personality. And simple remedies too. Like aspirin (a Bayer discovery) for the pain she will experience.

All of this was under two headings. The series was called the "Seven Ages of Man." This particular ad was labeled "Test-Tube Baby."

My first impulse was to point out that this was not only the single nude in the series, but the only woman. The combination seemed significant and sufficient (denunciation of the exploitative use of the female body). But close scrutiny of the text and its relation to the image generates something quite different. The whole of the text produces a tension between inner and outer, organic and artificial. Adolescence is the key condition; it is a moment of lack, waiting to be filled with meaning. It oscillates between notions of emptiness, a *tabula rasa* onto which personality and identity will be inscribed, and an imaginary fullness, the menstruating, fully-dressed, and made-up woman. Femininity is to be mapped onto the body by cosmetics, fabric, fashion, which echo definitions of femininity as "masquerade." The body is also subject to another signification of femininity in which the feminine body is pathological, ill, in need of drugs as a direct result of the reproductive function with which it is so often elided. This body is both a trace of that maternal body and its disavowal through the fetishes of costume and the mask of makeup. Adolescence is posited as a period of transition between the lack and the completion. But completion is a kind of masquerade, and it is presented here as depending

upon external interventions in the form of manufactured products. This psychosexual formation is thus articulated with commodity circulation. Bayer makes all the things this body needs to achieve "her-ness."

Yet Bayer is posited not merely as a producer of chemical commodities, but as a kind of midwife to the "test-tube baby." It is there to help and provide. There is an implied identification with the place of the mother, as that nurturing, formative Other. At this point it is important to connect this text with the image. We might simply describe the image as a figure without clothes, in a kneeling posture, hands crossed over the chest, head inclined. But these body gestures and postures and the lack of clothing signify connotationally, outside the image, within the culture. "Unclothed" is a willfully obscure way of not saying the obvious. This is a nude. The nude is a term of art (artifice, culture), but in that discourse it is a signifier for an ideologically construed notion of a state of nature, innocence, ignorance. The term "baby" implies a state of nature too, but the pose suggests another metaphor of the body as an organic entity. The pose may suggest an unfolding flower or bud. The pose and gesture are intensely rhetorical: the inclined head and crossed arms are both demure and submissive. We tend to associate these postures with woman, yet this body cannot be easily sexed. Indeed, its obvious sexual identity is carefully concealed by the legs and even the arms. The body is hairless and has no obvious signs of female gender, but it would be hard to dispute that most viewers would see it as a woman. Where does its femininity come from? From its submissiveness, its suggestion of unfurling flowers, its silence and to-be-done-to-ness? In some senses the visual image is the opposite of the image conjured up by the text. The connotations of nature oppose the notion of the body as the site of chemical, that is, cultural transformation. The image has to sell the idea that someone needs Bayer products, that becoming a woman is a matter of intervention, construction, and artifice accomplished by using Bayer goods. The image also has to portray Bayer as a mere helper on the way to a process that is as natural as childbirth, yet naturally uses Bayer's test tube products. These contradictory impulses are at one level signified by the opposition between image-iconic message, and text-linguistic message. I do not think it is as simple as image being woman and the text signifying man (Bayer). The advertisement as a semantic field tries to knot into its complex pattern associations of birth and its feminine sphere, medicine and its supporting role, femininity and its artifice. The nude body is not a stable signifier for a given, simple notion of woman. It introduces into the play of the semantic field of the ad as a whole a series of possibilities that include a momentary recognition by the viewer of this as female body. But the image does not work to fix that recognition, but rather to invoke and then destabilize it so that it can signify a lack that only Bayer can make good. Yet to put that lack on display involves defensive procedures to disavow that feminine body as a signifier of lack.

The text produces a body that lacks an identity, a self, and that needs Bayer to furnish those lacks, which will then produce "woman." Would there

be pleasure in looking at a body signifying lack; does not the female body in Freud's schema represent lack in a most terrifying way, threatening the potential mutilation of that by which masculinity figures itself as lacking lack? It has been argued that woman's body is an extremely threatening sight, and that its visual display is conditional upon a series of defensive strategies by means of which the threat of lack this body evokes can be disavowed and allayed. Fetishism is the prime defense, turning from the lacking body to some comforting substitute for that which is missing. Indeed, under the regime of fetishism, the female body is converted into a sign for the phallus itself. When such fetishism is combined with a tendency to compensate for the fright the body could offer by building it up into an abstractly or formally beautiful object, the body we see can in no way be deemed to be a body of woman— rather it is a sign for phallus, an inscription of masculine anxieties and fears displaced by aesthetic beauty. Merely to denounce this body as impossibly glamorized is precisely to miss the conditions of its existence, which have nothing to do with women. It may, of course, address and solicit women viewers into complicity with the order of sexual difference that generated it, which it actively signifies to its viewers.

This suggests not only that we are not looking at an image of woman, but also that we are hardly looking at a body at all. We may be looking at traces of several body *signs,* which can simultaneously occupy the fictive space of the image—or perhaps we should now introduce the real site of meanings. The point at which all the traces and currents activated by the signifying elements in the text (iconic and linguistic or graphic) converge is the putative viewer, who carries with him or her the necessary baggage to move in and out and across the many dimensions of the image that such systematic decoding inevitably impoverishes. The viewer is the split subject of semiotics (since Kristeva) and of psychoanalysis. The split subject operates in two discontinuous fields. Both word and image must address the conflicting demands of conscious and unconscious registers. Photographic representation has particular potency in this field for it offers fictive fields for fantasy located in credible spaces, likely scenarios, and fantastic possibilities. It addresses the demand for the legible and visible while servicing the less prosaic signifying systems of the unconscious with its multiple displacements, substitutions, and playfulness.

Let me now turn to another example originally used in my 1977 article. It is an advertisement for Levi's jeans in which again an unclothed body appeared. Rather, I should be precise—the advertisement offered a *corps morcelé,* a body fragment. The best way to summon it up is to invoke the viewer. The viewer is presented with buttocks that are situated at eye level. One cheek is visible and the other cut off by the edge of the image. Also included is a section of the arm and half a hand. On the fully exposed buttock are drawn the outlines of the stitching of a pocket to which is attached the Levi's label. I assumed that this had to be read as a female body, until a colleague pointed out its clear references to one of art's most famous buttocks, those of *David* by Michelangelo.

The hand, then, is there to underline the quotation. Why then did I see it as female while my colleague saw it as male? Probably because I know this image in color and he saw only the black-and-white reproduction, which emphasized the sharp line that the divide and crease in the buttock make. The effect is obviously more like the masculine anatomy. In the color version, this perception is effaced by the golden glow that bathes and unifies the surface of the whole image. The light is softening and creates highlights that emphasize the curves. Softened forms and contours connote a difference in the sexually demarcated rhetorics of representation, a difference signaled by the term "woman." The body is not sexed by reference to genital difference. The reading depends on the way light and color gloss the forms to convey feminine connotations. But to anyone for whom the reference to Michelangelo is available and vivid, the body would read as "masculine." The ambiguity is wholly to the point of the advertising campaign, which is serviced by an image that sells Levi's jeans both to men and women and can offer them to both kinds of consumer by pitching their desirability through a narrative of men looking at women's bums and women knowing that men find pleasure in looking at women's bums in tight jeans and thus imagine them without jeans, and so on. Jeans, moreover, have the added *frisson* of disrupting difference through confusing fixed-fashion codes for men and women. Yet this image has to be about desire and has to invoke it—a desire that will become attached to the commodity, which is itself here attached to the body as the site and figuring of desire. Could this image be read against this grain according to the viewer's sexual orientation? Its ambivalent gender identity only enhances that wide range of consumers. Yet without denying the potentiality of the images to be read variously according to the position of its viewers, there is a pressure within it towards a preferred reading. Color is vital here. Through it the body is drawn, photo-*graphy*. Yet at one point light signifies lack; between the legs there is a gap where the model's right thigh is clearly defined by the fall of light. The same lighting effaces the contours of the left buttock and thigh. In this dazzling brightness, form is obliterated. Does this create the void that signals a lack of masculine genitals, thus signifying a female body precisely as that which lacks? Does this bright shaft of light nonetheless stand in for what cannot be seen in its brightness? If it can erase the leg, what else has it merely erased?

More than a decade after writing my original essay, I still think that anyone brought up in western society would read the body in that image as a female body, an erotic proffering of a sexualized body part. But that hardly explains the success of this image or its possibility as an advertisement. The highly technical manufacture of this image, its management of scale and fragment, its play on disavowals and displacements, its use of saturated golden color, and the deployment of a phallic hand move us constantly back and forth over meanings generated by these specific elements in the image field and then out into a world of images, back across the fantasies of bodies and their sexualities and uses located in our psyches, in those unconscious formations

of fantasy that are synonymous with the manufacture of sexuality and sexual difference itself.[17]

The point being made here is that there really is no body on show. There is nothing there except the signs generated in the process of reproduction, which constitute a semantic field for a viewer, who is the only body present. These signifying elements yield the possibility of reference for a viewer. But the reference is not to the certain category of man or woman, but to the process that is sexual difference. That process is always a fantasy, a psychosymbolic domain in which sex and gender are ceaselessly produced and negotiated. These fantasies are sexual/erotic even as they are about sexual formation. They are mobilized within the system of commodity production and exchange.

The process of the image and its viewer, and the commodity and its consumer, are elided through the effect of "woman-as-sign," which signifies the lost object of desire and lack, for which the commodity is the momentary compensation.

One final image will complete the move from the image of a whole body to body part. In this, the image content is radically reduced. Into a plain black field are cut two inserts, one of reddened and opened lips, the other of an upright, unsheathed, and extended lipstick. Again we must acknowledge that there is nothing in the image to sex the lips. Redness, fullness, a suspicion of a tongue signify at the level of connotation, within a discourse associated with pornography. Its regimes of representation are typically fetishistic.[18] That is to say, that the representation of any body parts is subject to the process of conversion, displacement, and substitution for a viewer, who is both curious and afraid (to look at something that is not there) and who invents an impossible body that was never there (the phallic mother), in relation to which the viewer's own unstable sexual identity is being fashioned. This somewhat contorted formulation is necessary to undermine the common sense that we are, in fact, *looking at a woman's lips.* The signifier in the form of the photographed model may well have been a female person posing thus—but that does not determine the signifying effects of the image. The inset picture of the lips is at once a superimposed area of lightness and color on a black field and an opening framed by the surrounding blackness-a sense of exposure and revelation carefully controlled. The viewer can see but is safe, protected particularly from being seen, looked back at. The isolation of the lips from the totality of the face—a recurrent feature in many advertisements for food and drink—is so commonplace that it is hard to grasp the violation and terror it embodies.

17. Jean Laplanche and Jean-Bertrand Pontalis, "Fantasy and the Origins of Sexuality," in *Formations of Fantasy,* ed. Victor Burgin (London: Methuen, 1986).

18. See Laura Mulvey, "You Don't Know What Is Happening, Do You, Mr. Jones?" *Spare Rib,* no. 3 (1973), pp. 13-16, 30. Reprinted in Rozsika Parker and Griselda Pollock, *Framing Feminism: Art and the Women's Movement 1970-85.* (London: Pandora Press, 1987) pp. 127-131. See also John Ellis, "On Pornography," *Screen* 21, no. 1 (1980), for further discussion.

detail:
Max Factor advertisement

Why are our sense not deranged by the facelessness, especially when the formal order of the page puts the lip fragment precisely in the place of the head and face? Synecdoche, where the part can stand for the whole, is perhaps a reasonable but inadequate explanation. According to Lacan, subjectivity (the possibility of the ego) is precipitated by the encounter with an image that unifies the disparate drives and sensations playing over the infant body into a psychical image of the body. Western art—and, indeed, most cultures—maintain considerable respect for the human body and have made the body one of the central signifiers of ideals of humanity. To cut up the body is to enact both a symbolic and psychic violence upon that body as image, an ideal that is the basis of self. Since the later nineteenth century, and especially after Picasso had visually hacked up the body, we have been gradually accustomed to the cutting up of specifically feminine bodies; indeed, their cut-up-ness has come to be a sign of that femininity. This fetishistic regime of representation is not ahistorical. But we do not yet understand the way it was formed in the nineteenth century and came to be naturalized by photographic representation in film, advertising, and pornography, all of which are discourses about desire that utilize the dialectic of fantasy and reality effects associated with the hegemonic modes of photographic representation.

Displaced by the luminosity and lush color, reassuring because of the formal geometry of the layout, the image of the lips is nonetheless an image of violence. Keeping in mind that trace of a body provoked by the arrangement of the two inserted photographs, we come to the lipstick. It is phallic, but what

does that mean here? Typically, the phallus can never be represented. The penis may figure it, but more often it requires a whole body, which, as in the extreme case of bodybuilders, is a composite of many phallic signifiers; the whole body is phallic, tense, tumescent, hard. But the lipstick is not merely a stand-in for a man's organ, or a reference to masculinity, which would make the ad a straight masculine/feminine opposition. It too is coded "feminine" in our culture, and a link with the lips is made by the use of color. Its strategic placing is a fantasy of restoration to the carefully screened body that is signified by the mouth, both a possible sign of the mutilated maternal genitals and a metonym for the mother's breast through oral associations of sucking.

At a literal level, this ad is selling us a lipstick. But at the structural level, it creates a relationship of need premised not so much on lack as on deficiency with regard to the female body as an object of desire. All cosmetic advertisements work to promote a sense of women's deficiency in relation to an ideal of desirability. We have to buy their commodities to make us beautiful. Building up the aesthetic beauty of an object by the mechanism of fetishistic scopophilia is one of the defenses Laura Mulvey identified in the star system of Hollywood cinema.[19] The commodity of lipstick not only is fetishized in Marxian terms, but is a fetish in the sexual economy as well. The signifying system of advertising as a specific point of production of signs and meanings is articulated with, but not reducible to, economic practices. The commodity is a sign, as an exchange value and token of exchange in which value is invested and by which it is realized. It is also a sign in the psychosymbolic domain where order is secured by the circulation of the phallus.

Attempting to deploy psychoanalysis, structuralism, and historical materialism in the service of feminist analysis of the image requires me to locate my speech within discourses that themselves are fetishistic.[20] Masculinity and femininity are produced as terms of a hierarchical difference premised on assigning a lack to a perfectly whole body. Women's bodies lack nothing, have not been mutilated or castrated. But their position in the world is constantly subject to castration, symbolically, as a denial of being, a denial of speech, a denial of the means to figure the subject by means of its body. Therefore, we must conclude that there are no "images of women" in the dominant culture. There are masculine significations figured by deployment of body signs. Yet I have suggested that any figured body is a complex of traces of fantasies of several bodies, bodies constantly oscillating between lack and plenitude, threat and restoration. *The* body of this scenario is the mother's body, the repressed body, and the one that obsesses the phallocentric system. Every image of the feminine coded body is at the same time an image of woman and not an image

19. Laura Mulvey, "Visual Pleasure and Narrative Cinema," *Screen* 16, no. 1 (1975). Reprinted in Laura Mulvey, *Visual and Other Pleasures*. (London: Macmillan, 1989).

20. John Fletcher, "Versions of Masquerade," p. 52.

of woman. It is never simply fetishized and phallic, nor a memory trace of the *jouissance* imagined and desired in relation to maternal plenitude. Both and neither, the image is a field traversed by desiring subjects/viewers through whom meanings come into play only to be ceaselessly displaced by others. Advertising photography is a major scene of representation of sexual difference in this conjunction of two economies of desire, where commodity and psychic fetishism entrance us through their mutual investments in and constant trading of our subjectivities.

Abigail Solomon-Godeau

Living with Contradictions:
Critical Practices in the Age of Supply-Side Aesthetics

It should have become abundantly clear, especially during the Reagan years, that the function of criticism, for the most part, is to serve as a more or less sophisticated public relations or promotional apparatus. This is less a function of the critic's active partisanship (Diderot and Baudelaire, for example, are historically associated with the artist Greuze and Guys, whom they championed as exemplars) than a consequence of the fact that most contemporary art criticism is innocent of its own politics, its own interests, and its own ideology. In fact, the promotional aspect of most art criticism derives from the larger institutional and discursive structures of art. In this respect, the scholarly monograph, the temporary exhibition, the discipline of art history, and last but not least, the museum itself, are essentially celebratory entities. Further—and at the risk of stating the obvious—the institutions and discourses that collectively function to construct the object "art" are allied to the material determinations of the marketplace, which themselves establish and confirm the commodity status of the work of art.

Within this system, the art critic normally functions as a kind of intermediary between the delirious pluralism of the marketplace and the sacralized judgment seat that is the museum. But even this mediating process has now been bypassed; artists such as Julian Schnabel, to take on particularly egregious example, have been propelled from obscurity to the pantheon without a single serious critical text ever having been produced in support of their work. The quantum increase in the scale of the international art market, the unprecedented importance of dealers in creating (or "managing") reputations and manipulating supply and demand, the emergence of a new class of "art consultants," and the large-scale entry of corporations into the contemporary art market have all contributed to the effective redundancy of art criticism. Art stars and even "movements," with waiting lists of eager purchasers in their train, stepped into the spotlight before many art critics knew of their exis-

tence.[1] This redundancy of criticism, however, can hardly be understood as a consequence of these developments alone. Rather, the current state of most art criticism represents the final dissolution of what was, in any case, only a fragile bulwark between market forces and their institutional ratification, a highly permeable membrane separating venture capital, so to speak, from blue-chip investment As a result, art criticism has been forced to cede its illusory belief in the separateness or disinterestedness of critical discourse.

In this essay I am primarily concerned with the condition—and position—of critical practices within art criticism and art-making in the age of Reagan. In contradistinction to business-as-usual art promotion and the atavistic, cynical, and mindless art production exemplified by pseudoexpressionism, critical practices, by definition, must occupy an oppositional place. But what, we must ask, is that place today? Within the map of the New York art world, where is that place of opposition and what is it in opposition to? Second—and integrally linked to the first set of questions—we must ask what defines a critical practice and permits it to be recognized as such. What, if anything, constitutes the difference between a critical practice and a recognizably political one? If artists as dramatically distinct as, for example, David Salle and Sherrie Levine can both say that their work contributes to a critique of the painterly sign, what common political meanings, if any, ought we attribute to the notion of critical practice? Last—and here is where I am most directly implicated—what is the nature, the terms, even the possibility, of a critical practice in art criticism? Is such a practice not inevitably and inescapably a part of the cultural apparatus it seeks to challenge and contest?

Postmodernist Photography: The Third Time Around
A Case History

> When I think of it now, I don't think what Julian Schnabel was doing was all that different from what I was trying to do.
> —Sherrie Levine[2]

1. "Neo-geo," also referred to as "simulationism," the latest art package to blaze across the art-world firmament, is a good case in point. The artists involved (Ashley Bickerton, Peter Halley, Jeff Koons, Helm Steinbach, Meyer Valsman—to name only the most prominent) were the subject of massive media promotion from the outset. See, for example, Paul Taylor, "The Hot Four: Get Ready for the Next Art Stars," *New York* magazine, 27 October 1986, pp. 50-56; Eleanor Heartney, "Simulationism: The Hot New Cool Art," *Artnews* (January 1987), pp. 130-37, and Douglas C. McGill, "The Lower East Side's New Artists: A Garment Center of Culture Makes Stars of the Unknowns" The *New York Times*, 3 June 1986. The media blitz was subsequently ratified by a group exhibition at the Sonnebend Gallery and, on the museological front, by an exhibition at the Institute for Contemporary Art, Boston ("Endgame: Preference and Simulation in Recent Painting and Sculpture," 25 September-30 November 1986) with an accompanying catalogue featuring essays by prominent art historians and critics such as Yves-Alain Bots, Thomas Crow, and Hal Foster. For a less exalted and intellectualized view of this phenomenon, see "Mythologies: Art and the Market," an interview with Jeffrey Deitch, art advisor to Citibank, *Artscribe International* (April/May 1986), pp. 22-26. The interest of this interview lies in the way it clearly indicates the determinations and mechanisms in the fabrication and marketing of a new art commodity.

2. Sherrie Levine, "Art in the (Re)Making," interview with Gerald Marzorati, *Artnews* (May 1986).

By way of exploring these questions, and in the interest of providing some specificity to the discussion, I want to concentrate primarily on the evolution and development of postmodernist photographic work from the late 1970s to the late 1980s, using it as a case history in which to explore the salient issues. This corpus of work, identified with its now fully familiar strategies of appropriation and pastiche; its systematic assault on modernist orthodoxies of immanence, autonomy, presence, originality, and authorship; its engagement with the simulacral; and its interrogation of the problematics of photographic mass media representation may be taken as paradigmatic of the concerns of a critical postmodernism or what Hal Foster has designated as "oppositional postmodernism."[3] The qualifier "critical" is important here, inasmuch as the conceptualization and description of postmodernism in architecture—chronologically anterior—was inflected rather differently.[4] There it signaled, among other things, a new historicism and/or repudiation of modernist architecture's social and utopian aspirations, and a concomitant theatricalization of architectural form and meaning. In literary studies, the term *postmodernism* had yet another valency and made its appearance in literary criticism at an even earlier date.[5] Within the visual arts, however, postmodernist photography was identified with a specifically critical stance. Critics such as Benjamin Buchloh, Douglas Crimp, and Rosalind Krauss, for example, theorized this aspect of postmodernist photographic work as principally residing in its dismantling of reified, idealist conceptions enshrined in modernist aesthetics—issues devolving on presence, subjectivity, and aura. To the extent that this work was supported and valorized for its subversive potential (particularly with respect to its apparent fulfillment of the Barthesian and Foucauldian prescriptions for the death of the author and, by extension, its subversion of

ABIGAIL SOLOMON-GODEAU

3. See Hal Foster, "Postmodernism: A Preface," in *The Anti-Aesthetic: Essays in Postmodern Culture*, ed. Hal Foster (Port Townsend, Wash.: Bay Press, 1983), pp. ix-xvi. The conception of postmodernism in the visual arts as a critical practice was established in the following essays: Douglas Crimp, "Pictures," in *Art after Modernism: Rethinking Representation*, ed. Brian Wallis (Boston: David R. Godine, 1984), pp. 175-87; "On the Museum's Ruins," in Foster, *The Anti-Aesthetic*, pp. 43-56; "The Photo-graphic Activity of Postmodernism," *October* 15 (Winter 1980), pp. 91-101; "The End of Painting," *October* 16 (Spring 1981), pp. 69-86; "The Museum's Old, the Library's New Subject," *Parachute* 22 (Spring 1981), pp. 32-37. For a theorization of postmodernism as an allegorical procedure, see Craig Owens, "The Allegorical Impulse: Toward a Theory of Postmodernism, parts I and II, *October* 12 (Spring 1980), pp. 66-86 and *October* 13 (Summer 1980), pp. 59-80, and Benjamin H. D. Buchloh, "Allegorical Procedures: Appropriation and Montage in Contemporary Art," *Artforum* (September 1982), pp. 43-56. See, further, Rosalind Krauss's important essays "Sculpture in the Expended Field," in Foster, *The Anti-Aesthetic*, pp. 31-42 and "The Originality of the Avant-Garde," in Krauss, *The Originality of the Avant-Garde and Other Modernist Myths* (Cambridge, Mass.: MIT Press, 1985) pp. 151-70. For a synopsis of the above essays, see Hal Foster, "Re: Post" in Wallis, *Art after Modernism*, pp. 189-201. See also my essay "Playing in the Fields of the Image," *Afterimage* (Summer 1982), pp. 10-13.

4. See Robert Venturi, Denise Scott Brown, Steven Izenor, *Learning from Las Vegas* (Cambridge, Mass.: MIT Press, 1972), and Charles Jencks, *The Language of Postmodern Architecture* (New York, Rizzoli, 1977).

5. Irving Howe and Harry Levin were using the term in the late fifties.

the commodity status of the art object), Sherrie Levine and Richard Prince were perhaps *the* emblematic figures. For myself, as a photography critic writing in opposition to the academicized mausoleum of late-modernist art photography, part of the interest in the work of Vikkie Alexander, Victor Burgin, Sarah Charlesworth, Silvia Kolbowski, Barbara Kruger, Sherrie Levine, Richard Prince, Cindy Sherman, Laurie Simmons, and Jim Welling (to cite only those I have written about) lay in the way their work directly challenged the pieties and proprieties with which are photography had carved a space for itself precisely as a modernist art form.[6] Further, the feminist import of this work—particularly in the case of Kruger and Levine—represented a theoretically more sophisticated and necessary departure from the essentialism and literalism prevalent in many of the feminist art practices that emerged in the seventies.[7]

In retrospect, Levine's production in the late seventies to the mid-eighties reveals both the strength and weakness of this variant of critical postmodernism as a counterstrategy to the regnant forms of art production and discourse. The changes in her practice, and the shifts in the way her work has been discursively positioned and received, are themselves testimony to the difficulty and contradiction that attend critical practices that operate squarely within the framework of high-art production.

Levin's work first drew critical notice in the late 1970s, a period in which the triumph of the right was as much manifest in the cultural sphere as in the political one. As one might well have predicted for a time of intense political reaction, symptoms of morbidity included the wholesale resurrection of easel painting exemplified by German, Italian, and American pseudoexpressionism, a wholesale retrenchment against the modest gains of minority and feminist artists, a repression (or distortion) of the radical art practices of the preceding decade, a ghastly revival of the mythology of the heroicized (white male) artist, and last, the institutional consolidation and triumphant legitimation of photography as a fully "auratic," subjectivized, autonomous fine art.[8]

6. See my "Winning the Game When the Rules Have Been Changed: Art Photography and Postmodernism," *Screen* 25 (November/December 1984), pp. 88-102 and "Photography after Art Photography," in Wallis, *Art after Modernism,* pp. 75-85.

7. The occlusion of feminism from the postmodernist debate, remarked upon by Andreas Huyssen, among others, is significant. It is by no means incidental that many, if not most, of the central figures within oppositional postmodernism in the visual arts, film, and video, have been women, and much of the work they have produced has been directly concerned with feminist issues as they intersect with the problematics of representation. See note 16.

8. On the implications and ideology of the revival of pseudo- expressionism, see Benjamin H. D. Buchloh "Figures of Authority, Ciphers of Repression," in Wallis *Art after Modernism,* pp. 107- 36, and "Documenta 77: A Dictionary of Received Ideas," *October* 22 (Fall 1982), pp. 105-26; Rosalyn Deutsche, "Representing the Big City," in *German Art in the Twentieth Century,* ed. Irit Rogoff and Mary Anne Stevens, (Cambridge: Cambridge University Press, forthcoming), and with Cara Gendel Ryan, "The Fine Art of Gentrification," *October* 31 (Winter 1984), pp. 91-111; Craig Owens, "Honor, Power, and the Love of Women," in *Art in America* (January 1982), pp. 12-15. On the construction of photography as an "auratic" art, see Crimp, "The Photographic Activity of Post-modernism" and "The Museum's Old, the Library's New Subject," and Abigail Solomon-Godeau, "Winning the Game When the Rules Have Been Changed."

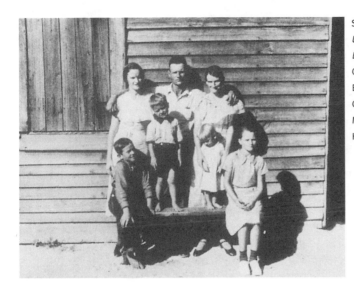

Against this backdrop, one aspect of Levine's work consisted of directly rephotographing from existing reproductions a series of photographs by several canonized masters of photographic modernism (Edward Weston's nude studies of his son Neil, Eliot Porter's Technicolor landscapes, Walker Evans's Farm Services Administration pictures) and presenting the work as her own. With a dazzling economy of means, Levin's pictures deftly upset the foundation stones (authorship, originality, subjective expression) on which the integrity and supposed autonomy of the work of art is presumed to rest. Moreover, her selection of stolen images was anything but arbitrary; the contents and codes of these purloined images—always the work of canonized male photographers—were chosen for their ideological density (the classical nude, the beauty of nature, the Depression poor) and then subjected to a demystifying scrutiny enabled and mobilized by the very act of (re)placing them within quotation marks. Finally, the strategy of fine-art-photography appropriations had a tactical dimension. For these works were produced in the wake of the so-called photography boom—meaning not simply the cresting of the market for photographic vintage prints, but the wholesale reclassification of all kinds of photography to conform with Kunstwissenschaft-derived notions of individual style and authorial presence.

It goes without saying that Levin's work of this period, considered *as* a critical practice (feminist, deconstructive, and literally transgressive—the Weston and Porter works prompted ominous letters from their estate lawyers), could make its critique visible only within the compass of the art world; the space of exhibition, the market framework, art (or photography) theory and criticism. Outside of this specialized site, a Sherrie Levine could just as well be a "genuine" Edward Weston or a "genuine" Walker Evans. This, in fact, was one of the arguments made from the left with the intention of countering the claims for the critical function of work such as Levine's and

Prince's (Prince at that period was rephotographing advertising images, excising only the text). The force of this criticism hinged on the work's insularity, its adherence to, or lack of contestation of, the art-world frame, and—more pointedly—its failure to articulate an alternative politics, an alternative vision.

In 1982, for example, Martha Rosler wrote an article entitled "Notes on Quotes" focusing on the inadequacies of appropriation and quotation as a properly *political* strategy:

> What alternative vision is suggested by such work? [She is referring here specifically to Levine.] We are not provided the space within the work to understand how things might be different. We can imagine only a respite outside social life—the alternative is merely Edenic or Utopic. There is no social life, no personal relations, no groups, classes, nationalities; there is no production other than the production of images. Yet a critique of ideology necessitates some materialistic grounding if it is to rise above the theological.[9]

Rosler's use of the term *theological* in this context points to one of the central debates in and around the definition—or evaluation—of critical practice. For Rosler, failure to ground the artwork in "direct social analysis" reduces its critical gesture to one of "highlighting" rather than "engaging with political questions that challenge...power relations in society." Moreover, to the extent that the artwork "remains locked within the relations of production of its own cultural field" and limited to the terms of a generic rather than specific interrogation of forms of domination, it cannot fulfill an educative, much less transformatory, function.

But "theological" in its opprobrious sense can cut both ways. It is, in fact, a "theological" notion of the political—or perhaps one should say a scriptural notion—that has until quite recently effectively occluded issues of gender and subjectivity from the purview of the political. Rosler's objections are to some degree moored in a relatively traditional conception of what constitutes the political in art ("materialistic grounding," "direction social analysis"). Thus, Rosler's characterization of a purely internal critique of art as ineffective because it is theological can, from a somewhat different vantage point, be interpreted as a theologized notion of the political. It is, moreover, important to point out that while unambiguously political artists (unambiguous because of their choice of content) are rarely found wanting for their total exclusion of considerations of gender, feminist artists are frequently chastised by left critics for the inadequacy of *their* political content. Nevertheless, the echoing cry of the women's movement—the personal is political—is but one of the remappings of political terrain that have engendered new ways of thinking the political and new ways of inscribing it in cultural production.

9. Martha Rosler, "Notes on Quotes," *Wedge* 3 (1982), p. 72.

But perhaps even more important, to the extent that art is itself a discursive and institutional site, it surely entails its own critical practices. This has in fact been recently argued as the significance and legacy of the historical avant-garde.[10] For Peter Bürger, the Kantian conception of self-criticism is understood not in Greenberg's sense of a *telos* of purity and essence, but rather as a critical operation performed within and upon the *institution* of art itself. Thus, art movements like dadaism and constructivism and art practices such as collage, photomontage, and the Duchampian readymade are understood to be performing a specifically political function to the extent that they work to actively break down the notion of aesthetic autonomy and to rejoin art and life. Bürger's rigorous account of art *as* an institution in bourgeois culture provides a further justification for considering internal critiques such as Levine's as a genuinely critical practice. Cultural sites and discourses are in theory no less immune to contestation, no less able to furnish an arena for struggle and transformation than any other.[11] This "in theory" needs to be acknowledged here because the subsequent "success" of postmodernist photography as a *style* harkens back, as I shall argue, to problems of function, critical complicity, and the extreme difficulty of maintaining a critical edge within the unstable spaces of internal critique.

In the spring of 1982, I curated an exhibition entitled *The Stolen Image and Its Uses* for an alternative space in upstate New York. Of the five artists included (Alexander, Kolbowski, Kruger, Levine, and Prince), Levine was by far the most controversial and sparked the most hostility. It was, in fact, the very intensity of the outrage her work provoked (nowhere greater than among the ranks of art photographers) that appeared, at the time, to confirm the subversive effects of her particular strategies. But even while such exhibitions or lectures on Levine's work were received outside New York with indignation, a different kind of appropriation of existing imagery, drawn principally from the mass media, was beginning to be accorded theoretical recognition across a broad range of cultural production. It was less easy to see this kind of appropriation as critically motivated. Fredric Jameson, for example, could in part identify his conception of postmodernism with the strategies of appropriation, quotation, and pastiche.[12] That these strategies could then be said to unify within a single field of discourse the work of Jean-Luc Godard and the

10. Peter Bürger, *The Theory of the Avant-Garde*, trans. Michael Shaw (Minneapolis: University of Minnesota Press, 1984).

11. The theorization of a localized "site specificity" for contestatory and oppositional practices is one of the legacies of Louis Althusser and, with a somewhat different inflection, Michel Foucault. See Michel Foucault, "The Political Function of the Intellectual," *Radical Philosophy* 12 (Summer 1977), pp. 12-15, and "Revolutionary Action: 'Until Now,'" in *Language, Counter- Memory, Practice: Selected Essays and Interviews by Michel Foucault*, ed. Donald F. Bouchard (Ithaca, N.Y.: Cornell University Press, 1977), pp. 218-33.

12. See Frederic Jameson, "Post-modernism, or the Cultural Logic of Late Capitalism," *New Left Review* 146 (July-August 1984), pp. 53-92. An earlier, less developed version of this essay, entitled "Post-Modernism and Consumer Society," is reprinted in Foster, *The Anti-Aesthetic*, pp. 111-25.

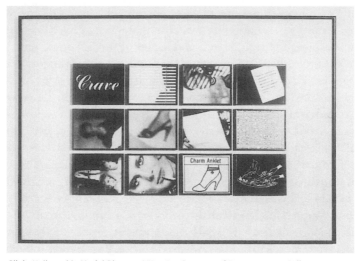

Silvia Kolbowski, *Model Pleasure VII*, 1984. Courtesy of Postermasters Gallery.

Photo: Mary Bachmann

work of Brian DePalma constitutes a problem for critical practice. Not only did such an undifferentiated model suppress a crucial consideration of (political and aesthetic) difference, it also implied the impossibility of cultural opposition within a totalizing system, a dilemma accorded growing intellectual prestige within the art world through the later writings of Jean Baudrillard. Rooted in such a framework, an appropriative strategy such as Levin's (although Jameson does not mention the specific practice of appropriation) would figure only as a synecdochical symptom within a master narrative on postmodernism.[13]

By 1983, plundering the pages of glossy magazines, shooting advertisements from the television set, or "simulating" photographic tableaux that might have come from either of these media had become as routine an activity in the more sophisticated art schools as slopping paint on canvas. In January of that year the Institute of Contemporary Art in Philadelphia mounted an exhibition entitled "Image Scavengers." Included in the exhibition were representatives of the first wave of appropriators and pasticheurs (Kruger, Levine, Prince, Cindy Sherman) and several other artists whose work could be allied to the former only by virtue of their formal devices. Invited to contribute a catalogue essay, Douglas Crimp was clearly disturbed at the domestication of what he had himself theorized as the critical potential of photographic appropriation. Under the title "Appropriating Appropriation," his essay initiated a

13. For various critiques of Jameson's arguments, see Mike Davis, "Urban Renaissance and the Spirit of Postmodernism," *New Left Review* 151 (May-June 1985), pp. 107-18; Terry Eagleton, "Capitalism, Modernism and Postmodernism," *New Left Review* 152 (July 1985), pp. 60-73; and Douglas Crimp, "The Post-modern Museum," *Parachute* (March, April, May, 1987), pp. 61-69.

reconsideration of the adequacy of appropriation as a critical mode. "If all aspects of the culture use this new operational mode," he wrote, "then the mode itself cannot articulate a specific reflection upon that culture."[14] Thus, although appropriative and quotational strategies had now become readily identifiable as a descriptive hallmark of postmodern culture, the terms by which they might once have been understood to be performing a critical function had become increasingly obfuscated and difficult to justify.

By this time, Levine's practice had itself undergone various alterations. In 1982, she had largely abandoned photographic appropriations and was confiscating German expressionist works, either by rephotographing them from book reproductions or by framing the reproductions themselves. In 1983 and 1984, however, she began making handmade watercolor and pencil copies after artbook illustrations, extending her *oeuvre*, so to speak, to include nonexpressionist modern masters such as Malevich and El Lissitsky. Her copies after expressionist drawings, such as Egon Schiele's contorted and angst-ridden nudes, were particularly trenchant comments on the pseudoexpressionist revival; master drawings are, after all, especially privileged for their status as intimate and revealing traces of the artist's unique subjectivity. In 1985, Levine made what might, or might not, be considered a radical departure from her earlier work and began to produce quite beautiful small-scale paintings on wood panels. These were geometrical abstractions—mostly stripes—which, Janus-like, looked backward to late-modernist works or minimalism and forward to the most recently minted new wave in the art world—neo-geo. Additionally, she accompanied her first exhibition of this new work with unpainted panels of wood in which one or two of the knots had been neatly gilded.

Mutatis mutandis, Levine had become a painter, although I would argue, still a somewhat singular one. Her work, moreover, had passed from the relatively marginalized purview of the *succès d'estime* to a new visibility (and respectability), signaled, for example, by her cover article in the May 1986 *Artnews*. In several of the comments she made to her interviewer, Levine explained her need to distance herself from the kind of critical partisanship that had not only helped establish her reputation, but—more important—had also, to a great degree, developed its position and analysis in relation to her work. Levine's professed discomfort with a body of critical writing that positioned her as a critical, indeed an adversarial, presence hinged on two factors. In championing Levine's work as either a poststructuralist exemplum or a demolition derby on the property relations that subtend the integrity of the art object, the (mostly male) critics who had written about her had overlooked, or repressed, the distinctly feminist import of her work.[15] But Levine

ABIGAIL SOLOMON-GODEAU

14. Douglas Crimp, "Appropriating Appropriation," in *Image Scavengers*, exhibition catalogue, University of Pennsylvania, Institute of Contemporary Art, 8 December 1982-30 January 1983, p. 27.

15. Craig Owens, "The Discourse of Others: Feminist and Post-modernism," in Foster, *The Anti-Aesthetic*, pp. 57-82, is an important exception.

also took issue with the interpretation of her work that stressed its materialist critique. In this regard, Levine insisted that hers was an aesthetic practice that implied no particular quarrel with the economic determinations of cultural production. Consequently, insofar as her critical supporters had emphasized those aspects of her work that subverted the commodity status of the artwork and demolished those values Walter Benjamin designated as the "theology of art," Levine began to believe that her activity *as* an artist was itself being repressed: "I never thought I wasn't making art and I never thought of the art I was making as not a commodity. I never thought that what I was doing was in strict opposition to what else was going on—I believed I was distilling things, bringing out what was being repressed. I did collaborate in a radical reading of my work. And the politics were congenial. But I was tired of no one looking at the work, getting inside the frame. And I was getting tired of being represented by men."[16]

The repositioning of Levine's work, with respect to both its meaning (now presented as a form of troubled obsequy mourning "the uneasy death of modernism") and the nature of her activity (commodity making), is disturbing from a number of perspectives. First, it involves its own forms of historical repression. For example, nowhere in the article was any reference made to Levine's two-year collaboration with the artist Louise Lawler, enacted under the title "A Picture Is No Substitute for Anything."[17] What is troubling about such an omission is that it parallels—no doubt wholly unintentionally—the institutional and discursive repressions that construct partial and falsified histories of art in the first place and in which the exclusion of women and radical practices are particularly conspicuous.[18] Second, it represses the active

16. Quoted in Gerald Marzorati, "Art in the (Re)Making," *Artnews* 85 (May 1986), p. 97.

17. The activities, events, and objects produced under the rubric of "A Picture Is No Substitute for Anything" collectively and individually functioned to foreground the mechanisms of cultural production, exhibition, and reception. Although the working title implicitly points to—by denying—the fetish status of paintings, the practices themselves (for example, inviting an art public to the studio of Dmitri Mertnoff, a recently deceased expressionist painter; the mailing [and exhibition] of gallery announcements: one-night-only exhibitions in which Levine and Lawler exhibited and arranged each other's work; the production of embossed matchbooks bearing the legend "A Picture Is No Substitute for Anything") were conducted as tactical interventions within the structures of art, inscribing themselves in the mechanisms of publicity, display, and curatorship served to focus attention on the framing conditions of art production, which are thereby revealed to be structurally integral, rather than supplemental, to the field as a whole. See, for example, Andrea Fraser, "In and Out of Place," *Art in America* (June 1985), pp. 122-28; Kate Unker, "Rites of Exchange," *Artforum* (November 1986), pp. 99-100; Craig Owens, review of Levine-Lawler exhibition, *Art in America* (Summer 1982), p. 148; Guy Bellevance, "Dessaisissement Re-appropriation," *Parachute* (January-February 1982/3); Benjamin H.D. Buchloh, "Allegorical Procedures"; Louise Lawler and Sherrie Levine, "A Picture Is No Substitute for Anything," *Wedge* 2 (Fall 1982), pp. 58-67.

18. That the official museum version of modernism we inherit is in every sense partial and, more important, founded on these conclusions and repressions is a recurring theme in Benjamin H. D. Buchloh's essays. See also Rosalyn Deutsche, "Representing the Big City," and Douglas Crimp, "The Art of Exhibition" and "The Postmodern Museum." In the last named essay, certain problems in Frederic Jameson's theorization of postmodernist culture are seen to derive from his acceptance of the official, museological, and auteural version of modernism.

Louise Lawler:
*Arranged by Carl Lobell
at Weil, Gotshal, and
Manges*, 1982.
Courtesy of the artist.

support of women critics, such as myself and Rosalind Krauss. But, more omi-
nously, it traces a move from a position of perceptible cultural resistance to one
of accommodation with existing modes of production and an apparent capitu-
lation to the very desires the early work put in question. Whether this move is to
be understood strategically (the need to be visible, the need to survive) or devel-
opmentally (an internal evolution in the artist's work) is not in itself a useful
question. Far more important to consider here are the material and discursive
forces that both exceed and bind the individual artist. Whether artists choose
to define their positions publicly in opposition to, or in strategic alliance with,
dominant modes of cultural production is important only insofar as such defi-
nitions may contribute to a collective space of opposition. But, in the absence of
a clearly defined oppositional sphere and the extreme rarity of collaborative
practice, attempt to clarify the nature of critical practice must focus on the art-
work's ability to question, to contest, or to denaturalize the very terms in which
it is produced, received, and circulated. What is at stake is thus not an ethics or
a moral position but the very possibility of a critical practice within the terms of
art discourse. And, as a fundamental condition of possibility, critical practices
must constantly address those economic and discursive forces that perpetually
threaten to eradicate their critical difference.

Some notion of this juggernaut can be obtained from a consideration of the parallel fortunes of Levine's earlier photographic appropriations and, indeed, postmodernist photography as a whole. In 1985, for example, three large group exhibitions featuring postmodernist photography were mounted: "Signs of the Real" at White Columns, "The Edge of Illusion" at the Burden Gallery, and most grotesque of all, "In the Tradition of: Photography" at Light Gallery. Not the least of the ironies attendant upon the incorporation of postmodernist photography into the now expanded emporium of photography was the nature of the venues themselves: the Burden Gallery was established in January 1985 to function as the display window of *Aperture*, the photographic publication founded by Minor White and customarily consecrated to modernist art photography; Light Gallery, a veritable cathedral of official art photography, represents the stable of officially canonized modernist masters, living and dead. The appearance of postmodernist photography within the institutional precincts of art photography signaled that whatever difference, much less critique, had been attributed to the work of Levine and others, it had not been fully and seamlessly recuperated under the sign of art photography, an operation that might be characterized as deconstruction in reverse.

How had this happened? The Light Gallery exhibition title— "In the Tradition of: Photography"—provides one clue, elaborated in an essay that accompanied the show. Postmodernist photography is here understood to be that which follows modernist photography in the same fashion that postimpressionism is thought to follow impressionism. The first of the two epigraphs that introduced the essay was taken from Beaumont Newhall's *History of Photography*—a sentence describing the conservatism of pictorial, that is, premodernist, art photography (that which preceded the Light Gallery regulars). The second epigraph consisted of two sentences from one of my essays, "Photography after Art Photography," asserting that the stakes that differentiate the two modes are a function of their position in relation to their institutional spaces. In much the same way that the modernist hagiographer Beaumont Newhall and I were equally useful in framing the thesis that postmodernist photography is part of an evolutionary *telos* having to do only with the internal development of art photography, so too did the gallery space both frame and render equivalent the two practices. This reduction of difference to sameness (a shorthand description for the eventual fate of most, if not all, initially transgressive cultural practices) was emblematically represented by the pairing— side by side—of a Sherrie Levine rephotograph of a Walker Evans and—what else?—a "real" Walker Evans beneath the exhibition title. That postmodernist photographic work and art photography came to inhabit the same physical site (although with the exception of the Levine-Evans coupling, the two were physically separated in the installation) is, of course, integrally linked with the nature of commercial space in the first place. In the final analysis, as well as a Marxist analysis, the market is the ultimate legitimator and leveler. Thus, among the postmodernist work, one could also find excerpts from Martha

Rosler's 1977 book project *The Bowery in Two Inadequate Descriptive Systems* (originally published by the Press of the Nova Scotia College of Art and Design). Variously an uncompromising critique of conventional humanist muckraking documentary photography, a text/image artwork, and an examination of the structuring absences and ideological freight of representational systems, *The Bowery...* was exhibited at the Light Gallery amid the range of postmodernist photographs and bore a purchase price of $3,500 (purchase of the entire set was required). But what was finally even odder than the effect of going from the part of the gallery in which the works of Aaron Siskind, Cartier-Bresson, and Paul Strand hung to the part devoted to the postmodernists was the revelation that postmodernists photography, once conceived as a critical practice, had become a "look," an attitude, a *style*.

Within this newly constructed stylistic unity, the critical specificity of a Rosler, a Prince, a Levine could be reconstituted only with difficulty (and only with prior knowledge). In this particular instance, this was in large part a consequence of the inclusion of a "second generation" of postmodernist photographers—Frank Majore, Alan Belcher, Stephen Frailey, and so forth—whose relation to the sources and significance of their appropriative strategies (primarily advertising) seemed to be predominantly a function of fascination. Insofar as stupefied or celebratory fascination produces an identification with the image world of commodity culture no different from the mesmerization of any other consumer, the possibility of critique is effectively precluded. Frank Majore's simulations of advertising tableaux—employing props such as Trimline telephones, champagne glasses, pearls, and busts of Nefertiti all congealed in a lurid bath of fiftieslike photo-

Frank Majore. *Cocktails*, 1983. Courtesy of Marvin Heiferman.

graphic color—are cases in point. By reproducing the standard devices of color advertising (with which Majore, as a professional art director, is intimately familiar) and providing enough modification to accentuate their kitschiness and eroticism, Majore succeeds in doing nothing more than reinstating the schlocky glamour of certain kinds of advertising imagery within the institutional space of art. But unlike the strategies of artists such as

Laurie Simmons,
Red Indians, 1984.
Courtesy of Metro Pictures.

Duchamp, or Warhol, or Levine, what is precisely *not* called into question is the institutional frame itself.[19] The alacrity with which this now wholly academicized practice was institutionally embraced by 1985 (in that year Majore had one-person shows at the International Center of Photography, the 303 Gallery, and the Nature Morte gallery) was possible precisely because so little was called into question.

Although this more recent crop of postmodernist artists could become visible—or saleable—only in the wake of the success of their predecessors, the shift from margin to center had multiple determinations. "Center," however, must be understood in relative terms. The market was and is dominated by painting, and the prices for photographic work, despite the prevalence of strictly limiting editions and employing heroic scale, are intrinsically lower. Nonetheless, the fact remains that in 1980, the work of Levine or Prince was largely unsalesable and quite literally incomprehensible to all but a handful of critics and a not much larger group of other artists. When this situation changed substantially, it was not *primarily* because of the influence of critics or the efforts of dealers. Rather, it was a result of three factors: the self created cul-de-sac of art photography that foreclosed the ability to produce anything new for a market that had been constituted in the previous decade; a vastly

19. My use of the term *institutional frame* is intended in its broadest, most inclusive sense. Thus, what is at issue is not simply the physical space that the artwork inhabits, but the network of interrelated discourses (art criticism, art history) and the sphere of cultural production itself as a site of ideological reproduction within the social formation.

expanded market with new types of purchasers; and the assimilation of post-modernist strategies back into the mass culture that had in part engendered them. This last development may be said to characterize postmodernist photography the third time around, rendering it both comprehensible and desirable and simultaneously signaling its near-total assimilation into those very discourses (advertising, fashion, media) it professed to critique. The current spate of Dior advertisements, for example, featuring a black-and-white photograph from the fifties on which a color photograph of a contemporary model has been montaged bears at least a family resemblance to the recent work of Laurie Simmons. But where Simmons's pictures derived their mildly unsettling effects from a calculated attempt to denaturalize an advertising convention, the reappearance of the same montage tactic in the new Dior campaign marks the completion of a circuit that begins and ends in the boundless creativity of modern advertising.

The cultural loop that can be traced here is itself part of the problematic of critical practice. The more or less rapid domestication and commodification of art practices initially conceived as critical have been recognized as a central issue at least since the time of the Frankfurt School. This means that irrespective of artistic intention or initial effect, critical practices not specifically calibrated to resist recuperation as aesthetic commodities almost immediately succumb to this process. In this respect, the only difference between the fate of postmodernist photography and previous practices is the rapidity of the process and the ease, if not enthusiasm, with which so many of the artist accommodated themselves to it.

As was the case with its pop-art predecessors, the first wave of postmodernist photography pillaged the mass media and advertising for its "subject,"

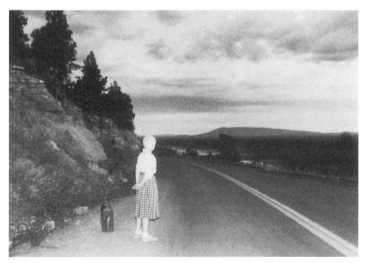

Cindy Sherman, *Untitled Film Still*, 1979. Courtesy of Metro Pictures.

by which I include its thematics, its codes, its emblems. These were then variously repositioned in ways that sought to denaturalize the conventions that encode the ideological and, in so doing, to make those very ideological contents available to scrutiny and contestation. Thus, Cindy Sherman's black-and-white movie stills—always her and never her—aped the look of various film genres to underscore their conventionality, whereas her infinite tabulation of the "images of women" generates equally conventionalized signs producing a category (woman) and not a subject. Additionally, the cherished notion of the artist's presence *in* the work was challenged by the act of literally inscribing the author herself and revealing her to be both fictional and absent.[20] Similarly, Richard Prince's rephotographs of the "Marlboro Man" advertisements, which he began to produce in the early years of the Reagan administration, pointedly addressed the new conservative agenda and its ritual invocations of a heroic past. Here, too, the jettisoning of authorial presence was a component of a larger project. By focusing on the image of the cowboy—the individualistic and masculine icon of American mythology—Prince made visible the connections between cultural nostalgia, the mythos of the masculine, and political reaction. Recropping, rephotographing, and recontextualizing the Marlboro men permitted Prince to unpack the menace, aggression, and atavism of such representations and reveal their analogical link to current political rhetoric.

Richard Prince, *Untitled (Cowboy)*, 1980-84.
Courtesy of Barbara Gladstone Gallery

In contrast to practices such as these, work such as Majore's abjures critique, analysis, and intervention on either its purported object—the seductiveness of commodity culture, the hypnotic lure of simulacra—or the material, discursive, and institutional determinations of art practice itself. Not surprisingly, the disappearance of a critical agenda, however construed, has resulted in an apparent collapse of any hard-and-fast distinction between

20. This aspect of Sherman's work was of particular importance to critics such as Douglas Crimp. For the interpretation of Sherman's photographs that stresses their feminist critique, see Judith Williamson, "Images of Woman,'" *Screen* 24 (November/December 1983), pp. 102-16.

art and advertising. In pop art, this willed collapse of the aesthetic into the commercial function carried, at leas briefly, a distinctly subversive charge. The erasure of boundaries between high and low culture, high art and commodity, operated as an astringent bath in which to dissolve the transcendalist legacy of abstract expressionism. Moreover, the strategic repositioning of the images and objects of mass culture within the gallery and museum reinstated the investigation and analysis of the aesthetic as an ideological function of the institutional structures of art. Postmodernism as style, on the other hand, eliminates any possibility of analysis insofar as it complacently affirms the interchangeability, if not the co-identity, of art production and advertising, accepting this as a given instead of a problem.

Perhaps one of the clearest examples of this celebratory collapse was an exhibition mounted in the fall of 1986 at the International Center of Photography entitled "Art & Advertising: Commercial Photography by Artists."[21] Of the nine artists represented, four came from the ranks of art photography (Sandi Fellman, Barbara Kasten, Robert Mapplethorpe, and Victor Schrager), two from the first wave of postmodernist photography (Cindy Sherman and Laurie Simmons), and two from the second (Stephen Frailey and Frank Majore); the ninth, William Wegman, whose work has encompassed both video and conceptualism, fell into none of these camps. As in the numerous gallery and museum exhibitions organized in the preceding years, the new ecumenicism that assembles modernist art photography and postmodernist photography functions to establish a familial harmony, an elision of difference to the profit of all.

Addressing the work of Frailey, Majore, Simmons, and Sherman, the curator Willis Hartshorn had this to say:

> The art of Stephen Frailey, Frank Majore, Laurie Simmons and Cindy Sherman shares a concern for the operations of mass media representation. For these artists to work commercially is to come full circle, from art that appropriates the mass media image, to commercial images that reappropriate the style of their art. However, for the viewer to appreciate this transformation implies a conscious relationship to the material. The viewer must understand the functions that are being compared through these self-referential devices. Otherwise, the juxtapositions that parody the conventions of the mass media will be lost.[22]

Now firmly secured within the precincts of style, postmodernist photography's marriage to commerce seems better likened to a love match than to a

21. "Art & Advertising: Commercial Photography by Artists," International Center of Photography, 14 September-9 November 1986.

22. Willis Hartshorn, gallery handout.

wedding of convenience. Deconstruction has metamorphosed into apprecia-
tion of transformation, whereas the exposure of ideological codes has mel-
lowed into self-referential devices. And insofar as the museum can now
institutionally embrace and legitimize both enterprises—art and commerce—
Harthorn is quite right in noting that a full circle has been described. For
those for whom this is hardly cause for rejoicing, the history of postmodernist
photography is cautionary rather than exemplary.

Working with Contradictions

The notion of critical practice, whether in art production or criticism, is notori-
ously hard to define. And insofar as critical practices do not exist in a vacuum,
but derive their forms and meanings in relation to their changing historical con-
ditions, the problem of definition must always be articulated in terms of the
present. Gauging the *effectiveness* of critical practices is perhaps even more diffi-
cult. By any positivist reckoning, John Heartfield's covers for *A-I-Z (Arbeiter
Illustriete Zeitung)* had no discernible effect on the rise of fascism, although he
was able to draw upon two important historic conditions unavailable to contem-
porary artists (a mass audience and a definable left culture). Still, the work of
Heartfield retains its crucial importance in any consideration of critical practice
insofar as it fulfills the still valid purpose of making the invisible visible and inte-
grally meshing the representation of politics with the politics of representation.
In other words, its critical function is both externally and internally inflected.

Although Heartfield was clearly a political artist, few contemporary artists
concerned with critical practice are comfortable with the appellation *political:*
first, because to be thus defined is almost inevitably to be ghettoized within a

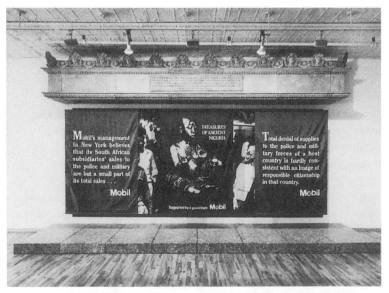

Hans Haacke, *MetroMobiltan*, 1985. Courtesy of John Weber Gallery. Photo: Fred Scruton.

(tiny) art world preserve; second, because the use of the term as a label implies that all other art is *not* political; and third, because the term tends to suggest a politics of content and to minimalize, if not efface, the politics of form. It is for all these reasons that throughout this essay I have chosen to employ the term *critical practice* in lieu of *political practice*. That said, the immediate difficulty of definition must still be addressed, and it is made no easier by the fact that a spate of recent practices—so-called simulationism, or neo-geo, and postmodernist photography in all its avatars—lays claim to the mantle of critical practice. Whether one is to take such claims at face value is another matter. But if we assume that critical practices conceptually assume both an activity and a position, the emphasis needs be placed on discursive and institutional function. In this regard Walter Benjamin's rhetorical question of 1938 is still germane: "Rather than ask, 'What is the *attitude* of a work to the relations of production of its time?' I should like to ask, 'What is its *position* in them?'"[23] The relevance of this question is that it underscores the need for critical practices to establish a contestatory space in which the *form* of utterance or address speaks to otherwise unrecognized, or passively accepted, meanings, values, and beliefs that cultural production normally reproduces and legitimizes. Insofar as contemporary critical practices operate within a society in which, as Victor Burgin observes, "the market is 'behind' nothing, it is *in* everything,"[24] the notion of an "outside" of the commodity system becomes increasingly untenable. This would suggest that the definition or evaluation of a critical practice must be predicated on its ability to sustain critique from within the heart of the system it seeks to put in question.

If we are to grant that a range of postmodernist photographic work that emerged at the end of the 1970s did, in fact, initially function as a critical practice, it did so very much within these terms. First of all, unlike other contemporaneous critical practices that positioned themselves outside the art world and sought different audiences (for example, Fred Lonidier's *Health and Safety Game*, Jenny Holzer's *Truisms, Inflammatory Essays,* and *Survival* series, the London Docklands project, Mary Kelly's *Post- Partum Document,* and D. Art's *Form Follows Finance,* to mention only a few),[25] postmodernist photo-

23. Walter Benjamin, "The Author as Producer," in *Reflections,* ed. Peter Demetz (New York: Harcourt, Brace, Jovanovich, 1938), p. 222.

24. "In contemporary capitalism, in the society of the simulacrum, the market is 'behind' nothing, it is in everything. It is thus that in a society where the commodification of art has progressed space with the aestheticisation of the commodity, there has evolved a universal rhetoric of the aesthetic in which commerce and inspiration, profit and poetry, may rapturously entwine." Victor Burgin, "The End of Art Theory" in Victor Burgin, *The End of Art Theory: Criticism and Postmodernity* (London: Macmillan, 1986), p. 174.

25. On Fred Lonidier's work and the London Docklands project, see *Cultures in Contention,* ed. Diane Neumaier and Douglas Kahn (Seattle: The Real Comet Press, 1985). On Jenny Holzer, see Bruce Ferguson, "Wordsmith: An Interview with Jenny Holzer," *Art in America* (December 1986), pp. 108-15. On Mary Kelly, see Mary Kelly, *Post-Partum Document* (London: Routledge & Kegan Paul, 1983). On "Form Follows Finance," see Connie Hatch, "Form Follows Finance," introduction by Jim Pomerory, *Obscura* 2, no. 5, pp. 26- 34.

graphy for the most part operated wholly within the parameters of high-art institutions. As the photographic work of Sherrie Levine clearly demonstrates, the critical specificity of such practice is operative, can be mobilized, only within a particular context. Its instrumentality, in other words, is a consequence of its engagement with dominant (aesthetic) discourses whose constituent terms (and hidden agendas) are then made visible as prerequisites for analysis and critique. As circumstances change (for example, with the assimilation of appropriative strategies into the culture at large), so too does the position of the artwork alter.

But within the overarching category of immanent critique, it is important to distinguish between those practices that elucidate, engage with, or even contest their institutional frame and those that suspend or defer the institutional critique in the belief that such critique is already implied within the terms of their focus on the politics of representation. Representation is, after all, itself contextually determined, and the meanings thereby produced and disseminated are inseparable from the discursive structures that contain and enfold them. Consistent with the terms of Peter Bürger's formulation, there is by now a lengthy history of art practices of the former type, ranging from those of the historical avant-garde through more recent production exemplified by Michael Asher, Daniel Buren, Marcel Broodthaers (d. 1976), Hans Haacke, Louise Lawler, and Christopher Williams. It is, I think, of some significance that the work of these artists has more or less successfully resisted the reduction to stylistics to which postmodernist photography so rapidly succumbed. This is in part due to the fact that, with the exception of Buren, these are all *protean* practices, whose changing forms are determined by the issues the work addresses, its venue, its occasion, the historical moment of its making. This formal flexibility not only militates against the fixity of a signature style but emphasizes the tactical and contingent aspect of critical practice that defines and redefines itself in response to particular circumstances. Working with contradictions entails not only a strategy of position as such but a degree of maneuverability as well.

This in turn suggests that art practices predicated on the production of signature styles rather than constantly modified interventions may be especially vulnerable to neutralization of their purported critique. The history of postmodernist photography overall would appear to confirm this analysis. As various theorists have argued, a position of resistance can never be established once and for all, but must be perpetually refashioned and renewed to address adequately those shifting conditions and circumstances that are its ground.[26]

It is one thing, however, for a critic to map out what she believes to be the necessary conditions for a critical practice and quite another to actively deal with, assess, or articulate a position in relation to the work she actually con-

26. For an excellent discussion of these issues, see Victor Burgin, *The End of Art Theory* (Atlantic Highlands, N.J.: Humanities Press, 1986).

fronts. Here, both critic and artist, situated within the restricted realm of high culture, are from the very outset enmeshed within a particularly dense matrix of contradiction. Once the decision is made to operate within the institutional space of art rather than outside it, critical writing and critical art are alike caught up in and subject to the very conditions such work attempts to contest. This is particularly the case with critical advocacy. Critical practice, if it is not to reduce itself to the tedium (and moralism) of the jeremiad, must be equally concerned with advocacy and partisanship. My own critique of the triviality and conservatism of official art photography was integrally related to my support of alternative photographic practices. This support, in turn, inevitably became part (a small part) of a cultural apparatus of undifferentiated promotion in the service of supply-side aesthetics. Critical advocacy, irrespective of the terms in which it is couched, is from the outset either part of the commodity system (for example, in the format of the museum or gallery exhibition catalogue or the commercial art magazine essay or review) or secondarily appropriated to it (as in the assimilation of critical writing into art journalism or the gallery press release). This means that critical writing, regardless of the writer's politics, can in no way consider itself as independent of the cultural apparatus it seeks to contest. This is not, however, to claim that there are no differences. Nor is this to suggest that critical writing is to be reduced to the opposite poles of partisanship or attack. On the contrary, ideally the work of the critic and the work of the artist—to the degree that they both conceive their practices critically—are theoretical, if not actual, collaborations. As is true of art practices with which such criticism collaborates, learns from, and shares its agenda, working with contradictions necessitates a practical sense of what those contradictions imply—what they enable and what they preclude.

Thus, although the prevailing conditions of cultural production are hardly cause for optimism, neither are they cause for unrelieved despair; it is, after all, the very existence of discernible contradictions that allows for the possibility of critical practices in the first place. That said, perhaps the most daunting of all the contradictions that critical practices must negotiate is the direct consequence of problematizing the concept of the political in art. In this regard, the writing of Brecht, the practice of Heartfield, and the prescriptions of Benjamin can no longer be looked to as the *vade mecum* of critical practice. For if we accept the importance of specificity as a condition of critical practice, we are thrown into the specifics of our *own* political conditions and circumstances in the sphere of culture. To the extent that these include a refusal of inside/outside dichotomies ("the market is *in* everything"), an interrogation of the notion of prescription itself (authoritative modes, practices, models), a recognition of the contingency and indeterminacy of meaning, and a general acknowledgment of the inescapable complicity of all practices within cultural production, it becomes increasingly difficult to say with any assurance what critical practices should actually or ideally seek to do. Needless to say, the putting in question of traditional conceptions of political correctness, of determi-

nate and fixed positions of address, of exhortative or didactic modes of critique, has been exclusively the project of feminism and a part of the left. The regnant right knows no such uncertainty as it consolidates its position with increasing authoritarianism, repressiveness, and certainty. To have thus problematized the conditions of political enunciation within cultural production at a moment of extreme political reaction is perhaps the most daunting contradiction of all.

I gratefully acknowledge the advice, suggestions, good counsel, and unstinting support of Rosalyn Deutsche in the writing of this essay.

A version of this essay originally appeared in *Screen* (Summer 1987).

Carol Squiers

Class Struggle: The Invention of Paparazzi Photography and the Death of Diana, Princess of Wales

> It would appear that every proprietor and editor of every publication
> that has paid for intrusive and exploitative photographs of her, encour-
> aging greedy and ruthless individuals to risk everything in pursuit of
> Diana's image, has blood on his hands today.
> —Charles, Earl Spencer [1]

I

THE DEATH of Diana, Princess of Wales, in a Paris car crash in the summer of
1997 brought immediate and mostly negative attention to the publicity mecha-
nisms and procedures of celebrity culture. Her fame had killed her, it seemed,
and the process by which celebrities were elevated and then brought low would
have to pay. Angry actors, journalists from the mainstream press, and ordinary
citizens in the United States and abroad took turns—on television talk shows,
in newspaper and magazine letters columns—demanding an end to the kind of
media practices that seemingly drove Diana to her shocking end.

The overriding theme of the pandemonium was that tabloid culture was
out of control and that even the quality news media had been infected and
overrun by tabloid sensibility. The first to feel the heat were paparazzi photog-
raphers, the most despised members of the news photographers's profession.
A posse of these motorized snapshooters had been following Diana and her
new paramour, Emad Mohamed (Dodi) Al-Fayed, the night of the crash.
Based on their proximity to the crash and on their well-documented aggres-
siveness, the photographers were quickly convicted in the court of public
opinion of responsibility for the accident, which claimed three lives. [2]

1. Howard Chua-Eoan, Steve Wulf, Jeffrey Kluger, Christopher Redman and David Van Biema, "Death of
a Princess," *Time*, 8 September 1997, p. 33.

2. Alan Riding, "Public Likes Celebrity Photos But Hates the Photographers," *The New York Times*, 2 Sep-
tember 1997, sec. 1, pp. 1, 11. All the early reporting on Diana's death emphasized the putative role of the
paparazzi in the car crash.

Much of what was said and written in the aftermath of the accident was based on the assumption that the concerns, methods, and subject matter of the tabloid press—and especially of its photographers—were relatively new developments. Until this occurrence, tabloid photographers had gone relatively unexamined in any serious way.[3] Certainly, in the days following Diana's accident, it became clear that there is no consensus even within the profession of journalism on the definition of paparazzi photography. It has been discussed as an illegitimate form of celebrity photography, a peripheral type of tabloid-press image-making that could easily be eliminated if only editors would stop printing it and the general public would stop buying the tabloids it is printed in. Even the paparazzi's defenders have been unable to make a convincing case for paparazzi photography's role as part of the star-making apparatus, with its dependence on both shielding and revealing secrets about stars, which has been in place since the 1920s.

The lack of clarity about paparazzi photography's position, status, and function is understandable. In the United States, until Diana's death, little attention had been devoted to it, except for isolated magazine articles and brief vignettes on individual photographers, usually produced by tabloid news shows; similarly, the French have mainly considered the activities of contemporary French paparazzi, with the British doing the same for British photographers, while the Italians have given attention to the original Italian paparazzi of the 1950s.[4]

This essay will look at the phenomenon of paparazzi photography to define what it is and how it relates to other types of photography such as photojournalism and documentary; show that a form of paparazzi photography emerged even before it began as an organized, albeit anarchic practice in Italy after World War II and then subsequently spread throughout Western news

3. There are a few studies available of the tabloid press, but none of them specifically treat tabloid photography. Among them are S. Elizabeth Bird, *For Enquiring Minds: A Cultural Study of Supermarket Tabloids* (Knoxville: University of Tennessee Press, 1992); Patricia Mellencamp, *High Anxiety: Catastrophe, Scandal, Age, and Comedy* (Bloomington and Indianapolis: Indiana University Press, 1992); John D. Stevens, *Sensationalism and the New York Press* (New York: Columbia University Press, 1991). Essays that do address paparazzi photography are Karin E. Becker, "Photojournalism and the Tabloid Press," in *Journalism and Popular Culture*, eds. Peter Dahlgren and Colin Sparks (London: Sage, 1992); Alan Sekula, "Paparazzo Notes" in *Photography Against the Grain* (Halifax: The Press of the Nova Scotia College of Art and Design, 1984).

4. The only publication available in English that gives an overview of the phenomenon is *American Photo* (July/August, 1992), pp. 46-85, 92, 93. For the British photographers see Stuart Wavell, "All Out for the Prints," and William Langley, "The Grapes of Wrath," in *The Sunday Times*, style and travel magazine, Sunday, 11 September, 1994, sec. 9, and Mark Saunders and Glenn Harvey, *Dicing with Di: The Amazing Adventures of Britain's Royal Chasers* (London: Blake Publishing Ltd., 1996). Daniel Angeli and Jean-Paul Dousset, *Private Pictures*, intro. Anthony Burgess (London: Jonathan Cape Ltd., 1980), is a look at the early work of two of the most infamous French paparazzi. The original Italians are covered in Jennifer Blessing, "Paparazzi on the Prowl: Representations of Italy circa 1960" in *Italian Metamorphosis, 1943-1968*, organized by Germano Celant, preface Umberto Eco (New York: Guggenheim Museum Publications, 1994), pp. 324-33, and Massimo Di Forti, "Flash Warning: The Paparazzi Are Coming," *Aperture*, (Summer 1993).

and entertainment media; examine its deployment in regard to its arguably most famous subject, Diana, Princess of Wales, and how it was thus used to reinforce the objectifying, voyeuristic position of women in representation while also staging an attack on the British monarchy as an institution.

<div align="center">II</div>

Paparazzi photography occupies a seemingly unique position outside the bounds of polite photography, defined by its self-admitted characteristics of aggression and stealthiness, narrow range of subjects, and elastic formal definitions of what constitutes a "good" picture. Despite its singular reputation, it is not a singular visual discourse. Instead, it is a rough-edged hybrid that is patched together from the visual regimes and positivist assumptions that constitute four types of photography that are practiced and consumed as if they are distinct from one another: photojournalism; documentary; celebrity photography, which is itself a hybrid of editorial and promotional photography; and surveillance photography. The paparazzo brings these photographies together in a way that maximizes outrage and seems to blanket the entire medium in disgrace.

Richard Dyer observes that the construction of celebrity personas, however artificial they may be, is aimed at making fans believe that can have access to the "truth" about the celebrities. "Stars are obviously a case of appearance— all we know of them is what we see and hear before us. Yet the entire media construction of stars encourages us to think in terms of 'really'—what is [Joan] Crawford really like."[5] Paparazzi photography supplies that 'really' better than anything else—seemingly incontrovertible visual documentation about the people it catches in compromising or embarrassing positions. And it does it in a timely fashion such that the photographs operate as news photographs, contributing visual vignettes of the small events and appearances that the tabloid press thrives on and that mimic documentary photography.

But paparazzi is a long way from the typical notions of documentary or news photography. It is generally disowned by practitioners of documentary photography, along with photojournalism and celebrity photography, because it does not share elements usually considered essential to each of them; in the case of surveillance photography, its practitioners usually defend its instrumental function rather than its expressive capabilities. This listing of caveats and negatives gives a clue to how paparazzi photography works, which is through a series of inversions, an upending of categories, subjects, definitions, and expectations.

Most obviously, it overturns the usual context and subjects of photojournalism and documentary photography, focusing the camera away from the battlefield of war's wounded and society's rejected to the theater of celebrity,

bar

271

CAROL SQUIERS

5. Richard Dyer, *Heavenly Bodies: Film Stars and Society* (London: The Macmillan Press Ltd., 1986), p. 2.

wealth, and privilege. In the typical arena of photojournalism, the most terrible aspects of political upheaval, intergroup violence, and human want are graphically portrayed on the human body, creating tableaux of profound abjection. The emaciated figures of famine victims, the dazed visages and contorted bodies of the wounded and the dead in the midst of civil war, the grief-stricken postures of those who bury the casualties are familiar sights in the catalog of human misery chronicled by photojournalism. The dire circumstances of the people pictured are generally considered sufficient reason for the photojournalist to record their plight, although the images will be reproduced only in publications which deem the victims worthy of attention.[6] In picturing the absolute vulnerability of civilian populations to all types of civil disorder, photojournalism helps create disparate visions of abjection, which variously pities, condemns, and dignifies its subjects.

The paparazzo's search for the effects of illicit assignations, exhibitionism, reputation degradation, and financial plenty on well-known individuals also ends in graphic but very different images of the human body. If the recorded figures are emaciated, that is liable to be the result of the self-imposed starvation of anorexia or bulimia rather than the politically and economically induced starvation that famine usually is today. Other self-perpetuated alterations of the body's contours that are subjects for the paparazzi are the distended stomach produced by overeating or the after-effects of a face lift or breast implant surgery. Uncontrollable bodily ravages, of illness and old age, are also typical paparazzo subjects. More likely, the observed bodies will be well fed, well exercised, and well rested. Rather than dire circumstances, these bodies will usually be found in the most luxurious of situations. While photojournalism wants to create visions of dignified abjection, paparazzi photography records the abjection of the dignified, reducing them to objects of ridicule and mocking laughter.

Indeed, the players and the context within which they are located marks a major difference between most conventional documentary and paparazzi photography. Like photojournalism does, documentary photography has largely focused on those who are vulnerable: the impoverished, the homeless, the damaged, the victimized. The documentarian, rather than looking at the immediate results of a shocking newsworthy event, instead attends to the ongoing, long-term situations of human degradation and despair in terms of conditions such as worker exploitation, brutalizing living conditions, family violence. Traditionally, these kind of photographs have had either an implicit or explicit agenda about correcting the conditions they illuminate.

In contrast, the paparazzo focuses on those who are least vulnerable, in terms of their access to money and power: film and television stars, European royalty, pop singers, politicians. Their day-to-day living situations will be diffi-

6. As celebrity reportage has taken up more airtime and space in the American print media, however, most victims of political violence have become marginalized.

cult to photograph, as they can usually secure their privacy when they are at home or on the set of a movie or television show.[7] So the paparazzi create their own space for documenting specific, very limited aspects of stars' lives. They are easiest to photograph when they travel and their vacations are usually taken in luxurious and exotic locales which change with the seasons and the fashions. Conversely, they are also photographed on busy city streets, restaurants, stores, and markets, where the celebrity can be seen to be engaged in everyday activities. Some famous subjects are of interest when he or she is alone, although celebrity love relationships are a major topic for the tabloid press.

Edward Herman and Noam Chomsky, in their discussion of the way news reportage functions as propaganda, proposed that people who receive the most extensive news coverage, particularly after a violent political event in countries outside the United tates, do so because they are considered "worthy victims," that is, people who have been harmed by those hostile to the interests of the United States. In contrast, "unworthy victims" receive little, if any, news coverage when they suffer grave injury and death because they have been injured by friends of the United States, or they themselves are defined as enemies of U.S. interests.[8]

In terms of photographic coverage, however, the opposite is often true. "Worthy victims," such as those killed and injured in a bombing in a country friendly to the United States, are often treated with greater respect by news organizations, who don't show explicit images of their injuries. The same is true of domestic stories: during the financial-industry scandals on insider trading of the 1980s, for example, none of the Wall Street financiers were photographed as they were being arrested.[9] The so-called "perp walk," the small event staged for the news media when a suspect is transferred from a courthouse or jail to a police vehicle, is a humiliating display generally reserved for young, male Hispanics or African Americans. In the case of Diana's death, it is the perception of her as a worthy victim that produced the outcry when it was claimed that some photographers had photographed her in the wreckage of the car. The theory of the worthy victim is another marker that is inverted by paparazzi photography: the worthy victim, who would usually be protected from the camera's intrusion, is instead its primary subject.

Just as an inversion of subject and context takes place between photojournalism, documentary, and paparazzi, an inversion of photographic style

CAROL SQUIERS

7. There was only a short period of time after World War II when stars allowed photographers to document their everyday lives with any freedom, mainly for the original *Life* magazine. Among the most unsparing of those pictures are the ones Eve Arnold took for her 1959 story on an aging Joan Crawford at work, taken at the star's request. Politicians sometimes still allow a truncated version of behind-the-scenes documentation.

8. Edward S. Herman and Noam Chomsky, *Manufacturing Consent: The Political Economy of the Mass Media* (New York: Pantheon, 1988), pp. 37-86.

9. See Carol Squiers, "Special Effects," *Artforum*, (November 1986), p. 12, for a short piece on the financiers.

takes place in paparazzi photography in comparison to posed celebrity portraiture. In the posed images taken for both editorial and advertising venues, a high value is placed on the star's ability to control and manipulate every aspect of the image—lighting, makeup, costume, hairstyle, facial expression, posture, and gesture. Big stars usually demand and receive blanket control over who takes the pictures, how they will be constructed, where in a publication they will be used, and which images will be reproduced.

In paparazzi images, the star as a subject is the only point of continuity with posed imagery. Other than that, the entire constellation of control and manipulation is rendered inoperative. The lighting in paparazzi photos is haphazard, professionally executed makeup and hairstyle are usually absent, costume is casual and often ill-kempt and ill-advised. Posture and facial expression will be the unthinking result of walking down a street or laying on a beach, rather than the conscious effort of looking one's best while gazing into the lens of a camera. Rather than molding a celebrity as a uniquely magical creature the way posed pictures do, paparazzi images show celebrities as more mundane figures who sometimes inhabit the same space (a city sidewalk, a parking lot), perform similar tasks (shopping, jogging), and wear the same clothing (blue jeans, sloppy sweaters) that the noncelebrity does.

The difference between what is "special" and what is "ordinary" is a major factor in comparing paparazzi and surveillance photography as well. Paparazzi is a focused kind of surveillance, as opposed to the usually unmanned, ubiquitous surveillance of much camera-based surveillance. For the average person, surveillance of all types is a fact of life, whether in public or in the workplace, although the surveillance is usually covert. People are routinely photographed as they shop, bank, drive their cars, and sit at their desks.[10] A wide spectrum of government authorities and employees of private businesses have the wherewithal to conduct surveillance, including security guards, police officers, store clerks, and IRS agents.

While the celebrity may be prey to much of this surveillance, his or her workplace monitoring is of a different order than what the average person is subjected to. The celebrity's shorter, more varied, and more concentrated work schedule—the three months it may take to make a movie in Paris, say—stands in stark contrast to the monotony of a ten-year stint as a payroll clerk at a paper factory somewhere in Tennessee, and whatever surveillance is in place there.

Celebrity members of the British royal family, however, are subjected to several layers of surveillance. They are watched by the upper-class palace courtiers—"a quaint sort of private hereditary civil service"—who have a historical, social, and financial stake in maintaining the privileges and monitor-

10. In addition, their telephone calls may be monitored by management, along with the number of key strokes per minute they log on their computers. Their credit history is accessible to anyone who knows where to look, as is their tax history. For a general roundup of some surveillance techniques as of mid-1997, see Joshua Quittner, "Invasion of Privacy," *Time*, 25 August 1997, pp. 28-35.

ing the behavior of the royals.[11] These strangely powerful "men in grey" visited continuous rebukes to the Princess of Wales for the slightest infraction of their unwritten rules. "Diana's enemies within are the courtiers who watch and judge her every move," writes Andrew Morton. "If Diana is the current star of the Windsor roadshow then senior courtiers are the producers who hover in the background waiting to criticize her every slip."[12]

Equally as devious and potentially more harmful for Diana (and other errant royals) was the monitoring done by MI5, the domestic branch of British intelligence, with both cameras and eavesdropping equipment. At Highgrove and Kensington Palace, for instance, "spy cameras" were in place to watch Diana's every move. "When she goes for a walk in the fields surrounding Highgrove the unblinking eye of a camera swivels and tracks her while the two policemen who constantly patrol the grounds discreetly alter their perambulations so that they have her constantly in their sight."[13] At all the royal residences, phone calls that pass through the switchboard are monitored and recorded around the clock. The famed Squidgygate conversation of Diana and James Gilbey, which was picked up and publicized by an amateur radio enthusiast, was actually taped several years earlier and rebroadcast, allegedly by MI5, with the aim of having it "intercepted" by an amateur.[14]

But any newsworthy celebrity is also watched by several tiers of tipsters, both paid and unpaid, who work for celebrities or in the vicinity of them. They report to gossip columnists, tabloid reporters, and paparazzi photographers, who operate on behalf of tabloid newspapers and television programs as well as more mainstream media outlets, who in turn fashion themselves as acting on behalf of the public's right to know or the public's endless fascination with celebrity. If a picture of an inaccessible event of intense popular interest is needed, a tipster will be enlisted to take it; it was a relative of Elvis Presley's who took the picture of him in his casket at his funeral.[15]

That unwieldy and infinitely flexible entity known as "the public" is in theory the arbiter and patron of the photographic celebrity surveillance that has come under such attack in the wake of Diana's death. In recognition of that fact, individual citizens performed various symbolic acts disavowing

11. Jeremy Tunstall, *Newspaper Power: The New National Press in Britain* (New York: Oxford University Press, 1996), p. 320. Tunstall also quotes an unnamed journalist to the effect that "many of the names [of the royal courtiers] had not changed since Queen Victoria's time; courtiers were appointed on the basis of family tradition," p. 333.

12. Andrew Morton, *Diana: Her True Story* (New York:Pocket Books, 1992), p. 196.

13. Andrew Morton, *Diana's Diary: An Intimate Portrait of the Princess of Wales* (New York: Summit Books, 1990), p. 19; also Andrew Morton, *Diana: Her True Story—In Her Own Words* (New York: Simon & Schuster, 1992; revised 1997), p. 157.

14. James Whitaker, *Diana vs. Charles: Royal Blood Feud* (New York: Signet, 1993), pp. 107-9.

15. S.J. Taylor, *Shock! Horror! The Tabloids in Action* (London: Black Swan Books, 1991), p. 87.

and/or repenting their roles as consumers of tabloid media. These included publicly burning tabloids and setting up sites on the Internet calling for individuals to take vows not to purchase tabloids.[16]

But it is "the public," the great mass of generally powerless citizens, that is usually the subject of surveillance. The paparazzo stages an inversion of that relationship in that the public, by proxy, becomes the motive force behind the paparazzo's surveillance of those who are used to possessing and wielding the kind of power that usually puts surveillance in place. The celebrity takes the position that is typically occupied by powerless "victims" in photojournalism or documentary, with the paparazzi image constructing an empowered gaze for the usually powerless public. For someone like Diana, who was subjected to so much surveillance within the boundaries of her at-home life, the additional surveillance by the photographers proved intolerable.[17] It is the surveillance aspect of paparazzi activity that celebrities react against the most violently, the sensation that they are being watched, followed, and photographed without their consent, that their most private moments or insignificant but embarrassing incidents are being caught on film for general consumption as part of the escalating traffic in pictorial sensationalism.

III

Commentators have noted the intrusive, prying capacity of photography virtually since the camera's public introduction. "A man cannot make a proposal or a lady decline one...a gardener cannot elope with an heiress, or a reverend bishop commit an indiscretion, but straightway, an officious daguerreotype will proclaim the whole affair to the world," wrote one editor in 1846.[18] The fact that the daguerreotype was too slow and its apparatus too cumbersome to accomplish either of those things mattered little; the editor correctly foresaw the camera's eventual use as an instrument that could capture one's most intimate and fleeting moments, although that development would not occur for almost forty years. When it did, ordinary people found themselves subjected

16. The Internet was peppered with sites calling for a variety of boycotts of supermarket tabloids, foreign publications that printed paparazzi shots, and tabloid television shows. One site in Georgia called itself PAT (People Against Tabloids) and another site adopted the name "Stoparazzi." Between August 31 and September 9, 1997, the site, "Remember Princess Diana: Stop Paparazzi," claimed to have received 23,332 hits.

17. The essay that defined and challenged certain liberal assumptions about the efficacy of documentary photography, is Martha Rosler's "In, Around and Afterthoughts (On Documentary Photography)," in *Three Works* (Halifax: The Press of Nova Scotia College of Art and Design, 1981). Diana spelled out how difficult the press attention was for her in her statement announcing she was leaving public life in 1993. *Diana: Her New Life* (New York: Pocket Star Books, 1994), pp. 138-139. Little did she suspect that her withdrawal would fuel certain photographers even more, which is graphically demonstrated in an entire book by two paparazzi, Mark Saunders and Glenn Harvey.

18. Michael L. Carlebach, *The Origins of Photojournalism in America* (Washington, D.C.: Smithsonian Institution Press, 1992), p. 3.

to intrusions similar to what celebrities would later experience, a point to which we will soon return.[19]

There are certain isolated images that, in their casual insolence, could be said to prefigure the development of the paparazzi style. One photographer who made such images was an Italian count named Giusseppe Napoleone Primoli, a descendent of Napoleon I. Between about 1888 and 1905, he made thousands of images of every strata of Italian life, from sleeping bums and street vendors to the king, Umberto I. His well-born or talented friends, in both France and Italy, were also his subjects. Among them was Edgar Degas, who was captured by Primoli in a classic paparazzi-worthy venue—both insignificant and embarrassing—seemingly buttoning his fly as he steps out of a Parisian pissoir in 1889.[20]

Perhaps Primoli's images inspired another Italian, Adolfo Porry-Pastorel, who was working as early as 1912, to photograph a variety of local news subjects. According to historian Italo Zannier, Pastorel "took action photographs that looked for the curious, the unusual, the unrepeatable, and even the scandalous..." He also owned the Veda photo agency, which trained and represented photographers who later became known as paparazzi, including Sergio Spinelli and Tazio Secchiaroli.[21]

The photos he took and the ones he sold in his agency would not have been possible without the lighter, hand-held cameras that were introduced in the 1880s. Their relative flexibility allowed photographers to catch people in unflattering or compromising positions, inspiring much overheated debate. "The layman feared and hated the amateur with his ubiquitous camera," writes Bill Jay, "and the snapshooters ignored the restraints of common decency and good manners. The problem rapidly reached such proportion that, for the first time, the act of taking—or not taking—a picture was less an aesthetic consideration and more a moral or ethical one."[22] Photographers were referred to as "fiends" and "lunatics."[23] The *New York Times*, with a 1884 story entitled "The Camera Epidemic," proclaimed that snapshooting had become a "national scourge".[24] The outrage aroused by amateur photogra-

19. From the time the daguerreotype was invented, operators realized the profit potential in photographing newsworthy clients. Carlebach, p. 15.

20. John Phillips, "Primoli's Due," *Connoisseur*, March 1984, p. 94. My thanks to Glen Willumson for providing me with a copy of this essay. See also Daniela Palazzoli, *Giuseppe Primoli: Instantanee e foto-storie della Belle Epoque* (Milan: Electra Editrice, 1979).

21. Italo Zannier, "Naked Italy," *Paparazzi Fotografie: 1953-1964* (Florence: Fratelli Alinari, 1988), p. 17. My thanks to Emily Miller for her translation of this text.

22. Bill Jay, "The Photographer as Aggressor," in *Observations: Essays on Documentary Photography*, ed. David Featherstone (Carmel, California: The Friends of Photography, 1984), p.9.

23. Ibid., p. 8 and p. 11.

24. Ibid., p. 10.

phers among editorial writers, judges, and legislators helped inspire a legal recognition of the right of privacy in New York.[25]

The growing community of amateurs was hardly dissuaded by irate citizens, who were aroused by stories about blackmail cases involving snapshots, with curates and prominent citizens being the favored targets of such schemes.[26] Actresses were always of interest to photographers, even when seen in less than ideal circumstances. "We must especially regret that Mdme. Sarah Bernhardt was not photographed the other day as she fell down the flight of stairs at a theatre!" wrote one writer in *The Amateur Photographer* in 1885.[27] Clearly, the desire to make the types of images that came to be known as paparazzi photographs—in all their embarrassing, trivial, and indecorous detail—began long before enterprising Italian photographers colonized the genre in the postwar era.

Those photographers are the ones Federico Fellini used as the model for his famed character, Paparazzo, the annoying news photographer who raced around Rome chasing celebrities along with the jaded gossip columnist played by Marcello Mastroianni in *La Dolce Vita* (1959). Once the film came out, the photographers—who up until then had been aptly called "assault photographers"—were thereafter known as "paparazzi," a relentless bunch who stalked the many movie stars and other celebrities who poured into Italy in the postwar years. (The origin of the name Paparazzo has never been conclusively established. Zannier says that Fellini knew a Calabrian hotel owner with the name Paparazzo.[28] Hollis Alpert quotes the writer Ennio Flaiano, whom Fellini worked with for many years, to the effect that Flaiano himself found the name in "an obscure Italian libretto."[29] Fellini wrote that he had had a friend at school called Paparazzo, who spoke very quickly and did strange imitations of insects, especially mosquitos, with his mouth.[30] Fellini has also claimed that the word was onomatopoeic, taken from a Sicilian word for an oversized mosquito, *papataceo*.[31]) Photography may have been considered intrusive in the past, but these men were the ones who formalized purposeful, strategic intrusiveness—as opposed to accidental,

25. Robert E. Mensel, "Kodakers Lying in Wait: Amateur Photography and the Right of Privacy in New York, 1885-1915," *American Quarterly* vol. 43, no. 1 (March 1991), p. 25.

26. Bill Jay, "The Photographer as Aggressor," p. 11.

27. Ibid.

28. Zannier, "Naked Italy," pp. 10-11.

29. Hollis Alpert, *Fellini: A Life* (New York: Paragon House Publishers, 1986), p. 125.

30. French Photo, March 1973, p. 63.

31. Blessing, "'*Paparazzi* on the Prowl': Representations of Italy circa 1960," in *Italian Metamorphosis, 1943-1968*, p. 325.

casual, or thoughtless intrusiveness—as a primary operating methodology. The techniques of today's paparazzi have gotten more sophisticated and combative, but there is little that is done today that was not pioneered on Rome's dark streets.

How and why that came to be is a story of war and recovery, of social and economic transformation. It includes the changing and contested place of women in traditional Italian society, the invasion of Hollywood celebrities and other members of the international jet set into the conservative, essentially provincial city of Rome, and the reaction of Italian journalism to these changes and to increased press freedoms in the wake of fascism's collapse. The story forms a necessary backdrop to understand the construction of paparazzi photography today, albeit one that must here be radically condensed.

There is no specific point at which paparazzi photography can be said to have begun. Its defining moment occurred in Rome in the late evening and the early morning of August 14 and 15, 1958, during the Ferragosto or Feast of the Assumption holidays.[32] During that time, photographers sought to catch a variety of newsworthy celebrity subjects in compromising situations. In the process, some photographers were themselves attacked and those incidents were then immortalized in images.

Among their subjects was Farouk, the exiled former king of Egypt, who confronted Tazio Secchiaroli after he took pictures of him at a café with two young female companions—one of whom was either a singer or a prostitute—and neither of whom was his wife; he tried to break Secchiaroli's camera and take his film while another paparazzo, Umberto Guidotti, snapped a hazy shot of the scene. The same evening Secchiaroli photographed the actors Ava Gardner and Tony Franciosa kissing in Bricktop's café on the Via Veneto, while Franciosa was still married to Shelley Winters. Lastly, Secchiaroli took a sequence of images of actors Anita Ekberg and Anthony Steel arguing and staggering down a street, after which Steel also attacked Tazio and other pursuing photographers.

Irate, cheating on their spouses, and in some cases knock-kneed drunk, the celebrities played out for the photographers everything the American gossip-mongering press had been saying about them since the 1920s. The privileged lovers of nightlife exhibited with abandon the bad tempers, surfeit of alcoholic consumption, and generally excessive behavior the gossip columnists had long reported.[33]

32. Attilio Colombo, "Paparazzo Alias Secchiaroli," *Tazio Secchiaroli*, I Grandi Fotografi Serie Argento (Milan: Gruppo Editoriale Fabbri, 1983). Translation by Emily Miller. For a one-page roundup of reportage on that infamous night, see the page from the August 24, 1958, edition of *L'Espresso* reproduced in Andrea Nemiz, *Vita, Dolce Vita* (Rome: Network Edizioni, 1983), p. 20. My greatest appreciation to Andrea Nemiz for giving me a copy of his valuable book.

33. The best single source on the development of gossip as a part of the news in the United States is Neal Gabler, *Winchell: Gossip, Power and the Culture of Celebrity* (New York: Alfred A. Knopf, 1994).

They had been saying it only in words, however. In the United States, photographers still cooperated with celebrities in constructing idealized or at least flattering images. The photographers who covered the film industry had a vested interest in having continued access to the stars who were their main subjects, as did the magazines that ran the images. Photographers like Phil Stern, Nat Dallinger, Sid Avery, and Bob Willoughby shot candid but respectfully sympathetic images for mainstream magazines such as *Life* as well as the fan and movie magazines. In the 1950s, if *Photoplay* or *Modern Screen* ran stories or images the studios objected to, the studios would withdraw advertising.[34] The paparazzi had no such investment in maintaining good relations with the ever-changing cast of transient leading men and aspiring starlets—many from the United States—who paraded before their cameras. And scandalous images sold for ten or twenty times the amount ordinary ones did. According to Secchiaroli, an image of an American actor alone would bring him the equivalent of about U.S. $3. But a picture of the actor socializing with a pretty escort— which he asked Secchiaroli not to take—was worth about $50.[35]

In addition to the antic quality of the depictions, another noteworthy aspect of the paparazzi was that the photographers began to share the stage with the celebrities; their belligerent confrontations would enhance the price of the image as well as bringing the photographers themselves a kind of celebrity. They would even work in teams, one photographer to provoke the celebrity and one to take the resulting imbroglio.[36] One of the first sets of images by the Italian paparazzi printed in *Life* magazine was Marcello Geppetti's series of Anita Ekberg threatening photographers with a bow and arrow and then physically tussling with one.[37] The worldwide publication of such images established this seemingly new and aggressively reckless type of press photography.

Some of the original paparazzi identify their reason for taking these pictures as being primarily financial. This stands to reason, as most came from very modest backgrounds. But the fact that Italian newspapers and magazines so readily printed these impolite and unflattering photographs indicates that the images illustrated something beyond their nominal subject matter: that the very form of the images—their awkwardness, their compositional and behavioral roughness, and the often explosive emotions and embarrassing situations shown in them—served as social expression as well as celebrity news.

34. Ronald L. Davis, *The Glamour Factory: Inside Hollywood's Big Studio System* (Dallas: Southern Methodist University Press, 1993), p. 155; also see Davis's entire chapter on publicity, especially for the role of studio photographers, pp. 137-57. In addition, see Carol Squiers, "Hollywood Glamour," *American Photo*, (May/June 1995), pp. 55-58, 106-7.

35. Tazio Secchiaroli, interview with author, Rome, Italy, 8 May 1994, translation David Secchiaroli.

36. Ibid.

37. "Swings and Arrows of Outraged Ekberg," *Life*, 31 October 1960, pp. 28-30.

Accordingly, most gossip theory has been developed by social anthropologists, sociologists, and psychologists looking at verbal forms of gossip within specific communities. Amongst its several uses, interpersonal gossip serves to establish and reinforce the normative standards of the community by commenting on those who depart from perceived norms. Photographs are used in the same way; in the case of those taken by the Italian paparazzi, they examine and ridicule the objectionable components of people from the privileged classes, many of them from other countries. Among other things, they are a visual form of protest against, and hostility to, the outsiders from Hollywood and elsewhere who came to make movies on the cheap in Italy—especially the modern postwar actresses in low-cut dresses who boldly paraded on Rome's provincial streets—the loose social and sexual mores they brought with them, and the continuing prominence of American culture abroad. The photographs served to negotiate—and to resist—social change during the years of reconstruction and modernization in postwar Italy.

Among the most important of the social issues being fought over was the position of women in Italian society, which had been contested since the end of World War I. The fascist philosophers and social scientists who were prominent during Benito Mussolini's rule delineated the definition of the modern Italian woman between the wars.

According to Victoria De Grazia, beginning in the 1920s, the fascist government saw the changing roles of women in modern society as a series of problems that affected social norms. Concern over the "sexual danger" for women posed by new freedoms was shared during this period by both the Roman Catholic Church and various fascist philosophers and social technicians. Modern fashion was one point that vividly illustrated those dangers in some quarters. Organizations such as the fascist National Committee for Cleaning Up Fashion, along with the church, inveighed against the "scandalous" quality of modern women's dress, and issued stern warnings to women about the consequences of violating their prescribed standards. "By the late 1920s major Italian churches had posted signs barring "immodest" dress."[38] In 1929, the fascist ideologue Paolo Ardali denigrated the modern woman for a variety of perceived shortcomings, among them the power of fashion to "enslave" her, which "seems almost like the diabolical power of evil itself."[39]

Italian women were subjected to other proscriptions beyond those aimed at the cut of their clothes. Among them was the use of public space, and especially the café, which was an all-male preserve. Young women who sauntered by the café in the evening might be seen as flaunting their new and still highly

38. Victoria De Grazia, *How Fascism Ruled Women: Italy, 1922-1945* (Berkeley: University of California Press, 1992), pp. 205-6.

39. Donald Meyer, *Sex and Power: The Rise of Women in America, Russia, Sweden, and Italy* (Middletown, Connecticut: Wesleyan University Press, 1987), pp. 31-2.

contested freedoms; at the same time they would be the subject of apprecia-
tive voyeurism by the male habitués. But it would be improper for a woman to
actually sit down with male friends at a café.[40] For a woman to appear in pub-
lic at all was problematic, according to fascist writer Ferdinando Loffredo.
Thus, women had to be dissuaded from working outside the home; he pro-
posed that women who showed themselves in public spaces, on buses, street-
cars, sidewalks, on their way to work be subjected to popular reproach.[41]
"Between church and state, there was a consensus that women out alone, their
company unmediated by authority, were a public danger."[42]

Mass culture, too, was seen as a problem in relation to women, especially
in the form of the new pastimes of shopping and going to the movies. The cine-
ma in general was identified with femaleness, and was deprecated as a result.
One contemporary intellectual, Giovanni Papini, constructed the commercial
culture of the cinema as whorish and venal, with the morals and aesthetics of a
streetwalker who appealed to vulnerable customers.[43] The cinema was female,
and like much other commercial culture, was a threat from America. Holly-
wood's images "devirilized Italian men" and "debilitated" young couples.[44] "Not
least of all, Americanized leisure threatened to transform Italian girls, making
them masculine and independent like their American counterparts."[45]

Along with the specter of independent women, another threat for the fas-
cists was an independent press. A former journalist himself, Mussolini
believed that "newspapers were the key to success."[46] Strict regimentation of
the press began in the early 1930s, when editors were forbidden to print news
about "crime, financial or sexual scandals," all of which were social distur-
bances that might prove distracting and bring the morality of the regime into
question.[47] Such subjects, of course, were the major components of a popular
press, well established in the United States, that the news photographers who
came to be known as paparazzi would pursue with a vengeance after the war.

Under Mussolini, however, photographers were censored; those who
wanted to work had to acquire government accreditation and to know the lim-
its on what they could photograph. Their brief was to produce images with "a
very solemn or cerebral character," which would include photographs of Italy's

40. De Grazia, *How Fascism Ruled Women*, p. 202.

41. Meyer, *Sex and Power*, p. 32.

42. De Grazia, *How Fascism Ruled Women*, p. 206.

43. Ibid., p. 208.

44. Ibid., p. 209.

45. Ibid.

46. John Whittam, *Fascist Italy* (Manchester and New York: Manchester University Press, 1995), p. 89.

47. Ibid. Also see Denis Mack Smith, *Mussolini* (New York: Alfred A. Knopf, 1982), p. 143.

major monuments or politically palatable photographs of fascist activities.[48] Great emphasis was placed on the cult of the Duce, including the ways in which he was to be photographed: as a statesman and warrior, as well as a man of the people, "gathering in the harvest, visiting schools."[49]

The components of Mussolini's image stressed his manly physicality as a visible proof of his powers as a head of state. He was the "first contemporary head of state to vaunt his sexuality: stripped to the waist to bring in the harvest or donning black shirt before Fiat workers, decked out as a pilot, boat commander, or virtuoso violinist, Duce was as vain as a matinee idol pandering to his female publics."[50]

Few matinee idols end strung up by their heels in a public square, as Mussolini was in 1945. His bloody repudiation notwithstanding, social relations elaborated during his regime outlasted its downfall. Among those that pertain here—and that seem to have fed the impulses that drove the paparazzi—are reactionary conceptions about the role of women, the contested and gendered definition of public space, a suspicion of the cinema's seductions, and a deeply conflicted love-hate relationship to the United States.

Many of the fascists' theories about femaleness and its proper place were temporarily nullified during the difficult years of World War II, however. Women were pushed out of the home by the war, and placed in factory and government jobs to fill in for 1.63 million men who were gone. Women played prominent roles in the Italian resistance to the Germans that began in September 1943 after the alliance between Italy and the Allies had been struck. After the war was over, of course, women were expected to return to the home. There were plenty of official pronouncements about the role that postwar women should fulfill. In 1946, Pius XII delivered a discourse on women, in which he proclaimed that every woman was destined to be a mother and to stay home, and thus avoid the "dazzle of counterfeit luxury" that women who work outside the home experience and desire.[51] Within a few years, the church continued its promulgation of increasingly traditional views: "the woman must be subordinate to man, his intelligent and affectionate companion. And this subordination of the woman in home and church must be extended into civil life."[52]

48. Zannier, "Naked Italy," p. 15 and Zannier, telephone interview with Emily Miller, 25 June 1997.

49. Whittam, *Fascist Italy*, p. 90.

50. De Grazia, *How Fascism Ruled Women*, p. 205. Also see Edward R. Tannenbaum, who quotes Carlo Emilio Gadda's *Eros e priapo* to the effect that Mussolini took and retained political power precisely because he was an exhibitionist, in *The Fascist Experience: Italian Society and Culture 1922-1945* (New York: Basic Books, 1972), pp. 214-15.

51. Meyer, *Sex and Power*, p. 141.

52. Ibid., p. 142. Although it is not specified, this quote was presumably from Pius XII.

The social pressure on women to return home was successful. By 1960 the number of women in the workforce had fallen significantly and was one of the lowest in Western Europe.[53] New women's magazines and television advertising encouraged urban women to spend money instead of earning it and exalted the "new figure of the modern Italian woman." Once married, and even after the children were grown, Italian women rarely returned to the workplace.[54] As Ginsborg puts it, "the idealized confinement of women to the home in the 1960s served to enclose them in a purely private dimension, and to remove them even more than previously from the political and public life of the nation."[55] This movement of women back into the home occurred during the years of the economic miracle, from 1958 to 1963, which were also the most active years of the paparazzi.

One big challenge to the conservative sexual and social mores of the traditional Italian was the cinema, and especially foreign cinema. The guardians of Italian culture could only look on with alarm as American movies aggressively moved into the Italian marketplace after the war. Because the film industry in the United States had been hurt by the loss of its European markets during the war, it was anxious to reestablish itself. "As Allied troops liberated Europe, American motion pictures followed in their path, with exhibition arranged by the Bureau of Psychological Warfare. The Office of War Information was handling the distribution of U.S. films in France, Belgium, the Netherlands, and Italy, until American companies could reopen their offices."[56] In the immediate postwar years, Italy was flooded with American films. Between 1945 and 1950, "the Italian market was virtually dominated by imports from America, which controlled between two thirds and three fourths" of it.[57]

During those same years, American producers suffered when the courts ruled that the studios had to divest themselves of their movie theaters, a major profit center.[58] This occurred just before television became a major competitor to film. Hollywood partially combatted television by producing movies with sexual content, which was out of the question for television, by using color and other technical gimmicks that television was not equipped for, and

53. Paul Ginsborg, *A History of Contemporary Italy: Society and Politics 1943-1988* (New York: Penguin Books, 1990), p. 244.

54. Any earnings they derived were from doing piecework at home or laboring parttime in the underground "black economy." See ibid., p. 244 and Meyer, *Sex and Power*, p. 40.

55. Ginsborg, *A History of Contemporary Italy*, p. 244.

56. Thomas H. Guback, "Hollywood's International Market," in *The American Film Industry*, ed. Tino Balio (Madison: University of Wisconsin Press, 1976), p. 395.

57. Peter Bondanella, *Italian Cinema: From Neorealism to the Present* (1983; reprint, New York: Continuum, 1990), p. 36.

58. For a good summation of this issue, see Michael Conant, "The Impact of the Paramount Decrees" in Balio, *American Film Industry*, pp. 346-70.

by reducing costs by going overseas, where labor prices in a country like Italy stayed severely depressed even during the economic miracle years.[59]

Before the war some Italian intellectuals saw the influence of American films on Italy as problematic. After the war they were confronted with the additional difficulty of hosting the many American films being made in their country. On the one hand, film production gave much-needed jobs to hungry Italians. On the other, the influx of Americans, including film personnel, tourists, and American stars, must have created substantial cultural friction.[60] There in the flesh were the independent, "masculine" American women the fascists had warned of—and that the Italians were still afraid of, as we shall later see—some of them in the person of starlet-wannabes and blondes in tight clothes.

The buxom, showy actresses and their male escorts were one of the paparazzi's major targets. While Italian women were being directed to go back into the home and to wear modest clothes, especially in public, American actresses flaunted themselves in revealing dresses on the streets of Rome. Jayne Mansfield, Ava Gardner, Linda Christian, and Elizabeth Taylor were among the best-known and most often-photographed of the American bombshells, along with the Swedish Anita Ekberg. But Ekberg's actual ethnicity meant little. She was perceived as an American-style sex bomb because she had begun her movie career in Hollywood and was crafted in the same mold as Marilyn Monroe and Jayne Mansfield. When Fellini tapped Ekberg for the role of Sylvia, the wanton film star, he predicated her on a "prototype" of this kind of woman that he had seen in an American magazine.[61] "In the film, Ekberg seems larger than life; she is the European stereotype of the hypertrophied American women, monumentalized."[62]

Ekberg was a prime target for the paparazzi: she was a prototypical sexual spectacle and she resisted them, rather than posing or staging run-ins the way Americans often did.[63] One classic series of paparazzi photos taken by Marcello Geppetti in 1960 shows Ekberg confronting paparazzi who had followed her to her Rome villa one night. Ekberg emerges from the villa in a rage, attired in her dinner dress and stocking feet and hoisting a formidable-

59. "Joseph E. Levine built himself a commercial empire on films with Steve Reeves and a cast of Italians which were produced for under $150,000 in Italy and then dubbed into English," according to Gerald Mast, during a time when the average cost of making a film in the United States was $800,000 to $1.14 million." Gerald Mast, *A Short History of the Movies* (Indianapolis & New York: The Bobbs-Merrill Co., 1971), pp. 317 & 324-5.

60. Of course, Italians had experienced American servicemen as part of the Allied occupation from 1943 on. See Ginsborg, *A History of Contemporary Italy*, pp. 39-42.

61. Alpert, *Fellini*, p. 125.

62. Blessing, "Paparazzi on the Prowl," p. 328.

63. Ibid., p. 329.

Marcello Geppetti: Mickey Hargitay lifts Jayne Mansfield into a car, Rome, c. early 1960s.

Marcello Geppetti: Anita Ekberg fights with paparazzi with box and arrow, 1961

looking bow and arrow. In the ensuing fracas, she grapples with photographer Felice Quinto, pulling his hair while kneeing him in the groin.

Although it was common for Italian men such as director Michelangelo Antonioni to fight with paparazzi, whether verbally or with his fists, few, if any, women did so. And especially not with the real weaponry and low blows proffered by this Americanized amazon. Ekberg managed to be a nightmarish vision of monstrous sexuality and masculinized behavior rolled into one, living proof of how (American) independence and wanton sex could destroy a woman's femininity.

Like many paparazzi shots, these images express criticism of Ekberg in the form of visual jokes. A number of scholars who have written about gossip—and paparazzi imagery is a visual form of gossip—draw parallels between joking and gossip. In her study on gossip as it is used in literature, Patricia Meyer Spacks uses Freud's ideas about joking to analyze the dynamics of the joke as it applies to gossip.

She notes that for Freud, aggressive content is a necessary element of the joke. She quotes him to the effect that jokes can be divided into two categories, "'innocent' and 'tendentious,' thus distinguishing those which constitute ends in themselves, serving no particular aim, from those filling a definable purpose. Two possible purposes emerge: a joke is either a *hostile* joke (serving the purpose of aggressiveness, satire, or defence) or an *obscene* joke (serving the purpose of exposure)."[64] Given that paparazzi images are taken for publication, it is apparent that they qualify more as tendentious jokes. But paparazzi images in fact collapse the categories: their purposes can be both hostile and obscene, they are variously aggressive and/or satirical, and aim particularly at the exposure of the celebrities who appear in them.

Spacks emphasizes that in order to satirize or expose effectively, the purveyor of the joke needs a hearer, just as the purveyor of a photograph needs a

64. Patricia Meyer Spacks, *Gossip* (1985; reprint, Chicago: University of Chicago Press, 1986), p. 49.

viewer. "This hearer plays an important part in the production of jokes," writes Spacks, who quotes Freud's contention that "no one can be content with having made a joke for himself alone."[65] Every joke demands a special "public," and "laughing at the same jokes is evidence of far-reaching psychical conformity."[66] Jokes, then, can serve as social regulation, targeting nonconformity in the interests of social cohesion.

And no one displayed greater nonconformity in the Italy of the 1950s than the outsized movie stars from other lands. When the magazine *Lo Specchio* ran the photographs of Anita Ekberg taking on the paparazzi, it paired one image of her aiming her bow with a film still of her in period Roman costume hurling a spear; the ersatz modern warrioress takes her cue from the filmic Amazon.[67] The humor in the images resulted not only from the actions being performed but from the way the bodies performing them looked: Ekberg, vacillating between physical adeptness and clumsiness, the photographers seemingly shocked into an addled passivity. In addition to the jokey absurdity of the images, they also delineate a comical physicality that would have been appreciated by an Italian audience accustomed to the physical expressionism of the traditional *commedia dell'arte*.

The *commedia* evolved as a form of popular entertainment in the Renaissance, when traveling companies of poor and usually illiterate players performed at fairs, markets, and city squares. "In the *commedia*...the bodies of the actors, their movements and behaviors, tell most of the story, along with verbal jokes noteworthy more for their color and rhythm than for their subtleties."[68] Some critics maintain that the entire tradition of Italian film has been influenced by the *commedia*, from the early twentieth-century dramas to the neorealist period and the more popular "comedy Italian style."[69] Angela Dalle Vacche notes that the neorealists had a particular interest in "the comedic impulse to magnify details of physiognomy and daily life."[70] Coming on the heels of neorealism, and taking some neorealist heroes as their victims/subjects, the paparazzi strove to look at the daily life of carousing celebrities, especially as it pertained to their romantic liaisons. The paparazzi hardly

65. Ibid., p. 50. Sigmund Freud, *Jokes and Their Relation to the Unconscious*, trans. James Strachey, (New York: Norton, 1963), p. 90.

66. Spacks, p. 50. Freud, p. 131.

67. Nemiz, *Vita, Dolce Vita*, pp. 50-51.

68. Angela Dalle Vacche, *The Body in the Mirror: Shapes of History in Italian Cinema* (Princeton, New Jersey: Princeton University Press, 1992), pp. 4-5. In addition to doing pantomimes and acrobatics, the actors wore facial masks (*maschere*) that represented well-known stereotypes.

69. Mira Liehm, *Passion and Defiance: Film in Italy from 1942 to the Present* (Berkeley and Los Angeles: University of California Press, 1984), p. 11. Also Bondanella, *Italian Cinema*, p. 145.

70. Dalle Vacche, p. 56. In *Italian Cinema*, Bondanella also notes the comic vein in neorealism—*neorealismo rosa*, p. 88.

needed to "magnify" physiognomic details, as the celebrities did that themselves: all the photographer had to do was be watchful so as to catch the spilling cleavage, the ungainly yawn, the drunken pratfall or ill-advised strut. But the paparazzi's provocations, which made celebrities lash out, get angry, flee from or chase the photographers, produced exaggerated reactions that created celebrities as comic visions.

Amusing in and of themselves, paparazzi images mirrored the difficult social adjustments necessitated in the postwar years, just as movies did when the tradition of the *commedia dell'arte* was transformed into the *commedia all'italiana*. "Flourishing at the height of what has been termed the 'Italian economic miracle,' the *commedia all'italiana* lays bare an undercurrent of social malaise and the painful contradictions of a culture in rapid transformation."[71]

At the same time that paparazzi were recording the physical excesses of celebrity, postwar Italian cinema was also busy creating a new ideal (body) image for the Italian woman that was untainted by frosty immobility of fascist prototypes. It was earthy, "rich with joyous sensuality, generous in its proportions, warm, and familiar."[72] The neorealists, all of whom had begun their careers in the fascist era, looked to popular theatre and variety shows for their actors. "In these kinds of theatre, *total use of the body* is the instrument and form of communication, rather than interpretative, psychological, or dramatic refinements." In addition, the neorealists also looked for the ideal Italian actress, such as Sophia Loren, Gina Lollobrigida, and Silvana Mangano, at beauty contests, "where the rite of 'Italianess,' now expressed in physical forms and movements, could be celebrated to the full."[73] In a culture that was developing an indigenous expression of the body, where "new actors were trained and film actors of the 1930s were retrained, on the basis of the assumption that *face and body are language*," the bodies of American sexpots spoke a language of the gutter rather than the earth.[74]

Nowhere is that more pointedly illustrated than in Geppetti's 1962 images of Elizabeth Taylor and Richard Burton, taken while the two were filming *Cleopatra* in Italy. At the time, Taylor was married to Eddie Fisher and Burton was married to Sybil Burton.

Along with many other paparazzi, Geppetti had been stalking the two lovers, hoping to get the shot that showed what was evident to onlookers: that the two were having an affair, which became a major news story. "Looking back on that era and to that affair, one is amazed that a couple of people, mesmerized by their own egos, should have monopolized for so many months the

71. Bondanella, *Italian Cinema*, p. 145.

72. Giovanna Grignaffini, "Female Identity and Italian Cinema of the 1950s" in *Off Screen: Women and Film in Italy* eds. Giuliana Bruno and Maria Nadotti, (London & New York: Routledge, 1988), p. 123.

73. Ibid., p. 123.

74. Ibid., p. 122.

attention of the world."[75] (Celebrity infidelity is a common story in the 1990s. But in the early 1960s, adultery was still scandalous, especially when it involved a star such as Elizabeth Taylor, who had been married three times and had already been painted as a scarlet woman.) Geppetti had photographed the couple together in a variety of situations around and outside Rome. He was able to capture them in odd, isolated situations, with each trying to move

Marcello Geppetti: Elizabeth Taylor and Richard Burton discovered in 1962.

away from the other so as not to be photographed together. One series of images shows the unhappy pair after they'd run their car into a ditch on a dirt road, which Taylor claims occurred after pursuing paparazzi had "jumped in front of the car".[76]

He persisted in his quest despite the fact that on March 29, another photographer (possibly Pierluigi Praturlon) caught the two actors, attired in bathrobes, kissing openly on the set, which seemed to "prove" the affair, although the stars laughed it off.[77] The next day, the two "decided to turn the tables on the paparazzi by publicly dating on the Via Veneto, grimly impervious to the cascade of popping flashbulbs all around them."[78] Within days the formal separation and pending divorce of Taylor and Fisher was announced.[79] The world press reacted with an avalanche of moralizing condemnation, almost all of it aimed at Taylor. Even the Vatican newspaper chimed in, in the form of a "reader's" letter that castigated her for her divorces and their effect on her children, saying she would end in "erotic vagrancy."[80]

The sheer size of the story fueled the paparazzi, who were still looking for photographs that showed real intimacy between the two. Some paparazzi supposedly got shots of them at a seaside resort in late April, but other photographers continued the quest.[81] Geppetti got the most telling pictures that

75. Alexander Walker, *Elizabeth: The Life of Elizabeth Taylor* (New York: Grove Weidenfeld, 1990), p. 250.

76. David Kamp, "When Liz Met Dick," *Vanity Fair*, April 1998, p. 386.

77. Alexander Walker, *Elizabeth*, p. 251.

78. Dick Sheppard, *Elizabeth: The Life and Career of Elizabeth Taylor* (New York: Doubleday & Co., 1974), p. 304.

79. Alexander Walker, *Elizabeth*, p. 252.

80. Sheppard, *Walker*, p. 309.

81. David Kamp, "When Liz Met Dick," p. 386. The paparazzi who got the photos are not named, nor are the pictures characterized as to the intimacy they showed.

summer in Ischia, an island near Naples, of the two on a small boat sunbathing and kissing. The pictures ran in publications around the world, generating further moral indictments.[82]

One particularly stinging piece in *L'Europeo* was written by the Italian journalist Oriana Fallaci and accompanied by four of Geppetti's boat-deck pictures. The piece was based on interviews with Burton, with cameos put in by Taylor, who is repeatedly described in wholly negative terms. According to Fallaci's descriptions, Taylor looks small and exhausted; dressed in her ludicrous costume with sweat pouring from under her "raccoon" wig, she is an object of pity; when she puts on a dress, covered in "flowers and pompons" she is even more pathetic. Further, "everyone" knew that Burton, who was under terrible strain because of the affair, was going to return to his wife.

Toward the end of the piece, Fallaci unleashed her most fervent criticism. "Liz was not born in America, she was born in London...but I have rarely met a more American woman: ruthless, masculine.... Outside she is a woman, but inside she is genuinely a man."[83] In the thirty-plus years since its enunciation, the fascist assessment of American women as "masculine" had survived as received wisdom. The postwar invasion of Italy by Hollywood had only strengthened that apprehension.[84]

It was a fear that the paparazzi capitalized on when they discovered resentment and aggression as a response to the preening perquisites of celebrity. And their pictures were embraced, as fascist press censorship was dismantled and the scandalous dirt that had been forbidden was allowed. Strict press codes for photographers were abandoned; in their place grew a range of practices, from investigative photojournalism to the celebrity scandal of the paparazzi.[85] According to historian Paolo Costentini, "This photography [paparazzi] transformed all conventions of representation."[86]

The Taylor-Burton affair was the last big story for the Italian paparazzi; the era of the Via Veneto was over by 1963, about the same time that Italy's economic boom ended. But the term "paparazzi" as well as the photography they produced had become a part of media culture.

82. Photoplay magazine ran one on the cover, headlined, "Liz and Burton—Shameless Lovers" and reprinted the letter from the Vatican newspaper in its October 1962 issue.

83. Oriana Fallaci, "Gli ozi di Ischia", *L'Europeo*, June 1962, p. 26. My thanks to Amy Wanklyn for her translation and to Alexandra Rowley for her assistance.

84. In a perhaps ironic recognition of the fascist overtones of this critique, Fallaci ended the piece with an anecdote about how no one was permitted to argue with Taylor because "Miss Taylor is always right," a gloss on one of the best-known catch-phrases of Mussolini's reign, that is, that "Mussolini is always right." Fallachi, "Gli ozi di Ischia," p. 27. See Denis Mack-Smith for Mussolini's belief in his own infallibility in *Mussolini*, p. 124. My thanks to Amy Wanklyn for pointing out Fallaci's invocation of Mussolini's motto.

85. Italo Zannier, "Naked Italy," pp. 15 and 17.

86. Paolo Costantini, "Evidenze," *Paparazzi Fotografie: 1953-1964*, p. 33.

Other European photographers began making paparazzi images, at the ski resorts, tropical getaways, and other exclusive haunts where the famous and the celebrated went to play; it took somewhat longer for the paparazzo style to catch on the United States. During the 1960s, the definition of celebrity changed as Hollywood actors began mingling with dispossessed European royalty, American socialites, and political activists. Increasingly they were featured in the fashion press and the gossip press, and would be photographed by the paparazzi. As the rich and the privileged began to preen themselves in public, the sense of growing social dislocation and economic disparities, peripatetic celebrity culture, and profit motivation that fueled the Italian photographers was seized on by photographers around the globe.

IV

By the time Lady Diana Spencer appeared on the scene as Prince Charles's girlfriend in 1980, paparazzi photography was an established business in Western Europe. In the United States, only Ron Galella was well known as a paparazzo, mostly because of his legal entanglements with Jacqueline Kennedy Onassis, which effectively ended his ability to photograph her.[87] If "paparazzo" wasn't a dirty word before, it certainly was after Galella sued the former first lady—and lost. Even Fellini, the godfather of the paparazzi, had denounced them in print when images of Jackie O sunbathing nude on the island of Skorpios were published. "There is no such thing as a good paparazzo. A good paparazzo, that's a paparazzo who has had his camera broken. In fact, they are bandits, thieves of photography."[88] Although he meant merely to denounce the paparazzi, in pointing to the illicit, stolen quality of these images, Fellini illuminated precisely what makes them so compelling.

Diana's arrival as a subject for the paparazzi coincided with and helped establish a golden age of tabloid journalism, in both Britain and the United States. In her study of American tabloids, S. Elizabeth Bird writes that "The 1980s were the decade of the supermarket tabloids, when their characteristic formats developed and circulations peaked. Four tabloids, the *National Enquirer, Star, Globe,* and *National Examiner* had the greatest circulation growth of all magazines in the United States in 1982, reaching a combined figure of 11.4 million.[89] (In this essay, "tabloid" will refer to a weekly supermarket

87. She had him arrested in 1969 while he was trying to photograph her and son John, prompting him to file an ultimately self-destructive lawsuit against her the following year. The upshot of his action was that he was enjoined from getting any closer than fifty yards from her or seventy-five yards from her children. Even though the distances were reduced during a 1973 appeal to twenty-five feet and thirty feet, respectively, Galella would never photograph her again. Ron Galella, *Jacqueline* (New York: Sheed and Ward, Inc., 1974), pp. 153-181.

88. *French Photo*, March 1973.

89. Bird, *For Enquiring Minds: A Cultural Study of Supermarket Tabloids*, p. 8. The statistic is from a *BusinessWeek* study in 1983.

tabloid when the publication in question is American, but to the tabloid-sized daily newspapers when they are British.) The expansion of the British tabloids was not comparably uniform, with one paper, Rupert Murdoch's *Sun*, accruing extraordinary gains and even more extraordinary power during the 1980s at the expense of the other tabloids. When he bought the paper in 1969, its circulation was slightly over one million. By 1988 its circulation peaked at 4,219,052.[90] Because of its popularity, the *Sun* set the editorial agenda—especially in terms of sensationalism and conservative politics—for all of the other tabloids, whose total daily sales in 1985 was 12,330,000 copies and 15,154,000 on Sundays.[91]

Perhaps because the British tabloids are marketed as daily newspapers, there is demographic information available on their readers.[92] Predictably, the readership splits along social-class lines. In 1995 the so-called "downmarket" papers—which are the *Daily Mirror, Daily Star,* and the *Sun,* and *News of the World, People,* and *Sunday Mirror* on Sundays—counted only about one-third their readers as being middle class, the rest presumably being working class. In contrast, two-thirds of the readers of the mid-market tabloids—the *Daily Express* and *Daily Mail* during the week and *Sunday Express* and *Mail on Sunday*—were counted as being middle class.

The American supermarket tabloids, however, closely guard whatever reader information they possess. One marketing study shows that in 1987 the *Globe* and *Examiner* appealed to "poorer and less-educated readers than the *Star* or *Enquirer*." According to the writer, the readers were "65 percent female, with a median age of thirty-five, and 51 percent having household incomes under $20,000. Sixty percent never graduated from high school."[93] Market research done by the *Star* shows that 75 percent of the tabloids's readers were married women in their thirties with larger-than-average families, who take the tabloid home, where it is read by the husband and children.[94]

In the case of both the American supermarket tabloids and the British daily tabloids, their social and political views generally run a gamut from merely conservative to rabidly reactionary, although the *Daily Mirror* in Britain has a more liberal readership, which is reflected in its support for the

90. Matthew Engel, *Tickle the Public: One Hundred Years of the Popular Press* (London: Victor Gollancz, 1996), p. 332.

91. Tunstall, *Newspaper Power,* p. 41 and p. 54.

92. Although some demographic information is available in Tunstall, he breaks it down only by identifying the percentages of middle-class readers, everyone else by default being classified as "not middle class," p. 8.

93. Bird, *For Enquiring Minds,* p. 108. The information is from an advertising agency's reader profile.

94. S.J. Taylor, *Shock! Horror!,* p. 146. Although it is tremendously problematic to construct a notion of the tabloid audience on such questionable research, tabloid editors apparently do make editorial decisions based on a constellation of ideas (and biases) about what this kind of "evidence" means.

Labour Party.[95] Because the British tabs are daily newspapers, they run editorials and articles on British politics along with more human-interest stories, gossip, and/or sensational items. Like most of the other British papers, tabloids and broadsheets alike, the *Sun* was a major supporter of Margaret Thatcher (although the paper had taken a generally pro-Labour line until she ran for office). After she was in office, her press secretary fed Thatcher's ideas to the *Sun* after helpfully translating them into "*Sun*-ese."[96]

The American supermarket tabloids mainly specialize in celebrity stories and largely ignore the workaday world of politics and politicians unless someone is caught in a sexual scandal. Indeed, it was a political sex scandal involving former Colorado senator Gary Hart and a young woman named Donna Rice, that apparently brought the supermarket tabs some measure of respectability and moved tabloid "dirt" from the margins of media respectability somewhat closer to the presumably clean, bourgeois center. The *National Enquirer* helped destroy Hart's presidential aspirations when it published a picture of the married ex-senator with Rice sitting on his lap, on board a pleasure boat aptly called the "Monkey Business." After that, editor Iain Calder said he could "detect a difference in the attitude from the national press toward the *Enquirer*."[97] That shift in attitude would then be seen in other scandals, especially in the O. J. Simpson double-murder story, when even such upscale papers as the *New York Times* would follow the lead of supermarket tabloid stories—and reap censure for doing so.[98]

The essential conservatism of the tabloids on both sides of the Atlantic is especially manifest in the way they treat stories on women—which is what we will be concerned with here—as well as gays, lesbians, and people of color, and in the celebrities they choose to feature. In the 1980s and '90s, American tabloids consistently trumpeted what the right wing liked to call "traditional American values."[99] Those values were largely constructed in opposition to feminism, homosexuality, liberalism, and identity politics of all kinds.

The coverage of women and the issue of feminism created a tricky situation for the tabloids, especially as the '90s wore on. The majority of tabloid

95. Tunstall, *Newspaper Power*, p. 251.

96. Ibid., p. 272. See Tunstall's chapter-long analysis of the rightward tilt of the papers, pp. 240-255. Also see Matthew Engel, *Tickle the Public*, pp. 264 and 167.

97. S.J. Taylor, *Shock! Horror!*, pp. 123-124.

98. "*Times* Is Criticized for Using Simpson Account from Tabloid," *The New York Times*, 25 Dec. 1994, sec. A. By early 1998, the source for political sexual scandal had further declined, when Matt Drudge, a right wing gossip purveyor on the World Wide Web, broke the story that *Newsweek* was withholding a story on President Bill Clinton's alleged sexual affair with White House intern Monica Lewinsky. See James Ledbetter, "Press Clips," *Village Voice*, 3 February 1998, p. 28.

99. Bird, *For Enquiring Minds*, p. 67.

readers are women—estimated at from 65 to 75 percent.[100] In contrast to the mainstream press, women make up almost half the subjects covered in American tabs, the great majority of them entertainers from television, movies, and the music world.[101] On the one hand the tabs openly ridicule "women's libbers" and all independent females.[102] But the women they cover are far from the norm of the traditional American housewife. The tabs negotiate this problem by stressing the aspects of star's lives that conform to conventional social notions, in terms of happy marriages, children, and even home-making prowess. As Bird puts it, "tabloid heroines are not successful career women but women who make unusual marriages and succeed as mothers. Villains, on the other hand, are women (and men) who disrupt the family ideal."[103]

In terms of the British tabs, Murdoch's papers set the tone for the coverage of women. His formula for the *Sun* was seemingly simple: at a 1969 staff meeting he announced "the three elements that were going to sell the paper: 'Sex, sport and contests.'"[104] That philosophy has been evidenced most famously and most overtly in its gleeful display and promotion of its bare-breasted "Page Three" pinups. By 1977 the *Sun* had abandoned any pretense of serious journalism. "It began not merely to report the salacious stories but to splash them on the front page: BLACK BRA BAN ON SCHOOL LOLITAS; VICAR QUITS FOR LOVE OF NURSE..."[105] And most salacious stories inevitably involve a woman whose sexual needs—or whose sexual effect on a man—lead to shame, social isolation, and destruction of the family unit.

It was within this journalistic milieu that the figure of Diana, Princess of Wales, was created and publicized. Despite the trivializing preoccupations of the tabloids, it was a grim period for Great Britain. The mid- and late 1970s had seen a huge jump in unemployment, factory closings, and inflation, and concurrent trade-union strife. At the same time, public expenditures on health, education, and art were cut. Sectarian violence between Protestants and Catholics in Northern Ireland escalated throughout the 1970s, culminating in 1979 with the bombing death of Charles's great-uncle, Earl Mountbatten of Burma, on board his yacht off the coast of Ireland. A round of strikes by public-service workers in the winter of 1978-79 led to a Conservative party victory, with Margaret Thatcher coming to power as prime minister. The worsening social problems, including bloody race riots in London in 1981 and

100. Ibid., p. 108.

101. Ibid., p. 77.

102. Ibid., p. 76.

103. Ibid., pp. 76-77.

104. Engel, *Tickle the Public*, p. 253.

105. Engel, *Tickle the Public*, p. 259.

deepening unemployment, were met with the harsh social measures of Thatcher's brand of triumphant conservatism. In June of 1981, just before the much publicized wedding of Charles and Diana, a teenager shot at the Queen as she rode on horseback in central London during the Trooping the Color parade to celebrate her birthday. With the news in England being unremittingly bleak, it has been argued more than once that the young princess was an especially attractive distraction from the domestic situation.[106]

Thus, Diana was not a figure seen in isolation. In addition to her husband and the royal family, Diana was also part of a shifting cast of characters that featured Margaret Thatcher, England's first female prime minister. In a *New Yorker* tribute, Simon Schama asserted that Diana played the antithetical role of royal "hugger" to Thatcher's Iron Lady.[107] But we must also (briefly) consider how Diana could be used by a conservative press as a weapon *against* Britain's women, working-class and professionals alike.

Much as Ronald Reagan was doing in the United States, Thatcher expended great political energy attacking women both directly and indirectly. Single mothers came in for particular abuse, especially for their supposed scheming reliance on welfare. The conservative championing of "father's rights" created a scenario in which "the single mother was easily regarded as threatening the traditional role of the father and the coherence of society in general."[108] A rhetoric of resentment and reaction against women was regularly splashed across Britain's newspapers. But women were adversely impacted by many other cutbacks, which while not overtly targeting them, nonetheless hit them the hardest, including reductions in state-sponsored health care, education, and housing.[109]

Alongside the discourse on the shortcomings of the feminized welfare state, images of Diana were counterposed. If poor, single women were the enemy, then the paragon was this responsible, traditional wife and mother, happily and uncomplainingly doing her part. Her milk-fed femininity was enhanced by the conservative pastel dresses and slacks she favored when her children were babies. There was a dual message in the way she was presented, on the one hand as a distant figure of royal privilege and on the other as a kind of timeless, classless ideal who was beloved for her display of "the common touch."

106. See Simon Schama, "The Problem Princess," *The New Yorker*, 15 September 1997, pp. 64-65, on his contention that the figure of Diana cannot be understood without considering the effect of Margaret Thatcher and her harsh social policies.

107. Ibid., p. 64.

108. Maureen McNeil, "Making and Not Making the Difference: The Gender Politics of Thatcherism," in *Off-Centre: Feminism and Cultural Studies* (London: Harper Collins Academic, 1991), eds. Sarah Franklin, Celia Lury, Jackie Stacey, p. 229.

109. Sarah Franklin, Celia Lury, and Jackie Stacey, "Introduction 2: Feminism, Marxism and Thatcherism," *Off-Centre*, eds. Franklin, Lury, Stacey, pp. 26-27.

Under Thatcher, though, welfare "scroungers" weren't the only women who came in for criticism. Conservatives also blamed national ills on the professions of teaching and social work, which are heavily populated by women.[110] Diana, too, was considered a working woman, her "job" being to make public appearances for good causes and other events that, however vaguely, were purportedly contributing to civic welfare. But she was a professional women in whom cherished feminine attributes were foregrounded—kindness, good manners, impeccable grooming. And verbal restraint: for the first three years of her marriage, she is supposed to have uttered only five hundred words in public.[111]

Diana, indeed, was treated not so much as a newly minted royal wife as a godsend. As such, she was supremely useful to the tabloids, from her years as an attractive young wife and mother, her increasing glamour, and then her good works, through all the rocky patches of unhappiness, separation, confession, divorce, rebellion against the Windsors, and sudden death. In both Britain and the United States, she was used to negotiate questions about spousal loyalty, public duty, maternal responsibility, female vanity, female duplicitousness, and the structure and meaning of the royal family. As they had in the past, photographs provided graphic "evidence" about all of these issues.

That evidence was inscribed at first on the young, lush, virginal body of Diana, which in quick succession became the sexual body, the swelling, maternal body, the glamorous body, the anorexic body. Her reduction to an essential body was neatly accomplished before she was even engaged to Charles, when a much-reproduced photo of her was taken at the nursery school where she worked. In it she is holding one small child on her hip and clutching the hand of another one. Sun shines through her sheer skirt, making it virtually transparent and revealing the strong outline of her legs; the right foot of the child she is holding hangs right over her crotch, both pointing to it and hiding it. It is an apt visual trope for the way in which the camera will be used to try to make virtual X rays that penetrate and reveal her, while children will alternately define and shield her.[112]

After her death, *Newsweek* wrote that the unwittingly revealing image showed "further proof of her naïveté," presumably for not knowing exactly how she would look when photographed.[113] In fact, its publication was only the beginning of a probing, ceaseless, and almost gynecological interest in the future princess's body. When Prince Charles was captured on tape over a

110. McNeil, "Making and Not Making the Difference...," *Off- Centre*, p. 232.

111. Kitty Kelley, *The Royals*, p. 308.

112. She agreed to pose for it after crying when photographers ambushed her. See Barbara Kantrowitz, "The Woman We Loved," *Newsweek*, 8 September 1997, p. 42.

113. Jeff Giles, "A Fairy-Tale Princess," in *Newsweek Commemorative Issue. Diana: A Celebration of Her Life*, p. 31.

decade later telling his lover Camilla Parker-Bowles that he would like to "live inside your trousers" and that he might "come back" as her Tampax, those were images the British press would have relished had they been made in reference to Diana simply because the press, along with much of the reading public, had been living—imaginatively—inside Diana's trousers for years.[114] That those words were addressed to Camilla, who has been vilified more because she is considered to be physically unattractive—with her lined and sagging middle-aged body—than because she has carried on with Prince Charles, seemed to strike dumb even seasoned commentators.

Not surprisingly, each part of Diana's anatomy was fetishized in turn. Her cleavage became an object of fantasy and a subject for the news during her first official date with Charles after their engagement. Wearing a low-cut black ball gown, she nearly spilled out of her dress as she bent over to exit her car at a Royal Opera benefit at Covent Garden in front of a mob of photographers.[115] The pictures were widely reproduced, causing consternation at the Palace and headlines in the newspapers. Diana's ungovernable bosom may have drawn the cameras, but it repelled her future royal in-laws, a dynamic that was played out on her body across the years.[116]

The fecundity symbolized by her lush breasts was coveted by the Windsors, who wanted an heir to the throne. That the press would point to her sexual desirability, however, was scandalous to the Palace, perhaps in part because it reflected so closely how the royals regarded her: as a primarily sexual being whose function was to reproduce.[117] That her sexuality could be decorative and titillating conflicted with rigid monarchical ideas about her sexual instrumentality and its proper expression, which was as mother rather than sex goddess.

These types of images are structured mainly by the imperatives of voyeurism and female spectacle. Other, later images of Diana were complicated by her increasingly more contentious relationship with Charles, his family, and the palace courtiers, the latter being an array of men who regulate and enforce the norms and perquisites of the monarchy. As photographers and reporters began to probe beneath the official news and images dispensed by Buckingham

114. Quoted in A.N. Wilson, *The Rise and Fall of the House of Windsor*, (New York: Fawcett Columbine, 1993), p. 54.

115. Kitty Kelley, *The Royals* (New York: Warner Books, 1997), p. 272. Also see Lady Colin Campbell, *Diana in Private: The Princess Nobody Knows* (Reprint; New York: St. Martin's Press, 1992), p. 154.

116. The Queen Mother was said to be especially offended by Diana's wardrobe gaffe. A "relation" of hers was quoted as saying that although she has an ample bosom herself and enjoys wearing low-cut dresses, the Queen Mother maintains a decided sense of propriety. "In fact, when she's dining at Clarence House and one of the footmen comes to serve or clear her, she always covers the royal bosom." Lady Colin Campbell, *Diana in Private*, pp. 155-156.

117. It has been suggested that bearing children was considered, especially by Charles, to be her main function. Whitaker, *Diana vs. Charles*, pp. 166-167.

Palace, the paparazzi wanted to function more as investigative photographers, taking pictures in which Diana was still a spectacle, but of another kind. She became the vehicle by which the tabloids instigated a public discussion of the royal family's role, privileges, and income. "If the queen and her family enjoy the privileges of royal life—the chauffeurs, the red carpets, the private jets, and people bowing to them—then they must accept that photographers will try to get the unofficial side of them," said photographer Jason Fraser.[118]

More important than any photographer's agenda, though, was Rupert Murdoch's well-known antipathy to the English class system and the monarchy, which saturated the newspapers he owned and which he reiterated in a 1989 interview. "I used to feel that this was a society that was held down by a very stratified class system and that the royal family was the pinnacle of that and that you would never really open up this society to opportunity for everybody until you tackled this class system and *it was very hard to see how you could tackle it with the royal family there*."[119] Diana's unapologetic physicality, her love affairs, and her problems with the royal family provided him the opportunity to accomplish two goals at once: to fill his newspapers with sex, while also weakening and perhaps even destroying the royal family.[120]

One thing that positioned the Windsors as a target of the press's ire was the vision of the monarchy that Elizabeth II had tried to perfect: the royal family as a domestic ideal, an exemplar for the nation. It was the image Elizabeth broadcast in the BBC's 1969 television documentary, *Royal Family*. In it are such scenes as the royal family making salad and grilling sausages at a barbecue, the Queen taking young Prince Edward into a store to buy him candy, and Prince Charles showing Edward how to tune a cello.[121] In retrospect, allowing the film to be made at all has been pronounced a tremendous blunder. As the longtime journalist A.N. Wilson put it, virtually nothing "is more humiliating for individuals than to make themselves into television 'personalities.' Television is the great leveller, and it quite indiscriminately devours those whom it attracts."[122]

Wilson's overstatement aside, much star-making publicity does indeed act to level, if not to devour. Paparazzi rely on the fact that fans want to see the images behind the image, the unofficial, the unposed, the unretouched—the "really" that Richard Dyer proposed as the aim of all celebrity coverage—and

118. Stephanie Dolgoff, "The Royals!," *American Photo*, July/August 1992, pp. 60 and 62.

119. Rupert Murdoch, rebroadcast in "The Princess and the Press," *Frontline*, 16 November 1997; emphasis added.

120. Matthew Engle, *Tickle the Public*, p. 253.

121. Kitty Kelley, *The Royals*, pp. 209-11.

122. Wilson, *Rise and Fall*, p. 109. Of course, Wilson's belief that being made into a television personality is the most humiliating thing that could happen is a measure of his own privilege as a former Oxford don and then journalist for steadfastly middle-class and upper-class newspapers such as the *Times Literary Supplement*, the *Sunday Telegraph*, and the *Daily Mail*.

they relentlessly pursue them. Like any other celebrity institution, the royal family wants to control the image that is projected of them. Elizabeth personally inspects every frame of film taken by the official photographer on every occasion. "In consultation with several senior advisers, Elizabeth decided which photograph should be given to the media, to ensure that the correct image was being seen by the people."[123] The disturbing image of Diana and Charles at odds was in direct conflict with Elizabeth's view of the British monarchy as the über-family that set the moral tone for a nation. Such are the workings of representation that Diana would have to pay for the hypocrisy of an image that she herself felt victimized by.

It was a double victimization, for when she tried to influence and shape the image of her that was presented in the media, most particularly through the "authorized" Andrew Morton book—once she tried to assert herself as a subject by dispensing "true" revelations instead of mere tabloid rumor through the agency of a hand-picked journalist—the rest of media turned on her, calling her a "manipulator" and declaring open season on her. "At the beginning of 1992 Lady Di had few critics in the Press, and by the end of it she had few friends."[124]

The difficulty, if not impossibility of representing herself—or re-representing herself—was that by this time the figure of "Diana" was well established in representation. It was one that had been built largely with images, in print and on television, constructed from the codes that have long defined the figures of "princess," which deployed the semiotics of the fairy-tale, and "secular saint," a category established by the empathetic vigor with which she performed royalty's traditional charitable duties. This royal edifice was, additionally, imbricated with the more traditional bourgeois definitions of "woman" as wife, mother, and figure of glamour.[125]

She countered those rosy representations with others that cut through the prevailing fantasy in Andrew Morton's 1992 book *Diana: Her True Story*. Her own portrayal of herself as martyr to an unloving husband, sufferer of depression and bulimia, victim of a cold and calculating royal family, unapologetic hysteric, and would-be suicide, proposed a "really" true version of Diana's life that the public rejected at first, in part because it had already accepted what had been retailed in the tabloids as the "really"—a storybook version of Diana's life. According to Morton, "the effect of the book's appearance was even more shattering than anyone had predicted. The Palace were horrified, the media outraged and the public profoundly shocked."[126]

123. Nicholas Davies, *Queen Elizabeth II: A Woman Who is Not Amused* (New York: Citadel Stars, 1996), p. 397.

124. Wilson, *Rise and Fall*, p. 44.

125. This discussion owes much to Abigail Solomon-Godeau's "The Legs of the Countess," *October* 39, Winter 1986.

126. Morton, *Diana: In Her Own Words*, p. 213.

But Diana did have some justification for thinking she could re-represent herself, especially after years of experience with the press, during which she learned how to put across an attractive image of herself as princess. By the early '90s, she apparently decided that an alternative image of pathos was in order. In 1992 she began to stage successful photo opportunities in which she displayed herself as the lonely, neglected wife. The first occurred when she and Charles traveled to India. While Charles was giving a speech, Diana went to the Taj Mahal, where she was photographed alone against the backdrop of that ornate monument to married love. Not only did she create a lovely visual trope with which to convey her own marital solitude, but she upstaged Charles as well; her image caused a sensation, while his speech received little attention.[127] A few months later she created a similar photo with similar results while she and Charles were on an official visit to Egypt when she posed alone at the pyramids; at some point Charles had left to meet secretly with Camilla in Turkey. The same month, Lord Rothermere, the chairman of Associated Newspapers, which publishes the *Daily Mail*, informed Lord McGregor, the chairman of the Press Complaints Commission, that "'the Prince and Princess had each recruited newspapers to carry their own accounts of their marital rifts,'" which complicates any notions of the two as mere victims of the tabloid press.[128]

At each step in this unprecedented royal battle for publicity, Diana's fortunes rose and fell with public perception. She was vilified for revealing too much—and was thought to be making some things up—after Morton's 1992 book was published. When the separation of Diana and Charles was announced in December of that year, the royal family launched a campaign against Diana through aristocratic proxies who denounced her to the press. Perceptions briefly swayed in her direction in January of 1993 when the infamous Camillagate tapes were released, in which Charles vowed his devotion to Camilla in weirdly graphic terms. Still, the palace continued to build Charles's public image while attacking Diana's. At the same time, her official duties were severely curtailed, robbing her of the consoling charitable visits at which she excelled.

Later in '93 Diana again created some masterful photo ops in response to Windsor Palace's very public slights. When the Queen failed to invite her to Royal Ascot, Diana took William and Harry on a festive spree to London's Planet Hollywood instead. When she was not invited to the Queen Mum's birthday party, she took the boys go-carting. Both forays netted her sympathetic and attractive pictures of a loving mother that featured prominently in the next day's papers, which had a good chance of being successful precisely

127. Wilson, *Rise and Fall*, p. 101. There is at least one more version of this story. In *Diana vs. Charles*, Whitaker says that Charles pointedly rejected the February photo call because of its "gruesome superficiality," p. 226. Wilson and Whitake both get the wrong year; it was 1992.

128. Wilson, *Rise and Fall*, p. 99. The press complaints commission is a sixteen-member watchdog group that polices the British press for "excesses," particularly those having to do with the monarchy. See Tunstall, *Newspaper Power*, pp. 400-4.

because the pictures reinforced notions of Diana-as-good-mother.[129] But her isolation from the world stage was apparent, as was the more generally negative press she was getting as a result of the Windsor's efforts to undermine her. The nadir of that year's media coverage of her occurred in November, when the *Sunday Mirror* published pictures of Diana, flat on her back, legs akimbo, working out on a leg-press machine at her health club. They were taken by a hidden camera rigged in the ceiling by the club's manager, Bryce Taylor, who was reported to have made anywhere from $150,000 to $1.5 million from their sale.[130] When Diana protested the pictures, Taylor claimed that she had secretly wanted to have them taken. Several influential columnists and politicians began to imply that Taylor was telling the truth, and Diana was again fashioned as "manipulating" the press.[131]

Those pictures were apparently what led to her ill-conceived withdrawal from public life in December 1993, which meant that she gave up doing many of her charitable appearances.[132] As part of her retreat, she had dismissed her personal police protection, which had shielded her not only from stalkers and other threats, but from the press as well. Certain photographers—most notoriously the freelancers Mark Saunders and Glenn Harvey—declared open season on her.

Lacking her police guard, and with the palace on the attack, Diana became a more vulnerable figure than ever before. She had tried to take a cue from Jacqueline Kennedy in renouncing her celebrity and retreating into privacy. But she lacked the crucial element that gave Jackie clout: she was not the widow of a tragic modern icon. She had no grievous mantle in which to shroud herself, no special subjectivity. Rather, she was shedding what measure of protection she had by separating from Charles and symbolically divesting herself of the royal cocoon.

What she had completely miscalculated was her ability to reject her own iconicity as Princess Diana without replacing it with some role of equal weight. Instead, she presented herself as merely another privileged woman who spent her time shopping, lunching, and exercising without the countervailing grace of her "good works" or the official glamour of her public persona. Given reports about her visits to a psychotherapist and her often tearful state, she was also going through emotional turmoil.

But the British media had come to depend on her image as a reliable seller, especially as newspaper sales declined in the latter 1980s, so there was no ques-

129. Kelley, *Royals*, p. 443.

130. Neil Graves, "Princess Di Steel Going Strong," *New York Post*, 8 November 1993, p. 3, reported $150,000. Michael Shain and Anthony Scaduto, "Diana Wins Lawsuit Over Sexy Gym Pix," *Newsday*, 9 February 1995, sec. A, reported the $1.5 million figure when Diana settled the lawsuit she brought against Taylor.

131. Morton, *Diane: In Her Own Words*, pp. 238-39.

132. Morton, *Her New Life*, pp. 136-39.

Diana, with eyes closed, hugging a child in Pakistan, 1996 (John Pryke/Reuters)

tion of simply leaving her alone. Once that became apparent, she began to make her way back into the public eye in her most praiseworthy role, that of public patroness of worthy causes, visiting the victims of war in Sarajevo and Angola in the months before her death.

Of course, sex, not good works, was what the tabloids sold best. They thought they had found new sexual fodder with the appearance of Dodi Al-Fayed, the wealthy Egyptian with whom she died. He provided rich semiotic possibilities for tabloid exploitation, as an Arab who set off alarms at the prospect that he might marry—and procreate with—an Anglo-Saxon princess, and as a wealthy, apparently self-indulgent man whose father, Mohamed Al-Fayed, had long and unsuccessfully sought to ingratiate himself with the British establishment.[133] Some very fuzzy photos, obviously shot at some distance, of Diana and Dodi embracing on vacation just before the accident, were said to have brought anywhere between $720,000 and nearly $6 million.[134]

The pictorial bonanza that Diana provided died with her in the Paris car crash, although newspapers and magazines have continued to squeeze out revenue by headlining stories about her.[135] Despite calls to rein in the tabloid photographers in the aftermath of the accident, nothing of any substance occurred, nor—in all likelihood—will it.[136]

Although paparazzi photography is a postwar phenomenon, the star-making apparatus that produced "Diana" is a much-enlarged version of the one that was originally put in place by the motion picture industry and

133. Evan Thomas and Christopher Dickey, "The Last Chapter," *Newsweek*, 15 September 1997, p. 42 and Marc Fisher, "What Money Couldn't Buy," *Washington Post*, 4 September 1997, sec. D.

134. Mark Hosenball, "Taking the Tabs to Task," *Newsweek*, 15 September 1997, p. 60 and Matthew Cooper, "Was the Press to Blame?" *Newsweek*, 8 September 1997, p. 37. *Time* magazine correspondents Thomas Sancton and Scott MacLeod put the figure the two photographers made—Mario Brenna, who took the pictures, and Jason Fraser, who brokered their worldwide sale—at "well over $2 million" in *Death of a Princess: The Investigation* (New York: St. Martin's Press, 1998), p. 128. All such figures are notoriously unreliable, with the truth usually being somewhere between the extremes.

135. See Christian Berthelson, "California Law Will Allow Celebrities to Sue Paparazzi," *New York Times*, 5 October 1998, sec. C, for what California lawmakers have done to date.

136. See Todd S. Purdum, "Two Senators Propose Anti-Paparazzi Law," *New York Times*, 18 February 1998, sec. A for what U.S. lawmakers are endeavoring to do.

the system of journalistic texts that supported it at the beginning of the twentieth century.[137] Integral to the writing of the apparatus was the discovery of secret information about the stars, although at first the secrets that were divulged were limited and banal.[138] The scope of reportable secrets was considerably expanded in the 1920s, when a string of shocking Hollywood scandals were reported, beginning with the drug overdose death of Olive Thomas, a young actress, and the arrest of popular comedian Roscoe "Fatty" Arbuckle for rape and murder, and his subsequent ruin.[139] In the 1930s, the universe of celebrity secrets most famously included those about British royalty, although they were secret only from the British public. The love affair of the Prince of Wales and an American divorcée, Wallis Simpson, was reported in newspapers around the world. He had been Edward VII, King of England for 326 days when the British public learned of the affair on December 3, 1936; he abdicated on December 11 when it became clear that he would not be allowed to marry Mrs. Simpson and retain his crown.

This historic crisis dogged the Windsors as the possibility of another ascension crisis loomed when Diana and Charles separated and new revelations surfaced about their marriage. "The abdication was a monarchical earthquake and the aftershocks continued for decades to come," writes Tunstall.[140] The Windsors's marital strife provided the basis on which the British tabloids continued to attack not only the royal family but the institution of the monarchy itself. By the fall of 1994, British polls showed for the first time that half the respondents did not think the monarchy would survive another fifty years.[141] A largely right-wing press had managed to create the conditions under which a British republic might come into being, which would be a victory for the republican left.

Diana's death, however, muted talk of disposing of the monarchy. In part that was because her death restored a certain balance in the monarchy. If, as Marina Warner has proposed, Margaret Thatcher replaced the Queen as the "symbolic centre of power in Britain" during her tenure as prime minister, once Thatcher was out of office, we might say that Diana replaced Thatcher as the symbolic center of *feminine* power.[142] With Diana's death, the Queen could

137. This is not to say that "fame" on a large scale is a twentieth-century phenomenon, because it is not. For a wider view of the production, maintenance, and dissemination of fame over the centuries, see Leo Braudy, *The Frenzy of Renown: Fame and Its History* (New York: Oxford University Press, 1986).

138. See Richard deCordova, *Picture Personalities: The Emergence of the Star System in America* (Urbana and Chicago: University of Illinois Press, 1990) for a definitive explication, especially pp. 82-84.

139. For one version of this often-told tale, see Kenneth Anger's *Hollywood Babylon* (New York: Dell Publishing, 1975), pp. 27-45.

140. Tunstall, *Newspaper Power*, p. 316.

141. Charles Lewington, "You've Let Us Down, Charles," *Sunday Express*, 16 October 1994, p. 1.

142. The quote about Thatcher is cited by Franklin, Lurie and Stacey in *Off-Centre*, p. 34.

again fully occupy her own position as Britain's most visible and (symbolically) powerful woman, which had been contested by these troublesome rivals. But Diana's death seems in some sense a sacrifice for the monarchy, for the celebrity that monarchy brought her. To dispense with the royal family would be to admit that her death was a waste. And the royal family, of course, included Diana's two young princes, who were now to be protected as the bearers of their mother's memory as well as the future of the Windsors. Rather than destroying the family that she hated, she may well have extended its longevity.

For a brief time, the grief over the end of Diana drew back the curtain on the antic, unthinking, grotesque atmosphere of tabloid culture. The abject foundation of its ersatz carnivalesque was all too clearly revealed. The abjection of its subjects, its producers, and its consumers reflects the Kristevean "want" on which the desire for celebrity and its effects is predicated—no glamour without execration, no beauty without defilement. That "want" helped drive the pursuit of Diana, just as it powered the original Italian paparazzi and the gossip system that has since been created. It will not vanish with Diana's demise nor the fixing of blame for the incredible pointlessness of her death.

Carole S. Vance

The Pleasure of Looking: The Attorney General's Commission on Pornography versus Visual Images

The Attorney General's Commission on Pornography, a federal investigatory commission appointed in May 1985 by then-Attorney General Edwin Meese III, orchestrated an imaginative attack on sexual pleasure and desire. The chief targets of its campaign were sexually explicit images, dangerous, according to the logic of the commission, because they might encourage sexual desires or acts. The commission's public hearings in six U.S. cities during 1985 and 1986, lengthy executive sessions, and an almost two-thousand-page report[1] constitute an extended rumination about visual images and their power. Although the term *representation* was not in its vocabulary, the panel of commissioners tenaciously clung to and aggressively advanced implicit theories of visual representation. More important, the commission took every opportunity to show sexually explicit images during its public hearings, using them to promote its point of view, to document the alleged nature of pornography, to offer a compelling interpretive frame, and to intensify a climate of sexual shame that made dissent from the commission's viewpoint almost impossible.

To enter a Meese Commission public hearing was to enter a time warp, an inviolable bubble in which the 1950s were magically recreated. Women were virgins, sex was dirty, shame and secrecy were rampant. Consider the testimony of

1. Attorney General's Commission on Pornography, *Final Report*, 2 vols. (Washington, D.C.: U.S. Government Printing Office, July 1986).

Public hearings were organized around preselected topics in six cities: Washington, D.C. (general), Chicago (law enforcement), Houston (social science), Los Angeles (production and distribution), Miami (child pornography), and New York (organized crime). Each public hearing typically lasted two full days. Commission executive sessions were held in each city, usually for two working days, in conjunction with the public hearings. Additional work sessions occurred in Washington, D.C., and Scottsdale, Arizona. All the commission's executive sessions were open to the public, following the provision of sunshine laws governing federal advisory commissions. Commissioners were specifically enjoined from discussing commission business or engaging in any information deliberations outside public view.

My analysis is based on direct observations of the commission's public hearings and executive sessions, supplemented by many interviews with participants.

self-described "victim of pornography" Larry Madigan.[2] He testified earnestly that at age twelve he was a "normal, healthy boy and my life was filled with normal activities and hobbies," when his life was radically disrupted by exposure to a deck of pornographic playing cards: "These porno cards highly aroused me and gave me a desire I never had before." Soon after that, he started to masturbate. Later, he went on to have "promiscuous" sex with two women and almost ended up "a pervert, an alcoholic, or dead," until he found Christ and was born again. How can we explain that this testimony was received in 1985 by several hundred people in a federal courthouse in a major American city without a single, publicly audible laugh? The answer lies in the commission's use of visual images to create a logical and emotional climate in which such claims were not only plausible, but convincing.

Appointed during President Ronald Reagan's second term, the commission paid a political debt to conservatives and fundamentalists who had been clamoring for action on social issues, particularly pornography, throughout his term of office. Pornographic images are symbols of what more conservatives want to control: sex for pleasure, sex outside the regulated boundaries of marriage and procreation. Sexually explicit images are dangerous, conservatives believe, because they have the power to spark fantasy, incite lust, and provoke action, as well as convey undesirable information. What more effective way to stop sexual immorality and excess, they reason, than to curtain sexual desire and pleasure at its source—in the imagination.

Conservatives also project their intense feelings about sexuality and gender politics onto pornography. Pornography, to them, is a standing for destructive sexual impulses that, left uncontrolled, threaten to destroy the stability of the family, the authority of men over women, and the power of parents over children. Sexual pleasure is always suspect and usually dangerous, unless harnessed within marriage, reproduction, and God's plan. Stirrings of desire, as well as individuals who would encourage or defend it, constitute a moral lapse and a personal threat. The battle against unruly sexual impulses is a never-ending struggle, even for those with strong convictions. Part of the charm of regulation pornography is that sexual images in the public arena can be banished more reliably than sexual impulses in the individual psyche.

The campaign against pornography comes at a time when moral conservatives' control over sexual behavior is shrinking. The past century has seen a relentless increase in the frequency and acceptance of sexual behavior outside the confines of marriage and even hetereosexuality.[3] Contemporary controversies

2. Larry Madigan, "former consumer of pornography," testified as the Miami hearings. He was introduced by his therapist, Dr. Simon Miranda, who claimed that most of his own clinical work was with patients whose problems were caused by pornography. "Larry," he stated, "has informed me recently that, in fact, he can trace many of the problems that he has had life long, to an encounter with pornography" (Miami hearing transcript, 21 November 1985).

3. For changes in sexual patterns in the last century, see (for England) Jeffrey Weeks, *Sex, Politics and Society: The Regulation of Sexuality Since 1800* (New York: Longman, 1981) and (for America) John D'Emilio and Estelle B. Freedman, *Intimate Matters* (New York: Harper and Row, 1988).

Anonymous witness. Meese commission hearings, 1985-86. Courtesy of the Department of Justice

about sexuality—teen pregnancy, lesbian and gay rights, sex education in the schools, abortion, and AIDS—make it obvious that traditional moral standards no longer hold absolute sway. Sexuality is an actively contested terrain, where diverse constituencies struggle over definitions, law, and policy. Amid this flux, regulation of visual images gives the illusion of control: visual images can still be regulated, although the actual sexual behavior they depict usually cannot be. Visual images remain an easy target, since many who participate in sexual pleasure in private remain unwilling and ashamed to defend images of it in public.

The goal of the Meese Commission was to implement a repressive agenda on sexually explicit images and texts: vigorous enforcement of existing obscenity laws coupled with the passage of draconian new legislation. The commission's ninety-two recommendations continue to pose a serious threat to free expression.[4] They include appointing a high-powered Justice Department ask force to coordinate obscenity investigations and prosecutions nationwide, developing a computer bank to collect data on individuals and businesses "suspected" (as well as convicted) of producing obscene materials, mandating high fines and long jail sentences for offenses, and using punitive

4. See *Final Report*, pp. 433-458, for a complete list of the panel's recommendations.

RICO legislation (the Racketeer Influenced and Corrupt Organizations Act, originally developed to fight organized crime) to confiscate the personal property—cameras, darkroom equipment, computers, even homes and cars—of anyone convicted of the "conspiracy" of producing or distributing pornography. Performers and producers of sexually explicit photos and films should be prosecuted under existing prostitution and pimping laws, the panelists reasoned, since money changes hands in exchange for sexual services. They regretfully noted a large body of sexually explicit images beyond prosecutorial reach, since the images could not be judged obscene by current legal standards. The commission endorsed citizen action crusades, providing pages of detailed instructions for neighborhood watchdog groups to target and remove material in their communities that "some citizens may find dangerous or offensive or immoral."[5]

For imagemakers, the impact of the commission is significant in generating more aggressive prosecutions at the federal, state, and local levels, in encouraging passage of new legislation that implements the commission's recommendations, and in increasing caution and self-censorship among those who produce sexually explicit visuals. In 1988, officials arrested artist Alice Sims at her home in Alexandria, Virginia, for allegedly producing child "pornography," photographs of two naked little girls, one of them her one-year-old daughter. The photofinishing lab had reported her, as required by new laws, for developing "sexually explicit" material using children (a felony charge with a maximum penalty of ten years in jail). Officials—including U.S. Postal Inspector Robert Northrup, who testified before the Meese Commission—searched Sims's house, carted away three bags of "evidence" (her art), and removed her children, including the still breast-feeding daughter, to foster care.[6]

5. Final Report, p. 420. See *Final Report*, pt. 4, chap. 7, "Citizen and Community Action and Corporate Responsibility." These instructions are significant because they outline a powerful, extralegal strategy for eliminating materials that are "non-obscene but offensive," that is, normally immune from legal action under obscenity law. Suggestions include forming antipornography activist groups and collecting detailed information on sexually explicit materials available in local stores, movie theaters, hotels, and through video, cable, and computer channels. A detailed checklist is provided for citizens to conduct "a thorough survey of these establishments and media." Citizens are also encouraged to pressure police and public officials, conduct court watches, picket and boycott local stores, and monitor rock music heard by their children. Commissioners also recommend that institutions that are taxpayer supported prohibit the "production, trafficking, distribution, or display of pornography on their premises or in association with their institution." Conservative politicians and right-wing decency groups used this strategy in 1989 to attack the National Endowment for the Arts for indirectly funding an exhibit of Robert Mapplethorpe's photographs, some of which were erotic, some sexually explicit, at the Corcoran Gallery, Washington, D.C. (For an account of the NEA-Mapplethorpe controversy, see Carole S. Vance, "The War on Culture," *Art in America*, September 1989, pp. 39-45.)

6. The children were returned home the next day, as social-service officials determined there was no evidence that the children were in danger. Charges were eventually dropped by the state of Virginia because of local protest, but the U.S. Postal Service has not officially closed the case. According to Sims, while searching her house agent Northrup told her, "Art is anything you can get away with," and referring to her work, "This is all filth." Later, in an interview with *Village Voice* art critic Elizabeth Hess, he said, "Artistic people are funny. Mrs. Sims's house was not like Ozzie and Harriet's." He asked, "How do you differentiate between an artist and a pedophile?" For a more complete account of the case, see "Snapshots, Art, or Porn?" *Village Voice*, 25 October 1988, pp. 31-32. Thanks to Jeff Weinstein for this citation.

In another instance of the commission's impact, Congress passed, by an overwhelming majority, the 1988 Child Protection and Obscenity Enforcement Act, which contained several Meese Commission recommendations. Retroactive to 1978, the act would have required producers and distributors of material that depicted "frontal nudity" or "actual sexually explicit conduct" (not necessarily obscene) to obtain and maintain for an indefinite period of time proof of the model's age. Opponents challenged the law, arguing that such burdensome record-keeping provisions and severe forfeiture penalties would, in effect, ban constitutionally protected art books, photography, and motion pictures that have sexual content. The federal court agreed and struck down the legislation, though the government is considering redrafting the legislation or appealing.

The commission's unswerving support for aggressive obscenity law enforcement bore the indelible stamp of the right-wing constituency that brought the panel into existence. Its influence was also evident in the belief of many commissioners and witnesses that pornography leads to immorality, lust, and sin. But the commission's staff and the Justice Department correctly perceived that an unabashedly conservative position would not be persuasive outside the right wing. For the commission's agenda to succeed, the attack on sexually explicit material had to be modernized by couching it in more contemporary arguments, arguments drawn chiefly from social science and feminism. So the preeminent harm that pornography was said to cause was not sin and immorality, but violence and degradation. In practice, the coexistence of these very different frameworks and languages proved uneasy, and modernized rhetoric at best disguised, but never replaced, the persistent bias of the commission.

I. Procedures and Bias
Appointed to find "new ways to control the problem of pornography," the panel was chaired by Henry Hudson, a vigorous antivice prosecutor from Arlington, Virginia, who had been commended by President Reagan for closing down every adult bookstore in his district. Hudson was assisted by his staff of vice cops and attorneys and by executive director Alan Sears, who had a reputation in the U.S. Attorney's Office in Kentucky as a tough opponent of obscenity.[7] Prior to convening, seven of the eleven commissioners had taken public stands opposing pornography and supporting obscenity law as a means to control it. These seven included a fundamentalist broadcaster, several public officials, a priest, and a law professor who had argued that sexually explicit expression was undeserving of First Amendment protection because it was

7. Alan Sears went on to become the executive director of Citizens for Decency through Law, a major conservative antipornography group. (The group has since changed its name to the Children's Legal Foundation.)

less like speech and more like dildos.[8] The smaller number of moderates sometimes curbed the staff's conservative bent, but their efforts were modest and not always effective.

The commission had a broad mandate to examine a wide range of sexually explicit texts and images, including pornography as well as the much smaller category of obscenity. Obscenity, a legally meaningful term, had been defined by a series of court decisions determining that obscene expression fell outside normal First Amendment protection and thus could be regulated in a manner that most speech could not.[9] Laws that restrict sexually explicit speech may do so only if the material meets the definition of obscenity established by the courts, as interpreted by judges and juries. Pornography, on the other hand, has no legal definition, is not regulated by law, and comprises a much wider range of material. Material can be sexually explicit and even pornographic without being obscene. Thus, the panel's challenge: how to control or eliminate the large body of material called pornography, when the available legal weapons targeted only obscenity? (One solution was to encourage extralegal citizen action against material that was merely pornographic. A second was to invent a new category of pornography—"violent pornography," which was so pernicious, the panel argued, that it should be assimilated into the category of obscenity and subjected to its harsher penalties.)

The conservative bias continued for fourteen months, throughout the panel's more than three hundred hours of public hearings in six U.S. cities and

8. Besides Hudson, the commission panel included the following James Dobson, head of the fundamentalist organization Focus on the Family: "I have a personal dislike for pornography and all it implies," he told *The Washington Post*. Judge Edward Garcia, recently appointed by then-President Reagan to the Federal District Court in California; Garcia prosecuted obscenity cases before becoming a judge. Diane Cusack, a member of the Scottsdale, Arizona, City Council; Cusack urged residents to take photographs and license numbers of patrons entering the local adult theater. Father Bruce Ritter, a Franciscan priest; Ritter directs Covenant House, a home for runaways in New York's Time Square area, and is an outspoken critic of pornography. Attorney Harold (Tex) Lazar; Lazar played an instrumental role in setting up the commission as an aide to Reagan's first Attorney General, William French Smith. Frederick Schauer, a law professor at the University of Michigan; Schauer has written extensively on obscenity. The four members of the panel with no public positions on pornography included Park Elliott Dietz, a psychiatrist at the University of Virginia and a consultant to the Federal Bureau of Investigation, who specialized in the subject of sexual deviations ("paraphilias"); Judith Becker, a Columbia University psychologist known for her research on rapists and rape victims; Ellen Levine, a vice president of CBS and editor of *Woman's Day;* and Deanne Tilton, head of the California Consortium of Child Abuse Councils.

9. A variety of state laws had resulted in prosecutions and convictions for obscenity in the nineteenth and twentieth centuries. In response to a challenge of one such law, the Supreme Court in 1957 articulated the First Amendment standard for what could be prosecuted as "obscene" in *Roth v. United States* [354 U.S. 476 (1957)]. The court decided that the normal protections given to constitutionally protected speech need not be given to legally obscene material.

The most recent attempt to define what is "obscene" in a constitutionally permissible manner is found in a 1973 case *Miller v. California* [413 U.S. 15 (1973)]. According to *Miller*, material is obscene if all three of the following conditions are met:

1. The average person, applying contemporary community standards, would find that the work, taken as a whole, appeals to the prurient interest, and

2. the work depicts or describes, in a patently offensive way, sexual conduct specified by the statute, and

3. the work, taken as a whole, lacks serious literary, artistic, political, or scientific value.

lengthy executive sessions. The list of witnesses was tightly controlled: 77 percent supported greater control, if not elimination, of sexually explicit material. Heavily represented were law-enforcement officers and members of vice squads (68 of 208 witnesses), politicians, and spokespersons for conservative antipornography groups like Citizens for Decency through Law and the National Federation for Decency. Great efforts were made to find "victims of pornography" to testify,[10] but those reporting positive experiences were absent. Witnesses were treated unevenly, depending on whether the point of view they expressed facilitated the commission's ends. There were several glaring procedural irregularities, including the panel's attempt to withhold drafts and working documents from the public and its effort to name major corporations such as Time Inc., Southland, CBS, Coca-Cola, and K-Mart as "distributors of pornography" in the final report, repeating unsubstantiated allegations made by Rev. Donald Wildmon, executive director of the National Federation for Decency. These irregularities led to several lawsuits against the commission.[11]

The barest notions of fair play were routinely ignored in gathering evidence. Any negative statement about pornographic images, no matter how outlandish, was accepted as true. Anecdotal testimony that pornography was responsible for divorce, extramarital sex, child abuse, homosexuality, and excessive masturbation was entered as "evidence" and appears as supporting documentation in the final report's footnotes. Chairman Hudson's hope that social science evidence could provide the smoking gun linking pornography to violence was dashed by social scientists' testimony, which cautioned against drawing such hasty conclusions. When it became clear that social science would not provide the indictment of pornography that he wanted, the chair announced that harm should be evaluated according to two additional tiers of

10. Victims of pornography, as described in the *Final Report*, included "Sharon, formerly married to a medical professional who is an avid consumer of pornography," "Bill, convicted of the sexual molestation of two adolescent females," "Dan, former Consumer of Pornography [sic]," "Evelyn, Mother and homemaker, Wisconsin, formerly married to an avid consumer of pornography," and "Mary Steinman, sexual abuse victim."

11. In February 1986, the executive director of the commission announced that in the future no drafts or working papers could be released to the press or public. The American Civil Liberties Union sued the commission for violating access laws governing federal panels, and the commission settled before the case got to court, agreeing to release these documents to the public (see *The Washington Post*, 7 March 1986; 4 April 1986; 12 April 1986).

When some commissioners objected to repeating unsubstantiated allegations in the final report, the staff sent letters to the corporation on Department of Justice letterhead, noting that "the Commission received testimony alleging that your company is involved in the sale or distribution of pornography." The letter noted that the companies had thirty days to respond and that "a lack of reply would indicate they did not differ" with the allegations. Some corporations strenuously protested these methods. Others, however, caved in. Southland Corporation, which owns forty-five hundred 7-Eleven convenience stores, announced that it would no longer carry *Playboy*, *Penthouse*, and *Forum* magazines. Bob Guccione, *Penthouse* publisher, called the move "blacklisting" and launched lawsuits against the commission. The commission settled one by agreeing not to publish the allegations in the report, but Guccione's suit for economic damages against the commission and individual commissioners is still pending (The *New York Times*, 15 April 1986, p. B5; *Newsweek*, 26 April 1986, pp. 38-39).

evidence: "the totality of the evidence," which included victim testimony, anecdotal evidence, expert opinion, personal experience, and common sense; and "moral, ethical, and cultural values." Pornography could thus still be convicted on two out of three tiers, despite the lack of more objective data.

The commission concentrated on sexually explicit images, although obscenity law applies to both texts and images. This marks a notable departure from the past century of obscenity regulation and moral crusades, when a significant part of censorship efforts were directed against written material.[12] During the period bracketed by 1933 (when the Supreme Court upheld the publication of *Ulysses*) and 1966 (when it ruled in favor of *Fanny Hill*), however, literary prosecutions became relatively unsuccessful, with all but the most zealous prosecutors losing interest in these doomed, and increasingly ridiculed, efforts. Conservatives like to explain their current emphasis on censoring sexually explicit images in terms other than the practical, maintaining that visual images have a special power to influence behavior. In addition, they argue that pornography has become increasingly visual and influential, due to the swelling numbers of hard-core magazines, new technologies like home video and cable television, and more audacious content. They complain that "porn" is flooding the nation, and now everyone can see it, even illiterates. This alarm signals a concern about the availability of visuals across boundaries of class, youth, and gender. This same concern fueled nineteenth-century attempts to restrict literature, when reformers worried that cheap printing processes and penny-papers would put pornography, formerly available only to classically schooled aristocrats, within reach of the barely literate masses.[13] The arguments made against pornographic visuals today are virtually the same as those made against pornographic texts in the late nineteenth and early twentieth centuries, even though twentieth-century arguments against sexually explicit texts have fallen into total disrepute.

Despite their overriding concern with visual images, the commissioners invited a few recognized experts on representation to testify. The small number included social psychologists reporting on their laboratory experiments on imagery and aggression, though their testimony concentrated on scientific questions and only briefly mentioned the stills or short video clips they had fashioned as experimental stimuli. More typical was a grandiosely titled lecture, "The History of Pornography," delivered by a vice detective. He provided a brief history of pornographic images in the twentieth century, illustrating his lecture with slides from adult magazines and films. No specialists were invited to

12. For accounts of the history of regulating indecency and obscenity in the United States and England, see Edward J. Bristow, *Vice and Vigilance: Purity Movements in Britain since 1700.* (New Jersey: Rowman and Littlefield, 1977); David Pivar, *Purity Crusade: Sexual Morality and Social Control: 1868-1900* (Connecticut: Greenwood Press, 1972); Walter Kendrick, *The Secret Museum* (New York: Viking, 1987); John D'Emilio and Estelle B. Freedman, *Intimate Matters* (New York: Harper and Row, 1988).

13. See Walter Kendrick, *The Secret Museum* (New York: Viking, 1987), for a discussion of the class concerns that motivated nineteenth-century obscenity regulation.

discuss the history of representing nudity, the body, or eroticism. It proved easy for the commissioners to falsely claim that their efforts to regulate commercial pornography would have no impact on the fine arts: their refusal to consider artistic material made it difficult to see the connections between them.[14]

Although few experts were called to testify, most witnesses—particularly vice cops, politicians, and more majoritarians—offered clear statements about the effect of visual images and their mechanisms of influence. Most were adherents of the "monkey see, monkey do" school of representation: viewers simply imitated the sexual behavior they saw in pornography. Most important, visual images were presented as having the capacity to arouse sexual desire and fantasy in a visceral and immediate way. Bypassing logic and moral standards, explicit pictures stimulated lust, which then demanded immediate satisfaction through masturbation, perverted sex, or rape. The effect was cumulative and addictive, with viewers purportedly graduating from reading more socially acceptable men's magazines such as *Playboy* and *Penthouse* to hard-core magazines depicting fetishism and child pornography. Soon, as the story went, viewers were dependent on pornography for the supercharged arousal it offered, causing ordinary sex to pale in comparison. The path could go only downhill, ending in sexual addiction, antisocial behavior, and personal ruin. Sexually explicit visuals also communicated information about unfamiliar behavior—anal sex, bestiality, group sex—which enterprising and curious viewers would be inclined to try for themselves, thus expanding the perverse forms desire might take. In this manner, pornography served to influence norms, suggesting that hedonism, sex for pleasure, and promiscuity were acceptable. The proof of this was easily seen, witnesses claimed, offering personal and professional anecdotes as evidence. The social scientists who testified about what they had discovered to be the thin connection between sexually explicit material and sexual violence were easily overwhelmed by melodramatic recitations of personal anecdote and assertions of moral certainty.

No visual artists or art groups were called to testify.[15] The absence of spokespersons for the visual arts community was striking, given the commission's intense preoccupation with images and the potentially serious impact of its restrictive recommendations on imagemakers. A moderate panelist, *Woman's Day* editor Ellen Levine, occasionally raised questions about the relationship between the images found in the photography of Bruce Weber, Robert Mapplethorpe, and Helmut Newton and the pornographic images

14. The falsity of this claim is made evident by the recent right-wing attack on the National Endowment of the Arts over the "blasphemy" and "obscenity" contained in the work of Andres Serrano and Robert Mapplethorpe.

15. In contrast to visual artists, print, and literary groups turned out in force. The commission heard testimony from the National Writers Union, Writers Guild, Association of American Publishers, the American Library Association, the Freedom to Read Committee, Bantam Books, and Actors Equity Association.

under discussion, asking about the impact of new regulation on their work. Since most commissioners seemed unfamiliar with contemporary work, the discussion never developed. But unlike writers' groups who vigorously testified about the possible impact of censorship on their writing, visual and graphic arts groups, as well as individual artists, were silent. The only testimony given on behalf of groups connected to the actual production of visual images was offered by trade organizations (the Motion Picture Association of America, the Adult Film Association of America, and the National Cable Television Association), a freelance porn producer, and representatives of several men's magazines, but they rarely addressed issues of interpretation and meaning. It is unclear if visual groups were absent because of their unwillingness to testify or their ignorance of the proceedings, but their absence was a serious loss.

II. Interpreting Visual Images

The commission's campaign against sexually explicit images was filled with paradox. Professing belief in the most naïve and literalist theories of representation, the commissioners nevertheless brilliantly used visual images during the hearings to establish "truth" and manipulate the feelings of the audience. Arguing that pornography had a singular and universal meaning that was evident to any viewer, the commission staff worked hard to exclude any perspective but its own. Insisting that sexually explicit images had great authority, the commissioners framed pornography so that it had more power in the hearing than it could ever have in the real world. Denying that subjectivity and context matter in the interpretation of any image, they created a well-crafted context that denied there was a context.

The foremost goal of commission was to establish "the truth" about pornography, that is, to characterize and describe the sexually explicit material that was said to be in need of regulation. Pornographic images were shown during all public hearings, as witnesses and staff members alike illustrated their remarks with explicit, fleshy, often full-color images of sex. The reticence to view this material that one might have anticipated on the part of fundamentalists and conservatives was nowhere to be seen, though the anomaly was not lost on wags in the audience, who jokingly referred to "the federally funded peep show." The commission capitalized on the realistic representational form of still photos and movie and video clips, stating that the purpose of viewing these images was to inform the public and themselves about "what pornography was really like." Viewing was carefully orchestrated, and a great deal of staff time went toward organizing the logistics and technologies of viewing. Far from being a casual or minor enterprise, the selection and showing of sexually explicit images constituted one of the commission's major interventions.

In fact, visual images dominated the hearings at all times. During screenings, pornographic images consistently captured the audience's attention with a reliability that eluded the more long-winded witnesses. The images were

arresting, vivid, memorable, and, one had to suspect, not infrequently arousing. A rustle of excitement swept through the audience at the announcement of each showing. The chance to see forbidden material had obvious appeal. In between slide shows, the images of sex still loomed large, as witnesses testified under a blank projection screen whose unblinking, steady eye served as a reminder of the pornography whose nature had been characterized with seemingly documentary precision. Residual effects were palpable, too, in the aroused emotional state of the audience and commissioners, which made dissent not only unwelcome, but incomprehensible and personally discrediting as well.[16]

The structure of viewing was an inversion of the typical context for viewing pornography. Normally private, this was public, with slides presented in federal courthouse chambers before hundreds of spectators in the light of day. The viewing of pornography, usually an individualistic and libidinally anarchic practice, was here organized by the state—the Department of Justice, to be exact. The normal purpose in viewing, sexual pleasure and masturbation, was ostensibly absent, replaced instead by dutiful scrutiny and the pleasures of condemnation.

These pleasures were intense. Some had called the commission a show trial in which pornography was to be found guilty, but if so, it seemed scripted by the staff of "Saturday Night Live." The atmosphere throughout the hearings was one of excited repression: witnesses alternated between chronicling the negative effects of pornography and making sensationalized presentation of "it." Taking a lead from feminist antipornography groups, everyone had a slide show: the FBI, the U.S. Customs Service, the U.S. Postal Service, and sundry vice squads. At every "lights out," spectators would rush to one side of the room to see the screen, which was angled toward the commissioners. Were the hearing room a ship, we would have capsized many times.

Alan Sears, the executive director, told the commissioners with a grin that he hoped to include some "good stuff" in their final report, and its two volumes and 1,960 pages faithfully reflect the censors' fascination with the thing they love to hate. Although the commission stopped short of reproducing sexually explicit images in a government document, the enthusiastic voyeurism that marked the hearings is evident in the report. It lists in alphabetical order the titles of material found in sixteen adult bookstores in six cities: 2,370

16. A number of potential witnesses told me that they were afraid to testify, in some cases declining actual invitations and in other cases deciding against requesting to speak. They feared hostile and humiliating cross-examination and, for producers of sexually explicit material, police retaliation in the form of harassment, investigation, and potential prosecution. Fear of reprisal was especially common among the freelance, and often more innovative, producers of sexually explicit material, whether pornography or radical political graphics. As independent producers, they could not rely on large parent organizations to offer legal protection and financial backing (and, some implied, payoffs to corrupt vice cops). With only modest financial resources at hand, the prospect of disrupted business or costly legal battles (even if ultimately victorious) spelled financial disaster. Most small producers felt it was prudent not to testify, leaving the job to mainstream men's magazines not known for radical sex politics or innovative graphics.

films, 725 books, and 2,325 magazines, beginning with *A Cock between Friends* and ending with *69 Lesbians Munching*. A detailed plot summary is given for the book *The Tying Up of Rebecca*, along with descriptions of sex aids advertised in the books, their cost, and how to order them. The report describes photographs found in ten sexually explicit magazines, for example, *Tri-Sexual Lust*, *Bizarre Climax No. 9*, *Every Dog Has His Day*, and *Pregnant Lesbians No. 1*. The interpretive approach may not be on the cutting edge of photographic criticism, but here it earnestly slogs along for thirty-three pages ("one photograph of the female performing fellatio on one male while the other male's erect penis rests on her cheek" and "one close-up photograph of a naked Caucasian male with the testicles of another naked Caucasian male in his mouth").[17]

The commission viewed a disproportionate amount of atypical material, which even moderate commissioners criticized as "extremely violent and degrading."[18] To make themselves sound contemporary and secular, conservatives needed to establish that pornography was violent rather than immoral and, contradicting social science evidence, that this violence was increasing.[19] It was important for the panel to insist that the images presented were "typical" or "average" pornography. But typical pornography—glossy, mainstream porn magazines directed at heterosexual men—does not feature much violence, as the commission's own research (quickly suppressed) confirmed.[20] Yet the slide shows did not present many carefully airbrushed photos of perfect

17. Descriptions of magazine photographs can be found in the *Final Report*, pp. 1614-1646. Videos and movies are also described, though the narrative concentrates primarily on plot and dialogue. The narrative reproduces long sections of dialogue verbatim, arguably constituting a copyright violation.

18. *Final Report*, statement of Judith Becker and Ellen Levine, p. 199. In addition, they wrote: "We do not even know whether or not what the Commission viewed during the course of the year reflected the nature of most of the pornographic and obscene material in the market; nor do we know if the materials shown us mirror the taste of the majority of consumers of pornography....While one does not deny the existence of this material, the fact that it dominated the materials presented at our hearings may have distorted the Commission's judgment about the proportion of such violent material in relation to the total pornographic material in distribution."

19. Recent empirical evidence does not support the often-repeated assertion that violence in pornography is increasing. In their review of the literature, social scientists Edward Donnerstein, Daniel Linz, and Steven Penrod conclude, "at least for now, we cannot legitimately conclude that pornography has become more violent since the time of the 1970 obscenity and pornography commission" [in *The Question of Pornography: Research Findings and Policy Implications* (New York: The Free Press, 1987), p. 91].

20. The only original research conducted by the commission examined images found in the April 1986 issues of best-selling men's magazines (*Cheri, Chic, Club, Gallery, Genesis, High Society, Hustler, Oui, Penthouse, Playboy, Swank*). The study found that "images of force, violence, or weapons" constituted less than 1 percent of all images (0.6 percent), hardly substantiating the commission's claim that violence imagery in pornography was common. Although the results of this study are reported in the draft, they were excised from the final report.

The study found that the most common acts portrayed were "split beaver" poses (20 percent), other imagery including touching (19 percent), oral-genital activity (12 percent), and activities between two women (12 percent). According to the Audit Bureau of Circulation (ABC) the thirteen top-selling mainstream magazines sold 12 million copies per month (4.2 million copies for *Playboy*, 3.3 million copies for *Penthouse*), with a monthly sales value over $38 million (1984 data).

females or the largely heterosexual gyrations (typically depicting intercourse and oral sex) found even in the more hard-core adult bookstores. The commission concentrated on atypical material, produced for private use or for small, special-interest segments of the market, or confiscated in the course of prosecutions. Slides featured subjects guaranteed to have a high shock value: excrement, urination, homosexuality, bestiality (with over twenty different types of animals, including chickens and elephants), and especially sado-masochism (SM). Child pornography was frequently shown (with no effort made to disguise the identity of the children), despite repeated testimony from the commission's own expert witnesses that severe penalties had made this material virtually unobtainable in the commercial market.

Predictably, the commission relied on the realism of photography to amplify the notion that the body of material shown was accurate, that is, representative. The staff also skillfully mixed atypical and marginal material with pictorials from *Playboy* and *Penthouse*, rarely making a distinction between types of publications or types of markets. The desired fiction was that extreme images were found everywhere and that all pornography was the same. Images existed in a timeless pornographic present, with little attention given to describing an image's date, provenance, conditions of production, intended market, or producer. Although representatives from major men's magazines testified, taking pains to distance what they called the "healthy adult entertainment" in their publications from the sleazy and degraded images, which they agreed deserved censorship, the mud-slinging only reinforced the idea that sexual images were suspect.

The panel's effort to modernize the case against pornography led to complex symbolic and rhetorical gymnastics. The most successful effort was the appropriation of the term *degrading*. Used by some antipornography feminists to describe sexist images, the term was rapidly appropriated to cover images of all sexual behavior that might be considered immoral, since in the conservative worldview, immorality degraded the individual and society. "Degrading" was freely applied to visual images that portrayed homosexuality, masturbation, and even consensual heterosexual sex. Even images of morally approved marital sexuality were judged "degrading," since public viewing of what should be a private experience degraded the couple and the sanctity of marriage.

A more difficult enterprise for the commission was managing the contradiction between the heavy emphasis on "violent" or "degrading" pornography in the hearings and the commission's concerns about more typical sexually explicit images, that is, the *Playboy* problem. Strategically, the panel emphasized atypical material to build a strong case against pornography. But even successful attempts to restrict these images (child pornography, SM, bestiality) would in fact have little impact on pornography available, because they constitute such a small fraction of the market. This reality surfaced in panel discussions periodically, and members' frustration exposed the panel's enduring interest in restricting all sexually explicit material, including mainstream

magazines that had never been judged obscene by the courts. Commissioners complained that the overemphasis on extreme material incorrectly implied that the worst harm of pornography was found at the edges of the porn industry. To the contrary, they stated, the real danger of pornography was in its most acceptable guise, the men's magazine, which endorsed hedonism, promiscuity, and sex without responsibility in homes throughout America.

The visuals, including commentaries, descriptions, and instructions about how to read them, were a crucial part of the commission's discourse. Yet the commission's strategic maneuvers and assertions about sexual images were covert and therefore exempt from argument. Many have commented on the way all photographic images are read as fact or truth because the images are realistic. This general phenomenon is true for pornographic images as well, but it is intensified when the viewer is confronted by images of sexually explicit acts that he or she has little experience viewing in real life. Shock, discomfort, fascination, repulsion, arousal all operate to make the image have an enormous impact and seem undeniably real.

But any photographic image, of course, reflects choice, perspective, intention, and conventions of production. And any collection of images said to represent a body of work—say, a slide show— bears the mark of an editing hand and an organizing intelligence or intentionality. Yet the ritual showing of pornographic images with their accompanying voice-overs throughout the course of the hearings erased the commission's editing hand, guaranteeing that many images and their interpretations would be given the status of unassailable truth. It is difficult to argue with a slide show.

The commission's frame was always a literal one. The action depicted was understood as realistic, not fantastic or staged for the purpose of producing an erotic picture. Thus, images that played with themes of surrender or domination were read as actually coerced. A nude woman holding a machine gun was obviously dangerous, because the gun could go off (an interpretation not, perhaps, inaccurate for the psychoanalytically inclined reader). Images of obviously adult men and women dressed in exaggerated fashions of high school students were called child pornography. Although meaning was said to be self-evident, nothing was left to chance.

Sadomasochistic pornography had an especially strategic use in establishing that sexually explicit imagery was "violent." The intervention was effective, since few (even liberal critics) have been willing to examine the construction of SM in the panel's argument. Commissioners saw a great deal of SM pornography and found it deeply upsetting, as did the audience. Photographs included images of women tied up, gagged, or being "disciplined." Viewers were unfamiliar with the conventions of SM sexual behavior and had no access to the codes participants use to read these images. The panel provided the frame: SM was nonconsensual sex that inflicted force and violence on unwilling victims. Virtually any claim could be made against SM pornography and, by extension, SM, which remains a highly stigmatized and relatively

invisible sexual behavior. Stigma and severe disapproval ensure that one normal channel of information about the unfamiliar, discussion with friends and peers about behavior they engage in, is closed, because the cost to participants is too high. As was the case for homosexuality until recently, invisibility reinforces stigma, and stigma reinforces invisibility in a circular manner.

The redundant viewing and narration of SM images reinforced several points useful to the commission: pornography depicted actual violence; pornography encouraged violence; and pornography promoted male dominance and the degradation of women. Images that depicted male domination and female submission were often shown. An active editorial hand was at work, however, to remove reverse images of female domination and male submission; these images never appeared, though they constitute a significant portion of SM imagery. Amusingly, SM pornography elicited hearty condemnation of "male dominance," the only sphere in which conservative men were moved to critique it throughout the course of the hearing.

The commission called no witnesses to discuss the nature of SM, either professional experts or typical participants. Given the atmosphere, it was not surprising that no one defended it. Indeed, producer of more soft-core pornography joined in the condemnation, perhaps hoping to direct the commission's ire to more stigmatized groups and acts.[21] The commission ignored a small but increasing body of literature that documents important features of SM sexual behavior, namely consent and safety.[22] Typically the conventions we use to decipher ordinary images are suspended when it comes to SM images. When we see war movies, for example, we do not leave the theater believing that the carnage was real or that the performers were injured making the films. But the commissioners assumed that images of domination and submission were both real and coerced.

In addition, such literalist interpretations were evident in the repeated assertions that all types of sexual images had a direct effect on behavior. Witnesses provided the evidence: rapists who were said by arresting officers to have read pornography, and regretful swingers who said their careers were started by exposure to pornography. According to the commission, the danger in sexually explicit images was that they inspired literal imitation, as well as more generalized and free-flowing list. The less diversity and perversity available for viewing, the better.

21. The proclivity of mildly stigmatized groups to join in the scapegoating of more stigmatized groups is explained by Gayle Rubin in her discussion of the concept of sexual hierarchy ["Thinking Sex: Notes for a Radical Theory of the Politics of Sexuality" in *Pleasure and Danger: Exploring Female Sexuality*, ed. Carole S. Vance (Boston: Routledge & Kegan Paul, 1984), pp. 267–319].

22. For recent work on SM, see Gini Graham Scott, *Dominant Women, Submissive Men* (New York: Praeger, 1983); Thomas Weinberg and G. P. Levi Kamel, *S and M: Studies in Sadomasochism* (Buffalo: Prometheus Books, 1983); Gerald and Caroline Greene, *S-M: The Last Taboo* (New York: Grove Press, 1974); Michael A. Rosen, *Sexual Magic: the S/M Photographs* (San Francisco: Shaynew Press, 1986); Geoff Mains, *Urban Aboriginals* (San Francisco: Gay Sunshine Press, 1984); Samols, ed. *Coming to Power*, 2d ed. (Boston: Alyson Press, 1982).

The commission downplayed the most common use of pornography—for arousal during masturbation. To fully acknowledge this use would put the entire enterprise dangerously close to seeming to attack masturbation, a distinctly nineteenth-century crusade that would seem to defy most forms of rhetorical modernization. The idea that sexual images could be used and remain on a fantasy level was foreign to the commission, as was the possibility that individuals might use fantasy to engage with dangerous or frightening feelings without wanting to experience them in real life. This lack of recognition is consistent with fundamentalist distrust and puzzlement about the imagination and the symbolic realm, which seem to have no autonomous existence; for fundamentalists, imagination and behavior are closely linked. For these reasons, the commission was deeply hostile to psychoanalytic theory, interpretation, or the notion of human inconsistency, ambiguity, or ambivalence. If good thoughts lead to good behavior, a sure way to eliminate bad behavior was to police bad thoughts.

The voice-over for the visual segments was singular and uniform, which served to obliterate the actual diversity of people's response to pornography. But sexually explicit material is a contested ground precisely *because* subjectivity matters. An image that is erotic to one individual is revolting to a second and ridiculous to a third. The object of contestation *is* meaning. Age, gender, race, class, sexual preference, erotic experience, and personal history all form the grid through which sexual images are received and interpreted. The commission worked hard to eliminate diversity from its hearings and to substitute instead its own authoritative, often uncontested, frequently male, monologue.

It is startling to realize that many of the Meese Commission's techniques were pioneered by antipornography feminists between 1977 and 1984. Claiming that pornography was sexist and promoted violence against women, antipornography feminism had an authoritative voiceover, too, though for theorists Andrea Dworkin and Catharine MacKinnon and groups like Women Against Pornography, the monologic voice was, of course, female.[23] Although antipornography feminists disagreed with fundamentalist moral assumptions and contested, rather than approved, male authority, they carved out new territory with slide shows depicting allegedly horrific sexual images, a technique the commission happily adopted. Antipornography feminists relied on victim testimony and preferred anecdotes to data. They, too, shared a literalist interpretive frame and used SM images to prove that pornography

23. Major works of antipornography feminism include Andrea Dworkin, *Pornography: Men Possessing Women* (New York: G. P. Putnam & Sons, 1979); Laura Lederer, ed., *Take Back the Night* (New York: William Morrow, 1980); Catharine A. MacKinnon, "Pornography, Civil Rights, and Speech," *Harvard Civil Rights— Civil Liberties Law Review* vol. 20 (Cambridge: Harvard University, 1985), pp. 1-70.

Opinion within feminism about pornography was, in fact, quite diverse, and it soon became apparent that the antipornography view was not hegemonic. For other views, see Varda Burstyn, ed. *Women Against Censorship* (Vancouver: Douglas & McIntyre, 1985) and *Caught Looking: Feminism, Pornography, and Censorship* (New York: Caught Looking, Inc., 1986).

was violent. It was not a total surprise when the panel invited leading antipornography feminists to testify at its hearings, and they cooperated.

In the Meese Commission's monologue, even dissenting witnesses inadvertently cooperated by handing over the arena of interpretation to the commission. Not a single anticensorship witness ever showed a slide, provided a competing frame of visual interpretation, or showed images he or she thought were joyful, erotic, and pleasurable.[24] All lost an important opportunity to present another point of view, to educate, and to interrupt the fiction of a single, shared interpretive frame. Visual images remained the exclusive province of the censors and the literalists. This further cemented the notion that the visual "evidence" was uncontested and indeed spoke for itself. Why did the anticensorship community not do better?

The Meese Commission was skilled in its ability to use photographic images to establish the so-called "truth" and to provide an almost-invisible interpretative frame that compelled agreement with its agenda. The commission's true genius, however, lay in its ability to create an emotional atmosphere in the hearings that facilitated acceptance of the commission's worldview. Its strategic use of images was a crucial component of this emotional management. Because the power of this emotional climate fades in the published text, it is not obvious to most readers of the commission's report. Yet it was and is a force to be reckoned with, both in the commission and, more broadly, in all public debates about sexuality that involve the right wing. Though the commission was not infrequently ridiculed by journalists for its lack of objectivity and its overzealous puritanism, logical objections to its manipulations often faded in the hearing room.

III. Creating a Climate of Sexual Shame

The commission relentlessly created an atmosphere of unacknowledged sexual arousal and fear. The large amount of pornography shown, ostensibly designed to educate and repel, was nevertheless arousing. The range and diversity of images provided something for virtually everyone, and the concentration on taboo, kinky, and harder-to-obtain material added to the charge. Signs were evident in nervous laughter, rapt attention, flushed cheeks, awkward jokes, throat clearing and coughing, squirming in seats, and a charged, nervous tension in the room. Part of the discomfort may have come from the unfamiliarity of seeing sexually explicit images in public, not private, settings, and in the company of others not there for the express purpose of sexual arousal. But a larger part must have come from the problem of managing sexual arousal in an atmosphere where it was condemned.

The rhetoric of the commission suggests that pornographic material is degrading and disgusting and that no decent person would seek it out or respond to it. Although it is obvious that millions of people buy pornography, none of them

24. These witnesses included legal scholars, representatives from the American Civil Liberties Union, the Freedom to Read Committee, and publishers' and authors' groups.

appeared in the hearing room to defend it. And, as the testimony elicited by the panel suggested that porn consumers are likely to be rapists, raving maniacs, and perverts easily detected by their flapping raincoats and drooling saliva, certainly no one present at the hearing was willing to admit to feeling sexually aroused. As a result, anyone who experienced any arousal to the images shown felt simultaneously ashamed, abnormal, and isolated, particularly in regard to homosexual or SM imagery, which had been characterized as especially deviant.

The commission's lesson was a complex one, but it taught the importance of managing and hiding sexual arousal and pleasure in public, while it reinforced sexual secrecy, hypocrisy, and shame. The prospect of exposure brought with it fear, stigmatization, and rejection. Sexual feelings, though, did not disappear; they were split off as dangerous, alien, and hateful, projected onto others, where they must be controlled. Unacknowledged sexual arousal developed into a whirlwind of confused, repressed emotion that the Meese Commission channeled toward its own purpose.

Dissenting witnesses rarely attacked the commission's characterization of pornography. Although they made important arguments about censorship, they left the commission's description of pornography, interpretive frame, and account of subjectivity unchallenged. The commission's visual interventions and narrative voice-over remained powerful because no one pointed to their existence or the mechanisms through which they were created.

No one offered a deconstruction of the commission's visual techniques or offered images that would problematize its constructions. A counter slideshow might have included erotic images from the fine arts as well as from advertising, calling into question the neat category of "the pornographic." It could have historicized sexually explicit imagery by relating images to time, place, genre, audience, and conditions of production. It might have included images of similar bodies and body parts whose context made all the difference in meaning, or included viewers talking about the diversity of their responses to the same image. And it could have included artists talking about erotic creativity. To show positive images of sexual explicitness would have been a radical act.

To be fair, it was extraordinarily difficult to offer a dissenting perspective. The overwhelming emotional climate created by the hearings turned anyone who disagreed into a veritable monster, a defender of the most sensational and unpalatable images shown. The frame demonized pornography, but it also tarnished the reputation of anyone who questioned the commission's program. Most prospective dissenting witnesses correctly perceived that the atmosphere was closer to a witchcraft trial than a fact-finding hearing. Some declined to testify, and others moderated their remarks, anticipating a climate of intimidation.[25]

25. Some producers of sexually explicit material declined to testify, because the commission had no authority to immunize witnesses from criminal prosecution. They feared that their testimony would be used by law enforcement officials to investigate or prosecute them. This was especially true during the Los Angeles hearing devoted specifically to the sex industry, since local officials were just then conducting an especially vigorous effort against producers.

Indeed, an important aspect of the commission's work was the ritual airing and affirmation of sexual shame in a public setting, a practice that was embedded in the interrogatory practices of the chair. Witnesses appearing before the commission were treated in a highly uneven manner. Commissioners accepted virtually any claim made by antipornograpny witnesses as true, while those who opposed restriction of sexually explicit speech were often met with rudeness and hostility. Visual images proved to be the Achilles' heel of anticensorship witnesses, since the witnesses were often asked if they meant to defend a particularly stigmatized image that had just been flashed on the screen, such as *Big Tit Dildo Bondage* or *Anal Girls*. The witnesses were often speechless, and their inarticulateness about images often undercut their testimony.

Sexual shame was also ritualized in how witnesses spoke about their personal experience with images. "Victims of pornography" told in lurid detail of their use of pornography and eventual decline into masturbation, sexual addiction, and incest. Some testified anonymously, shadowy apparitions behind translucent screens. Their first-person accounts, sometimes written by the commission's staff,[26] featured a great elaboration of the sexual damage caused by visual images. To counter these accounts there was nothing but silence: descriptions of visual and sexual pleasure were absent. The commission's chair even noted the lack and was fond of asking journalists if they had ever come across individuals with positive experiences with pornography. The investigatory staff had tried to identify such people to testify, he said, but had been unable to find any. Hudson importuned reporters to please send such individuals his way. A female commissioner helpfully suggested that she knew of acquaintances, "normal married couples living in suburban New Jersey," who occasionally looked at magazines or rented X-rated videos with no apparent ill effects. But she doubted that they would be willing to testify about their sexual pleasure in a federal courthouse, with their remarks transcribed by a court stenographer and their photos probably published in the next day's paper as "porn-users."

Though few witnesses chose to expose themselves to the commission's intimidation through visual images, the tactics used are illustrated in the differential treatment of two female witnesses, former *Playboy* Playmate Micki Garcia and former *Penthouse* Pet of the Year Dottie Meyer. Garcia accused Playboy Enterprises and Hugh Hefner of encouraging drug use, murder, and rape (as well as abortion, bisexuality, and cosmetic surgery) in the Playboy mansion. Her life was endangered by her testimony, she claimed. Despite the serious nature of her charges and the lack of any supporting evidence, her testimony was received without question.[27] Meyer, on the other hand, testified that her association with *Penthouse* had been professionally and personally

26. Statement of Alan Sears, executive director, (Washington, D.C., transcript, 18 June 1985).

27. Los Angeles hearing, 17 October 1985.

beneficial. At the conclusion of her testimony, the lights dramatically dimmed and large blowups of several *Penthouse* pictorials were flashed on the screen; with rapid-fire questions the chair demanded that she explain sexual images he found particularly objectionable. Another commissioner, prepared by the staff with copies of Meyer's nine-year-old centerfold, began to pepper her with hectoring questions about her sexual life: Was it true she was preoccupied with sex? Liked sex in cars and alleyways? Had a collection of vibrators? Liked rough-and-tumble sex?[28] His cross-examination was reminiscent of that directed at a rape victim made vulnerable and discredited by an image of her own sexuality.

The commission's success in maintaining and intensifying a climate of sexual shame depended on the inability of witnesses to address the question of sexuality and pleasure. Most witnesses who opposed greater restriction of sexually explicit material framed their arguments in terms of the dangers of censorship, illustrating their points by examples of literature that had been censored in previous, presumably less enlightened, times. Visual examples were rare. Speakers favored historical, rather than contemporary, examples around which a clear consensus about value had formed. Favored examples were the plays of Eugene O'Neill and D. H. Lawrence's *Lady Chatterley's Lover*. The frame was cultured and high-minded, calling on general principles like free speech and the Bill of Rights.

The motives behind this strategy differed. The small number of witnesses directly associated with the sex industry (producers of X-rated films, books, or magazines) believed that their disreputable image could be uplifted by associating themselves with higher, unassailable principles that had a minimal connection with sexuality. Although they had practical experience with visuals, they judged it a wiser course to say little about their real-world connection. The second group, a much larger number of witnesses representing literary, artistic, and anti-censorship organizations, was totally unprepared to talk about visuals. They had thought little about questions of representation or sexually explicit images, often shared the same unsophisticated premises as the commissioners, and appeared to feel that association with sexuality was potentially discrediting.

The second group was fair game for the chair. Relying on his well-honed prosecutorial abilities, he was selectively relentless. He went right to the heart of witnesses' reluctance to associate themselves with anything sexual, visual, or pleasure-filled. Pointing to the latest slide or holding aloft the latest exhibit, he questioned them about their organization's position on *Hot Bodies* or *Split Beavers*. Did their members produce such images? Did their organization mean to defend such material? Did they think such material should be available?

Like vampires spying crosses and garlic cloves, witnesses shrank back. Having never seen the sexually explicit material or thought about it, having no

28. New York City hearing, 22 January 1986.

well-developed position about sexuality or visual representation, and sensing the increasingly dangerous turf they were being lead into, they said, "No." They were unprepared, speechless, and unwilling to defend anything so patently sexual. The chair had proven his point: even anticensorship advocates would not defend visual pornography. He politely excused them, with bland, if inaccurate, assurances that antipornography efforts would target only indefensible sleaze, not worthy high culture. More important, he appeared to establish a consensus, which included even liberals, that sexually explicit visuals were beyond the pale. Despite their valiant effort, the testimony of anticensorship witnesses never succeeded in deconstructing or interrupting the Meese Commission's rhetorical and symbolic strategies. The right-wing's commitment, however, to controlling symbols means that there will be other times, other battles in which to elaborate a richer, more complex response.

IV. Speaking Sexual and Visual Pleasure
The antidote to the Meese Commission—and by extension all conservative and fundamentalist efforts to restrict sexual images, whether in pornography, sex education, or AIDS information—is a complex one, requiring vigorous response that goes beyond appeals to free speech. Free expression is a necessary principle in these debates because of the steady protection it offers to all images, but it cannot be the only one. We need to offer an alternative frame for understanding images, one that rejects literalist constructions and offers in their place multiplicity, subjectivity, and the diverse experience of viewers. We must challenge the conservative monopoly on visual display and interpretation. The visual arts community needs to employ its interpretive skills to unmask the modernized rhetoric conservatives use to justify their traditional agenda, as well as deconstruct the "difficult" images fundamentalists pick to set their campaigns in motion. Despite their uncanny intuition for choosing culturally disturbing material, their focus on images also contains many sleights of hand, even displacements, which we need to examine. Images even we allow to remain "disturbing" and unconsidered put us anxiously on the defensive and undermine our own response. To do all this, visual artists and arts groups need to be willing to enter public debate and activism, giving up the notion that art or photography is somehow exempt from right-wing crusades against images.

The most robust and energetic response, however, must be to take courage and begin to speak to what is missing, both in the Meese Commission's monologue and in the anticensorship reply: desire, sexuality, and pleasure. Truly dissenting voices and speakers must start to say in public that sexual pleasure is legitimate and honorable, a simple statement that few witnesses in the commission's hearings dared to make. If we remain afraid to offer a public defense of sex and pleasure, then even in our rebuttal we have granted the right wing its most basic premise: sexuality is shameful and discrediting. The rigid, seemingly impenetrable symbolic and emotional façade constructed by

the Meese Commission can, in fact, be radically undermined by insistently confronting it with what it most wants to banish—the tantalizing connection between visual and sexual pleasure.

I am grateful to many individuals for helpful discussions, comments on early drafts, and encouragement, especially Ann Snitow, Frances Doughty, Sharon Thompson, Lisa Duggan, David Schwartz, and Gil Zicklin. Special thanks to Frances Doughty for insightful and invaluable suggestions about writing. Thanks to Carol Squiers for editorial suggestions and to Gayle Rubin for last-minute help.

Over Exposed

An early version of this paper was given at the Society for Photographic Education convention, Rochester, New York, 1989; thanks to the audience for a stimulating exchange and to the Women's Caucus for Inviting me. Portions of this argument first appeared in "The Meese Commission on the Road," *The Nation,* 2-9 August 1986, pp. 65, 76-82.

Acknowledgments

ANY PROJECT of this scope inevitably relies on the hard work, intelligence, and goodwill of a number of different people. There were no acknowledgments in the first edition of this book, so I'd like to thank all those who contributed to it, and to this edition as well.

The book could not have been done without the support, ideas, and all-round assistance of Philomena Mariani, who offered crucial help in shaping the final contents of the original book; David Sternbach, who was involved in the editorial process from the beginning and who titled the collection; and Thatcher Bailey, the founder of Bay Press and an astute reader of critical writing. Andy Grundberg had the idea for an unrealized, co-edited tome, which provided a base for the original volume. Barbara Kruger, Maurice Berger, and Therese Lichtenstein all contributed ideas and encouragement, even in casual conversation. Sally Brunsman pushed me to do a revised edition of *The Critical Image: Essays on Contemporary Photography*, which forms the basis for this new book, and Lee Damsky had endless discussions about it with me. André Schiffrin acquired the title after Bay Press's untimely demise, and Grace Farrell ably saw it through the transition and into print. I am grateful to the writers/critics/scholars who are featured in both editions, for their insightful, often provocative contributions. I thank the photographers for making the photographs that inspired us—whether positively or negatively—to write about them. And I wish to remember Richard Bellamy, who gave me so much.

CAROL SQUIERS

About the Contributors

GEOFFREY BATCHEN, an Australian cultural critic, is currently teaching in the Art and Art History Department at the University of New Mexico in Albuquerque. His first book, *Burning with Desire: The Conception of Photography*, was published by the MIT Press in 1997. His second book, *Each Wild Idea: Writing, Photography, History*, will be published in 2000 by the MIT Press.

DEBORAH BRIGHT has received international recognition for her artwork and her critical essays on photography and cultural politics, which have been published in *Afterimage, Exposure, Views*, and *Art Journal*. She edited *The Passionate Camera: Photography and Bodies of Desire* (Routledge, 1998), and is a professor of photography and art history at the Rhode Island School of Design.

VICTOR BURGIN, artist and writer, was born in England and now lives in California. He is the editor of *Thinking Photography* and coeditor of *Formations of Fantasy*. A collection of his essays, *The End of Art Theory*, and a comprehensive book of his photographic work, *Between*, have also been published. He is a member of the editorial board of *New Formations*. Burgin is chair and professor of art history at the University of California, Santa Cruz, where he teaches critical theory in the Art History and History of Consciousness programs.

ROSALYN DEUTSCHE, art historian and critic, is a member of the editorial board of *October*.

TIMOTHY DRUCKREY is an independent curator, critic, and writer concerned with issues of photographic history, representation, and technology. He has taught in graduate programs at the International Center of Photography, the School of Visual Arts, and the Center of Creative Imaging. He was coeditor of *Culture on the Brink: Ideologies of Technology*, and *Electronic Culture: Technology and Visual Representation*, and editor of *Iterations: The New Image*.

JAN ZITA GROVER lives in Duluth, Minnesota. She curated the exhibition *AIDS: The Artists' Response* at Ohio State University in 1989 and has contributed to several anthologies, most notably *AIDS: Cultural Politics/Cultural Activism* (1987), *Fluid Exchanges: Artists and Critics in the AIDS Crisis* (1991), and *A Leap in the Dark: AIDS, Art and Contemporary Cultures* (1993). She is the author of *North Enough: AIDS and Other Clear-Cuts* (Graywolf Press, 1999), *Northern Waters* (Graywolf Press, 1999), and is working on two new books, *Ditched and Drained: A Minnesota Story* and *Dulcimore*, a study of contemporary folk revival music.

ANDY GRUNDBERG is an art critic whose reviews of photography exhibitions and books have appeared regularly in the *New York Times* since 1981. He is the coauthor of *Photography and Art: Interactions Since 1946* (1987) and co-curator, with Kathleen McCarthy Gauss, of the exhibition of the same title. His is also author of a book about graphic designer *Alexey Brodovitch* (1989).

THERESA HARLAN is the director of the Carl Gorman Museum in the Department of Native American Studies at the University of California at Davis. She has writtne for photographic journals including *Aperture, Exposure, San Francisco Camerawork, Views*, and *Contact*. She is an enrolled member at Santo Domingo Pueblo in New Mexico and currently lives in Vallejo, California.

SILVIA KOLBOWSKI, artist and writer, has contributed to *Blasted Allegories*, a book of artists' writings, *Artforum*, and *Parachute*.

ROSALIND KRAUSS, distinguished professor of art history at Hunter College, City University of New York, is the author of *Terminal Iron Works: The Schulpture of David Smith* (1972), *Passage in Modern Sculpture* (1977), and *The Originality of the Avant Garde and Other Modernists Myths* (1986). She is editor and cofounder of *October*.

KOBENA MERCER is currently a visiting professor in the Africana Studies Program at New York University.

CHRISTIAN METZ is director of research and director of the Theory of Film Section at the Centre Universitaire Américain du Cinéma and the Ecole des Hautes Etudes en Sciences Sociales, Paris. Three of his books on cinema have been translated into English.

KATHY MYERS is a television producer and director for the British Broadcasting Corporation. She has written extensively on advertising and is the author of *Understains: The Sense and Seduction of Advertising*. She produced a six-part television series on advertising for the BBC.

GRISELDA POLLOCK is a senior lecturer in the history of art and director of the Centre for Cultural Studies at the University of Leeds, England. She is coauthor, with Rozsika Parker, of *Old Mistresses: Women, Art and Ideology* and *Framing Feminism: Art and the Women's Movement 1970-1985*, and the author of *Vision and Difference: Femininity, Feminism and the Histories of Art*.

ABIGAIL SOLOMON-GODEAU, photography critic, art historian, and curator, has published widely and curated shows on subjects as diverse as post-modernists art photography and wartime devastation of Hiroshima. A collection of her essays, *Photography at the Dock*, was published by the University of Minnesota Press.

CAROL SQUIERS, currently senior editor of *American Photo*, was photography critic for *Vanity Fair* and *The Village Voice*, and is a regular columnist for *Artforum*. She has contriubted to a wide variety of publications including the *New York Times*, *Vogue*, the *New York Post*, *Parkett*, *Art in America*, *Art News*, and *Aperture*. She lives in New York City.

CAROLE S. VANCE, an anthropologist, teaches at Columbia University and writes on issues of representation. She is the editor of *Pleasure and Danger: Exploring Female Sexuality*.